MW01001140

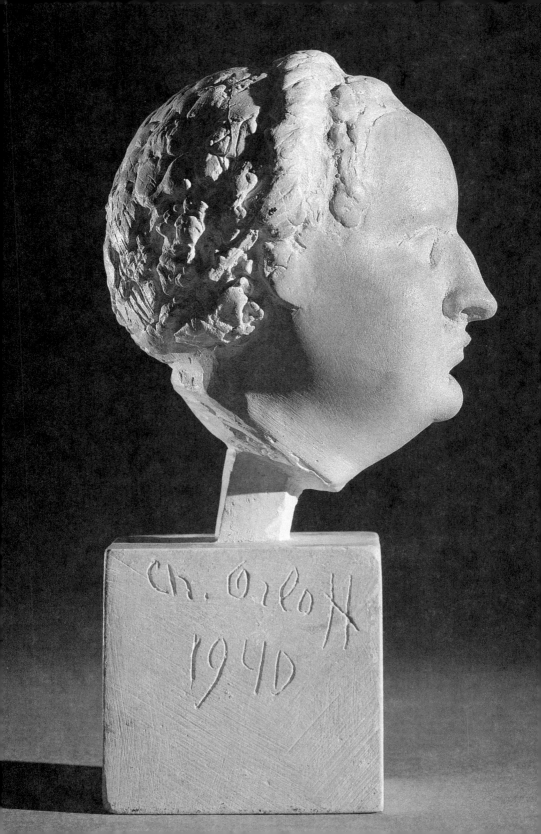

Sculpting a Life

Chana Orloff between Paris and Tel Aviv

Paula J. Birnbaum

BRANDEIS UNIVERSITY PRESS

Waltham, Massachusetts

Brandeis University Press

2022 © Paula J. Birnbaum

All rights reserved

Manufactured in the United States of America

Designed by Richard Hendel

Typeset in Miller and Bunday Sans by Rebecca Evans

For permission to reproduce any of the material in this book,
contact Brandeis University Press, 415 South Street, Waltham MA 02453,
or visit brandeisuniversitypress.com

Library of Congress Cataloging-in-publishing Data

Names: Birnbaum, Paula, author.

Title: Sculpting a life: Chana Orloff between Paris and Tel Aviv / Paula J. Birnbaum.

Description: Waltham, Massachusetts: Brandeis University Press, [2023] |
Series: HBI series on Jewish women

Includes bibliographical references and index.

Summary: "The first biography of sculptor Chana Orloff, and the first to include
stories from her unpublished 'memoir,' which focus on the artist's early life
in Ukraine, her family's move to Palestine and Orloff's life there (1905–1910),
and her subsequent years between Paris and Tel Aviv" —Provided by publisher.

Identifiers: LCCN 2022037390 | ISBN 9781684581139 (cloth) | ISBN 9781684581146
(ebook)

Subjects: LCSH: Orloff, Chana, 1888–1968. | Sculptors—Israel—Biography. |
Women sculptors—Israel—Biography. | BISAC: BIOGRAPHY & AUTOBIOGRAPHY /
Artists, Architects, Photographers | ART / Sculpture & Installation

Classification: LCC NB979.O65 B57 2023 | DDC 730.92 [B]—dc23/eng/20220810
LC record available at https://lccn.loc.gov/2022037390

5 4 3 2 1

For Neil, Jordan, and Mariel

CONTENTS

Color plates follow page 172

INTRODUCTION

I first encountered Chana Orloff's (1888–1968) work when I was researching my book *Women Artists in Interwar France: Framing Femininities* (2011). Standing in her studio in Paris, I was captivated by the rows of plaster, wood, marble, and bronze portrait busts lining the wooden shelves on several skylit walls.[1] The sculpted faces—portraits of her friends, fellow émigré artists and intellectuals—are grouped together as if in hushed conversation (see figure I.1). Who were these people, and what could their portraits tell me about this fascinating woman? Orloff produced over five hundred documented sculptures in a range of materials. In light of the constraints that she faced as a woman and a Jewish émigré, her productivity and commercial success is astounding. She made her career in France and Israel, but always returned to this Parisian studio to make her work. In 1926 she commissioned the notable French architect Auguste Perret, one of Le Corbusier's teachers, to design this studio as one of the first "livework" spaces for artists in the Montparnasse neighborhood. It became a popular meeting place for international artists, writers, and intellectuals, especially those from Palestine and later Israel. My first visit to this magical place led to a decades-long fascination with Orloff and a desire to share her life story with a broader public.

In 1924, Orloff, age thirty-six, hired the American photojournalist Thérèse Bonney (born Mabel Thérèse Bonney) to photograph her in her studio to promote an upcoming exhibition (see figure I.2). This photograph reveals Orloff's imposing physical presence, muscular body type, and forceful attitude. What I find most fascinating about the image is Orloff's bold pose. She sits on a pedestal, her arms folded proudly across her chest. I'm reminded of the Greek myth of Pygmalion, the sculptor who fell in love with a statue of a woman he created. Only in this case, the artist, not merely the sculpture, is a woman. She is both the maker and the object of our gaze. Her determined posture echoes that of *Man with a Pipe* (1924), her life-size full-body portrait

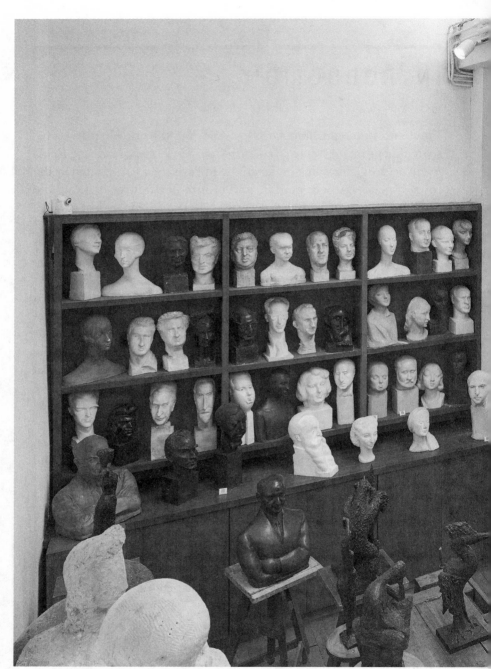

Figure I.1. Ateliers-Musée Chana Orloff, Paris.

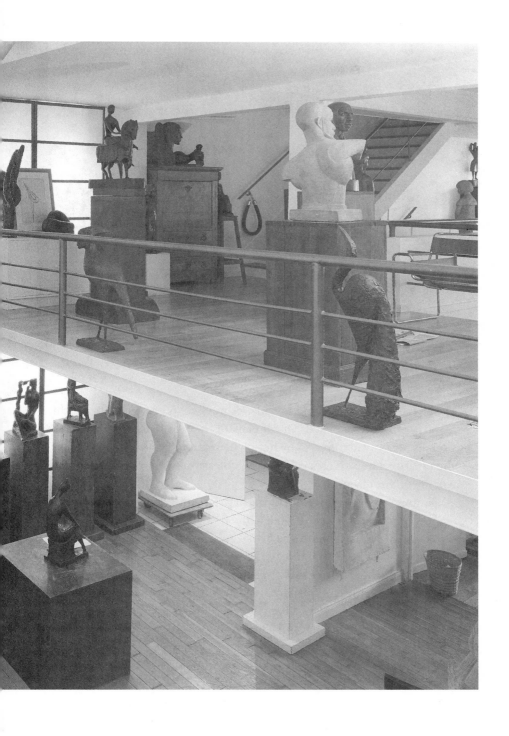

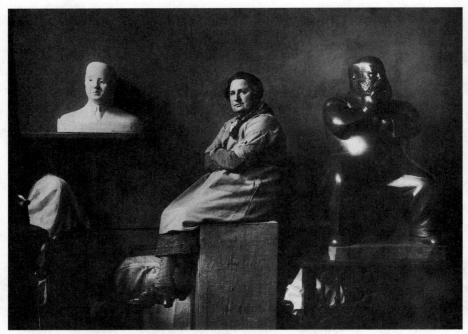

Figure I.2. Thérèse Bonney, Chana Orloff in her studio, 1924.

of her Russian artist friend David Ossipovitch Widhopff to her right. By sitting on the pedestal, Orloff elevates her own status as a professional sculptor surrounded by her own creations. And in that process, she positions herself as a self-made professional woman artist who is worthy of our attention.

Bonney's 1924 photograph of the artist prompted me to ask a series of questions that inspired this book, the first biography of Orloff and the first book in English about the artist. Assuming the pose was Orloff's own idea, what gave her the audacity to hop onto that pedestal and model beside her own work with such self-confidence? Her chutzpah reminds me of stories about my great-grandmother, who took over the family business in the Lower East Side of Manhattan in the early 1930s. As an American feminist and Francophile whose Ashkenazi Jewish roots also lead back to Ukraine, I have a special identification with Chana Orloff. She inspires me with her fearlessness and determination in forging an international career despite so many obstacles. With this biography I show how women artists like Orloff, who led independent

lives in a constant state of migration, produced significant bodies of work that challenge us to reconsider who makes history.

Orloff was a Jewish émigré many times: first a forced migration from the brutal pogroms of Ukraine to Palestine; then a voluntary move to study fashion and art in Paris; followed by a forced exile in Geneva during the Nazi Occupation of Paris in World War II; and even a fourth time with her return to Paris as a victim and survivor of the Nazi atrocities. She chose to make a second home in Israel after the founding of the state in 1948. For the final two decades of her life (1948–1968), Orloff traveled back and forth frequently between Paris and Tel Aviv. As a result, she experienced the contradictory feelings of displacement and belonging associated with moving from one country to another, even after the torment and upheaval of war required such dislocation. Migration is a key component of her experience of Jewish diaspora and of both living and making art as a woman in French and Israeli contexts, leading her repeatedly to renegotiate different aspects of her identity.

Orloff had strong connections to three nation-states—Russia, France, and Israel. This book asks how she navigated the friction between "cosmopolitanism," which, according to cultural critic Ien Ang, "endorses a borderless, global world," and nationalism, which "inevitably establishes boundaries, and the separating out of 'us' and 'them.'"[2] In Bonney's photograph, we can see how Orloff is using her unique blend of cosmopolitan modernity and hybrid French and Russian identities to enhance her broad appeal. The image was from a series she commissioned to promote her international reputation as a Parisian *femme artist moderne* (modern woman artist). Popular magazines like *Vogue*, *Vu*, and *Vanity Fair* regularly featured such images of young, ostensibly emancipated, and economically independent women artists in Paris in the 1920s. On the one hand, the combination of her cropped hairstyle and stylish heels signals the look of the French *garçonne* (tomboy), made famous by the publication in 1922 of Victor Margueritte's controversial and bestselling novel *La Garçonne*.[3] On the other hand, the smock and the bandanna around Orloff's neck call to mind contemporary imagery of the Russian woman worker. In other photographs taken in her studio during this period, Orloff donned a headscarf, which recalls both Jewish traditional dress and

the activism of women in the Russian workforce.[4] Just over a decade after emigrating to France from Ukraine, through Palestine, Orloff was celebrated by critics as "the Russo-French sculptress," "portraitist of Montparnasse," "one of the leaders of modernism in Paris," and "the greatest of women sculptors." Their language connected her work with a diversity of national and cosmopolitan styles, from academic French sculpture, to Russian folk art, to the cubist avant-garde, associated with the émigré artists of Montparnasse.[5] Although Orloff welcomed this broad recognition, she resisted rigid categorization of her work in terms of gender, style, and nationality.

Orloff's story as a commercially successful international female artist is exceptional, and her personal migration story has strong resonance today, when women like her continue to navigate what cultural theorists describe as "transnational" lives. The American pacifist Roger Bourne coined the term "transnationalism" in 1916 in a speech to the Menorah Society at Harvard University entitled "The Jew and Trans-National America," during which he described the Jewish diaspora and Zionist movement as "a model for how cultures could be both strongly cohesive and very flexible at the same time."[6] While critics did not use the words "transnational," "migrant," "émigré," or "diaspora" during Orloff's lifetime, I am engaging loosely with these contemporary terms to offer a new perspective on both her identity and work as a Jewish artist who had a divided sense of home and belonging.

Orloff exuded perseverance and defied categorization from a young age. As a Jewish girl in Ukraine, she refused the traditional path to early marriage and motherhood. She sought training as a seamstress so she could earn her own living. When her Zionist family moved to Palestine in 1905, she continued to challenge social conventions for women. Finding neither professional nor personal fulfillment as a young woman in Palestine, Orloff moved to Paris, the capital of couture, to study dressmaking. After two years, dissatisfied by her career, she pivoted to the world of fine art.

During her artistic formation, Orloff straddled academic and avant-garde circles. She became close friends with many of the Jewish émigré artists of Montparnasse, most notably Amedeo Modigliani, Marc Chagall, and Chaim Soutine. Like them and other émigré colleagues working in sculpture, she looked to diverse artistic traditions

for inspiration. Experimenting with avant-garde styles and sculpting techniques prevalent in Paris just before and after World War I, she developed her own unique approach to representing the power of both female and male bodies. She regularly exhibited her work to great acclaim at the annual Parisian salons and had solo shows in prestigious galleries across Europe, the United States, Palestine, and later Israel. Her work stands out for its monumental treatment of domestic themes such as pregnancy and motherhood, and challenges stereotypes often associated with women's art.

Throughout her career, Orloff navigated diverse critical interpretations of her multinational identity. Critics usually emphasized her association with one country more than another, depending on their own nationality and background and the context of their commentary. The phrase "École de Paris," which critics used loosely to refer to modern art produced in Paris after World War I, was recast in the mid-1920s by a group of French critics in a xenophobic attempt to identify a school of "genuinely" French artists (the "École Française"), at the expense of foreigners and especially Jews.[7] These antisemitic critics believed the arrival of so many Jewish émigré artists in Paris in the first decades of the twentieth century endangered French cultural well-being. Nonetheless, for over fifty years French curators and critics celebrated Orloff as one of France's leading women sculptors.

Many Israelis writing about Orloff after the birth of the state wanted to claim her for their own, "a faithful daughter" who "returned home" after being out in the world.[8] Conforming to the dominant Zionist ideology, they tried to reconcile the fact she lived in Paris by highlighting her Jewish identity and commitment to Israel. Soon afterward, she was commissioned for numerous Zionist public monuments honoring the role of women and men in pivotal moments in Israeli history, and was considered an important artist in the early years of the state.

Although she sought and received strong critical endorsement of her work in both France and Israel, Orloff's own sense of home was always in question. She recognized that her hybridity was a strength and created a powerful, complex voice that was not limited by the concept of a single nation-state. This strategy enabled her to speak from multiple subject positions to diverse audiences over the course of her long and prolific career.

Orloff's gender, Jewish identity, and social class play an important role in her own questioning of place and status. When asked about her early stylistic evolution in Paris in a 1959 interview with journalist Sioma Baram in the French-Jewish magazine *L'Arche*, she reflected: "The cubists reproached me a lot." One time the French cubist artist André Lhote told her she needed "to do so little to become one of us."[9] He suggested that by adding "less individuality" to her work, she could fit in more easily with the mainstream cubist aesthetic of that time. "He thought I wouldn't get anywhere," she added. Although Orloff experimented productively with cubist theories and formal strategies, she was never interested in "becoming one of them" or aligning her work consistently with one avant-garde style or group. She described her experience of her early years in the Parisian art world as one of gendered competition with her male colleagues: "My dear comrades provoked me so that I would leave, so that I would disappear."[10]

In Orloff's case, although she became a French citizen and contributed to nation-building in Israel, she was not truly at home in either country. In France she experienced antisemitic persecution during the Occupation. Even after returning to Paris after the war, she chose to stay. She also never completely belonged in Palestine and later Israel. In her early days living there, she felt misunderstood as an independent young woman and did not fit in. Later, as a mature and celebrated artist, she contributed to nation-building by constructing Zionist portraits and monuments. Orloff may have found advantages to being placeless or in-between, as a woman and a Jew. Her life story suggests that there are new ways of conceptualizing artistic identity that consider the fact that artists often have multiple affiliations that can complement each other in their work.[11]

Orloff's work has been featured in numerous group exhibitions in international museums focusing on the multicultural group of largely Eastern European Jewish artists known as the "Circle of Montparnasse," following Kenneth Silver and Romy Golan's groundbreaking exhibition of that title at the Jewish Museum, New York (1985).[12] Golan contributes important insights on Orloff's engagement with portraiture in *Paris in New York*, also organized by the Jewish Museum, New York (2000).[13] A number of Orloff's works are featured in *Chagall, Modigliani, Soutine: Paris pour école, 1905–1940* (Musée d'Art et d'Histoire

du Judaïsme [MAHJ], Paris, 2020).[14] Although this exhibit gives her a more prominent role than any other previously focused on the Jewish artists of École de Paris, the fact that her name is excluded from the title indicates that she usually plays a supporting role to these three artists. A few of her works have been included in recent exhibitions focused on the work of women artists and modernism.[15] There are very few publications devoted to Orloff, especially in English, and none of them, apart from my own articles preceding this book, analyze in depth the complexities of gender, Jewishness, and the tension between cosmopolitanism and national identity in her work.[16] By expanding knowledge about her extraordinary life and work, this book will encourage future curators and scholars to delve deeper into her important contributions to the history of modern art as well as Jewish history.

The project of writing an artist's biography, specifically a biography of a woman like Orloff who lived in diaspora, is complicated by the fact that the archival research itself mirrors the complexity of the artist's life and work. One of the reasons her biography had not been written before is that her itinerant life does not fit neatly into the discipline of art history, which historically was written according to fixed notions of national style grounded in a stable idea of the nation-state. Art associated with the history of Palestine, the foundation of Israel, and the Zionist movement over the course of the twentieth century is deeply implicated in these questions. The diasporic nature of Orloff's life also presents linguistic complexities in conducting research in an archive that exists in diverse locations.

This book is the first to include stories Orloff told during a series of unpublished interviews, conducted in Tel Aviv and Paris and written in Hebrew in 1957 by the late Israeli journalist Rivka Katznelson.[17] Katznelson interviewed the artist over several months, when Orloff was sixty-nine years old. Katznelson intended to develop and publish the interviews as the first biography of the artist, written in the first-person voice in the style of a memoir. It focuses on Orloff's early life in Ukraine, her family's move to Palestine and her life there from 1905 to 1910, as well as her early years in Paris (through World War I). I will hereafter refer to this unpublished document as Orloff's interviews. It presents a specific narrative that is full of anecdotes, some of them embellished, surrounding the artist's life story. Orloff repeated and

sometimes conflated some of these stories in later interviews with journalists and curators. For example, when offering her own "origin story" about first becoming an artist, in her interviews she says that her very first sculpture was a small portrait of her grandmother. However, Orloff later told Haim Gamzu, director and chief curator of the Tel Aviv Museum of Art, that the very first time she attempted to try her hand at sculpture, she thought of Hayim Nahman Bialik, the Hebrew national poet, and began kneading his portrait in clay.[18] Whether or not either anecdote is true, the narrative about Bialik demonstrates how Orloff wished to publicly self-fashion her image as an émigré artist compelled to contribute to the visual culture of Zionism in her very first sculpture.

As with any interview, memoir, or biography, Katznelson's account does not contain all the facts of Orloff's life, but highlights specific events and anecdotes strategically in order to shape a particular narrative. I have incorporated some of these stories into the biography. The most prominent leitmotifs in the interviews are Orloff's sense of fierce independence, unfaltering strength, and persistence in the face of trauma and displacement. Through the use of the first-person narrative, both author and subject wished to show how these experiences affected Orloff, and how they guided her to become a prominent international public figure. In my own role as Orloff's first biographer, I, too, have had to make choices about the way her story is told. I chose to highlight key events and works of art that help the reader understand how Orloff's complex relationship to identity and place influenced her life and work.

When Katznelson shared the first draft of the manuscript with Orloff, soliciting her feedback, the artist rejected it, refusing its publication. Although there is no documentation of why Orloff responded in this way, her handwritten notes in the margins of the typescript provide some clues. These notes indicate that when she thought certain information was irrelevant or too personal, she felt it should be omitted. In the course of this study, I analyze some of these notes in order to show how she wished to fashion her public reputation.

Orloff's unpublished interviews function as what Pierre Nora refers to as "lieux de memoire" ("sites of memory").[19] According to Nora, memoirs and biographies both enrich and complicate our understanding of an individual's life by raising questions directed to the

process of memory itself. Which stories did Orloff choose to share with Katznelson, and which did she omit? How did Katznelson then choose to emphasize specific anecdotes, while omitting others from her text, to create an interesting narrative of the arc of the artist's life? Given that Orloff marked specific passages in the text that she did not wish the public to read, and then ultimately refused publication of the manuscript, how do we, as readers, negotiate questions about the translation of a private life into public memory? How does the intricate dance between author and subject, as well as memoir or biography and memory, challenge the reader to question assumptions? These are some questions to keep in mind as we explore Chana Orloff's life story.

In addition to Katznelson's interviews with the artist, my account of Orloff's early life also relies on the recollections of two of the artist's siblings, also written in Hebrew. Her older brother Zvi Nishri was the founder of the physical education movement in Israel, and the first physical education teacher at the Hebrew high school. Nishri also founded the Maccabi movement and the Hebrew Scouts movement in Israel. His commentary offers important insights into Orloff's early life in Ukraine and the experiences of Jews arriving in Palestine during the Second Aliyah (immigration to the Holy Land), 1904–14. Orloff's older sister Miriam Eitan wrote a short unpublished narrative of the family's early life as part of her desire to document her sister's career, which has been useful in understanding Orloff's early choices in the context of how her family members presented them.

To provide new insights into Orloff's personal life and career as a visual artist and a woman, I incorporate correspondence in multiple languages found in archives located across three continents; published and unpublished writings of her friends and colleagues; and many interviews with journalists, family members, and other figures who knew Orloff. I also conducted interviews with still-living subjects in three different countries who knew Orloff and her family. Photographs scattered over many locations gave me insights in documenting Orloff's life and existing work, and also revealed works lost due to the events through which she lived. In compiling this research, I observed the ways in which museum archives and other institutional records with a stake in the artist's legacy reproduce nationalist ideologies and prejudices. For example, in France her work is perceived of as French, and

her Jewish identity is not foregrounded, whereas in Israel her work is understood as Zionist and noncolonial.

This project also required me to contextualize the artist's life and work within the changing nature of Ashkenazi Jewish identity over the course of the twentieth century due to antisemitism in Russia and its territories, as well as in France with its history of the Dreyfus Affair and the Nazi Occupation. I also considered Orloff's position within the changing nature of Zionism from a politics of liberation in the early twentieth century, to the nationalism of a new nation-state, to a postwar redemptive brand of Zionism. Finally, Orloff's Parisian home, which is now run by her family members as both a museum and an archive of the artist's work from 1926 up to the present, plays an important role in constructing her legacy.

Chana Orloff's multiple migrations and forced exiles, combined with her gender and Jewish identities, had a cumulative effect.[20] Although terms like "diaspora," "transnationalism," and "cosmopolitanism" evade easy definition, this book shows how this framing lends itself to new directions in the study of Orloff's life and work. Considering the sheer diversity of archival sources, languages, and geographies, perhaps there is currently no word or concept that truly characterizes Orloff's career. This would help explain the lack of a biography to date, and the partiality of prior accounts of Chana Orloff. This project proposes a new model for investigating artists' lives and works, especially women and gender nonconforming artists, as well as members of the École de Paris, who may also identify as being multinational or placeless. Women artists like Orloff have been overlooked by history and excluded from the canon of modernism within art history. Although feminist art histories have been criticized for their overreliance on biography at the expense of rigorous analysis of an artist's work, I argue that biographies are essential for contesting such omissions.[21] They expand our knowledge of the complex lives of our subjects and how their choices and life circumstances informed their work. By offering in-depth research into Chana Orloff's life and work, through her stories of multiple migrations, I aim to challenge notions of center and periphery as well as provide a model that encourages a more global and inclusive art history.[22]

CHAPTER 1
Ukrainian Beginnings,
1888–1905

A few days after Chana Orloff's birth, on July 12, 1888, she had trouble breathing and lost consciousness. Her paternal grandmother, Leah (born in 1826), a midwife who had assisted with the birth and lived with the family, repeatedly beat on her chest to resuscitate her. Orloff recounts, "I almost died: I came back to life after receiving 'murderous blows' for two hours. The blows still 'hurt' me to this day and are embedded in my body."[1] Miriam, her older sister by two years, recalls how their mother was extremely distraught and asked for the child to be saved. Orloff's grandmother, Leah, responded to her daughter-in-law: "Why are you crying?! It's not so bad, it's the eighth child, and in addition, it's the fourth girl" (reflecting the higher value of boys over girls in Jewish culture of this period). Miriam continues, "But Chana decided to live, to everyone's joy!"[2]

Orloff grew up at a time that was traumatic for Jews living in Ukraine. She was born and raised in Kamenka, also known by the name of Tsaraconstantinovka.[3] It was an agricultural colony in the Kherson district, Alexandrovesk county, Ekaterinoslav (Dnepropetrovskaya) province in southeastern Ukraine, on the coast of the Sea of Azov, part of the Black Sea. The largest nearby city was Mariupol, the second largest port city after Odessa in the Southern Russian Empire. Kamenka was then part of the Russian Pale of Settlement, the area where the Russian Imperial government restricted Jews. It was one of seven colonies founded in 1806 by a group of Jewish families from the cities of Vitebsk (future hometown of Marc Chagall) and Mogilev (both on the Dnieper River, in Belarus).[4] The minister of the interior

encouraged these families to move to southern Russia or "New Russia," to start a new life in agriculture.[5] In exchange, they received temporary exemption from military service, tax abatements, and reduced land prices. The *ukase* (edict) of the Russian government of December 9, 1804, allowed Jews to purchase land for *kolonii* (farming settlements) for the first time in Russia. However, they had to establish these colonies at a certain distance from Christian settlements and could not purchase land in Christian villages. This first era of colonization was an attempt to demote Jews from "merchant" status inherited from the Polish Partitions to the lower-ranking "peasant" social class.[6]

The first wave of these colonies failed. Many of the Jews who moved lacked sufficient training in agriculture. Successive migrations to southeastern Ukraine followed, and conditions eventually improved as the Jews gained farming skills and taught new arrivals. With natural population growth, the Ekaterinoslav colonies grew to approximately twenty thousand Jews at its height in the 1880s, the decade in which Orloff was born. While most of these Jews who moved to the colonies initially made their living through agriculture, as the population increased, small towns developed around each colony to support the growing economy. Soon there was a lack of land available to new settlers for agriculture, and new immigrants settled in these towns. Orloff's birthplace of Kamenka became one such village community.

According to the census in 1896, the population of Kamenka was 771 when Orloff was eight years old.[7] Her older brother Zvi Orloff (later Nishri) said that by 1904 the total population was approximately one thousand and included thirty Jewish families. Many of these families made their living in trades supporting local agriculture. They worked as shopkeepers, millers, blacksmiths, shoemakers, tailors, seamstresses, bakers, butchers, and merchants in textiles, leather goods, spices, and so on. These towns attracted significant numbers of hometown relatives or neighbors of the original colonists from Belarus, Latvia, and Lithuania, who made up the majority in the developing urban communities in Ekaterinoslav.

Life for Ukrainian Jewish families like the Orloffs posed many challenges due to escalating ethnic violence. In the chaos that followed the March 1881 assassination of Czar Alexander II, Jews became the scape-

goat of the Russian government.[8] Pogroms (government-organized anti-Jewish riots) broke out in several towns and shtetls. Mobs looted and burned down Jewish homes and shops, and rape and murder were prevalent. Zvi recalls his very first memory of the large pogrom of 1881 (seven years before Orloff was born), when he was just three years old.[9] A rioter beat up one of his uncles, who later died from his wounds: "A neighbor hid us in a barn. I peeked through a hole and watched our house being burnt down. After the pogrom, we moved to a neighboring Jewish village. Another thing that was carved in my memory was the rebuilding of our house."

The May Laws of 1882 systematically expelled Jews from towns and villages where they had lived for almost a century. The government canceled deeds of sale and lease of real estate in the name of Jews outside the towns and shtetls. They prohibited Jews from trading on Sundays and Christian holidays. The Orloff family rebuilt their house just before these laws passed, eventually accommodating fourteen people (Orloff's two parents, her two paternal grandparents, nine siblings, and an orphaned female cousin).[10] One morning the family awoke to find that their neighbors had abruptly moved their fence to the middle of the Orloffs' yard, expropriating half of the family's land. The Orloffs started a series of lawsuits, which took a financial toll. According to Zvi, their case went all the way to the Senate and the Supreme Court. But nothing helped, and the neighbors did not return the land to them.

FAMILY LIFE

Orloff's father, Raphaël Orloff (1852–1924), was a religious Jew and ardent Zionist (see figure 1.1). He had a striking physical presence, always wearing elegant clothing, with an intense gaze and a long black beard that turned white in middle age. An admirer of Theodor Herzl, the chief founder of modern, political Zionism, Raphaël believed in the impossibility of Jewish assimilation and the necessity of the "promised land." In 1891, when Orloff was three years old, he traveled to Palestine and took part in Bilu'im, a movement of Jewish pioneers of the First Aliyah (1882–1903) whose goal was the agricultural settlement of the land. According to Orloff's sister Miriam (Eitan), "Raphaël returned . . . because he thought and feared he could not live there with such a large

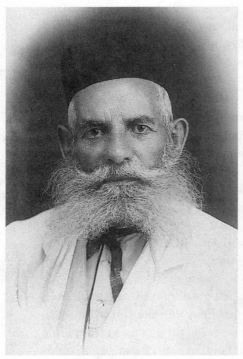

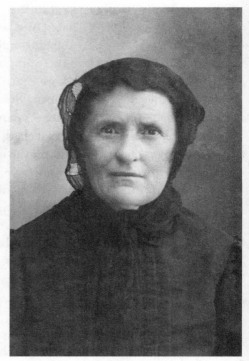

Figure 1.1. Raphaël Orloff, ca. 1905. Figure 1.2. Rachel Orloff, ca. 1905.

family. But his brief visit left an impact on us kids, and his stories about the Bilu'im were highly influential, contributing to our great love of this land."

Raphaël was a leader of Zionist efforts among his community. He sought to purchase what was then called a "colony" of land for his family from Petah Tikvah (Gate of Hope), the first Jewish settlement established in Palestine. This first attempt failed due to what Zvi called "the crisis of land acquisition at that time." Raphaël and the many Jewish neighbors that later sent him to Palestine with funds to purchase plots for them were oblivious of the Arab families who had inhabited and cultivated the land for generations, without a *koushan* (valid title and deed).

Raphaël's leadership in his community encompassed not only political but also economic and religious authority. He owned several small stores in Kamenka, including a convenience store and a fabric and sew-

ing supplies store. The parents of his wife, Rachel Orloff (1850–1932), Dov and Ada Lifshitz, gave them to him as a dowry. Orloff's father sold products to local peasants, Jews and Christians alike, who supported his reputation for integrity. Raphaël was a religious Jew and "a scholar." Besides managing his stores, he also worked as a tutor, traveling to private homes to instruct children in Hebrew. Orloff's mother had been one of his pupils. Rachel's parents opposed the marriage because she was from a higher social class, but they eventually gave in. At the synagogue, he was a paid prayer leader (*baal keriah*), a Torah study leader, a shofar blower, and a synagogue manager. His chanting became famous, and people enjoyed listening to him. Zvi described him as a master storyteller, and on Sabbath nights many of the village's Jews came to the house to listen to his stories over tea.

Raphaël's storytelling talents resonate with the vivid anecdotes of Orloff's own memoir. Her artistic abilities also echo her father's influence. In addition to being an excellent handyperson, Raphaël painted decorations on the west-facing walls of many of the Jewish villagers' homes, in the religious tradition of praying toward the Kotel or Western Wall. His paintings included images of animals and birds (lions, deer, eagles, pigeons) as well as elements of nature (trees, flowers, etc.). He wrote religious phrases beside the artwork, like "God is always present with me" and "If I forget you, O Jerusalem, may I forget my right hand." Throughout her career, Orloff portrayed some of these same animals with great empathy in freestanding sculptural works and monuments in Israel.

Despite her conservative appearance in this undated photograph (see figure 1.2), Orloff's mother, Rachel, was progressive. Dressed modestly here in all black, she wears a kerchief over her head, covered with black muslin tied around her neck. Rachel was not religious in her own beliefs, nor did she expect her children to follow religious laws strictly, unusual for a mother of a large Ukrainian Jewish family. Although men were the "head" of the household, women like Rachel were the "managers."[11] She had an especially strong work ethic in raising her nine children (to whom she gave birth in a period of over twenty years) and orphaned niece while tending to the needs of her household. She prepared all the daily meals, weekly Sabbath dinners, and other celebratory feasts for the large family. Every Friday, before Sabbath,

Rachel was busy with housework, cooking, and caring for her children. She trained the older daughters to help care for their younger siblings, including Orloff. Besides preparing the food and table, Rachel washed the younger children's hair. The elder children and parents bathed weekly at the public bathhouse. It had a *mikveh* (Jewish ritual bath) and saunas, where the older children and adults generated steam by pouring water on top of scalding rocks.

Orloff's mother also provided clothing for her large family before Orloff and her sisters later trained as seamstresses. The family purchased new clothing only once a year for the Passover holiday. The boys had a suit made, and the girls a dress, along with a new pair of shoes and a hat. Besides taking responsibility for childcare and maintaining the home, livestock, and garden, Orloff's mother also helped with generating family income. She worked occasionally at a local pensioner's house, and baked and sold bread to Jews in their village. Rachel helped her husband sell goods at the marketplace and minded his shop when he went into town to buy merchandise. This work in the community was typical of Ukrainian Jewish women, who were "key decision-makers" and "much more independent" than their Slavic counterparts.[12]

Orloff's household also included her paternal grandfather, Yehoshua, and grandmother, Leah. Trained as a *shochet* (ritual slaughterer of animals), Yehoshua inspected and killed poultry and cattle (animals "designed by God to be the food of man") ritually according to Jewish law. He practiced Shechitah, the ancient Jewish methods of kosher slaughter. Believed to "cause a minimum of pain," these ancient methods serve as a model even today for those wishing to mitigate animal suffering.[13] Orloff's grandfather was also a scholar and taught children—both boys and girls, including all of his grandchildren—in the town to read.

Orloff and her siblings studied in a mixed *cheder* (schoolhouse), unlike most other Jewish families and communities where boys and girls studied separately.[14] The siblings learned to read and write Yiddish and Hebrew alongside one another, with support from their father and grandfather. This was quite unusual for the times, as customarily only boys attended classes, while girls remained in the home where their mothers trained them for housework. Although traditionally boys began learning the Hebrew alphabet on their third birthday, they usu-

ally entered the cheder around the age of five. After learning to read Hebrew, they immediately began studying the Torah.

Even in mixed schools like Orloff's, teachers did not give girls the same attention as boys, and rarely held them to the same rigorous expectations. Some girls learned to read Yiddish, which was their spoken language; however, far fewer of them learned Hebrew, as did Orloff and her sisters.[15] This was likely the result of her father and grandfather's support. Of her cheder, Orloff remembered: "The teacher was a bitter and strict Jew and used to beat us, his pupils, on our palms with a yardstick, as was customary in those days. As punishment, he forced my older brother Zvi, who studied with me, to stand on his knees on top of a pile of salt, and made me stand in the corner next to him. I cried till I was breathless, so he called me by one more derogatory name: *klog mutaar* ("mother of tears" in Yiddish)." Orloff's interviews include many similar stories, giving us a taste of her daily life growing up in this tight-knit Jewish village community.

Even though she had Jewish educational advantages, Orloff was eager to learn to read and write the Russian language. She understood it as the cosmopolitan literary language for educated Jews living in Eastern Europe and the Pale of Settlement; however, her father adamantly opposed her learning the language of their oppressors. When a Russian *akusherke* ("midwife" in Yiddish) came to their village from Poland, Orloff became friendly with the woman and began studying Russian with her in secret. The young midwife spoke to Orloff's mother of her daughter's intelligence and potential. Rachel asserted, "My husband doesn't want his children to learn the Russian language. This is not our language." Nonetheless, Orloff and her sisters learned the local Ukrainian language and, according to Zvi, "spoke it with the gentiles."

Orloff looked up to Leah, her paternal grandmother, as a strong female role model. She was a professional midwife trusted by Jewish and non-Jewish Ukrainian villagers alike. Orloff was close with her grandmother and sometimes accompanied her to prenatal visits and births. Midwives received great respect among Ukrainian Jews. They were engaged from the beginning of a woman's pregnancy, when they would determine the expecting mother's due date. They typically visited the pregnant woman initially once a week and later every day. Their clients paid them upon the birth of a child, and usually paid more

if the child was a boy, "because at the circumcision, all the guests left something for her."[16] Jewish children maintained special relationships with the midwife who attended their birth. For Orloff, Leah was a powerful example of a successful professional woman with deep ties to her community. Through her grandmother's career, Orloff also received an education in the anatomy of the female body that was rare for Jewish girls in this period, given the strong culture of sexual purity. Such prior experience with pregnancy, childbirth, and lactation must have affected her lifelong fascination with the female body and motherhood as artistic themes (see plate 1).

Orloff faced differences in how Jewish children grew up in the shtetl based upon gender. Her mother expected her and her sisters to help with the extensive housework, and there was always plenty of it in a family of fourteen people. All the daughters, including Orloff, regularly sewed and mended clothing, leading her and her sisters eventually to become seamstresses. Their mother also relied on their help in preparing for large Sabbath dinners. In contrast, boys did not have to do housework. Instead, they engaged in Torah study, wore tefillin, and attended religious services.

In addition to more intensive religious education, boys received greater opportunities to travel beyond the village. By age thirteen, the age of bar mitzvah, Orloff's father sent her brothers out to a nearby town to barter goods. He also sent all his sons away from home on an apprenticeship to learn a trade in order to support themselves and their future families. This decision was quite unusual, as most fathers placed Torah study at the top of the hierarchy of Jewish values for boys. Orloff's two eldest brothers became coachmen (they prepared wooden parts for horse-drawn carriages), the third a bookbinder, and the fourth brother, Zvi, a coachman and carpenter. Zvi experienced his apprenticeship as "being sold, almost like a slave." In exchange for room and board and several years of intensive training, he worked long hours in the workshop and assisted with chores. Zvi eventually sought further education and opened a cheder of his own, before entering required military service.

Girls were unable to take up a trade like the boys, and they were prohibited from doing heavy agricultural work.[17] Instead, they married young and immediately had children. Arranged marriages were regular,

and Orloff's eldest sister, Reina, got married unwillingly in 1896. At twenty years old, Reina was considered an "old maid." With the help of her maternal grandfather, Orloff's parents found a man whom Zvi described as "an old and totally old-fashioned bachelor, in one of the far-flung villages, and married her off against her will." Orloff's grandmother told her that her parents forced her into marriage to an older man when she was only twelve years old and still playing with dolls.

Orloff was only eight years old when Reina married. She experienced her eldest sister's wedding as a significant loss. Reina, twelve years older, was like a mother to her. Orloff watched with despair as her sister was placed in the "bridal chair," surrounded by musicians who played a traditional Yiddish wedding song that included the words "Cry bride, to cry, your life will be bitter as a bitter herb." Orloff remembers Reina crying throughout the entire wedding ceremony and celebration, unhappy about her fate. Upset by her sister's sadness, Orloff had negative associations with weddings for the rest of her life.

Orloff described herself as an awkward child who was physically large for her age and thus had trouble fitting in socially. Her siblings regularly teased her and called her *yatke klatz* ("a clumsy person" in Yiddish). She often felt ostracized from their group outings, and they told her she that she "didn't fit in":

> They also used to make fun of me and say that my big forehead and my large body showed my stupidity. These insults and exclusion hurt me very much. All of this made me extremely miserable and want to commit suicide by drowning myself in the river. So once I left home and decided not to return, but after a few hours I came back crying. My mother saw me and asked, "Why are you crying?" "I went to commit suicide," I replied in tears. "So, what happened?" she asked sarcastically. "Was the water too cold?" In time, this sarcasm saved me from suicidal thoughts and attempts as a solution to the difficulties of life.

Orloff's report of attempted suicide comes as a bit of a shock. However, the rest of her account aligns with experiences typically described by younger siblings in large families. There are no means of knowing the seriousness of Orloff's reported childhood suicide attempt. Perhaps she used that language to get her mother's attention. The interviews

do not otherwise suggest that she experienced a severe depression in childhood. Her mother's sarcastic and seemingly cruel response suggests that she was an unflappable woman committed to teaching her children the values of resilience and self-worth at all costs.

After Reina's wedding, Orloff and her sisters tried to maintain their independence and avoid arranged marriages. Zvi recalls, "For this reason, the other three learned the sewing profession so they could earn their own living and not have to depend on our parents' decisions regarding their future." They took classes at a nearby sewing school in Mariupol, where their eldest brother lived. Miriam remembers, "Chana was happy about leaving the house and standing on her own. And here Chana, who had been so unaccomplished, returned from learning to sew in the big city, completely changed. She was already fifteen years old. She had become beautiful, interesting, and independent, and didn't need our parents' help anymore, and she even wanted to help the family."

CHAIM ALTER

In a family photograph from circa 1904, a young woman presumed to be Orloff, age sixteen, stands at the center of a group of family members (see figure 1.3). Beside her are several other young women, presumably her older sisters, Miriam, age seventeen, and Masha, age twenty-one, along with other unidentified friends and family members. The women wear dark, high-collared clothing, and the men don Cossack hats. It is unclear who owned a camera and would have photographed them this way. They pose before a makeshift wooden fence beside their house. The Orloff family home included a spacious yard with a small farming area. They kept chickens, a cow, geese, a vegetable garden, a plot of potatoes, and fruit trees. While everyone contributed to planting and maintaining the crops, Orloff's mother, Rachel, was primarily responsible.

Every season, Orloff's mother put the hens from their small poultry farm to incubate in a brooder or heated house for chicks. To her delight, when spring came, dozens of chicks would chirp in their backyard. One day, in 1900, when Orloff was twelve years old, the brooder stopped working. Four eggs did not complete the incubation process. Her grandmother, Leah, suggested they not waste the eggs and moved them to a warm place inside the house so that the embryos could thrive.

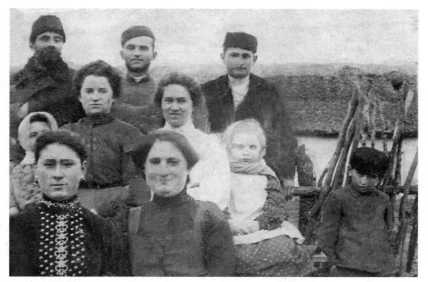

Figure 1.3. Orloff family, Ukraine, ca. 1904.

She put Orloff in charge of tending to the eggs. To Orloff's surprise, two of them eventually hatched.

Not knowing the protocol, after the first chick hatched, Orloff placed it outside with the flock of older chickens. They immediately killed it with their beaks. Stunned by their cruelty, she held the second chick protectively in her lap after it hatched. When it ran to join the others, they injured it. This time she was nearby and able to rescue the young chick. Her grandmother suggested she name the chick Chaim Alter, a Yiddish name denoting a long life, so that it would have a better chance of survival. This followed the Ashkenazi tradition of adding the names "Chaim" (meaning "life") and "Alter" (meaning "old man" or "old woman" in Yiddish) to a child's first name when their life was in danger. Leah's intention was to confuse the Angel of Death, who seeks the life of youth, rather than that of the elderly. Orloff describes how Chaim Alter "grew up in [her] lap," and became a large and "brilliant" rooster. When she told him it was time to eat, he would jump up onto the table from her lap. However, when she tried putting him outside in a tree so he could learn to crow, the rooster let out a weak squawk and then fell to the ground. He was not like the other roosters, and she

resolved that "his place was not in the yard, but in the house with us." Chaim Alter became her beloved pet and lived in proximity to Orloff throughout her childhood years.

When the family later left Ukraine for Palestine in 1905 because of antisemitic violence, Orloff's mother built a special wooden crate to transport Chaim Alter. Now an old rooster at age five, he accompanied them on the boat to Palestine. They transported their other chickens and livestock into separate wooden crates. Chaim Alter survived the journey, and even in Petah Tikvah, where they settled, in Palestine, "he was a source of laughter and joy to us, and my mother treated him like a baby." When Orloff left Palestine for Paris in 1910, she recalled how difficult it was to part with "the beloved soul" of her pet rooster. When she returned from Paris to see her family in the summer in 1913, she learned Chaim Alter had died of old age. Her mother showed her where she had buried him, and Orloff created a small wooden tombstone. Upon the stone, she wrote: "Chaim Alter is buried here. His own kind hated him, but humans loved him."

Orloff erased part of the heading to this section of the interviews and wrote that she found the story "boring" and "irrelevant." Although she felt it was unrelated to the project of documenting her life as an artist, it offers a poignant metaphor for her own long life. Filled with struggle and resilience, the story also shows her deep appreciation for the joys of family and loyalty. Her invitation of the rooster into the home also demonstrates the subversion of domesticity and gender roles that would echo through her life and career.

THE BIG TEA PARTY, 1904

A second wave of violent pogroms occurred throughout the Pale of Settlement between 1903 and 1905, associated with the Russian Revolution of 1905. Simultaneously, the Zionist movement became more active in their region of Ukraine. Led by Haim Bograshov, a teacher in local Hebrew schools (and later an Israeli politician and member of the Knesset for the General Zionists, 1951–55), and Benzion Mosinzon, an educator and Bible teacher (and one of the future founders of Tel Aviv), the movement encouraged young people to read Zionist newspapers and organize by attending meetings. Even though women typically were not welcome at such political meetings, Orloff, now a teenager,

and her sisters "took an active part" in a "Zionist seminar" in their community. Both of her parents were fully supportive, attesting to their progressive nature. Zvi described her father as a true "lover of Zion," and her mother, "a 'liberal' in favor of youth action."

As the situation for Jews worsened in their village, Orloff mobilized her newfound confidence and resilience to sustain her family. Their home was vulnerable because of its proximity to the church in their village. The Russian Orthodox Church played an active role in inciting violence against Jews. The villagers often became violent during religious processions. The family was especially fearful after the Kishinev pogrom, a massacre of Ukrainian Jews that occurred on Easter Sunday in 1903. It brought worldwide attention to the crisis of the persecution of Jews in Russia.[18] The *New York Times* reprinted an account of the horrific pogrom as described in the *Yiddish Daily News*:

> The mob was led by priests, and the general cry, "Kill the Jews," was taken-up all over the city. The Jews were taken wholly unaware and were slaughtered like sheep. The dead number 120 and the injured about 500. The scenes of horror attending this massacre are beyond description. Babes were literally torn to pieces by the frenzied and bloodthirsty mob. The local police made no attempt to check the reign of terror. At sunset the streets were piled with corpses and wounded. Those who could make their escape fled in terror, and the city is now practically deserted of Jews.[19]

Other pogroms in the region followed in reaching the international media, including the Gomel pogrom (in present-day Belarus) in September 1903. This time, the police and military openly participated in the violence, murder, rape, and plundering. According to the press, "many educated and well-to-do Christians" supported the troops in their actions.[20] Orloff and her family experienced this growing support of antisemitism from the leaders in their local church and town council. According to Zvi, in their own town, "the priests would incite the churchgoers against the Jews." After drinking on holidays, they "were ready and willing to lynch the Jews." For years, the family refused pressures to vacate their home until eventually they chose to emigrate to Palestine.

Zvi emigrated to Palestine in 1903, and the rest of the family fol-

lowed soon afterward. Besides the rampant antisemitism and pogroms, forced military conscription for young men motivated many Jewish families to leave Ukraine. Zvi already had served in the Russian military for seven years, but they wanted to send him to Japan to fight in the Russo-Japanese War (1904–5). This was the final straw that prompted him to leave for Palestine. Orloff's siblings, Aaron (by then married), Masha, and her youngest brother, Abraham, followed and arrived a year later, in 1904. Chana and Miriam were the last two siblings and youngest of the daughters to remain in the family home in Ukraine, living with their parents and grandmother, Leah (their grandfather, Yehoshua, passed away before they moved).

Orloff and her sister Miriam were intent on helping their parents fulfill their Zionist dream and join their siblings in the Yishuv (the Jewish community in Palestine prior to the declaration of the state). Raphaël initially worried that as an older man he could not earn a living and support his family in Palestine. His younger daughters eventually convinced him that they would lead the effort and make the arrangements for their emigration. Orloff and her sister sold stamps of the Keren Kayemet le'Israel (Fund for Israel). They also sold the clothing that they made as seamstresses to local villagers. Over the course of one year, they saved enough funds, organized their travel documents, and prepared for the emigration of the remaining Orloff family members to Palestine in 1905.

Orloff and her sister also played a central role in the development of organized self-defense movements among Jews in their village. When antisemitic riots occurred in the fall of 1904, their parents went to stay at her aunt's house in a neighboring village. Orloff, then sixteen, and Miriam, seventeen, stayed back in the family home with their grandmother, Leah. Because Leah was well respected as a midwife in the Christian farming community, Orloff's parents believed she and the girls would be safe while protecting their home and belongings. They also hoped that Zvi's prior service in the Russian army would offer the family some protection.

Orloff teamed up with two other Jewish girls from the village (from the Koropov and Roskov families) to defend their families and the town. "The three of us decided we would not go as lambs to the slaughter, and would organize a 'protection,' as the Russian Jews called it.

All the men disappeared from the village, but some girls stayed. We gathered several girls. I was sixteen, and because I was tall and strong, I took it upon myself to take the initiative and train the others for active defense." The girls came up with a plan to encourage the farmers, who were non-Jewish socialists, to protect them. They hosted daily festive tea parties in the Orloff home and invited a select group of villagers to attend. Chana stood guard outside, while Miriam and the other girls prepared and poured the tea. All day long, people came for tea. Some were those they had invited, others not, including people from neighboring villages. Guests amused themselves by taking part in a Russian tradition where one "sucked" the tea through a sugar cube held between their teeth. Laughter filled the house, and for nine days the girls continued hosting the tea parties. Each night after their guests left, they felt reassured that they were safe. As stories of horrific violence spread throughout the community, local riot organizers beat up the commissioner of police of Kamenka for his protection of the Jews. Orloff and her sister Miriam joked that the socialists of their village didn't join the riot organizers because they didn't want to miss out on their infamous tea parties and "sucking" sugar.

By taking a domestic and feminine custom like a tea party and using it to enlist multicultural allies, Orloff subverted societal norms in defense of her community's survival. It is striking that as a teenage girl she could play such a forceful role in protecting her family and village and in leading their preparations for emigration. Her family's experience of repeated persecution ultimately increased their desire to emigrate to Palestine as part of the Second Aliyah. They had little choice.

While Orloff felt awkward and excluded from the social life of her older siblings as a young child, she developed into a confident young woman. Shaped by her parents' progressive views and desire to educate their daughters, she learned a trade and became a seamstress in the big city. Both her grandmother, Leah, and her mother, Rachel, were powerful female role models who helped her gain self-assurance and independence. It is to her credit that the dangerous political reality became an opportunity for her to establish herself as a competent leader in the Jewish resistance movement in her village. These experiences of resilience and strength were foundational to the tenets of both Zionism and feminism that Orloff carried to her new life in Palestine.

CHAPTER 2

Moving to the Promised Land,

1905–1907

On one of her first days in Palestine, Orloff visited the beach in Jaffa with her family. Upon arrival, seventeen-year-old Orloff was overjoyed to see young people dancing the "Hora," a traditional folk dance.[1] "An experienced dancer," she joined them without hesitation. Here was a community of émigrés, expressing newfound freedom to practice Jewish traditions, without fear of persecution. Orloff's celebratory dance ignited a new chapter in a place full of opportunities. A dream ingrained in her since childhood had become a reality.

IMMIGRATION

While Orloff's first experiences in Palestine brought promise, the journey from Russia was long and arduous. By March 1905, Orloff and her eighteen-year-old sister Miriam had convinced their parents that they were ready to join their elder siblings in Palestine. Helping prepare for emigration, the sisters sold clothing and items from their home to local villagers. Raphaël sold the house and "received peanuts for it." He closed his businesses and paid off his debts. He even paid the non-Jewish villagers who persecuted him over the years. Of the family members remaining in Russia, all but Reina, who would join the rest of the family a year later with her husband and children, packed their belongings into steamer trunks and wooden crates and prepared for their journey. They planned their March departure in order to arrive in Palestine in time to celebrate the Passover holiday. They were among

thirty-five thousand Jews from the Pale of Settlement who joined the Second Aliyah to escape persecution and start a new life.

The Orloffs purchased railway tickets from Mariupol to Odessa, and boat tickets from Odessa to the port of Jaffa in Palestine. We can estimate the cost of the journey for the entire family at 174 rubles (about $87 at the beginning of the twentieth century, and about $2,000 today).[2] They needed a passport to leave Czarist Russia legally. However, like many Jews traveling to Palestine at the time, they instead likely acquired a less expensive travel document called a "pilgrim's certificate." The certificate indicated travel motivated by religious obligation, and it cost only half a kopeck (equal to one-hundredth of a ruble).[3] It implied they would return to Ukraine, but it was common knowledge that Jews traveling to Palestine wished to make Aliyah.

The two-week journey from Russia to Palestine began with two days of train travel from Mariupol to Odessa, followed by a twelve-day passage by steamship from Odessa to Jaffa.[4] The Odessa station was a "bottleneck for emigrants," from which thousands of Jews departed Czarist Russia weekly by ship.[5] Most of them were moving to begin a new life in Palestine, the United States, and other possible destinations for Jews (Australia, South Africa, Argentina, Brazil). Orloff and her family had to be mindful of crooks, thieves, and deceitful hotel proprietors along the way. With the Russian defeat in the Russo-Japanese War (1904–5), the scapegoating of Jews intensified and there was a mass exodus from Odessa. Only seven months after they passed through the port, rioters murdered over twenty-five hundred Jews in the October 1905 pogrom in Odessa.[6]

Travel by boat brought yet another set of adventures for Orloff and her family. The one Russian steamship line that went to Palestine from Odessa departed every Wednesday at four o'clock in the afternoon. It sailed through the Black Sea, with an overnight stop in Constantinople. It then passed through the Bosporus Strait, followed by Izmir and another overnight in Beirut. Finally, they arrived at the port of Jaffa in Palestine. The advantage of this route was that Orloff and her family could stay on one ship the whole time, without having to transfer and take risks associated with moving their belongings.[7]

There were approximately fifteen hundred passengers on the ship; roughly nine hundred of them were Jewish. Upon boarding, the crew

separated them into groups based on the class of their ticket. The Orloffs and other Jewish passengers traveled in third class or steerage. They had to squeeze into a separate living quarter at the ship's lowest level.[8] The shipping companies justified the separation based on their dietary restrictions. Even though there were dining halls on such ships, most Russian Jews like the Orloffs only accepted food prepared in a kosher kitchen supervised by a certified rabbi. This was not available until 1910, when the Russian steamship company recognized the economic potential of Jewish émigrés.[9]

On Friday night, all the Jewish women on the ship lit the Sabbath candles and blessed them. After this ceremony, it became sweltering in their living quarters. Orloff's grandmother, Leah, eighty-one years old, passed out. Unsure what to do, they called for a doctor. When he arrived, he immediately extinguished all their Sabbath candles, exclaiming, "Why did you light all these candles? You are savages!" This was Orloff's first encounter with a trained medical doctor, as there were none in her village in Ukraine. When Leah recovered, she said of the doctor, "God will punish him for his actions." This was just one example of Jewish ritual practice on the ship becoming a spectacle.

Orloff, like most passengers, had never traveled by sea. People regularly suffered from nausea and vomiting due to seasickness; fresh water was scarce and available from only a single tap. Passengers were in a perpetual state of hunger, as any provisions they brought turned stale within days. There were only two washrooms available to third-class passengers, and the stench coming from the bathrooms was unbearable.[10] At night, Orloff slept upon a thin, straw mattress in tight sleeping quarters, encountering the odors and sounds of complete strangers.[11] She wondered what to expect of her new life in Palestine.

ARRIVAL IN THE PROMISED LAND

After a long and arduous journey, the ship arrived to Jaffa early in the morning on Monday, April 10, 1905, ten days before the start of the Passover holiday. The crew dropped anchor a kilometer from shore, since Jaffa did not have a proper port where ships could dock safely. Orloff and her family navigated a harrowing process in which rowboats transported small groups of émigrés and their belongings to shore. Crew members used ropes to secure passengers into the boats because

the passage through jagged rocks and choppy surf was notoriously dif-
ficult. After clearing customs, Orloff connected with her older brother
Zvi, who had been living in Palestine for over a year. The family trip to
the beach took place the following day.

In making Aliyah, Orloff was expected to embrace the recent revival
of Hebrew (started in the 1880s) from a liturgical to a literary and col-
loquial language that would unite Jews worldwide.[12] Hebrew was the
common language that would help define a new nation. Shortly after
her arrival in Palestine, however, she resisted speaking in Hebrew.
Surprisingly, she declared that in fact she "longed" to engage with the
Russian language: "I considered myself a Russian revolutionist, and
although I came to Israel, I longed to learn the Russian language and
to become familiar with Russian literature. . . . It was a strange reaction
to my immigration to Israel, although it had some justification because
my father did not allow me to learn the Russian language when we were
living in Russia." Orloff's ambivalence about language suggests she
simultaneously longed for and felt detached from her country of origin
and the homeland she never truly had. Eventually, she hired a young
man to tutor her in Russian, a decision her parents found "ridiculous"
and that made her brother "furious." In stark contrast, Orloff's brother,
who now went by the Hebraicized name of Zvi Nishri, like many young
Zionists from Russia and Europe, chose his new last name shortly
after his arrival in Palestine. "Orloff" in Russian means "eagle," and
his chosen name of "Nishri" translates as "my eagle." Orloff's tension
between assimilation and resistance around language is a common
reaction to the trauma of migration.

Aware of the fact that she was not loyal to one national language,
Orloff eventually came around to embracing Hebrew as a spoken and
written language used in daily life in Jewish Palestine. She credits this
shift to a dramatic experience of hearing a poem by Hayim Nahman
Bialik, Israel's recognized national poet and champion of the revival
of the Hebrew language, read aloud to her in Hebrew.[13] Bialik had
become a cultural hero and celebrity in the Yishuv and diaspora and
was known as "the father of Hebrew poetry." Transfixed by the literary
power of his language, Orloff hired a series of tutors to help her work
toward her goal of improving her fluency and reading all of Bialik's
published work in Hebrew.[14]

Orloff described Bialik, the man in 1909, as a larger-than-life figure following a firsthand encounter:

> It was his [Bialik's] first visit to Eretz Israel, and he stayed at a hotel on the beach. I believe its name was Lebanon. We gathered one Saturday night, a group of youth from the Moshavot, Jaffa, and Tel Aviv. And on this charming night, under the light of the summer moon, we stood outside his hotel and sang his Hebrew songs. Young people at that time idealized his name, poetry, and personality. I remember this meeting as if it was yesterday. I can see Bialik—young, enthusiastic, and excited, standing on the little balcony, with the aura of the moon above his head, looking at us enchanted, while he listened to us singing his songs with a clear, genuine, and effortless Hebrew. Until late at night, our uplifting singing echoed in the silence of the surrounding sands. After that, Bialik became a tangible entity in my life, encouraging and intimate.

Bialik and his work made a powerful impression upon the young Orloff that stayed with her for the rest of her life. When offering her own "origin story" about first becoming an artist in Paris, she told Dr. Haim Gamzu, chief curator and director of the Tel Aviv Museum (from 1962 to 1976), that the very first time she attempted to try her hand at sculpture, she thought of Bialik, and began kneading his portrait in clay.[15]

PETAH TIKVAH:
BECOMING THE NEW HEBREW WOMAN

Orloff and her family settled in Petah Tikvah, the first Jewish agricultural settlement in Palestine. Her siblings were already living there. Petah Tikvah was founded in 1878 by a group of observant Jews from the Old City of Jerusalem.[16] Known as the "Mother of the *Moshavot*," plural of a *moshav* (settlement or village), it was a community of privately owned farms. The farmers shared equipment and resources, but the individual owner profited from each farm's yield. This model differs from that of the *kibbutzim* (gathering, group, or collective), where farmers also share resources but their families collectively distribute the income from crops and industries to provide food, shelter, clothing, and other services to all community members. The first Jewish settle-

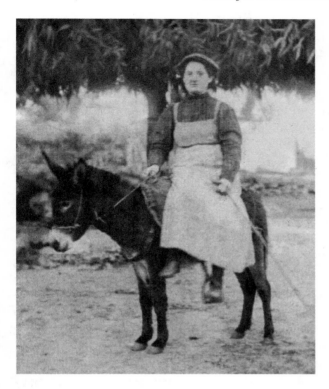

Figure 2.1.
Chana Orloff,
Petah Tikvah, 1906.

ment in Petah Tikvah failed because of outbreaks of malaria and poor harvests due to lack of farming experience.

The Bilu immigrants of the First Aliyah arrived in 1883. They drained the swamps by digging trenches and planting eucalyptus trees. The trees soaked up the moisture and made the land fit for farming. With significant financial support from Baron Edmond James de Rothschild, Petah Tikvah was the first Jewish settlement to introduce orange groves successfully. Baron Rothschild was a French member of the Rothschild banking family and a strong supporter of Zionism. He paid stipends to the families of settlers to support their work on the land, in addition to covering fees for the synagogue, kosher ritual slaughter of animals, medical and midwifery expenses, and the education of children.[17]

In 1906, Orloff, age eighteen, was photographed riding atop a donkey in the yard outside the family's first home in Petah Tikvah (see figure 2.1).[18] She wears her own handmade, ankle-length, pale-colored

jumper, with a dark, high-neck, European-style blouse underneath. Behind her is a prominent eucalyptus tree that provided shade for the Orloff family from the Middle Eastern sun. Orloff's parents, with the help of her eldest brother, Shimshon, eventually bought a small piece of land near the market in Petah Tikvah, at the center of the settle-ment.[19] They took out loans in order to build their first home, which comprised a kitchen, porch, and two small rooms, one of which they rented out for income.[20]

Jewish settlers during the First, as well as the beginning of the Sec-ond, Aliyah started out by living in what they called a "shack." These were small, poorly constructed wooden structures, soon replaced by brick buildings.[21] In a 1965 interview in the Israeli newspaper *Maariv*, Orloff recalls how they made the bricks themselves, purchasing supple-mental wooden boards, iron bars, doors, and windows: "The Orloff family built our own house, with our own hands (with pride). Those bricks that I made in my early days in Petah Tikvah were in fact my first sculptures! (Shaking her head) It was a great house! It's still standing! I forgot the name of the street but it was near the market (longingly). Our eucalyptus is still blossoming as well!"[22] The family spent most of their time underneath the eucalyptus tree in the photograph: "On the right my mother cooked; on the left I studied; over here (pointing to her right) father rested on a mat; over there the hens clucked. Oh, those were wonderful days!"[23]

This grainy image of the eighteen-year-old artist as a newly im-migrated, young pioneer woman suggests all the possibilities of the Zionist dream of working the land. Zionist groups circulated similar images in postcards and posters to recruit Eastern European Jews to emigrate to Palestine.[24] With her sturdy physique and powerful arms, Orloff embodies the image of the "new Hebrew woman." We can compare this photograph of Orloff to an image of a young Jewish woman settler as the biblical figure of Ruth from a 1917 Zionist poster published in Russia (see figure 2.2). Dressed in ancient garb while gathering sheaves of corn in the fields, the woman's image is accompa-nied by the Yiddish slogan "The Rebirth of Our Land Through Hebrew Labor." The image, like the photograph of Orloff on the donkey, offers a robust, female counterpart to the masculine "new Hebrew" or "new Jew." In opposition to stereotypes of the diaspora Jew as weak, both

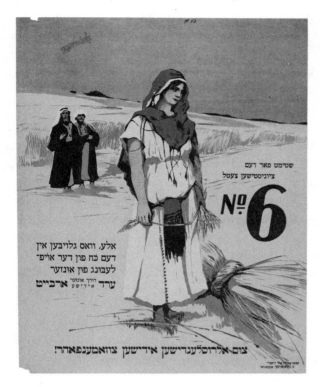

Figure 2.2.
Zionist poster,
artwork and
printing by
Pivovarski, 1918.
Petrograd.

images communicate the Zionist ideal of the robust pioneer woman in the Yishuv.

We can consider the 1906 photograph of Orloff riding a donkey as symbolic of her early efforts in navigating her own way of contributing to the Zionist ethos, while also fostering a strong sense of independence as a young woman. Israeli historian and gender studies scholar Margalit Shilo has written about the contradictory nature of the "modern Hebrew woman" as a female type: "On the one hand," she is "a new woman, exemplifying the hoped-for equality . . . and, on the other, the traditional woman, still loyal to her commitments to husband and children."[25] Women of the First and Second Aliyahs were committed to a Zionist vision of national redemption. However, the patriarchal society marginalized them in the labor market in both rural and urban settlements, with very few exceptions.[26] Expected to maintain primary responsibility for the home and family, women were excluded from positions of authority.[27] Many, however, found other ways of contrib-

uting to nation building. They worked as pioneers, teachers, kibbutz members, political organizers, suffragists, and more.

Orloff described her family's work ethic in her interviews with Israeli journalist Rivka Katznelson: "We made a pretty good living for those times. . . . Our life was hard, but we were all so happy to be in Israel." Even though her parents were considered old when they first settled in Petah Tikvah—Rachel, fifty-five, and Raphaël, fifty-three years old—they were confident about making a living because of their work experience and skills.[28] Her father joined the religious community and took part in daily prayer meetings. According to Zvi, he made a positive impression: "The devout farmers wanted to show that they will help 'a true good Jew' make a living, in contrast to those socialists, secular youngsters, so they took care of him."[29] Zvi's comment points to an ongoing debate at the time on Jewish national identity and the value of "Hebrew labor."[30] The farmers considered the Arab labor as an "economic boon and as a way of developing good relations with the Arabs, whereas the Jewish laborers believed that their 'conquest of labor' was a key criterion in creating a normal, national (Jewish) society in Eretz-Israel."[31] By hiring Orloff's father, as an older, observant Jewish worker, the local religious farmers of Petah Tikvah confirmed their Zionist values and rejection of Arab labor as well as that of secular Jewish workers.

One day while plowing in the dunes southwest of the *moshava*, Orloff's brother Zvi got into a fight with an Arab worker. It was prompted by a conversation he overheard between the Jewish landowner, Leib Gissin, and an unnamed Arab worker on Gissin's farm. Zvi noted that he heard the worker utter three words in Arabic he did not initially understand: *Moscov*, an Arabic term for people from Russia; *Yahud*,[32] an Arabic term from the Qur'an used to refer to Jews; and *Walid al-mut*, which translates as "son of the dead."[33] Because Zvi wrote these Arabic terms in Hebrew letters in his text, and we do not know how familiar he was with the Arabic language at the time, we can only speculate on the exact phrases the worker used and their intended meaning. Feeling threatened, Zvi wrestled with one of the Arab workers, breaking his collarbone and knocking him out cold. Wishing for revenge, Zvi got into several ensuing fights with local Arabs, claiming that his physical prowess and experience in the Russian army led him

to victory. He wrote, "These and similar incidents slightly challenged the beliefs of our disrespectful neighbors in their superior power, and as time passed, the epithet *Walid al-mut* became less frequent, until it was completely gone."[34] Zvi's account gives context to the intensity of the resentment and defensiveness felt by many young Zionists toward the local Arab community.

Orloff did not comment on her relations with local Arabs in interviews, but several other accounts by her peers reveal how Jewish women at this time had conflicted feelings toward the local Arab population. Hannah Barnett-Trager, an English writer, activist, and daughter of one of the Jewish founders of Petah Tikvah, wrote in her book *Pioneers in Palestine* (1923): "Our men always went to work armed with a pistol or a revolver, for the Arabs are as unaccountable as children, and there was always the possibility of trouble, owing to the way they had of letting their cattle graze on our land. They were very responsive to kindness, the women especially, but any show of weakness would have brought misfortune on us and them."[35] Barnett-Trager describes a familiar culture of disrespect, mistrust, and fear of the "other" expressed by Jewish émigrés in the 1880s and 1890s toward Arab inhabitants of the land.

A generation after Barnett-Trager, Esther Raab, known as Israel's first Sabra woman poet, was born into another founding family of Petah Tikvah. Slightly younger than Orloff and later a friend and colleague of the artist, Raab's writings and interviews give us an idea of how difficult life was in the moshava, especially for women. With few resources and poor sanitation and hygiene, she describes how the men went out for long periods of time to get water and other supplies, leaving women and children in isolation. Typhoid outbreaks were common. In several writings and interviews, Raab described the difficult relationship between Jews and Arabs at the time. For example, even though she was very close with her Arab nanny, Hadijah Shilbaya, who taught her Arabic and told her many stories, Raab reflected: "But I don't trust Arabs. It may be the result of both life experience and education. The common assumption in our colony was that Arabs are murderers and killers, and indeed we had many who remained crippled as a result of the Arabs' attacks."[36] However, in a later interview with Israeli journalist Zalman Yoeli, with *Davar* newspaper, Raab offered a more complex and respectful account of how Jews perceived Arabs:

At the time, we were immersed in the Levantine culture, though to my opinion, we were less cultured and civilized than the Arabs. They had a rich language, elegance of manner, and courtesy. We, especially the youth, had nothing. . . . The Arab maids who worked in Jewish homes had a huge influence on the children, positive and negative alike. They told us a bunch of folk stories, which stimulated our imagination. At the time, we were a small minority in this country, and we found here a nation of itself, with land, horses, riders, bandits, rich language, beautiful poetry and picturesque daily lifestyle. This was the source of the Arabs' great influence on us.[37]

Surely Orloff, from a family of far less resources than Raab's, shared some of these views and respect for Arab culture and influence. Nonetheless, Raab presents a very different picture than Zvi in his account of insults and ensuing brawls with local Arab farmers. Together, these narratives give context to Orloff's early experience emigrating to Palestine and the complex relations between Palestinian Arabs and Palestinian Jews at that time.

Scholarly literature often positions Jewish women's role in pre-state Israel as peripheral compared to that of the men; however, a close examination of Orloff's parents' work and contributions suggests a different picture.[38] Even though the religious community of Petah Tikvah respected Raphaël, he could not play an active role in the public life of the moshava. In those days, only the farmers who privately owned the land could make decisions. After a series of temporary jobs at different farms, Raphaël began working in the orchards supported by Baron Rothschild. He insisted on working long days, in spite of his age. His workday routine comprised waking up before dawn, reciting his prayers at sunrise on their small balcony, and then setting out to the orchards, a basket of food in hand. He worked all day, picking fruit and tending to crops in the scorching sun, and returned home at sunset. This life of intense physical labor in a hot climate was a challenging transition for Orloff's father, but he did not complain.

In an undated photograph from the period, Orloff's mother, Rachel, sits in front of their wooden "shack," cutting a piece of bread (see figure 2.3). She contributed to the family income by regularly cooking

Figure 2.3. Rachel Orloff, Petah Tikvah.

food for the workers in the settlement. Many of them came to dinner after they finished working in the orchards. Known for her generosity, Rachel allowed the workers to buy their meals on credit when they couldn't afford to pay her. Before the Sabbath, she prepared a large pot of traditional Jewish stew known as *Cholent* or *Hamin* that simmered overnight for at least twelve hours. She then sold it in portions (as they prohibited cooking on Sabbath). Eventually, the family built a large oven in the yard. People from the colony brought their dough in baking dishes, and Rachel baked their bread for a fee. She handled the many chickens, geese, and ducks in their yard where she cooked and also sold their eggs. Sometimes, visitors to their home would find several chickens perched on top of the dining table inside the shack, reminiscent of the days of Chaim Alter in their home in Kamenka.

Orloff's mother also earned income by supporting the community's engagement in a Jewish tradition known as *tahara*, the ritual cleansing of bodies of the deceased before burial. After she finished washing the body of the deceased, Rachel often uttered a Yiddish phrase that translates to "a slap on my buttocks." This implied "Come on, who's next?" Orloff's mother's work handling dead bodies recalls her grandmother's work as a midwife, each focused on opposite ends of the life

cycle. Exposure to their respective work with bodies likely influenced her own career in sculpting the human form.

Orloff's mother, Rachel, helped ensure the community's participation in *tzedaka*, the moral obligation to charitable giving. Zvi recalls how the farmers' wives or "landladies willingly and generously gave her their charity, and she [Rachel], who was familiar with the needy, secretly transferred the donations to them, adding a tenth from her [own] allowance."[39] The Orloff parents respected the Jewish commandment of hospitality. Raphaël never returned from synagogue without having invited people over for Sabbath dinner. "They [Orloff's parents] refused to accept, under any circumstances, financial help from their children, and continued working till their very last days."[40]

Even though Rachel was a strong role model, Orloff wanted to break from her mother's generation and work outside the homestead to achieve economic independence.[41] Drawing upon her sewing skills, Orloff recognized a need for seamstresses to design and sew clothing for the wives of wealthy farmers who "refused to give up wearing dresses, even though it was the Zionist pioneering period." Orloff began designing and sewing European-style clothing, primarily long dresses in dark colors. Her first clients were the rural women of Petah Tikvah. Later she created fashions for professional women in the urban neighborhood of Jaffa.

Despite the urban growth leading to the founding of Tel Aviv in 1909, vocational opportunities for women remained limited.[42] Most women, like Orloff, immigrated with their families and shared their income with the household. However, some were self-supporting upon arrival and wished to continue with their prior careers. Menahem Sheinkin, director of the Zionist organization Hovevei Zion's information and immigration office in Jaffa, explained in a 1907 letter to Rivka Stein of Dubossary, Ukraine: "Not only in Palestine but everywhere," he wrote, "it is harder for a woman to get by than for a man. Women receive inferior preparation for life's struggles."[43] In the letter, he listed the professions available to women in the Yishuv: sewing, hat-making, nursing, medicine, cooking, and teaching. Sheinkin added that women often are frustrated by their new life in Palestine: "Most of the women who have come are homesick for Russia and would like to go back."[44] Orloff never expressed such sentiments, but described her growing

"dissatisfaction" with sewing and her longing for a career that was more interesting and meaningful.

Because a needle and thread were easily attainable, working as a seamstress was a viable means for women to support themselves. It was also considered an acceptable "feminine" occupation. Sarah Thon, a feminist and an activist in Palestine in this period, recognized the need for women's professional training. She founded five separate lacemaking workshops (in Jaffa, Jerusalem, Tiberias, Safed, and Ekron) that served over six hundred lower-income women in this period, many of them Sephardic Jews.[45] There was a market for lace because wealthy farmers' wives liked to incorporate it into their home décor. Women workers received vocational training during the first year of the workshop and then looked for work that engaged their new skills. In an article published in the Zionist weekly newspaper *Die Welt* (founded by Theodor Herzl and published in Vienna) in 1910, Thon declared that "women's work in Palestine is 'extraordinarily important,' and that the goals of building the land" must include women in social reform.[46] Thon's article provided a detailed breakdown of the specific occupations of Jewish women living in the cities of Jaffa, Jerusalem, Tiberias, and Haifa, including seamstresses, sock makers, milliners, shop girls, cigarette makers, physicians, nurses, midwives, dentists, masseuses, teachers of various kinds, school principals, artists, and journalists. By the time Thon had published her article in 1910, Orloff was among the 180 seamstresses in residence in Jaffa serving the local Jewish population.

Becoming a New Hebrew Woman, 1907–1910

NEVE TZEDEK: A ROOM OF ONE'S OWN

After a year of selling her dresses to local women in Petah Tikvah, Orloff was earning enough money to rent a room of her own that was closer to her clients. She moved to Neve Tzedek, a Jewish neighborhood founded in the northern part of Jaffa in 1887, which would become "an important locale in the foundation of secular Hebrew culture in Palestine."[1] The distance to her parents' home was about fifteen kilometers and a two-and-a-half-hour carriage ride, making it more difficult for her to see them. According to Orloff, the room was located "in a beautiful Arabic house, owned by a woman named Peak. The view from the house was of the railroad track, Jaffa-Haifa." It was unusual for a twenty-year-old unmarried Jewish woman to move away from her family on her own, and Orloff's parents were not wholly supportive of her decision. However, the increased proximity to her clientele offered Orloff greater earnings and opportunities.

Several prominent Jewish writers, artists, and thinkers lived in Neve Tzedek, among them, the future Nobel laureate author Shmuel Yosef Agnon.[2] Orloff recalled having an uncomfortable encounter with Agnon during this period when she was around twenty years old. During the warm summer evenings, after long days of work, she often studied Hebrew quietly in her rented room. It was located on the ground floor of the house, and during the summer she left the windows open at night. One evening, a man she did not know startled her by peering in

directly through the open window. She later recognized him as Agnon, a famous and widely admired writer, also known as Czaczkes. Realizing that Orloff was frightened, he immediately ran away. A few days later, she encountered him again, while they were both walking along the rail tracks near her house. This time, standing beside Agnon was a beautiful woman named Chaya (who later on married Yosef Haim Brenner, another Jewish author who lived in Neve Tzedek during this period). After recognizing her, Agnon teased, "You know, Chana, it was I who peeked into your room." Orloff responded, "I know it was you." His taunting continued: "What are you doing all these evenings by yourself?" Before she could reply, he added, mockingly, "You are abnormal." She was deeply hurt and chose not to respond. The insult was more painful in the presence of Chaya, who Orloff described as "a beautiful girl . . . who never knew what it meant to be lonely." Once he realized he had insulted her, Agnon tried to apologize, but she remained silent. Orloff surmised that Agnon "realized how very lonely I was."

Although more than fifty years had passed between this incident and the writing of her interviews, Orloff never saw Agnon again in person. Now and then, as a mature artist, she heard rumors of his "interest in her personal dealings." But she never forgot his insult from a time when she was "a young and sensitive girl," and she avoided meeting him. In the margins of her typed autobiography, Orloff wrote in pen: "This section is unwanted." Perhaps she did not want to share this story publicly because it exposed her vulnerability; or maybe she did not wish to highlight the fact that she never made amends with Agnon, given their respective reputations as contributors to Jewish artistic culture in the Yishuv.

Her unwillingness to discuss sexuality is not surprising in the context of Zionist culture, where sexual purity was a central concern until the 1960s. A rare exception, Esther Raab wrote in her diary about coming to terms with her own sexual desire as a young woman within the patriarchal context of her religiously observant household in Petah Tikvah.[3] Raab described how her mother called her "vulgar" for taking a walk alone at night with a boy as an adolescent, and "how these restrictions . . . opened the door to forbidden thoughts."[4] Orloff's account of the early encounter with Agnon suggests the tension between the progressive nature of her decisions in her early life and her simulta-

neous adherence to the traditional values prevalent in her social and cultural milieu.

ZIONIST AFFILIATIONS

Orloff made an active choice while living in Neve Tzedek to engage in several interrelated Zionist coeducational social and political groups for young adults. Whether joining reading groups, formal classes, or athletic or political groups, she embraced the revival of the Hebrew language and popular image of the new Hebrew woman. These groups helped her formulate her ideological positions regarding the building of the future state. Orloff's brother Zvi was a powerful role model. He promoted pioneer-oriented socializing that included women as a part of the Zionist project of nation building. Because of his military background in Russia, Zvi was recruited as the first physical education teacher at HaGymnasia HaIvrit (hereafter referred to as the Gymnasia). It was the very first Hebrew high school (later known as "Gymnasia Herzliya") in Palestine.[5] Founded by a husband-and-wife team, Judah Leib Metman-Cohen and Fania Metman-Cohen, the school first opened in Jaffa in October 1905. It moved in 1909 to a prominent new building on Herzl Street in the new neighborhood of Ahuzat Bayit. The building was designed by Joseph Barsky based on descriptions of Solomon's Second Temple.[6] "The intellectual center of Jewish Palestine," as Orloff put it, the Gymnasia was not only the first Hebrew secondary school but also the first post-elementary school that was both secular and coeducational.[7]

Orloff appears in a photograph taken in 1909 picturing a group of students and faculty at the new Gymnasia Herzliya (see figure 3.1). She is one of the few women in the group who wears her hair cropped short. Her facial and bodily expression appear more serious than that of many other young women, who seem to smile for the camera. Dressed in a simple white cotton smock dress, she folds her hands in her lap. It appears here and in several other photographic portraits from this period—including this formal, studio portrait taken by Avraham Soskin (see figure 3.2)—that Orloff wished to resist codes of ingratiating femininity that were still practiced by many young women in the Yishuv and encouraged by the photographers, even in this supposedly gender-equal high school.

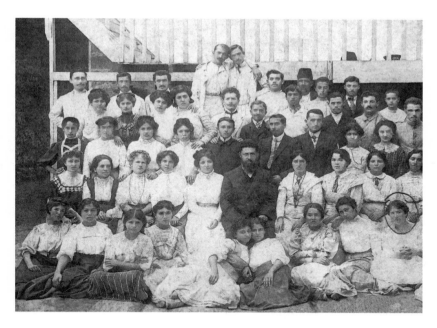

Figure 3.1.
Gymnasia Herzliya, 1909.
Orloff, *bottom right corner*.

Figure 3.2.
Avraham Soskin, Portrait
of Chana Orloff, 1906.

Orloff, age nineteen, was too old to enroll in the Gymnasia as a full-time student. She and other young women took classes there and socialized with its young teachers while studying the Hebrew language and Zionism.[8] The school's commitment to coeducation related to its larger goal of creating a new Hebrew woman.[9] Numerous teachers moved away from traditional educational models of the First Aliyah that promoted the view of woman as wife and mother. Instead, they exposed students to new ideas that included women's emancipation. An unnamed teacher wrote: "Through the emancipation of women, we will change the face of the world. . . . Who says it is the woman's task to sew buttons rather than the man's? If we decide to teach domestic science, we will have to reach all the pupils, regardless of sex."[10]

Despite these progressive ideas, they did not always realize gender equality at the Gymnasia Herzliya. For example, besides her administrative and teaching duties, it was the female cofounder Metman-Cohen who washed the school's floors, a task not shared by her husband, the other cofounder. Administrators suspended Judith Harari, a young teacher, from teaching after she gave birth.[11] And student Cila Feinberg, in yet another example, fought for the right to wear trousers in gym class.[12]

Orloff benefited from the Gymnasia's introduction of the notion of equal education for men and women, no matter how imperfect, in her journey to become a new Hebrew woman. She took courses in Hebrew language and literature, along with Bible studies (she studied the latter with Dr. Benzion Mossensohn, a well-known teacher who became the school's principal from 1912 to 1941, and also played an important role in the founding of Tel Aviv). Unlike traditional Jewish religious studies, the Bible studies in the secular Gymnasia Herzliya was not solely studying the Old Testament as a religious text but also analyzing the Bible "as history, philosophy, literature, a compendium of laws, and as a book of ethics."[13]

Orloff was part of a social milieu of teachers from Gymnasia Herzliya whose strong support of the Hebrew language revival greatly impacted the leisure culture of Jaffa. In 1909 the teachers formed a theater group called Lovers of the Hebrew Stage that performed in schools and community centers to promote the use of Hebrew.[14] Various artists and theater people, residents of Jaffa, joined them in establishing an

organization called Merkaz Hamorim (Teachers Center) committed to adapting Hebrew as an ideological artistic language in the process of nation building.[15] This group can be seen as a precursor to the popular Habima Theater, the national Hebrew theater of Israel (established in Russia in 1912, and then in Palestine in 1928).[16] This community of Zionist teachers was strongly opposed to the public use of Yiddish in Palestine. They organized public lectures and events at the Gymnasia and other cultural centers that promoted Hebrew language and culture. And they took part in actively rejecting public displays of Yiddish. At times members of the Gymnasia teachers' group used aggressive and even militant techniques, from throwing tomatoes to "stink bombs," to protest theater performances conducted in Yiddish.[17] Even though we do not have evidence of Orloff directly participating in such aggressive actions, this was her social milieu. And her brother Zvi, as the Gymnasia's physical education teacher, was a leader in this community in providing a link between the Hebrew language revival, theater, and sport.

In another group photograph from 1909, Orloff appears as an active member of Rishon LeZion (First in Zion, which later became Maccabi Tel Aviv), one of the first Zionist sports clubs in Palestine (see figure 3.3). The club was founded in Jaffa in 1906 by Dr. Leo Cohen (the first doctor at Gymnasia Herzliya), Meir Dizengoff, and Yehezkel Hankin. Such clubs offered a way of "developing group spirit, controlled movement and discipline, and for serving the goal of nationalism by cultivating unity and cohesion."[18] Zionism as a political movement embraced physical culture as a prominent vehicle for countering claims of Jews' alleged physical inferiority.[19] Orloff's brother Zvi was a leader in organizing Rishon LeZion activities and recruiting Gymnasium student participation. He organized trainings on the school premises and weekly Saturday wrestling matches and gymnastics routines that attracted large crowds.[20]

The Rishon LeZion club in which Orloff took part offered training classes for girls and young women in physical fitness and a wide variety of sports. It was part of the Zionist ethos of the Second Aliyah that the new Hebrew woman should play sports and adopt masculine characteristics as a sign of her participation in building the land, although the role of women in sports in the Yishuv did not gain full momentum

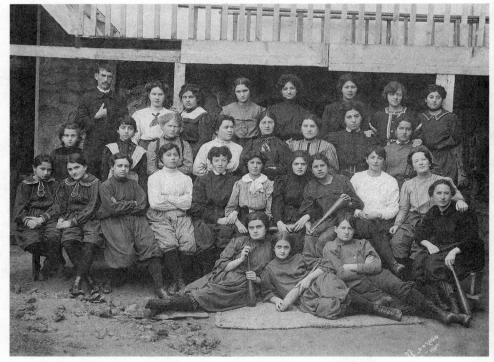

Figure 3.3. Orloff, seated on the ground, *far right*, Rishon LeZion, Jaffa, 1909.

and recognition for several decades.[21] In this photograph, Orloff resembles a man in both physical appearance and attire. She is among multiple girls and young women who wear their hair cropped short. All of them sport trousers and boots in order to facilitate their physical activity. Some of the group members are holding stubby wooden clubs that resemble bowling pins of different sizes and shapes. Known as Indian clubs or *meels*, they were used across the Middle East as a type of exercise equipment for developing strength.[22] "Club swinging" even appeared in 1904 as an Olympic sporting event (and again in 1932).

Nishri likely exposed Orloff and the other students in Rishon LeZion to the sport because of its growing popularity.[23] They swung the clubs in specific patterns as part of an exercise or gymnastics program, and performed at the Gymnasia and competed with other sports clubs that emerged in this period in Palestine.[24] Nishri later became an important figure and leader in the Zionist physical culture movement in

Jewish Palestine and later Israel. He was also a founding organizer of the international Maccabiah Games, the quadrennial Jewish Olympics (held in Israel the year following the Olympic Games), and the Tzofim (Scouts organization) in Israel.[25]

Sports clubs like Rishon LeZion picked up on the Zionist ethos that linked physical culture and militarization. They actively prepared young women and men alike for self-defense through organized sports. We think back to Zvi's account of his own prowess in "wrestling" with Arabs as a young farmworker in Petah Tikvah. Similar clubs emerged at the same time in other parts of the Yishuv, leading Nishri to launch an umbrella organization, Maccabi Eretz-Israel (1912), with the Gymnasia as its sponsor and home base.[26] Through her participation in this movement, Orloff confronted the reality of tensions between the Yishuv and the Arab community. In the period when this photograph was taken, Rishon LeZion actively debated the question of "Hebrew labor," further exposing Orloff to controversies surrounding the political reality of Jewish and Arab relations in Palestine.[27] With their Zionist ethos and positioning of Arabs as the enemy opponent, these clubs later became linked with political movements like Hashomer (The Watchman; also written as HaShomer), a Jewish defense organization and youth movement in Palestine founded in April 1909 out of a similar organization called Bar-Giora. Orloff's sister Miriam married an active member of Hashomer, Eliyahu Eitan. Through her family ties, Orloff was well aware of the strong connection between sports clubs and Zionist militarization efforts to defend the country.

Orloff also had to resolve the tension between her work as a seamstress who designed "feminine" dresses in classic European styles, and her own choice in her personal life to adopt a more "masculine" appearance identified with the new Hebrew pioneer woman. Decades later in the 1930s and 1940s, some of the most prominent feminist leaders in pre-state Israel were critical of young, independent Zionist women who, like Orloff, took on masculine traits. For example, Judith Harari explained, "I am fearful of the excessive desire among our young women to resemble men."[28] Sarah Thon wrote about a similar process that was taking place "out of their desire to be like men in all things."[29] Likewise, the teacher Sarah Glicklich Slouschz, in her pamphlet *El ha-Ishah* (To woman), published after World War I, strongly

advocated that women should not deny their femininity: "Women must finally understand that their characteristics are indeed different from those of men. And in keeping with those characteristics, their activities are also different; but regarding their worth, they are equal."[30] It is useful to contextualize such commentary as part of women's political struggles for equal pay. Thon and Harari were representing the voice of the new Hebrew civil (non-labor) woman of the 1930s and 1940s, concerned with women's adoption of "masculine" traits in pursuit of equal political and economic power. Other feminist voices at the time spoke out in support of such initiatives in the fight for women's equality.[31] Orloff was among a group of women who were experimenting decades earlier with taking on masculine traits that broke from traditional feminine ideals to assert their independence.

One of the domains in which Orloff encountered discrimination for her gender roles was political organizing. Seeking active involvement in the shaping of Zionist politics, she was one of eighteen women in the over ninety members of Hapoel Hatzair (The Young Worker), a socialist-oriented labor organization based in Jaffa. The organization was founded by Zionist leader A. D. Gordon in 1905. Party members mostly consisted of men who came from Eastern European backgrounds who, like Gordon, had emigrated to Petah Tikvah. The group focused on the idea that they could best uplift Jews politically and spiritually through manual labor and working the soil of the Holy Land.[32] It served its members pragmatically as a labor union, a social club, and a mutual aid society. Members were involved in encouraging young Jewish workers to emigrate to Palestine from Europe, especially Russia. The group also focused on creating agricultural outposts comprised entirely of Jewish laborers and their families. This placed their project in conflict with Arab farmers in Palestine. Rather than pushing existing inhabitants out of arable regions, the organization stressed the creation of new agricultural areas.[33]

Even though Hapoel Hatzair included women in the organization from its beginning, they comprised approximately 13 percent of the membership between 1905 and 1911. Although they accepted female members, the male leadership excluded Orloff and the other women members from the various decision-making forums and did not welcome them at conferences. The women who took paid positions in the

group had no choice but to work in service roles—from staffing the group's communal kitchen to maintaining its laundry facilities. Women earned less than their male peers who were delegated the agricultural labor. They rarely received promotions even though they comprised a majority in these service-oriented occupations within the organization.

Sara Malkin wrote a letter in 1912 to Hapoel Hatzair describing the enormous gap between rhetoric and practice around labor and gender faced by young women in the organization:

> We, the young women, were faced not with obstacles but with an apathetic and derisive response to all our aspirations. We had hoped to work in the same branches, together with our male comrades who had previously shared our view. However, from the very first step, we confronted mockery and insults. We appeared a queer breed to the farmers. They refused to accept the notion of a woman working, not out of necessity, but in pursuit of an ideal. Even more incomprehensible was the idea of a woman working in the fields and villages.[34]

This is but one testimony of the extreme sexism women in the Yishuv faced. Any woman with aspirations faced similar frustrations. Even the women associated with Hapoel Hatzair who worked in the field were harshly criticized by older male farmers, who relied upon the rhetoric of moral and religious grounds in objecting to their labor. Undoubtedly related to these dynamics, female members of Hapoel Hatzair went on to become the leaders of the Jewish feminist movement, including Ada Fishman-Maimon and Yael Gordon, A. D. Gordon's daughter. Both were later involved in founding the women's labor organization known as the Women Workers' Movement, as an arm of the Histadrut in 1921.[35]

DECISION TO LEAVE

Despite her Zionist beliefs, institutional affiliations, and contact with influential people, Orloff's decision to leave Palestine in 1910, at age twenty-two, in order to move to Paris and study fashion design, is not shocking. Most professional women her age in the Yishuv were opting to marry and have children, in spite of their contributions to the Zionist project. She clearly rejected traditional gender roles and struggled to find her place in the patriarchal society. Her interviews with

Katznelson offer an account of her decision to leave a result of her deep desire to take on a larger professional goal:

> I continued to sew during the daytime and to study Hebrew and Bible studies in the evening, but I was dissatisfied. It was not my life purpose. My parents, who were in Petah Tikvah, were not happy with me staying alone in Neve Tzedek, and in addition my earning a living from the sewing had a temporary and provincial nature. The entire family gathered and decided that I should go to the U.S., where we had many relatives who could help me to find something to do. I agreed, and we sat down and prepared a detailed plan. First, I will go to Paris—the world sewing center—and since I had good hands, I will gain superior skills in dressmaking pattern, so I could earn a living in New York.

Orloff crossed out this entire section of the typewritten text, and wrote by hand in pen in the margins, using the third-person voice: "Chana does not agree with this description," followed by "she herself decided to go away, without her family's advice." She rejected Katznelson's narrative of her family's involvement and instead asserted control over her decision.

Orloff had a burning desire to pursue her independence. Perhaps at the time of their collaboration on the interviews in 1957, Katznelson did not believe that Orloff could have moved away from Palestine as a young unmarried woman in 1910 without parental consultation and approval. Neither of Orloff's siblings who wrote their own unpublished memories (Zvi and Miriam), nor her granddaughter or other relatives and friends interviewed for this book, ever mentioned or knew of a plan for her to move from Paris to New York. Nor is there evidence of the family's connection to relatives in the United States, making this part of the narrative questionable. The most credible part of this description is that Orloff "was dissatisfied" by her career as a seamstress. Sewing had become far too limiting. She continued working on her Russian language skills with a private tutor as a much-needed vehicle of escape: "I continued to study with him for a year, and that helped me not to despise my sewing, a chore I didn't see as a life goal." Orloff's sister Miriam also recalls that her sister "found no satisfaction" in her life as a seamstress and wanted to take on a larger professional goal.[36]

Zvi offers a different version of this story that sheds more light on the events and logistics leading up to Orloff's decision to move to Paris. Besides teaching physical education at the Gymnasia Herzliya, he was engaged in teaching at a second school, the Hovevei Zion School for Girls, in Neve Tzedek, near where Orloff lived. Administered by the Zionist Hovevei Zion movement in Russia, founded by Ahad Ha'am (Asher Ginsburg) in 1889, the school was part of an educational movement offering European immigrant families an alternative to the ultra-orthodox Talmud schools (cheder).[37] Like the Gymnasia, the school became a cultural and educational center; the teachers lived on the second floor above the classrooms and were involved in a variety of Zionist initiatives, from the Hebrew theater movement to Jewish political movements. According to Zvi, soon after he started working there, Dr. Nissan Turov, the school's director, told him about a job opening for a sewing instructor. Dr. Turov had heard about Orloff and likely knew her personally from the neighborhood. He offered her the position and, according to Zvi, suggested that before starting the job, she might consider going to Paris to get a formal education in sewing and dressmaking, as well as work experience in *haute couture*. Zvi borrowed 300 francs from Dr. Hissin, the school's treasurer, in order to finance Orloff's trip. Later in life, she paid him back in double by giving him several of her sculptures.[38]

We don't know whether Orloff formally accepted the position and agreed to return to Jaffa by a specific date. It was common in this period for junior teachers to seek a formal education and training in their field in Europe, in order to provide the best pedagogical experience to their students in Palestine. Zvi himself later traveled to parts of Switzerland and Denmark to learn the latest advances in teaching gymnastics in order to continue developing as a physical education teacher and coach back home. That he borrowed money from the school to fund Orloff's trip suggests an expectation that she would return and work there. It would have been in Dr. Turov's interests, both economically and politically, to support Orloff's education and formation in Paris. By financing her education, he could recruit future students to study sewing and design under her tutelage at his school in Jaffa in support of the Zionist vision of growth of Jewish Palestine. Women had limited career options, which made becoming a seamstress

an increasingly popular career choice. Also, there was a shortage of well-trained teachers.

Despite the variations in these accounts, it is clear that Orloff had become frustrated and dissatisfied with her life and routines as an ambitious young woman in the patriarchal society of the Yishuv. She longed for a new environment with new possibilities, and a career that would nurture her creativity in exciting ways. It was difficult as a woman in Palestine to have a strong sense of professional identity and potential. She also craved mentorship and a wider variety of professional colleagues, all while ensuring her economic independence. At that point, Orloff was unsure of her career path. In moving alone to Paris at age twenty-two, far from home, family, and all that was familiar, she was willing to take a risk.

CHAPTER 4

Paris

From Haute Couture to Avant-Garde, 1910–1913

ANOTHER IMMIGRATION

"It is Summer 1910 and I am ready to set off. I was a strong, tall girl with lust for life and plenty of energy." Orloff, age twenty-two, climbed the stairs to board a large ship docked in the port of Jaffa. In search of professional opportunities beyond Jewish Palestine, she departed for Paris to get certification as a sewing instructor at an *école de style* (fashion school). Walking across the boat, she heard the faint jingling sound of "Napoléon" coins (widely used in Palestine at the time), each worth twenty francs. She had placed a handful of them inside a fabric bag and sewn it to her corset, under her dress. The coins, Orloff recalls, "caused a minor bump over my belly, but I did not consider it an aesthetic flaw." Though the conditions of traveling by ship were now familiar to her, this was her first journey alone. Using her sewing skills to protect herself from thieves, Orloff was ready to face a new world as an independent young woman. She looked back from the ship and waved goodbye to her father, now age fifty-eight, her mother, sixty, and her grandmother, now age eighty-four, as well as a large group of young adult siblings and friends. She did not know many people in Paris and didn't speak French. It is uncertain whether she intended to return home after completing her studies, and she must have felt mixed emotions, not knowing when she would see her family again.

Orloff's journey started by sailing from Jaffa to Alexandria, Egypt. She changed boats there and boarded the North German Lloyd Steam-

ship line, which ran across the Mediterranean, stopping in Naples, before reaching the eventual destination of Marseilles. From there she would travel to Paris by train. She was once again in the ship's underbelly, in a separate area alongside other travelers of limited resources. There she became acquainted with young Palestinian Jews who were planning to study and gain professional experience in Paris or in other parts of Europe.

After five days, Orloff's ship arrived in the port of Marseilles, a bustling site of international commerce. She had to wait in a long line at customs after setting foot onto French soil. When her turn came, the border patrol officer asked her to provide her name and place of birth. When she gave her first name, which she originally spelled "Hanna," the officer apparently did not understand (her pronunciation of the "H" confused him like the Spanish *Jota*); he recorded her name spelling as "Chana," pronounced in French as "Shana." Orloff adopted this French spelling and pronunciation of her first name for the rest of her life, a way of assimilating to what would become her adopted home country.[1]

Once her paperwork was secure, Orloff and her new acquaintances from steerage made their way to the Gare de Marseilles-Saint-Charles, an architecturally striking station, perched on top of a hill and isolated from the rest of the city. The station was a hub for travelers to and from the Middle East and Africa before flying became popular and affordable. Orloff retrieved coins from her secret pouch and purchased a one-way train ticket on the Paris-Lyon-Mediterranean railway line. While the train travel was long and the cabin hot and crowded, the journey gave Orloff an opportunity to appreciate the vast and verdant landscape of the French countryside.

Finally arriving at the Gare de Lyon in Paris, she encountered crowds of people speaking French and other languages she did not understand. The station was built only a decade earlier, for the World Exposition of 1900. With its striking bell tower, it made a profound impression on new arrivals as they descended from their trains. As she made her way to a modest hotel on the rue de Rosiers in Le Marais, the Jewish Quarter of the city, Orloff heard the sounds of street merchants pushing their trucks, shouting out in French. Crowds of people, some in religious attire, packed the windy, narrow streets. They lived in tenement housing—an average of thirty families in an apartment building and toilets

in the corridors.[2] Signs in Yiddish alerted her to kosher butcher shops, wine and cheese shops, and bookstores. Known as the Pletzl (Yiddish for "the square"), a small Jewish community lived in this neighborhood in Le Marais since the Middle Ages. After centuries of expulsion, they flocked from Eastern Europe in recent years to escape the pogroms, just as her family had fled to Palestine. France was the first European country to recognize Jewish men as citizens with civil rights.

After checking in to her hotel, she set out by herself to explore the sights and sounds of the urban landscape by foot. The architectural grandeur of city immediately struck her. She had seen nothing like its monumental structures—Notre-Dame, the Louvre, and other historic buildings—decorated with sculptures in stone and bronze and laden with history. The endless sea of boulevards and apartment buildings were erected only decades earlier, in the late nineteenth century, under the direction of Baron Haussmann. She admired their picturesque rooftops, decorative balconies, and protruding chimneys.

As the hours passed, Orloff became hungry. She noticed a Russian restaurant and stopped for a meal. After eating, she continued to wander down the scenic boulevards "like a drunkard," taking in the architectural beauty and light-filled August evening sky. As sunset approached, she was tired and wanted to return to the hotel. At that point, she could remember neither the name nor the address of the hotel where she was staying; with all the excitement of her arrival in Paris, she had forgotten to write them down. After a full afternoon roaming the streets, they all looked the same to her. She did not know where she was. Not knowing French, initially she felt scared. However, she quickly caught her breath and found an old Jewish man with whom she could speak in Yiddish. She explained to him her predicament, and he asked her what she could remember about the hotel. She recalled seeing "a fat woman" sitting in the hotel's restaurant. Her description of this woman, perhaps a proprietor or regular customer, gave enough of a clue for the man to identify the hotel and direct her. Orloff felt this was "not a random first acquaintance with Paris," and "it well tied my destiny with the city."

During her first weeks in Paris, Orloff reconnected with old acquaintances from Palestine who had moved there. She also made new contacts by delivering letters written by friends back home. Through

these connections, she inquired about lodging and work opportunities, and created a social network. Many of these Jewish friends and acquaintances worked in the arts. They had moved to Paris specifically because of its wealth of opportunities for artistic training and exhibition. One such friend, Reuven Lifshitz (Leaf), who had studied at the Bezalel School of Art and Crafts in Jerusalem and later became a teacher there, helped her find her very first room to rent in Paris.[3] It was on a quiet street in the Latin Quarter, rue de Feuillantine, not too far from the rue Mouffetard and the Jardin du Luxembourg.[4]

Lifshitz introduced her to other young émigrés from Palestine who lived on this street. Orloff describes how thrilled she was to join this community of young people with whom she could speak Hebrew. This is interesting considering the prior account of her initial resistance to speaking Hebrew upon her emigration to Palestine. Faced with her lack of knowledge of French, Orloff realized that Hebrew, Yiddish, and Russian were still her primary vehicles for communication as they had been in Palestine. She enrolled in French classes at a language school that was conveniently located nearby.[5] She quickly became immersed in this new world that was dominated by Jewish émigré artists, writers, students, and intellectuals.

ENTERING THE WORLD
OF HAUTE COUTURE

Soon after she settled in Paris, Orloff enrolled in a three-month course leading to a diploma certifying her as a teacher of sewing and fashion design. She registered at an unnamed school that she described as being well known for teaching the best techniques in sewing and dressmaking patterns. Perhaps it was the École supérieure des arts et techniques de la mode (ESMOD), a private school founded in Paris in 1841 by Alexis Lavigne, a master tailor. But given her limited financial means, it is more likely that Orloff attended one of the free écoles *professionelles* that opened in the 1880s. Financed by the city of Paris, the mandate for these schools was to provide training and apprenticeships to young working-class women in "women's crafts," including dressmaking, corsetry, lingerie, embroidery, millinery, and other female-dominated trades.[6] These vocational programs placed

Figure 4.1. Henri Gervex, *Five o'clock at Paquin's*, 1905.

a strong emphasis on drawing, and some of them also offered formal training in the teaching of these trades.

Orloff found a prestigious placement for her apprenticeship at the haute couture house of Paquin, confirming that her skills impressed her teachers in the fashion school. Her Russian neighbor, Madame Rosenblum, who worked at Paquin, helped her get the job.[7] As the "largest and most stylistically influential couture house of the Belle Époque," Paquin attracted affluent female clients wishing to modernize their fashion image at the end of the Victorian era.[8]

A 1906 painting by the French artist Henri Gervex, *Five o'clock at Paquin's* (see figure 4.1), depicts Paquin's fashion salon "as a space where the commercial, the artistic, and the social collide."[9] We see saleswomen (without hats) showing clients (wearing ornate hats) samples from which they can choose their dress fabric. All the clients wear elegant dresses, some of them holding parasols and accompanied by small dogs. Madame Jeanne Paquin had a reputation for abandoning corsets and stays that constricted the female figure, and creating a new silhouette based upon the female body's natural contours. She

always wore her own designs and was the first internationally success-
ful couturiere to become a fashion icon.

At Paquin, Orloff created preliminary sketches for designs to be
worn by socially elite Parisian women. Her experience was quite dif-
ferent from her prior work as a seamstress in Palestine, where she
designed and sewed European dresses independently for female set-
tlers and farmer's wives. Paquin designed garments for the Queens of
Belgium, Portugal, and Spain; for famous actresses such as La Belle
Époque stars Liane de Pougy and La Belle Otero; and for the wives of
American tycoons such as the Astors, Rockefellers, and Vanderbilts.[10]
She regularly hired professional artists to promote her designs through
avant-garde fashion illustrations that were widely reproduced in popu-
lar Parisian magazines. The publication of such works promoted a new
style that was liberating for women.

Orloff changed her own appearance dramatically with her move to
Paris. She looks both modern and Parisian in a photograph standing
beside an unidentified female friend from 1911 (see plate 2). It shows
the two young women posing outdoors before the camera. While they
wear more modest outfits than Paquin's female patrons in Gervex's
painting of five years earlier, they appear stylish. Orloff is wearing a
"hobble skirt," with hidden pleats in the back to facilitate her ability
to walk outdoors. She and her friend wear nearly identical flat, white
shoes that were popular among modern women in this period and
facilitated walking on the rocky, uneven terrain. Both women also wear
small leather purses draped over one shoulder. Orloff sports a wide-
brimmed hat that is decorated with a single large flower, a popular style
of women's haberdashery in this period. In just one year since her move
to Paris, she transformed both her physical appearance and her life.

Despite Orloff's efforts to assimilate and embrace modern French
fashions, she was still a Jewish émigré from Ukraine through Palestine,
who did not speak French. She dressed modestly in comparison to her
peers, and had a sturdy physique, unlike most women working in the
fashion industry in Paris. Although the house of Paquin employed
émigrés, Orloff initially did not feel accepted by her new colleagues
as she integrated into the work environment. In her interviews, she
describes how she felt like an outsider following her arrival in France,
because of her émigré status: "At the time, they still considered me as a

foreigner-immigrant. I hardly penetrated the essentially closed French society, which is usually estranged toward its foreigners and immigrants. From the first day I arrived, my friendly connections were with the non-French community, mostly Russian immigrants and students, as well as people from Eretz Israel, who studied or visited in Paris."

Orloff earned one franc a day for her work at Paquin, which was barely enough to support her daily living expenses in the student and artist accommodations of the Latin Quarter. Archival records suggest that the working conditions at Paquin were poor, and employees made frequent complaints to the Chambre syndicale de la couture Parisienne that Madame Paquin did not treat them well.[11] They even reported Paquin to have locked some of them in closets upon finding fault with their work. These accounts, recorded in the Archives of the Préfecture de Police in Paris, show how the police documented the grievances, strikes, and union meetings that regularly affected the fashion industry.[12]

After working a full day at Paquin, Orloff attended classes at the professional school for dressmaking in the evenings. She sat for hours at a long wooden table beside her classmates, sketching samples of women's clothing. She relied on a young Jewish classmate from Palestine who spoke French to assist her in communicating with their teachers. One evening, about halfway through the course, one of her teachers (through this friend who translated) noted her "extraordinary talent for drawing," and suggested that she consider studying fine art instead of dressmaking. Having long felt dissatisfied by her work as a seamstress, the teacher's comment and support of her artistic abilities and professional promise elated Orloff. She was, however, conflicted. She almost never mentioned this part of her biography in interviews and prohibited Katznelson from discussing her experiences in the fashion school and in Paquin's salon in the interviews. Perhaps she felt that these details about her life as a young émigré who supported herself as a seamstress diminished her achievements as a professional sculptor in France.

In contrast, the interviews dramatize the day in which Orloff created her very first sculpture, an "origin story" she liked to share in interviews.[13] The story contributes to a narrative that sculpture was her "natural calling" and that she picked it up almost effortlessly. One

day in 1911, an artist friend from Palestine asked her to accompany him to the studio of a Russian artist, Aleksander Shervashidze. When they arrived, Orloff quietly observed her friend sit for his portrait. Shervashidze began to sculpt, but instead of focusing on the portrait, he ran around the studio in an "agitated" manner. He turned to Orloff, sighed deeply, and uttered in Russian, "difficult." She responded in an off-handed manner, without giving it much thought: "Difficult? Not at all. Why is it difficult?" This angered Shervashidze, who replied, "You said it isn't difficult? You should give it a try and then we will see if it is an easy task or not." Without any sign of intimidation, Orloff responded calmly, "I will."

When she and her friend left the studio, she took home some clay, promising to return to show Shervashidze her work. When she entered her room, she was struck by the framed photograph of her elderly grandmother sitting on her table and decided to sculpt from it. She set to work: "Immediately, I started to mold the clay and create my grandmother's portrait. To my endless delight I succeeded." Orloff was so pleased with her work, she shared it with a friend who mistook it for the work of Joseph Chaikov, a Ukrainian sculptor who was well known in Paris at the time. When she returned to Shervashidze's studio and showed him the small piece, he "shrugged his shoulders with skepticism" and responded, "If indeed you created this sculpture, then you should know the meaning of the word 'difficult.'"

This origin story reinforces the way in which the interviews position Orloff as fearless, innately talented, and possessing a very strong self-esteem. Her skills as a sculptor are described as coming to her effortlessly, which seems rather unrealistic. She suppresses the stories about fashion school in her artistic formation and instead spotlights this formative moment of passion and artistic creation.

TRANSITION TO THE WORLD OF FINE ART

Orloff began her official transition from a career in fashion to fine art by making another momentous decision. After living in Paris for about six months and working and studying in the world of fashion, she applied to the École Nationale des Arts Décoratifs, or National School of Decorative Arts ("Arts Décos"), one of the two state-funded

art schools that offered free full-time courses of study in Paris. Inspired by the encouragement of her artist friends and drawing teacher at the fashion school, she decided to pursue fine art as a career. Both Rodin and Matisse had been among the notable former students who took classes at Arts Décos. She knew that a degree from this school would open up her professional opportunities.

When she applied to the school in 1911, Arts Décos was known as the Petite École, in contrast to the Grande École, as they called the other statefunded art school, the École Nationale Supérieure des Beaux-Arts.[14] In both schools, women studied in classes separate from men, and faced curricular limitations. Both schools prohibited female art students from studying the live nude model, female or male, until the turn of the century. At this time, the most notable independent female artists emerged from private instruction, which Orloff could not afford. Some late nineteenth-century Parisian schools, like the Académie Julian, offered separate studios for women at double the cost. By 1910 a number of private academies had followed suit, offering mixed classes to large numbers of both French and international women.[15]

When Orloff applied to Arts Décos in 1911, the school recently restructured the women's curriculum and was more encouraging of those who wished to pursue careers as professional artists. Women were allowed to draw from the nude model, female and male, in life-drawing class, unlike their predecessors. By this time, the school attracted students from bourgeois family backgrounds and those from families of artists. Tensions persisted between the school's vocational aims for female art students, and the aspirations of women like Orloff, who wished to become professional fine artists.

Soon after she completed the fashion training course, Orloff spent her free hours each day preparing to compete for a coveted spot at Arts Décos. A rigorous national exam, held every spring in Paris at the high school for decorative arts, determined admission. Realizing that her tiny, dimly lit room in the Latin Quarter was inadequate for the serious study of fine art, she rented a larger and brighter room in the Hôtel Medical, a well-known student residence in Paris, next to the Sorbonne Faculty of Medicine. After spending her first night there, she startled when the building manager knocked on her door at six o'clock the next

morning. He demanded that she join the other young women boarders in showering en masse, apparently part of a rigid bathing schedule in this student residence.

> While I looked for a place to hang my robe, I suddenly noticed an Arab man standing among the naked women. Unknowingly, I tightened my robe around me and got ready to yell out loud. The Arab sensed it, approached me, and said, "Don't be afraid, Miss. I am a eunuch . . ." We started talking in Arabic and the eunuch enjoyed very much talking with me, ostensibly in private, while the French students, who didn't understand the language, surrounded both of us. His role was to massage the bathers, and he did that with great expertise.

Her initial reaction to this man, who identified himself as a eunuch or impotent bath attendant, recalls the Jewish women of Petah Tikvah's fear and loathing of Arab men. After conversing with him in Arabic, Orloff realized she had more in common with him than she did with the young French women who could not understand their conversation.

Despite this regimen of rising so early, her room at the Hôtel Medical thrilled her. It had ample natural light, electricity, and even a small balcony. In the evenings, a Russian artist friend of hers from Palestine named Zagorodny came to visit regularly. She described him as a painter who trained at the art academy in Odessa and, thereafter, at the Bezalel School of Art and Crafts in Jerusalem. He was currently studying architecture at the Arts Décos. He was familiar with the entrance exam and curriculum and encouraged her to apply. Zagorodny generously offered to work with her to develop her skills in drawing, composition, perspective, and more. She also spent nearly every Sunday visiting the Louvre, where she studied the history of art with great curiosity.[16] Orloff worked diligently for two months and felt well-prepared when it was time to sit for the examination in May.

When she got home from taking the exam, she developed a high fever that lasted days while she waited for the results to be posted at the school. Too nervous to go by herself, she asked Zagorodny to accompany her. She suggested he look by himself while she waited outside, at the corner of the rue Bonaparte. If they rejected her, he should make a negative sign with his hands; if they accepted her, she

told him, he should "make a sign to show it." The two friends parted, and Zagorodny disappeared inside the school. Orloff waited outside for a grueling thirty minutes. When he finally reappeared, Zagorodny ran toward her, his "hands waving like a crazy person." She moved toward him with tears of joy. Not only had she passed the exam and gained a spot in the prestigious art school, but her name appeared second on the ranked list, meaning she got the second highest score on the exam.

Orloff began her studies at Arts Décos on October 3, 1911. Her name was inscribed, along with one hundred other young students that day, in the registry for its "section for young women." Despite excelling on the entrance exam, she still felt like an outsider there. The registry included the date of birth and name of the country of origin for most of the foreign-born students, but for some reason these two sections were left blank besides Orloff's name. Twenty-three years of age, she was among the older female students enrolled in the program, where age range was between sixteen and twenty-five. Palestine was not officially a state, she was not yet a French citizen, and as a Jewish émigré from the Pale of Settlement, it is unclear whether she had a Russian passport. Her socioeconomic status also differed from that of most of her class-mates. She listed her father's occupation as "farmer" (*cultivateur*), in contrast to many of the women in her class who came from bourgeois, artistic, and even noble family backgrounds. Given her financial limita-tions, poor command of the French language, and lack of background in either geometry or art history, Orloff faced several obstacles.

She spent the next three years taking part in Arts Décos's classes for women at 10bis rue de la Seine, around the corner from where the men studied on rue de l'École-de-Médecine. The women's curriculum focused on drawing (including from female and male life models), anatomy, painting, principles of decoration, along with art history and specific training in a variety of types of decorative arts. Sculpture was "strictly forbidden," according to Orloff, and the faculty discouraged female students from exploring artistic media that fell outside the parameters of their curriculum. Making sculptures required physical exertion that some believed posed challenges for women and prevented them from pursuing the field professionally. It was possible, however, for women to specialize in the study sculpture at the École Nationale Supérieure des Beaux-Arts.

Several female sculptors emerged in Paris to disprove such theories, most of them having trained in private academies. Among the most critically acclaimed female sculptors working in France in this approximate period were Camille Claudel, Anna Bass, Lucienne Heuvelmans, Berthe Martinie, Jane Poupelet, Anna Quinquaud, Janet Scudder, and Yvonne Serruys. Heuvelmans, an academic sculptor who trained at the École Nationale Supérieure des Beaux-Arts, was the first woman to win the Prix de Rome in 1911. It was, however, nearly impossible for any of these women to achieve the status of *statuaire*, or academically trained, "monumental sculptor," given the costs and practical difficulties of space to create and exhibit sculpture.[17] Beyond academic training, artists like Aristide Maillol and Charles Despiau, two of the most popular academic French sculptors in the first decades of the twentieth century, got hands-on work experience as assistants for Rodin in a variety of sculptural techniques. In salons, most academic sculptors showed plaster models hoping to gain commissions or attract clients who could afford to pay for full-scale execution in stone or bronze.

She continued working at Paquin in the evenings while enrolled as a full-time student at Arts Décos. Even though admission was free, she needed to earn a living, unlike many of her Parisian peers. Orloff's interviews shed light on her interest in a career in sculpture despite the constraints placed upon her as a female art student. She recalled how one day her favorite painting professor, a man named von Friesland, asked her what type of work she liked to make outside of class. In response, she told him about her passion for experimenting with clay, plaster, and other sculptural materials. In response, von Friesland offered to bring Orloff to the Louvre with him in order to show her some of his favorite sculptural works. Together they visited the Department of Egyptian Antiquities, which she recalled made a "huge impression" on her. They returned to the Louvre multiple times together, and Orloff describes how this professor "became my confidant in all that had to do with my sculpture, which was officially forbidden in the school. I sculpted now in the underground, with the permission of von Friesland—my painting teacher."

Even though she could not study sculpture formally at Arts Décos, Orloff experimented with different sculptural techniques in the stu-

dios of her friends and colleagues. Soon she was attracted to a range of materials: clay, wood carving, plaster, terra-cotta, marble, and so on. She transferred her classroom sketching from the live model into classical-style sculptures, with great attention to symmetry and solidity of form. Though she was prolific from the beginning, the earliest sculptural work Orloff produced while still an art student in Paris is missing. Certain pieces disappeared when she left Paris briefly during World War I, followed by the Nazis' violent pillaging and vandalizing of her studio during World War II.

MY LITTLE SCULPTURE

A photograph of Orloff at twenty-four years old, taken in 1912, gives us some clues about her beginnings as a sculptor (see figure 4.2). Previously thought to have been taken in a studio at Arts Décos, the location is questionable if they prohibited her from studying sculpture there.[18] The photograph shows Orloff standing posed beside a reclining female nude she called *My Little Sculpture*, a piece whose whereabouts are unknown. She wears a simple artist's smock, and her hair, grown longer since her days in Palestine, is braided and pinned back from her face in coils. She looks downward, her gaze echoing that of her sculpted figure, a modest smile suggesting pride in her work.

This photograph documents the progress Orloff was making as an emerging fine artist. Her treatment of the figure's reclining female form reveals her early objectives as a figurative sculptor. Its slender proportions, smooth modeling, and S curve of the twisted torso call to mind Praxiteles's *Crouching Aphrodite* or so-called *Venus of Doidalsas* (mid-third century BC), which Orloff viewed many times at the Louvre. The sculpted figure, however, is much less upright than the *Crouching Aphrodite*, suggesting Orloff was looking at various models of inspiration. The curriculum required students at Arts Décos to draw canonical works of European art in the permanent collection. Some of her professors also served as curators there. For example, she became passionate about French medieval sculpture in her art history courses with Paul Vitry, curator of sculpture at the Louvre. Orloff also took courses in drawing, design, and anatomy with Philippe Bruneau, curator of Greek and Roman art at the Louvre. So, at the very outset of her career, she

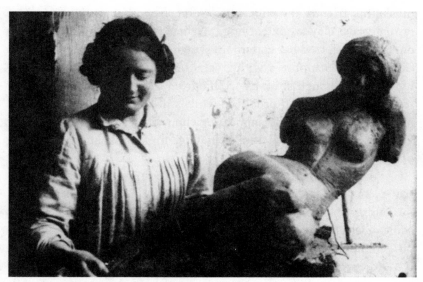

Figure 4.2. Orloff with *My Little Sculpture*, 1912.

engaged with foundational and art-historical concepts that informed her later work, particularly the notion of the power of the classical female body as a symbol of national strength and unity.

The photograph also raises the question of who Orloff's contemporary role models were while experimenting with sculpture outside the curriculum for women at Arts Décos. When asked in an interview which modern sculptors had influenced her, she replied, "Oh, the influence of "masters"? Like Maillol, Despiau? Never. My great love was always Rodin. But it's silly to steal from Rodin."[19] Both Maillol and Despiau worked in a predominant sculptural style that she may have found decorative and formulaic, and they often depicted traditional mythological and allegorical themes.[20] In contrast, Rodin's work was controversial at the time because his naturalistic renderings of the human body emphasized physicality and subjective human experience. Orloff's *Little Sculpture*, with its lack of arms and compactness of form, shows her first efforts at navigating these debates around figurative sculpture in French academic art circles circa 1912.

Once immersed in her studies at Arts Décos, Orloff became preoccupied by her desire to make her own artwork in the evenings. She had to continue her work at Paquin in order to support herself. Often

bored while drawing models of women's garments, she came up with creative ways to break up the monotony and stay engaged with her own art practice. For example, one evening she brought some Plasticine, a brand of modeling clay, with her to work at Paquin, in order to experiment with her latest ideas in sculpture. She hid the material in her lap and secretly modeled a small sculpture of a cat that often roamed around the sewing workshop in the evenings. Her supervisor at Paquin, noticing something was amiss, demanded to know what she was doing underneath the table. Embarrassed, she showed him the sculpted cat she had made. In response, he uttered, "Fine, never mind . . . but everything that you do here belongs to me." The supervisor took the sculpted cat away from her, which both unnerved and amused her.

Orloff performed so well during her first year of study at Arts Décos that they awarded her a scholarship at the start of her second year in the fall of 1912. It provided her with a small living stipend (since the school was tuition free) that enabled her to work fewer hours at Paquin and focus more on her art. Having this financial support also allowed her more freedom to explore sculpture as a medium and avant-garde styles of art-making outside the constraints of the state-funded academy.

AVANT-GARDE ADVENTURES

By fall 1912 she had become part of a close-knit community of Jewish and Russian émigré artists and intellectuals who lived in the Latin Quarter. She met her friends for lunch in the neighborhood, or in the evenings at popular gathering places such as Café de la Rotonde (La Rotonde), founded in 1911 by Victor Libion, which quickly became a hangout for Parisian artists and intellectuals and Russian revolutionaries, including Leon Trotsky. She recalled how they "hung around there for many hours, arguing, singing, dancing, and talking, our spirits high and our hearts full of joy."

It was at La Rotonde or the competing café, La Coupole, that Orloff may have first met Picasso, who had a studio nearby. She was, as usual, with a host of notable Jewish émigré artists who came to form the corps of what we today call the "circle of Montparnasse" or the École de Paris (School of Paris).[21] Among her eventual group of close friends were Marc Chagall (born in Vitebsk, Russia, who arrived in Paris in 1910), Amedeo Modigliani (born in Leghorn, Italy, and arrived in Paris in

1906), and Chaim Soutine (born in Smilovitchi, Lithuania, and arrived in Paris in 1912).[22] She befriended these artists and many others during the 1910s as she transitioned from fashion to fine art and navigated her way between the official academy and the avant-garde. Most of them lived in or near Montparnasse. Chagall and Soutine, along with Moïse Kisling, Jacques Lipchitz, Ossip Zadkine, Alexander Archipenko, and others, lived in a large building known as La Ruche (The Beehive), an old three-story circular building in the fifteenth arrondissement that resembled a large beehive. Designed by Gustave Eiffel for the Great Exposition of 1900, it originally functioned as a wine rotunda but later was repurposed as low-cost live-work spaces for artists and others with little financial means. Modigliani, as well as Tsuguharu Foujita and Constantin Brancusi, lived in Cité Falguière, in damp, unheated studios and a cheap live-work space without running water. Initially Orloff looked to her artist friends for social and intellectual companionship, but they also inspired her to imagine a different life for herself that validated the arts as a viable career path.

Every Thursday, the one weekday when she did not have classes at Arts Décos, Orloff visited Académie Vassilieff (21 avenue du Maine), a private art establishment founded by Russian artist Marie Vassilieff. Located in a small house in a little alley off the avenue du Maine in Montparnasse, it was not too far from Orloff's room on the rue du Faubourg-Saint-Jacques.[23] A photograph of Orloff from 1912 shows her standing beside academy founder Marie Vassilieff (see figure 4.3) and other artist friends. Vassilieff, who emigrated to Paris from Smolensk, Russia, in 1907 and studied briefly with Matisse, was a cubist painter and an independent woman only slightly older than Orloff.[24] She first opened her own art organization in 1910 at Villa Steinheil (8 impasse Ronsin, Paris), where she curated a number of exhibits in collaboration with the Société russe artistique et littéraire. Following dissention within that group, she became secretary and then director of the Académie russe de peinture et de sculpture (54 avenue du Maine). Vassilieff's goal was to create a hub for artistic exchange and avant-garde experimentation while providing support to émigré artists with limited financial resources. Ultimately she broke from that group as well, and moved across the street (21 avenue du Maine), where she founded the Académie Marie Vassilieff in November 1912.

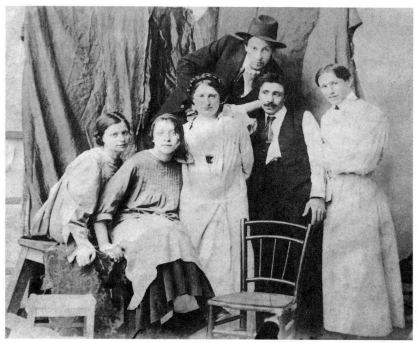

Figure 4.3. Orloff (*center*), Marie Vassilieff, and friends, Académie Vassilieff, 1912.

In her own unpublished memoir, Vassilieff wrote: "The Académie Russe became very popular, because of the price, three francs per week. Not at all expensive! But the foreign students always paid regularly, even the poor Russians who today have become rich, like Zadkine, Chana Orloff and Chagall."[25] Vassilieff's academy provided Orloff with access to studio and exhibition space, life model sessions, guest lectures, and a regular venue to exchange ideas and engage in critiques with colleagues. There were no formal courses or exams. The most common languages spoken by those who frequented the academy were Russian, Yiddish, and Hebrew. It was there or in the local cafés like La Rotonde and La Coupole that Orloff first met those artists who formed the nucleus of her social and artistic community.

Figure-drawing sessions were available on a drop-in basis at Vassilieff's academy for a small fee. From five to seven every evening, a nude model emerged, ready to pose and change postures in intervals that lasted between five and thirty minutes. The models were women

and men of a variety of ages, races, sizes, and shapes. Rather than rushing to capture every change of posture on paper, as did most of the painters, Orloff preferred to sit quietly and watch. She then returned to her room and sketched from memory. She made thousands of drawings over the course of a year in which she developed her own personal method for capturing a wide range of motions. Orloff claimed that this method became an "inseparable part of all my sculptures and endowed them with my artistic and personal style." These sessions also gave her the foundation for applying the principles of cubism to sculpture, by depicting the human form through shifting viewpoints of volume or mass.

Soon Orloff straddled two worlds: the conservative Arts Décos and the more progressive spirit of avant-garde experimentation. Although she committed to completing her diploma at Arts Décos because of the professional doors it could open, including being licensed to teach in the arts, she became most passionate about making modern sculptures. She submitted and had accepted two of her earliest sculptures in the eleventh annual Salon d'Automne, held at the Grand Palais in Paris from November 15, 1913, through January 8, 1914. The Salon d'Automne first opened in 1903 as an alternative to the more conservative exhibitions associated with the official Parisian Salon tied to Académie des Beaux-Arts. It quickly became a prestigious venue for showcasing innovations in painting, sculpture, engraving, architecture, and decorative arts. Between 1910 and 1913, it was one of the largest annual exhibition venues that supported artists engaged with cubism. The 1913 Salon d'Automne also included a small exhibit of Russian folk art that brought together the artistic circles of Russian Paris, including the Académie russe in which Orloff participated.[26]

In her early works, a central theme for Orloff was the representation of the Jewish body. *The Two Jews* appears in a photograph from 1912 with Orloff posing proudly alongside it (see figure 4.4). This relief sculpture in plaster depicts a young Jewish couple from the neck upward in profile, dressed for prayer. The male figure wears a yarmulke on top of his curly, matted hair, and a prayer shawl covers the woman's head, her bangs echoing the artist's modern hairstyle. The figures' features are stylized, their noses aquiline and reminiscent of regal portraiture from both Egyptian relief sculptures and Roman

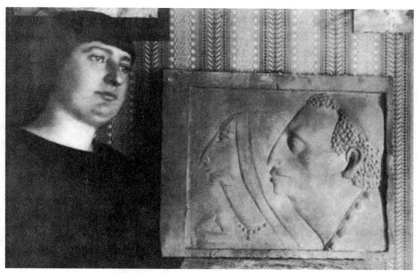

Figure 4.4. Orloff with the *Two Jews*, 1912.

coins. Orloff idealized and classicized the couple's facial appearance and physiognomies, emphasizing identically shaped, long noses and angled profiles with brows in high relief.

The photograph sheds light on Orloff's emerging self-image as a modern Jewish woman artist. She wears a plain black shirt, and her thick, newly cut dark bangs are a recognizable sign of the modern, economically emancipated French woman of the period. She revisited the short hairstyle and masculine appearance that she previously had adopted in Palestine, but with a modern Parisian style. Her own facial features seem to ask of her audience: what does it mean to create a Jewish portrait and to be a modern Jewish woman artist?

Orloff's early visual representations of Jews countered the many negative stereotypes of the Jewish body that circulated in French popular culture and in Europe at large in the wake of the Dreyfus Affair.[27] The debate surrounding the controversial 1894 trial of the Jewish Captain Alfred Dreyfus for treason resulted in the wide dissemination of imagery promoting long-lived stereotypes of Jews in France. They commonly portrayed males as either weak and emasculated or avaricious and conniving, and females as overweight and overbearing maternal figures, or hypersexualized femmes fatales. In Paris of the

Figure 4.5. Charles Huard, poster advertisement, *En Israël*, 1899. Paris.

1890s, 1900s, and 1910s, it was common to see caricatures of European diaspora Jews with "Orientalizing" facial features as a way of marking non-white difference and questioning just how far east the racial origins of Jews in fact extended (see figure 4.5). Such caricatures relied upon the fin de siècle discourse of so-called primitivism that engaged with the emerging disciplines of anthropology and ethnography to offer new definitions of "the Jew" as "other."[28] The relationship between the Orientalist and antisemitic discourses in France is complex, and Orloff's early imagery of the Jewish body offers a powerful point of intervention. She relied upon the logic of physiognomy to counter popular negative stereotypes of Jews that circulated in France during the first decades of the twentieth century by creating her own new visual archetypes.

During this same period in which she began exploring Jewish identity in her work, Orloff also developed her own new formal style of sculpting portraits based upon figural abstraction. *Woman with Arms Crossed (Madonna)* (1913) (see plate 3) shows the dramatic shift in her style from the previously discussed *Two Jews* (see figure 4.4) and *My Little Sculpture* (see figure 4.2).[29] Analysis of this work provides a better understanding of the relationship between modernism, "primitivism," and Jewish identity in Orloff's developing sculptural practice. She presents her subject with an oval-shaped face, accentuated by large, flat, almond-shaped eyes void of detail or expression. The figure's prominently arched eyebrows merge into the bridge of her long, straight nose, accentuated by the thin lips turned slightly downward.

The sinuous curves of her folded arms and long, slender fingers draw our attention to the finely detailed bodice. The simplified geometric features and poses of Greek Archaic and Cycladic sculpture that she studied at the Louvre likely influenced Orloff here.

As her knowledge of art history grew, she began integrating her interest in a wide variety of cultures and periods into her work, all while finding her own place in the avant-garde. Many of Orloff's friends and colleagues (including Picasso, Modigliani, Lipchitz, Brancusi, Archipenko, and Zadkine) were engaged at this time in developing a new field of modern, abstract sculpture inspired by their study of what they called "l'art nègre" or "l'art primitif" ("black art" or "primitive art"), which referred to African and Oceanic arts.[30] The cubists' appropriation of the formal qualities of African art is now familiar in the history of art. According to art historian Patricia Leighton, "primitivism became a method for revolutionizing style" and presented "an alternative to currently entrenched social and aesthetic norms."[31] The practices and attitudes surrounding modernist primitivism have been widely critiqued for their reflection of colonialist perspectives. While there is no direct evidence that Orloff studied African art in the Parisian Musée d'ethnographie du Trocadéro, the shift in her style that occurred in 1912 suggests she was aware of this trend among her colleagues. She was familiar with African masks and statues from the colonies readily available in Parisian flea markets and secondhand shops.

Woman with Arms Crossed (Madonna) shows Orloff's continued interest in exploring themes of "Jewish primitivism." The sitter was her close friend Pauline Lindelfeld, a Polish Jewish émigré from Lodz who came to Paris to study philosophy at the Sorbonne. Orloff created the piece at the time that Lindelfeld made the momentous decision to convert from Judaism to Roman Catholicism and enter the convent of the Congregation de Notre-Dame de Sion (NDS). While the original goal of the convent was to promote the conversion of Jews to Catholicism, it also has a long history of working to improve the relationship between Catholics and Jews.[32] They eventually baptized Pauline Lindelfeld with the name Pauline Emmanuelle Lindelfeld, Mère Marie Danièle de Sion.[33] The convent was part of a congregation founded in the mid-nineteenth century by a group of Brothers and Sisters, some of whom were born as French Jews and converted.

Orloff later renamed the piece *Madonna*, perhaps as a way of calling out Lindelfeld's religious conversion and identification with the Virgin Mary. Both titles suggest Orloff did not wish to view this work as a specific portrait intended to convey her friend's physical likeness. Rather, the piece may be in dialogue with *The Two Jews* (see figure 4.4), created that same year, as representing a specific "type" or identity. Perhaps it stands as another example of Orloff's desire, early in her career, to grapple with questions of Jewish identity, difference, and primitivism, as well as how to best represent the female ideal in her work.

She exhibited and reproduced the piece widely throughout her career, and executed it at different times in various materials (wood, plaster, cement, marble, and terra-cotta). It became one of her most famous early works, and the marble edition is now in the Tel Aviv Museum of Art. Orloff's colleague, the American sculptor Malvina Hoffman, purchased a bronze cast of this work in 1935.[34] Hoffman herself was engaged throughout her career in the sculptural representation of people of diverse racial and ethnic backgrounds and the logic of physiognomy. Most notably, the Field Museum of Natural History in Chicago commissioned the creation of the controversial *Hall of the Races of Mankind* (1933), which was later accused of perpetuating racial stereotypes. This makes Hoffman's appreciation of Orloff's prior work even more interesting.[35] It also gives us insight into the fact that Orloff was part of a network of international women sculptors who knew one another and supported each other's work.

A VISIT HOME TO PALESTINE

Orloff returned to Palestine for a visit in the summer of 1913. She had not seen her family in three years. Somehow, she scraped together enough money to purchase a fourth-class ticket on an Italian ship. She arrived full of excitement to see her family and share with them her experiences as an artist in Paris. Amid the simultaneous joy and chaos of their reunion, her mother pulled her aside and asked her in a serious tone, "Chana, what is a model?" She replied to her mother, "Why are you asking me that?" "It is important," her mother responded.

Orloff gave her mother's question some thought and then explained, "Models are beautiful young women who pose for Parisian painters as part of the creative process of painting the nude." Rachel seemed

reassured by this response and dropped the issue. Later on, however, her mother returned to the topic. She revealed that some residents of Petah Tikvah had falsely accused Orloff of choosing to attend art school in Paris in order to work professionally as an artist's model. Her mother continued, "But you are not pretty enough for that."

Her own mother and community questioned her motives and abilities to pursue a professional career in the arts. The stereotype of a woman in the arts as a model rather than a professional artist was difficult to overcome. Although Rachel quickly came around to understanding the seriousness of Orloff's artistic endeavors, the residents in "this small provincial" settlement continued to gossip. They questioned Orloff's sexual purity, because they believed the bohemian lifestyle of the Parisian art world encouraged promiscuity. Orloff recalled how she "became the notorious 'talk of the town'": "Everyone who bumped into me on Petah Tikvah's few streets instantly asked me in Yiddish the same, ostensibly naive question: How did you find yourself in this situation?'" She continued:

> They posed this question, which contained a combination of astonishment and venom, with a shrug of the shoulders. Its true meaning was: How could I, who came from a good and extremely religious observant Jewish family, be lured into a despicable and impure artistic lifestyle in the big city? A lifestyle that is unfit for a kosher and sensible Jewish daughter. The people of Petah Tikvah have asked me this dumb question so many times that my ears are ringing till today with its provincial venom.

Her farming community in the Yishuv had no context for appreciating the nuances of the professional art world. As a result, Orloff felt shunned.

Sullen and depressed, she retreated from interactions and public events throughout her stay in Palestine that summer. As the end of the summer approached, she wondered how she could afford to purchase her return ticket to Paris so that she could complete her third and final year of studies at Arts Décos. Orloff's eldest brother, Meir Dov, responded to her dismay: "Why are you howling away? Do you have your diploma from the sewing school? Enough . . . stay in Eretz Israel and practice the profession you gained, and that will provide you a

living." Fortunately, her brother Zvi took a different stand. So did her father. He said, "You need to finish what you have started; we will think and figure out a way to bring you back there." Orloff's mother also came to understand her wishes to return to France and eventually supported her decision. While both of her parents were observant Jews who respected the commandment of "Thou shalt not make unto thee any graven image," Orloff believed that they "saw my affinity with art as a holy fire that one should not extinguish, but encourage by any means possible."

Her family members tried hard to find money to pay for her return trip to Paris. As a testament to their encouragement and caring for her, Orloff's father, mother, and elderly grandmother all offered to serve as models for her drawings that summer. They sat for her countless hours "with patience and reverence." Orloff remained anxious about her future, and spent the hottest part of her days lying on a mat on the floor inside the house, sleeping and worrying. Depressed and forlorn, she no longer felt at home in Palestine given how much she had grown and changed over the past three years in Paris.

One afternoon, Orloff was awakened from a nap by the sound of coins hitting the floor. She looked up, startled to find her brother Zvi standing outside the open window. He had just thrown twenty Napoléon toward her, a loan from a friend. It was just enough to finance her return trip to Paris.

Overjoyed and filled with gratitude, she began to prepare for her departure. She planned to return to Paris in September 1913, just in time to start her second year of studies at Arts Décos. She also was eager to return to Vassilieff's academy and immerse herself in the culture of the avant-garde. In some ways, she was an "outsider" now in both places: Petah Tikvah and Paris. But France now felt more like home than Palestine. She was not religious, and while proud of her Jewish identity, she aspired to develop as a professional sculptor and member of the Parisian avant-garde. She believed it was possible for her to earn a living from her art.

CHAPTER 5
Forging a Career at the Onset of War,
1913–1916

Following her debut at the Salon d'Automne and completion of her degree at Arts Décos, there were fewer opportunities for Orloff to exhibit her work. After World War I erupted, the official annual art salon closed, as did the independent salons, including the Salon d'Automne and the Salon des Indépendants. The Germans bombed Paris from the air for the first time on August 29, 1914, and the city was under blackout. Traffic ceased on the major streets and boulevards, and air-raid wardens and police stood guard. The newspapers stopped production. In order to keep up with the latest news, Orloff joined the crowds that gathered daily at kiosks in her Montparnasse neighborhood to read single-page handouts. The French imposed an eight-o'clock curfew, and the Parisian metros shut down at seven thirty. Taxis became scarce and were extremely expensive, and the French military requisitioned private automobiles.

Most of the leading French-born artists were mobilized, including André Derain, Georges Braque, Albert Gleizes, Fernand Léger, André Lhote, and Roger de la Fresnaye. Among the avant-garde poets and critics that enlisted in the French army were André Salmon, Pierre MacOrlan, and Francis Carco. Foreign-born and female artists had to figure out their next steps. Some of Orloff's émigré friends and colleagues, including Zadkine, Apollinaire, and Kisling, voluntarily joined the Foreign Legion. The latter two sustained serious injuries, as did Braque. Others fled France, either returning to their countries of origin

or going to neutral locations to ensure their safety. Another group of émigré artists, including Modigliani, Archipenko, Foujita, and Soutine, spent the latter part of the war years living and working in Nice to escape the difficulties. Orloff was among a group of artists—along with Picasso, Gris, Lipchitz, and others—who initially stayed active in the Montparnasse neighborhood. Some volunteered to help in the war effort in various ways. For example, Vassilieff took a nursing course and volunteered as a medic in the French Red Cross before organizing an important canteen to support artists. The painter Per Krohg (whom Orloff later portrayed as the *Accordionist* [1924], figure 7.4) joined a volunteer ambulance corps of Norwegian skiers supporting those engaged in mountain fighting in the Vosges.[1] The French academic sculptor Jane Poupelet worked for the American Red Cross in the Bureau for Reconstruction or Re-education in Paris making prosthetic masks for victims of trauma.[2]

Without immediate prospects for exhibitions or gallery affiliations, Orloff was in serious financial trouble. She still worked part time at Paquin but had spent nearly all her scholarship money and had no savings. She was completely cut off from her family back in Palestine, and could not receive funds from them. One day, as Paquin's daughter handed out the weekly paychecks, she announced to all employees that the fashion house was about to close. Upset by the news and concerned for her well-being, Orloff asked the younger Paquin, could she borrow twenty francs, equal to one Napoléon? Unsure how long the war would last, she calculated that this modest sum was just enough to help her through the short term. She offered to pay her employer back by working more hours once the company resumed operations. In response, the younger Paquin uttered "À la guerre, comme à la guerre" (all is fair in love and war), a French proverb meaning "in times of trying circumstances (such as war), any actions are justified." Deeply offended by this rebuff, Orloff left the fashion house after receiving her final paycheck, determined never to return. Once the war was over, Paquin was one of the first fashion houses to reopen its doors. The manager invited most of the employees, including Orloff, to return to their jobs. Because of her pride and dignity in the face of adversity, Orloff rebuffed the offer. It was time for her to make a clean break with the world of fashion and find a way to make a living as a full-time artist.

LIFE AS A WAR REFUGEE

When the Germans reached the banks of the Marne River in the late summer of 1914, Orloff received an order from the Préfecture de Police to leave Paris immediately. She was told she must move temporarily within the French countryside because her Russian citizenship could put her safety at risk in the event of a German occupation of Paris. The interviews engage the phrase "orders are orders," suggesting she felt she had no choice but to adhere to this directive. Once again, Orloff became a refugee. Her ethnic outsider status made her vulnerable during the war.[3] French authorities established different regions that were considered "safe zones" for immigrants and refugees, and she moved briefly to an unnamed "small village in northern France."[4] While she was not politically radical, as an immigrant she was at risk if the police questioned her allegiance to the French government.

Orloff dutifully followed instructions and left the city as quickly as possible. She entrusted French friends with the care of what she considered her most ambitious and valuable sculpture, *Woman with Arms Crossed* (*Madonna*), and left her other works in her small studio on the rue du Faubourg-Saint-Jacques, unsure of when it would be safe to return. She packed her belongings into one suitcase and said goodbye to her friends. With "no money or an actual address," she boarded the train at the Gare du Nord. Now age twenty-six, she was once again being asked to leave all that was familiar to her. This was not what she expected, having just graduated from the prestigious state-funded art school. The train travel was hot and tiresome, and the uncertainty of not knowing exactly where she was going and for how long weighed heavily on her mind.

When she arrived at the village, she noted how "life continued" in this town, as if the world were not at war. She secured free room and board in the home of the village doctor, "an amiable woman" who "welcomed 'the refugee from the city.'" It was the harvest season, and Orloff relished in taking in the rich smells and tastes of the ripe fruit that piled up in the streets and courtyards. She described picking baskets of walnuts, and she must have worked in farming for some income. Her experiences growing up in a Ukrainian village followed by the moshava of Petah Tikvah gave her familiarity with day-to-day life in a small agricultural village. Nonetheless it was a culture shock to move to

such a remote place after having lived and worked in Paris for the last four years.

Determined to continue her art practice, Orloff approached the village priest to inquire about work space. He offered her the use of his garage as an art studio. She went there every morning, focused on refining her technique of figure drawing. She did not work from a live model, but rather from her memories of those sessions at Vassilieff's academy back in Paris. One day she decided to paint large images of the female nude from memory on the walls of the priest's garage. While presented in the interviews rather matter-of-factly, it is unclear whether she painted the imagery on paper or canvas that she hung on the walls, or directly upon the garage walls. The latter would have been a brash move given that the building was not her own personal property. When the priest saw what she had done, he became vocally upset. He was afraid that exposure to her renderings of the nude female body could lead to promiscuity among the villagers. We think back to her mother's fears about the impropriety of her "modeling" in Paris when she returned to Petah Tikvah. It is unlikely that the priest, or anyone living in the village, had ever met either a female artist or a Jewish émigré from Ukraine or Palestine. And here she was, once again embodying several potentially subversive identities, and daring to paint what a Catholic priest perceived as indecent imagery on his garage walls.

One day while drawing in the "studio-garage," Orloff noticed a piece of wood standing in the corner. Although she did not have the proper tools for carving, she found a hammer and began experimenting with ways to use it to make a sculpture. Every morning, she entered the dark studio and spent hours pounding on the wood. The "naive" local villagers could only hear the noise coming from the closed garage, and did not know what she was doing inside. She speculates that they avoided the garage because they believed "the Paris refugee is 'crazy.'" In the years that followed, Orloff recounts that she preferred to work with wood over marble because it brought unique qualities to her artistic process:

> I felt as if the wood instructs me in my artistic way and I will find it in my personal expression. The wood had a distinctive life

that merged into a portrait that was designed by an artist. These double lives did not contradict each other, or get lost inside one another, but balanced each other in the artistic creation. Since the experience in the priest's warehouse, [I perceived] working in wood . . . as an embodiment of all nature's elements: man, animal, plants.

For Orloff, this experience of carving in wood was a formative one. She gained new insights into her use of natural materials and developed an organic process that she took to her future practice of sculpting portraits in wood.

Eventually, she finished what she described as her first wood sculpture. Most likely it was *Mother and Child* (1914), an elegant sculpture of an abstracted woman standing upright like a column, attached to a small pedestal, and embracing a naked child closely against her chest (see figure 5.1). She reflected on her choice of the maternal theme:

I chose the theme because of the peaceful life in the village, which continued ordinarily, while in Paris people suffered from the horrors of war, and so much French blood was spilled. . . . By the rough style and composition I meant to express a primordial power, which will always exist despite the wars and misfortunes that man brings upon himself, although I must confess that the hammer didn't contribute to the refinement of the images' facial features. The hard material and the rough carving express my feeling. I achieved in my first wood sculpture all that I wanted.

By emphasizing the "primordial power" of motherhood during wartime, the language used in the interviews foreshadows a prominent theme that permeated Orloff's life and work. Although this one particular sculpture of a mother and child dating from 1914 lines up chronologically to this story in her narrative, there are some discrepancies between her description of the piece and the style of the actual work. Orloff's maternal statue in wood from 1914 has smooth surfaces, in contrast to her account of a "rough style and composition." Regardless, Orloff presents her time as a refugee during World War I as one of artistic experimentation and productivity in the face of adversity and ostracism.

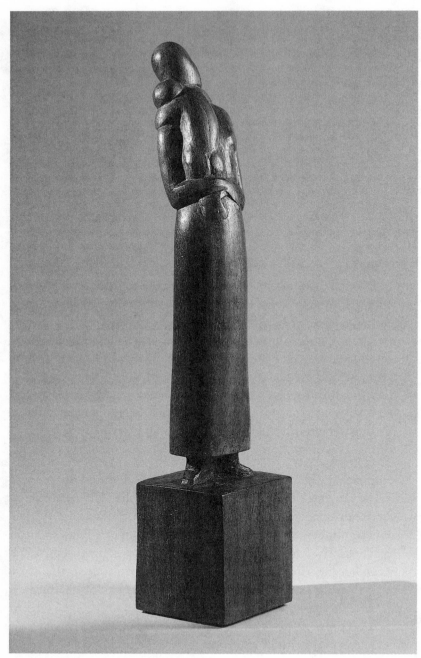

Figure 5.1. *Mother and Child*, 1914. Wood.

DAILY LIFE IN WARTIME PARIS

After approximately eight weeks of living in the village as a war refugee, Orloff returned to Paris sometime in the fall of 1914. She was quite dismayed to find that several of her early sculpted busts in wood and plaster were missing from her studio, likely stolen. She had to rebuild her life and art practice once again, ultimately finding an affordable place where she could live and work and find a way to support herself. She rented a modest room on the rue du Pot-de-Fer (near the rue Mouffetard) in the Latin Quarter. It was there, in what she described as a "narrow, dark, and moldy room," where she made some of her most ambitious sculptures from this period. She was determined to make up for "lost time" and focus on her work "with double energy and passion."

Paris had changed even more dramatically over the course of her absence because of the war. As she walked through her Montparnasse neighborhood, she noticed that the streets felt strangely dark and quiet. Most of the Parisian art salons, galleries, and studios were now closed, and the few theaters that had reopened were staging plays with patriotic themes. The Grand Palais, where she had first exhibited her work at the Salon d'Automne a year earlier, had become a makeshift military hospital, replete with electricity, plumbing, medical equipment, and hundreds of rows of beds. With few resources or places to go, she often spent the entire day at La Rotonde, sketching and conversing with friends, while nursing a single café crème. If she was lucky, the café's generous patron Monsieur Libion handed out complimentary baguettes.

Most of the émigré artists who stayed in Paris during the years of World War I lived in a chronic state of hunger. Widespread food shortages and rationing across the country only grew worse as the war progressed. A law passed in October 1915 that allowed the state to requisition wheat and other grains at a price fixed by the government. By the following year, they extended these regulations to milk, sugar, and eggs. One morning, realizing that she was broke, Orloff came up with an idea for how she might find something to eat. She visited a friend of hers, the painter Jeanne Hébuterne, who was her classmate at Arts Décos (she also studied at the private Académie Colorassi). Jeanne, age sixteen when the war began, was a full decade younger than Orloff. The two women formed a bond in art school and visited each

other frequently during this period. Jeanne lived in her parents' house on the rue Amyot, behind the Panthéon and not too far from Orloff's studio. Jeanne was one of her only friends during this period who came from a bourgeois French Catholic family background. Orloff's plan was to arrive at Jeanne's apartment in the late morning, with a goal of staying until noon. She presumed that Jeanne and her older brother André, also an aspiring artist and a friend of Orloff's, would invite her to stay for lunch.

Once she arrived at their house, Jeanne and André seemed happy to see her. They conversed for a while, catching up on each other's lives and discussing the impact of the war on the Parisian art world. André was about to report for duty in the French army, and Jeanne worried about his safety. When the lunch hour arrived, it surprised Orloff that no one called them in to the dining room. She even waited an extra hour, still expecting to receive an invitation. Eventually she realized that they would not serve a meal as long as she remained in the Hébuternes's home. So she reluctantly said goodbye to her friends, "fuming on the inside, but dared not say anything."

Only later in life, after she had become familiar with "the strict rules of the petite-bourgeoisie" that permeated French society, did she understand why they did not invite her. According to the social mores of their upbringing, invitations should be extended well in advance. As an older woman looking back at this incident, Orloff realized that Jeanne and André "could not have imagined that I could stay for lunch, 'just like that.'"

Orloff offers more context on her experiences with social prejudices and antisemitism in Parisian society. On a separate occasion, before the war, Jeanne Hébuterne in fact had extended a "proper" invitation, one that was issued well in advance, to Orloff to dine at her home. When she arrived that day at the front door and introduced herself to the concierge, as was the custom, the woman apparently took one look at her and told her she must enter the apartment through the back door leading to the kitchen. They relegated this entrance to the working-class staff. Only after Orloff, embarrassed with a "flushed face," explained to the cook who she was could she confirm her identity as a legitimately invited guest. The story concludes with Jeanne and her brother laughing after she told them about the incident. In the inter-

views, she describes herself as still a "green foreigner" and surmises that the concierge judged her simply because she "was not wearing a hat," which was proper attire for an invited guest. In reality, Orloff's overall appearance, including her facial and bodily features, comportment, and dress, must have made an impression that she did not belong to the same social class as her hosts.

The interviews do not suggest that Orloff's Jewish identity was the reason the concierge humiliated her. Another story from the period insinuates this possibility. She recalls that Israël Zangwill, the well-known British Zionist writer, once had a similar experience of "being shown the back door" when he came to Paris. He was paying a visit to his and Orloff's mutual friend, Edmond Fleg, an assimilated French Jewish writer:

> One time Zangwill came to visit at Fleg's rich and aristocratic house, and, as it was customary in those days, approached the concierge. Without knowing who he was, and because of his "too Jewish" appearance, she referred him toward the servants' door, the one which was reserved for foreign beggars. So, rather than entering into Fleg's living room, this respectable guest arrived at . . . his kitchen. I couldn't stop laughing like crazy when Edmond Fleg told me this story in a sad tone.

She describes Zangwill's appearance as "too Jewish," a clear signal of his "otherness" when visiting the home of his affluent and assimilated Jewish friend and colleague. This time, Orloff is the one laughing, perhaps signaling her own uncomfortable identification with Zangwill. Her narrative points to the cumulative effect of these early experiences of Parisian antisemitism and other prejudices that were deeply embedded in French society. Resonating with her early upbringing in Ukraine, she used her own artistic voice to challenge discrimination toward Jews throughout her long and prolific career.

Eventually Orloff registered on a list of artists eligible to receive financial aid from the French government during the war, regardless of nationality. Having a degree from one of the two prestigious state-funded art schools facilitated this process. Once her official paperwork was complete, it entitled her to two low-cost meals a day at a special canteen for artists. She also received a small stipend of a quarter of a

franc per day to cover other living expenses. In a later film interview, Orloff reflected with nostalgia on the freedom she felt during this period: "During the war it was marvelous. It's embarrassing to admit it. . . . And so the French government organized a fund to support artists. We received twenty-five centimes [cents] a day and meals in the canteens. So it was the ideal life, because one could work on their art day and night without having to worry about earning a living."[5] While the years of the war were especially difficult for most young artists, Orloff gives the opposite impression. For the first time since she arrived in Paris, she did not have to work because of the governmental support she received.

She began taking her daily meals at Marie Vassilieff's famous canteen, launched in December 1914 at the site of her studio and academy in the impasse at 21 avenue du Maine.[6] Vassilieff, who trained as a volunteer medic, realized the impact of the war as well as the resulting poverty and food shortage on her artist friends. Her studio and canteen became a site of artistic exchange and daily sustenance for Orloff. Decorated "with odds and ends from the flea market, chairs and stools of different heights and sizes," she always felt welcome there.[7] Vassilieff slept on a sofa and usually was present to welcome the artists at mealtime. As before the war, it also functioned as a perpetual "pop-up" gallery. Paintings by Chagall and Modigliani and drawings by Picasso and Léger hung on the walls, and a wooden sculpture by Zadkine sat in the corner. She set up a tiny kitchen area in the corner, "behind a curtain," and "the cook Aurèlie made food for forty-five people with only a two-burner gas range and an alcohol burner. For sixty-five centimes, one got soup, meat, vegetable, and salad or dessert, everything of excellent quality and well-prepared, coffee or tea; wine was ten centimes extra."[8] Many of Orloff's friends and colleagues joined her there for meals at various times, including Picasso, Braque, Léger, Friesz, Valadon, Modigliani, Picabia, Diaghilev and his troupe, André Gide, Erik Satie, Blaise Cendrars, Salmon, Max Jacob, Poulenc, along with others. Vassilieff's studio and canteen became a cosmopolitan site of modernism, where artists from all over the world, speaking ten or more different languages and working in diverse disciplines, regularly convened to socialize and exchange ideas during the war. Popular cafés

like La Rotonde and La Coupole functioned similarly as important locations for building community.[9]

When winter fell in 1915, Orloff experienced the widespread shortage of heat and electricity that affected the entire nation. The major coal mines of northern France had become inaccessible due to their location behind German lines. With no means of heating her small flat, she recalled "draping myself with every piece of cloth I could find and staying in bed most of the day." One day a friend visited her and, after finding her buried under the covers, alerted her to a service where free coal was distributed to artists: "Several hours later, someone brought to my room a big, black, shiny pile of coal, a sight for sore eyes." Rather than using all the coal that arrived for herself, Orloff shared it with her neighbors, a "poor family with small children, freezing and swollen with hunger. Seeing their joy, as I gave the poor mother those expensive lumps of coal, was my reward."

WARTIME COURTSHIP

During the winter of 1915, Orloff met Ary Justman (1888–1919), a Warsaw-born poet and writer from a Jewish background whom she married the following year. A photograph of Justman taken in Berlin in 1914 shows him as a well-dressed young man (see figure 5.2). Prior to coming to Paris, he studied literature in a German university. Justman wrote avant-garde poetry and prose, and was a close friend of Apollinaire, Max Jacob, and Modigliani when Orloff met him. We do not know a lot about his background, including what made him to move to Paris, or even how much French he actually spoke. Pierre Albert-Birot, the French writer, journal editor, and a friend of both Orloff's and Justman's, described how he wrote in Polish and spoke little French. The two men spent many hours together discussing poetry and working on the translation of his poems from Polish into French (Albert-Birot apparently did not understand Polish, making this particularly challenging).[10] Orloff must have communicated with him in Yiddish. She described her husband as soft-spoken, and noted that they had a lot in common, as well-educated Jewish émigrés immersed in the Parisian artistic and literary avant-garde milieu.

During this period of their courtship, they often took nightly walks

Figure 5.2.
Ary Justman, 1914. Berlin.

together, despite the dangers of the war. Paris, the international "City of Light," was shrouded in darkness because of the electricity shortage. Flashing lights and the harsh sounds of sirens often interrupted the dark nights. One night, while walking with Justman, Orloff was taken by surprise:

> Suddenly an alarm started. Instead of running to an underground shelter, we kept on standing at the entrance of some random house, and because of that, we witnessed a spectacle, terrifying in its glory, which I will never forget: the flying airship "Graf Zeppelin," the monster of those days, appeared in the Paris sky. We knew that its purpose was to bomb the Eiffel Tower. The French started to shoot in its direction from anti-air weapons of the time, which were located on the ground. And lo and behold, in front of our astonished eyes, the majestic airship burst into flames and turned from stars in the sky into fire blazes. We were

both breathless. The magnificent aircraft sank down as a burning cigarette from heaven's high to the pit of earth.

She was likely referring here to the night of March 21, 1915, when the Germans attacked Paris with two large Zeppelin airships that dropped 1,800 kg (4,000 lb.) of bombs, killing one person and wounding eight.[11] Newly in love, and roaming the streets of Paris late at night with her husband-to-be, Orloff did not fear for her life.

In October 1916 Orloff and Justman married in a modest ceremony. None of Orloff's family members attended or had even met her husband; they were in Palestine, cut off from her because of the war. Thinking back to her traumatic experience as a young child attending her sister's arranged marriage, it is not surprising that her own celebration was modest, and that she said little about it in her interviews or elsewhere. Presumably their closest friends who were not enlisted in the war effort, or living in the South of France or abroad, attended their wedding, including, perhaps, Kisling, who had recently returned wounded from the front, Pascin, Soutine, Modigliani, Zadkine, and others. The celebration took place at the apartment of Madame Rosenblum, a friend of Orloff's family back in Palestine, who lived at 43 rue Tournefort in the Latin Quarter, not too far from her studio.[12] We can presume that a rabbi performed the ceremony, as the couple signed a *ketubah*, a traditional Jewish marriage contract written in Hebrew. Their marriage, however, did not strictly follow the patriarchal tenets of Jewish law ascribed by most Jewish marriage contracts. They shared an equal partnership in which Orloff kept her surname professionally and forged ahead with her ambitious plans for her own artistic career.

In an interview later in her life, Orloff described how when she announced her impending marriage, many of her colleagues made dismissive remarks regarding her professional future: they "nudged me to leave, so that I would disappear . . . they said 'Ah, you will no longer make sculptures!'" And similarly, when she informed some of her contemporaries that she was expecting a child a year later, some of them chided, "It's finished, sculpture!"[13] Such assumptions that married women and mothers could not simultaneously be successful professional artists were not surprising at this cultural moment in

France. Orloff would confront these very challenges in her own work with great resolve and determination to disprove them.

ENGAGING WITH MODIGLIANI AND MODERNISM

Orloff created work during the years of World War I in dialogue with her new husband, Justman, along with some of their shared friends and colleagues, including Modigliani.[14] While most accounts claim that she first met and befriended Modigliani through Justman, as the two men reportedly were close friends, she already knew him through their tight circle of artist and writer friends in Montparnasse. One day in 1916, while sitting together at a café, Modigliani created a quick facial portrait in charcoal of Orloff on the back of an envelope (see figure 5.3). He inscribed it in both Roman and Hebrew letters, "to Chana, daughter of Raphael," and offered it to her as a token of his appreciation of their friendship. This was something he did regularly among close friends, a means of asserting loyalties and shared identities, perhaps in exchange for a drink at the café. For example, Modigliani similarly sketched Picasso in April 1916 while they sat at a table together at La Coupole, and sketched Justman two years later, in 1918.[15] The inscription on his drawing of Orloff makes a pun on her father's name, Raphaël, that links both artists to the Jewish tradition; Raphael, one of the angels, was also the name of the classic Italian Renaissance painter. The drawing acknowledges Modigliani's awareness of their connection as young Jewish émigré artists beginning their careers in Paris, both seeking to make names for themselves in the contemporary art world.[16] The fact that Orloff kept the drawing in her personal collection throughout her life speaks of its importance to her as a remembrance of their connection as friends, colleagues, and compatriots during this period in her life.

As is often the case with accounts of collegial relationships between prominent female and male artists (for example, Cassatt and Degas), some scholars assume that Modigliani, as the more famous male artist, must have "influenced" Orloff. For example, in response to Orloff's *Nude (Torso)* (1912) (see figure 5.4), created in plaster, art historian Griselda Pollock points to what she sees as the deep connection between Orloff and Modigliani in this work: "Her serious engagement with Modigliani's work writes his legacy into her sculpture."[17] In 1912,

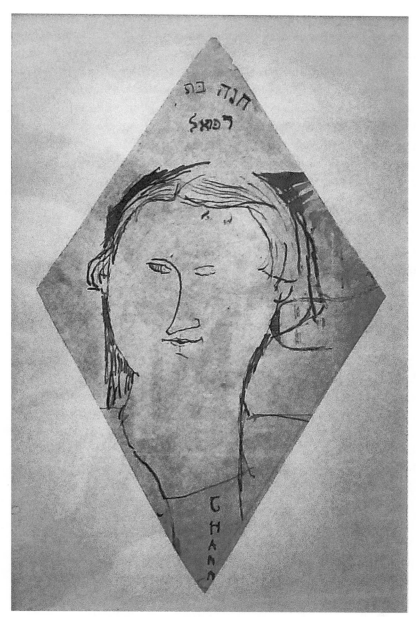

Figure 5.3. Amadeo Modigliani, *Chana Orloff*, ca. 1916.

however, when Orloff sculpted *Torso*, Modigliani did not yet have a "legacy." He was still largely unknown, and both artists were early in their respective careers. As friends and colleagues, they were both familiar with each other's work and respective interest in representing Jewish bodies and identities. Between 1908 and 1912 Modigliani was engaged primarily in carving a series of large, stylized stone heads with long noses and tiny mouths, inspired by Renaissance tomb sculptures. Orloff knew this body of work, exhibited at the Salon des Indépendants in 1910 and 1911 and in the Cubist Room of Salon d'Automne of 1912, as well as his many drawings and paintings of caryatids.[18] However, in the case of her 1912 *Torso*, the striking affinity is with Modigliani's formal approach to the attenuated female nude in his later paintings.[19] He refocused on painting around 1914, and it seems therefore that Orloff's 1912 sculpture actually influenced his later (1917–20) paintings of the female nudes.

Her piece hovers between the flatness of a relief sculpture like her previously discussed *Two Jews* (see figure 4.4), and the three-dimensionality of a sculptural figure in the round. She carved soft lines into the stone to delineate the figure's hair, masklike almond-shaped eyes, outstretched arms, and torso with small breasts. The formal similarities to Modigliani's later painted nudes, after he abandoned sculpture, are straightforward. He also may have looked to Orloff's sculpted portrait busts for inspiration in representing facial and bodily features that engage subtly with abstraction while remaining recognizable in his own painted portraits of the later 1910s.[20] Although Modigliani is by far the more famous of the two artists today, it is important to acknowledge Orloff's impact on his work.

Later in her life, Orloff recognized the need to assert her own strong artistic voice and identity as part of Modigliani's biography to establish her importance to this period and in the history of modernism. In several publications as well as in her interviews, she elaborates on her central role in his inner circle of friends and colleagues in a way that has not yet been fully acknowledged in the literature.[21] For example, in one interview, Orloff says that she saw Modigliani "daily" between 1913 and 1920.[22] While it is unlikely that they met with this frequency, documentation suggests that she was a regular and important presence in his artistic milieu. Orloff also takes credit for first introducing

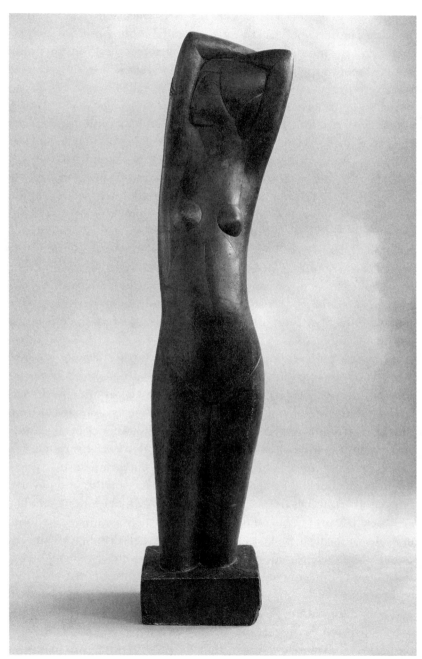

Figure 5.4. *Nude (Torso)*, 1912. Cement.

Modigliani to Jeanne Hébuterne, her Arts Décos classmate and an aspiring painter who became his most famous romantic partner, his muse, and the mother of his child (they lived together from 1917 until both of their untimely deaths in 1920). Orloff tells of how she arranged their very first meeting at La Coupole: "We called her 'Coconut.' We never thought her destiny would be tied to his. Slender as a Gothic statue, with two long braids, her eyes blue and almond-shaped; such she was as I presented her to my friends from Montparnasse. She was at first involved with Foujita, but when she met Modigliani, she only had eyes for him."[23] Her description of Jeanne's appearance calls to mind the aesthetic qualities of her very own sculpted portrait of her friend, *Virgin–Jeanne Hébuterne* (1914) (see figure 5.5), created in different versions in plaster, wood, and bronze, as well as Modigliani's later portraits of her. The piece likens the young Hébuterne to the Virgin Mary, standing piously with her hands folded across her long and slender torso in a manner that echoes that in *Woman with Arms Crossed (Madonna)*. Her signature long braids seem to meld into the vertical folds of drapery that form her dress, creating the effect of a Gothic caryatid.

The work represents Orloff's admiration for her friend's ethereal beauty and naivete. She does not choose to emphasize Hébuterne's sexuality, instead representing her as a symbol of virginal innocence. In several interviews and narratives, Orloff projects an image of Hébuterne that reinforces the popular mythology of her delicate beauty and fragility. Her descriptions of Modigliani reinforce his reputation as the *peintre maudit* (cursed painter) and elaborate on his suffering from alcohol and drug abuse, tubercular meningitis, and poverty. She describes him as frequently losing control and becoming a public spectacle because of his addictions. Hébuterne regularly picked him up from the local jail in the mornings following his drunken escapades. Orloff's tendency to reduce her colleagues to stereotypes extends to Hébuterne. Orloff consistently describes her as "always silent," ethereal, and passive, overlooking the fact that Hébuterne was also a talented and ambitious painter and designer in her own right. While there has been much secrecy regarding Hébuterne's artwork and estate over the years, recent research shows that she produced her own paintings that included striking portraits, self-portraits, and nudes, designed

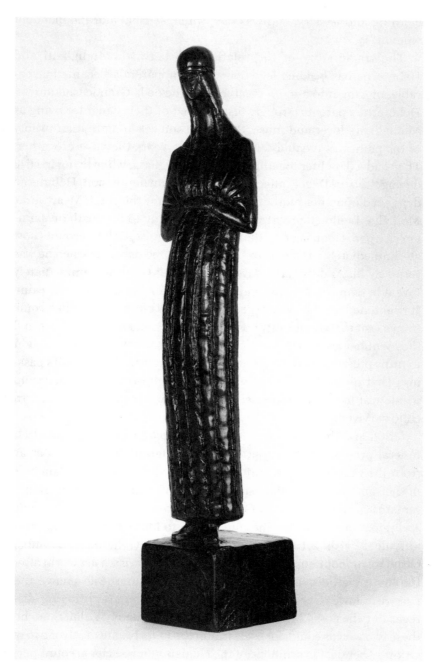

Figure 5.5. *Virgin–Jeanne Hébuterne*, 1914. Bronze.

clothing and jewelry, and was "a spirited, sensual and independent woman."[24]

The tragic story of the relationship between Modigliani and Hébuterne has become legendary. They apparently became inseparable, moving into a room together at 8 rue de la Grande Chaumière. Hébuterne's parents strongly disapproved of their daughter living as Modigliani's lover and muse. She is the subject in more than twenty of his paintings created during the three years they lived together. They had a daughter together, Jeanne Modigliani, while living in Nice during the war. Deeply affected by postpartum depression, Hébuterne depended upon her mother's help in caring for the child. Meanwhile, Modigliani's illness progressed rapidly, leading to his death on January 24, 1920. Upon hearing the news of his demise, Orloff recounts how she immediately went to comfort Jeanne: "One day we learned he was seriously ill. And the next day we learned of his death. Immediately I went in search of Janette, and I found her calm as a statue. Too calm. It frightened me. She was expecting a second child and had just come from a visit to the maternity hospital. They told her it was too soon, and they sent her away." Hébuterne's parents reluctantly took her in, eight months pregnant with a second child, the day after Modigliani's passing. That night, Jeanne, age twenty-one, jumped from her bedroom window at her parents' house; tragically, neither she nor her unborn child survived.

Orloff and their circle of friends gave Modigliani a large, heartfelt funeral procession; however, Hébuterne's family turned them away from the graveside. The family also refused to bury their daughter in the same cemetery alongside Modigliani, and only later were her remains moved beside his. Orloff reflects on the fate of "this tragic and remarkable couple." She could relate to Modigliani as a "quintessentially Jewish" artist who was proud of his own heritage, a symbol of the cosmopolitanism that characterized the Parisian art world after the Great War.[25] In contrast, she positions Hébuterne as a naive and passive follower from an "old world," French Catholic upbringing, disregarding the possibilities for her ambition. Ultimately, Orloff thought, these two worlds could not coexist, and the unfortunate death of two of Orloff's friends was symbolic of the changing times. Her account perpetuates stereotypes of women artists in this period in Montparnasse

(and elsewhere) in the role of objectified muse and lover to a more famous male artist (such as the famous Kiki de Montparnasse, the photographers Lee Miller and Dora Maar, and others), in certain ways.

In contrast to Hébuterne's and Modigliani's relationship, however, Orloff shows how her own romantic partnership with Justman was based on a different model of creative exchange. When she married him in 1916, she had matured as an artist and was already showing her work in esteemed professional venues. Even as they settled into domestic life and considered having a child, they deeply respected one another's talents and need for space to nurture their creativity. They also collaborated regularly on literary and artistic projects that allowed her to continue developing her interest in creating empowering images of women and the female body.

CHAPTER 6
Orloff during Wartime
Amazon, Mother, and Widow, 1916–1919

During World War I, Orloff had her very first solo exhibition, held in her own home, the apartment she shared with Justman on the rue d'Assas in the heart of the Montparnasse.[1] Organized by the Parisian avant-garde magazine entitled *SIC*, which stands for *Sons, Idées, Couleurs (Formes)*, or *Sounds, Ideas, Colors (Forms)*, it featured thirteen of her sculptures and ten drawings.[2] A photograph from March 4, 1917, documents the occasion of the opening (see figure 6.1). She appears beside her work as a stylish modern woman of the period. Her hair is cut short, and she wears a simple black dress with what looks like a fur muff in her lap. Surrounded by several sculptures on pedestals, *The Amazon* (1915) (see figure 6.2) stands out as one of her most important works from this period.

Carved in wood (and cast in plaster and bronze) and measuring seventy-five centimeters high, it depicts a lone, unidentified female figure, riding a horse. Amid the war, Orloff, age twenty-nine, was invested in modernizing the Greek myth of the powerful female warrior. She also was navigating new roles in her life, from professional artist and member of the avant-garde, to wife and soon-to-be mother, as she gave birth to a son less than a year later. The photograph and accompanying exhibit testify to Orloff's use of her sculptural practice to reimagine gender roles in this period of wartime.

A propaganda poster for a 1918 documentary film created by the French army shows the conflicted roles for women Orloff absorbed

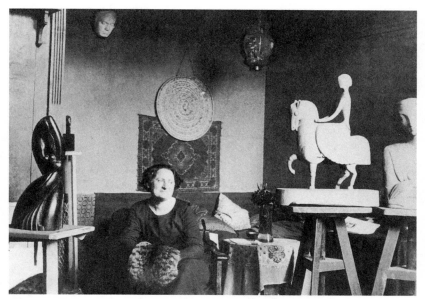

Figure 6.1. Orloff at her solo exhibition, *SIC Ambulant*, March 1917.

while walking the streets of Paris (see figure 6.3).[3] On the one hand, the country needed women to contribute to the war effort by running the factories (the *munitonnette* in blue, on the left) and tending the fields (the peasant woman in red, on the right). On the other hand, the government promoted an active campaign of pronatalism, embodied by the woman nursing a child in the red-and-white striped skirt in the center. Motherhood was becoming an obsession and a "panacea" for a wide range of wartime and postwar anxieties: "demographic, military, economic, cultural, and sexual."[4] The poster and related film suggest that all three women, dressed in the colors of the French flag, demonstrate their patriotism through their respective contributions to the war effort. In the background, "Marianne," a symbol of the French Republic as "Mother France," looms as a woman warrior with helmet and armor. How did Orloff respond to all these French nationalist messages about women's heroism and patriotism?

Orloff experienced the daily bodily traumas inflicted by war indirectly through her husband. As a non-citizen, Justman was not eligible for conscription into the French army, but wanted to show his com-

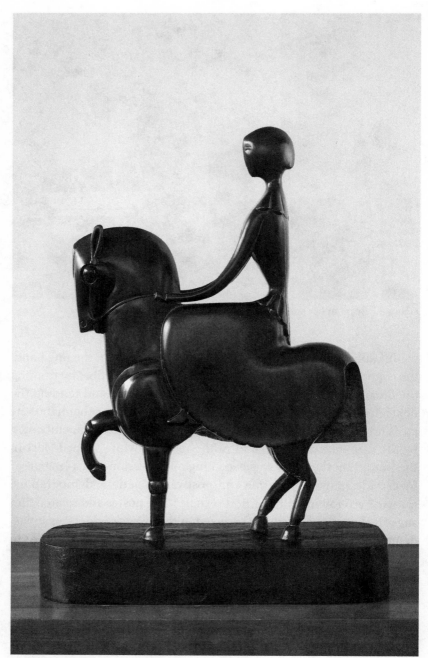

Figure 6.2. *The Amazon*, 1915. Bronze.

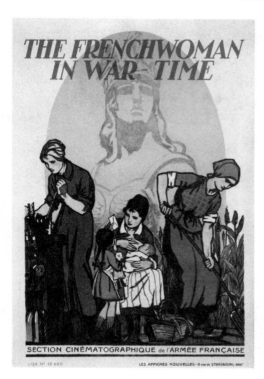

Figure 6.3.
G. Capon, *The Frenchwoman in war-time*, 1917.

mitment to the cause of the French Republic by serving as a medic in the American Red Cross. A photograph from this period shows him looking proud in his uniform, arms folded behind his back (see figure 6.4). Although Justman enlisted voluntarily, he was paid for his work, which provided him and Orloff with some financial support. Each day, he shared with her the harrowing details of carrying wounded soldiers from the streets and transporting them to the overcrowded hospitals. They lived just a twenty-minute walk from the military hospital of Val-de-Grâce, where their colleagues, André Breton and Louis Aragon, the future leaders of the surrealist movement, met in 1917, while training to become military physicians.[5] Orloff walked the streets of Paris and saw the newly injured men, bandages covering their faces and other body parts. Some of them sported crutches, prosthetic limbs, and facial masks. Those who returned to Paris from the recent battles of Verdun and Somme faced the reality that modern women had taken over their jobs and other aspects of public life. Living as an émigré woman artist

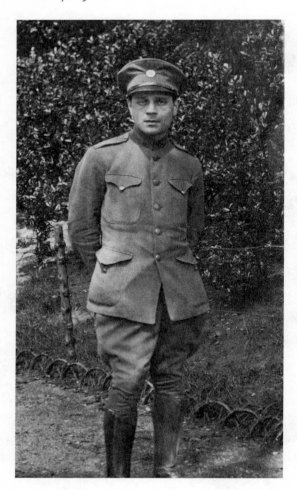

Figure 6.4.
Ary Justman, American
Red Cross volunteer,
1916.

through this time of dramatically altered borders, bodies, and mores, Orloff responded in both her art and professional activities.

Shortly after Orloff met Justman, the two became involved in launching the avant-garde group and magazine, *sic*, that organized her solo exhibition.[6] Their friend Pierre Albert-Birot (who went by his initials PAB) founded the group in January 1916. Although *sic* had no formal program or clear-cut agenda, during war it became a platform for productive discourse between the literary, visual, and musical arts (hence the reference to "sounds, ideas, colors, forms" in the title).[7] Besides publications, *sic* organized its own exhibitions, performances,

Figure 6.5. Pierre Albert-Bireau, *SIC* logo; Orloff, *untitled*, woodcut. *SIC*, no 31. October 1918.

and events outside of traditional venues and institutional structures, as with Orloff's exhibition. With its logo in Gothic typeface (see figure 6.5), the *SIC* journal offered a response to the contemporary German models of the art and literary magazines *Der Sturm* and *Die Aktion*. Like those magazines, it played with the juxtaposition of original wood-cuts and text and embraced the accessible and democratic nature of print culture. The word "sic" usually appears in brackets, [*sic*], to in-

form a reader that any errors or apparent errors in quoted material are reproduced exactly as they appear in the source text. The name shows how the group embraced avant-garde print culture and the idea of "happy accidents" that occur when workers set type or operate a printing press. It also conveys humor and sarcasm toward those who insert the word "sic" to call out the original writer's spelling errors or faulty grammar or logic. The magazine was published regularly through December 1919 (fifty-four issues in total). *sic* became one of the most important of the early modernist magazines produced in Europe, although later writers associated with surrealism critiqued it. Without directly aligning itself with any one movement over another, *sic* associated with a wide selection of innovative cosmopolitan artists and thinkers who offered courageous critiques of the war and questioned traditional values in French art.

Both Orloff and Justman became immersed in *sic*. She created woodcuts and drawings in tandem with her sculptural work that were reproduced over the course of the magazine's four-year run. He wrote poetry for the magazine and collaborated with Albert-Birot on matters of production.[8] Through this collective activity, Orloff discovered her passion for making woodblock prints. It was in this avant-garde context that she created *The Amazon*.

Orloff published a drawing related to this sculpture in *sic* (number 11) in November 1916 (see figure 6.6). Both the drawing and the sculpture articulate the image of the modern woman that emerged during World War I in literature and visual art as a member of a mythic, matriarchal tribe. The Amazon is the only classical myth about female agency in which women live in a culture without men.[9] With her bobbed haircut echoing the artist's own coiffure, *The Amazon* engages with visual codes of social, sexual, and economic emancipation ascribed to working women during wartime in France. Historians have shown how the blurring of sexual difference was an essential aspect of the "crisis of civilization" during the final years of the war and its aftermath. The public struggled with how to respond to those women who joined the workforce or became nurses and were leading independent lives that threatened the social order. The figure in Orloff's drawing and sculpture hardly fits the stereotype of the androgynous women dressed in boyish fashion; she wears a dress or skirt embellished with

Dessin pour une sculpture sur bois.

CHANA ORLOFF. — L'AMAZONE

Figure 6.6.
The Amazon, SIC, no. 11.
November 1916.

ruffles, accentuating an unrealistically cinched waistline. A waistline that thin could only be attained by wearing a corset. This feminine body type also stands in contrast to associations of Amazon women as sturdy warriors, with broadly built, muscular bodies. The figure's full skirt spreads out over the side of the horse, fusing their bodies. Orloff presents a radical reinterpretation of the Amazon as a hybrid "woman-horse," a symbol of female power and strength who possesses the stylish attributes of the Parisian modern woman. Although Orloff herself had a heavy-set build, this work can be read as her symbolic self-portrait as a full-fledged member of the wartime *sic* collective and the Parisian avant-garde.

Another photograph taken in the studio gives us a glimpse into

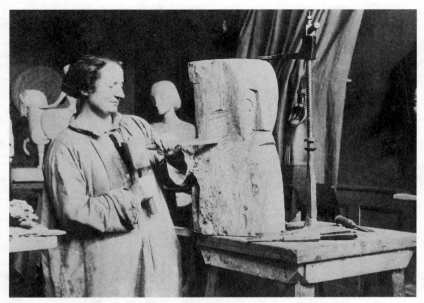

Figure 6.7. Orloff at work on *The Prophet*, 1916.

Orloff's working process in this period (see figure 6.7). We see her in the studio, carving another sculpture, *The Prophet* (1915), from a large vertical block of wood. *The Amazon* is visible in the background, and we can assume she used the same technique to make it. Orloff, along with Brancusi, Zadkine, and others, was part of a revival of direct carving in wood. Some of her critics in the 1920s linked her interest in wood carving to her Russian background, which they assumed included artisanal and peasant origins.[10] Here she works with a mallet and gouge at reducing the solid mass of wood to create the desired form on the side of the figure's head. She used wood primarily during the years of World War I. She collected it on regular walks on footpaths through undeveloped areas of the city. She likely had access to plaster through Justman's work with the wounded in the Red Cross; however, it was in great demand for treating the wounded.

Orloff exhibited *The Amazon* (1915) at the Salon des Indépendants in 1920, as well as in the First Russian Exhibition of Art & Craft, held in 1921 at the Whitechapel Art Gallery in London. Curators considered it a signature work from her early years in Paris and often highlighted it

with a prominent placement in her exhibits. She returned to this theme five years later, in 1920, in her sculpted relief portrait of her friend, the American expatriate writer Natalie Clifford Barney (figure 7.8). The portrait celebrated the attributes of the *Amazon* (also the title of the work), Barney's nickname for many years, and portrayed her dressed in a prominent Western-style riding hat. Orloff shows an awareness of the significant role of the Amazon symbol in gay and lesbian culture.

Orloff developed an iconography of self-determined women as symbols of strength while also playing an Amazonian role in the male-dominated avant-garde. She was at the center of a dialogue between different factions of the European avant-gardes. Her work was reproduced alongside writings by cubist poets (led by Guillaume Apollinaire, Max Jacob, André Salmon, Blaise Cendrars), writers and artists associated with the nascent Dada movement (Tristan Tzara, Francis Picabia) and later surrealism (Louis Aragon, André Breton, Pierre Reverdy, Philippe Soupault) and Italian Futurism (visual artists Gino Severini, Umberto Boccioni, Giacomo Balla). *sic* was affiliated with the experimental music of Ravel, Stravinsky, and Erik Satie. These artists regularly included excerpts from their musical scores in the pages of the journal.

sic, as a magazine, also functioned "as a 'meeting place' for those who did not belong to any 'ism,' a notion of which Albert-Birot remained suspicious after the war and into the twenties, when he found himself increasingly isolated from an avant-garde dominated by the Surrealists."[11] Orloff appreciated this about the group, as she also did not strongly identify with a single avant-garde movement even though she felt pressured to do so. Although she explored cubist ideas in some of her sculptures and works on paper from this period, she wished to develop her own individual approach that blended figuration and abstraction, along with diverse art-historical and cultural influences.

When asked in an interview later in her life about her stylistic evolution, Orloff reflected that she never fully "belonged" in the cubist movement and milieu: "Naturally, when I began it was the time of cubism. The cubists reproached me a lot. [André] Lhote said to me: 'You need to do so little to become one of us.' I said, 'What?' 'Less individuality,' he responded. He thought I would get nowhere. After twenty years, Lhote came to ask me for forgiveness."[12]

Orloff's graphic contributions to *SIC* largely were figurative and focused on the female body. They provided a stark contrast to the predominantly abstract visual art that was featured in the journal (including Albert-Birot's "visual poetry"; futurist drawings celebrating the power of speed and technology by Balla and Severini; and cubist-inspired works by Zadkine and Survage). Thematically, most of the work that she reproduced in *SIC* offers a fresh and modern perspective on themes relating to female embodiment, from the female nude, to images of pregnancy, motherhood, and nursing, to portraits and symbolic female figures. Many of these woodcuts engage with formal innovation by using the vertical grain of the wood plank as part of the composition.

SIC was distributed widely, not only within France but also to those engaged with the arts and stationed abroad during the war. Marcel Millasseau, a French friend of Orloff's enlisted in the French army and serving as secretary of a unit stationed in the Balkans, wrote to her after receiving the November 1917 edition of *SIC* by mail: "Your woodcut made a strong impression on me. This rigid woman, enveloped by sadness, immobile, in a permanent state of pain, slumps under the heavy weight of the infinite threshold. You translate (and it's exquisite) the exterior appearance and the interior soul, the contour of what's inside. This newly designed work is a striking realization of construction and emotion. I congratulate you."[13] For Millasseau, Orloff's cubist-inspired graphic work, featuring a fragmented image of a seated woman, conveyed an emotional quality that resonated with him considering his own wartime experience (see figure 6.8).

Despite the magazine's support of her work, men dominated the *SIC* collective. Orloff described how it gave little agency to female practitioners, apart from herself and Germaine Albert-Birot, Albert-Birot's wife and a poet, musician, and composer. It marginally involved a few other women in specific issues, such as the artist Irène Lagut, who offered a visual tribute to Apollinaire in the January 1919 issue following his death. The poets Juliette Daesslé and Marguerite Renault read aloud the work of their male colleagues at a *SIC* Ambulant event on February 25, 1917, and the journalist Louise Faure-Favrier also attended some meetings. The group held informal meetings on Saturdays in Montparnasse at the Albert-Birots' apartment on rue de la Tombe

Figure 6.8.
Untitled, November 1917.
Woodcut. *SIC*, vol. 2,
no. 23, p. 5.

Issoire. In her interviews, Orloff recalled how Apollinaire, seriously injured in the war (a shrapnel wound to the temple, from which he never fully recovered), always took over the conversation:

> At the *sic* gatherings, his loud voice silenced all the other conversations and dominated the room, while he broadly developed his ideas, throwing in convincing examples. Everybody listened to him, fascinated by his arguments, waiting for him to reach his two friends, Pablo Picasso and Diego Rivera. According to him, these two were the bold pioneers who rescued the noble geometric shape from the abyss of the deceptive sentiment.

Orloff critiques the cult of a few celebrated male "geniuses" and marginalized women associated with *sic*. She responded to her ostracism in avant-garde settings by immersing herself in the journal's activities with perseverance and determination. Her reaction differed from that of her colleague, the French painter Marie Laurencin, who was

Apollinaire's lover and muse for six years (1912–17). In a 1923 interview with journalist Gabrielle Buffet (spouse of Dadaist Francis Picabia), Laurencin maintained an essentialist view of herself and her artistic enterprise as feminine, and she denied any serious engagement with cubism:

> Cubism has poisoned three years of my life, preventing me from doing any work. I never understood it. I get from cubism the same feeling that a book on philosophy or mathematics gives me. Aesthetic problems make me shiver. As long as I was influenced by the great men surrounding me, I could do nothing. Generally, I paint to calm my nerves, and that is no easy task. I am always in bad humor; I am somber and unsociable. I love the details of life. I attach great importance to costumes, to hats, to all that is suitable to woman and beautifies her. A fashionable woman is to me the greatest work of art.[14]

Laurencin not only denies her seriousness as a viable member of the avant-garde but emphasizes her adherence to traditional bourgeois femininity as described in the mid-nineteenth-century rhetoric of popular French writers such as Jules Michelet (*La Femme*, 1860): extreme nervousness, attention to detail, a passion for women's fashion and appearance. Laurencin's modern manner of painting in a flat and simplified style inspired Apollinaire, followed by a host of reputable critics and poets, to articulate a visual vocabulary of femininity (with a focus on childlike innocence).[15] In spite of her statement that she did not wish to be part of the cubist circle, Laurencin did choose to include herself, albeit more as a feminine muse than an active artist, in her painting *Apollinaire and His Friends* (1909). In contrast to Laurencin's veiled efforts, Orloff actively sought professional interaction with her male colleagues. She saw real advantages to being part of an avant-garde group like *SIC*, even if she did not wish to subscribe to a strictly cubist style in her own work. Also, unlike Laurencin, in works like *The Amazon*, she aspired to challenge widely accepted cultural beliefs about femininity.

The most prominent of *SIC*'s external activities was the staging of Apollinaire's controversial play *Les mamelles de Tirésias* (The breasts of Tiresias), performed on June 24, 1917, at the Théâtre Maubel in

Montmartre.[16] The plot offered an inversion of the myth of the Theban soothsayer Tiresias, by telling the story of a woman who changes her sex in order to gain power, challenge patriarchy, and promote equality between the sexes. Thérèse sheds her breasts and becomes General Tiresias, and actively engages in battle while her husband is transformed into a woman who figures out how to bear and raise children without men (and bears 40,049 children in a single day).[17]

Although Orloff was not directly involved with the production, the program included a sketch by Picasso, a woodcut by Matisse, and poems by Max Jacob, Pierre Reverdy, Jean Cocteau, and Albert-Birot himself. Serge Férat designed the sets and costumes, and Germaine Albert-Birot composed the music. The performance elicited a wide range of reactions because of what some contemporary critics understood to be the play's strong feminist and pacifist messages. For example, one critic wrote that the reason Thérèse discards her breasts is because they are "distressing symbols of a servility that has become unbearable."[18] Another critic wrote: "Serious sociological problems are addressed: depopulation, the extinction of poverty, the future of women, the food cared system, etc. I do not think they are resolved."[19] Some members of the press targeted *sic*, as both a journal and artistic collective, for its alignment with these ideals of feminism and pacifism.[20] Scholars have debated a variety of possible motives for Apollinaire's apparent fascination with gender reversal in this and other works, from his own sexual ambiguity to his preoccupation with the androgyne. A detailed analysis of Apollinaire's play and its critical reception is beyond the scope of this book, but it can be noted that a feminist interpretation does not match with either Orloff's or Laurencin's experiences of his marginalization of women in the avant-garde.

Albert-Birot commissioned Orloff to create a graphic work to accompany a selection of press reviews of *Les mamelles de Tirésias* in the July/August 1917 edition of *sic* (vol. 2, no. 20). The result was her woodcut *Judith* (1917), a cubist-inspired rendition of a female nude with its own decisively feminist message (see figure 6.9). It offers her interpretation of the biblical Jewish heroine who murdered the enemy of her people, the Assyrian general Holofernes. Orloff stacked a series of geometric forms in a totemic formation in order to suggest an abstracted female figure. She used the woodblock medium to emphasize

Figure 6.9. *Judith*, July 1917. Woodcut. *SIC*, vol. 2, no. 20, p. 10.

the play between different parts of the figure's body and the negative space surrounding it. A flat plane of black ink in the background suggests a mass of long, dark hair, separating Judith's head from that of the bearded Holofernes, whom she has just beheaded. *Judith* speaks to Orloff's desire to develop a robust iconography of women associated with Jewish identity and tradition. When juxtaposed in the pages of *sic* with the compendium of critical reviews of Apollinaire's *Tirésias*, Orloff's woodcut reinforced the journal's public resistance to the patriarchal values of the French government during wartime. As one of the few female artists who engaged regularly with *sic*, and one of the sole visual artists to focus consistently on images of women in its pages, Orloff played an important role in shaping the journal's commentary on women and gender during wartime.

The Pregnant Woman (1916) (see figure 6.10) is another important work from Orloff's *sic* exhibition that illustrates her strong convic-

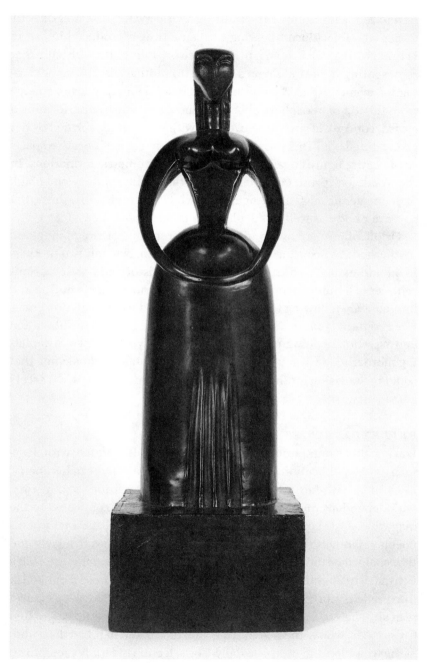

Figure 6.10. *Pregnant Woman*, 1916.

tion to reimagine gender roles during World War I. It relates directly to her woodblock print bearing the same title, reproduced in *sic* in February 1917 (vol. 2, no. 14, p. 4). Both works show her early efforts at representing domestic themes relating to motherhood as embolden- ing for women. In this sculpture, the figure's long, thin arms emerge from the top of her spherical breasts and curve downward, forming a closed, concentric circle that overlaps with yet another, formed by her protruding belly. This pose stresses small triangles of negative space, as the entire figure engages with interacting geometric formations. In the woodblock print, Orloff uses the vertical grains of the wood plank to delineate the mass of the figure's long hair, the folds of the dress that cover her body, as well as the platform that supports her.

Orloff offers her own modern interpretation of pregnancy and motherhood as inspiring experiences for women. Not only was mother- hood understood as a trope of Western art history and an important signifier of femininity, but it also became a resonant theme during and immediately following the war in response to the depopulation crisis. *The Pregnant Woman* demonstrates how she negotiated the liberation and assertion of power of the female body. She was invested in depict- ing motherhood without playing into the pronatalist propaganda that could not envision mothers as being independent women with careers and agency.

REFLEXIONS POÉTIQUES

During this same period of 1916–18, Orloff collaborated with Just- man on the publication of *Reflexions poétiques*, a volume of his poetry, illustrated with her artwork and published by editions *sic* in 1917, an independent press directed by Albert-Birot and connected to the magazine. Justman's preface was devoted to pacifism, and many of his poems referenced war, evoking imagery from airplanes to angels and titans. Since he did not speak French well, Pauline Lindelfeld, Orloff's Polish friend, helped him with the translation of his prose from Polish into French.[21] Justman has been described by scholars as a "visionary" poet and "heir to Rimbaud."[22] His poems reflect his experience as a Red Cross medic who witnessed the tragedies of war and handled the bodies of the wounded and deceased daily. The selection of Orloff's sculptures included in the volume—*The Amazon*, *The Pregnant Woman*, and *Two*

Dancers—features themes of women's physical strength and agency. In addition, the volume featured several untitled cubist-inspired drawings and woodcuts featuring the female nude. Orloff and Justman's works, initially created in separate contexts, when juxtaposed in the volume offer a lyrical investigation into the human condition during wartime.

Reflexions poétiques received praise from many in the avant-garde. Paul Reverdy, the French poet and advocate of cubism, Dada, and later surrealism, wrote a review of the volume for *Nord-Sud*, the Parisian literary magazine that he edited and published concurrently with *SIC* (between March 1917 and October 1918).[23] Reverdy responded to Orloff's work in the volume: "Madame Chana Orloff's sculptures have grace and a certain character. *Two Dancers, The Amazon, The Pregnant Woman*, among others, demonstrate a talent that I would like to see become more daring. One more step and Madame Orloff will be one of our cubist sculptors. She will leave description for creation. She will have regained a foothold in eternal sculpture."[24] Such praise is veiled, as Reverdy encouraged Orloff to push harder on developing a sculptural style that moves away from naturalism and is grounded more consistently in cubist principles of abstraction. Orloff must have wondered, what did it mean to be included as "one of our cubist sculptors"? Reverdy likely was referring to a group of Orloff's colleagues, namely Alexander Archipenko, Jacques Lipchitz, and Ossip Zadkine, all of whom were among the first to bring the cubist influence in painting and collage to sculpture. Lipchitz, for example, in works like *Man with a Mandolin* (1917), stripped his works of details he deemed superficial and reduced the human form to stark geometric planes and angles.[25]

Albert-Birot made similar observations about Orloff not going far enough in a talk he gave at her exhibition opening and then published in *SIC*. He named her as one of the leading "courageous ones," whom he hopes "will follow painters and poets towards '*la réalité pensée*,'" or the reality of thought, rather than '*la réalité de vision*,'" or the reality of vision, adopted by the majority in sculpture.[26] It was important to both Reverdy and Albert-Birot to encourage her in this direction, as they likely believed this aesthetic offered an important form of resistance to tradition. At this specific moment of 1916–18, the final two years of the war, cubism held a specific meaning both in its approach to art and in the implications of choosing this style when men were

dying in the trenches, or returning with disfigured bodies. Ultimately, Orloff did not wish to "follow" her colleagues and completely abandon figuration, even though she brought aspects of cubism to her early sculptures and woodcuts. She apparently took such criticism in stride, and developed her own personal wartime aesthetic focusing on potent images of women and the female body.

WARTIME EXHIBITIONS: MAKING UP FOR LOST TIME

After her marriage, Orloff was intent on having her work seen by the most influential art dealers and critics who were still active in Paris. She was invited to take part in several important exhibitions that took place during World War I. Although the major Parisian art salons remained closed, by 1916 some of the more influential galleries had reopened. Prominent among them was the Galerie Bernheim-Jeune. Félix Fénéon, the notable critic, editor, collector, and champion of modern art since the late nineteenth century, served as the gallery's artistic director. The Bernheims commissioned Fénéon to discover and sign artists who would bring recognition to the gallery. Among those he featured in groundbreaking exhibitions up to this point were Bonnard and Vuillard (1906), Cezanne (1907), Seurat and van Dongen (1908), Matisse (1910), the Italian futurists (1912), and le Douanier Rousseau (1916). Determined to provide financial support to his artists while keeping the public engaged, Fénéon, with the support of the Bernheims, reopened the gallery doors in 1916.

The details of how Orloff connected with Fénéon are unknown, but her friends surmised she had the self-confidence to request a meeting in order to show him her work.[27] The gallery was located at the elegant Place Vendôme (rue Richepance), far from her modest Montparnasse apartment. Fénéon must have seen her two sculpted portrait busts on display at the 1913 Salon d'Automne. Bernheim's family was Jewish, and Fénéon was a staunch supporter of Dreyfus, making the gallery perhaps receptive to supporting the work of a Jewish artist.

Fénéon selected three of Orloff's sculptures in the Galerie Bernheim-Jeune's *Exposition de Peinture, Serie C*, an exhibit of symbolist, neo-impressionist, Nabis, and fauve painters held from June 19–30, 1916. It is quite remarkable that she was the only sculptor to have her work

included in this prestigious display. The exhibition included one other female artist, the French painter Jacqueline Marval, who painted nudes and self-assured imagery of modern women.[28] There was also one other Jewish artist included, a male painter named Samuel ("Sacha") Finkelstein.[29] Six years after her arrival in Paris and only two years after art school, Orloff's work was featured alongside theirs as well as a group of the most notable avant-garde painters of the day: Pierre Bonnard, Maurice Denis, Georges Seurat, Paul Signac, Henri Edmond Cross, Henri Matisse, Albert Marquet, Georges Rouault, and Kees van Dongen.

Orloff's *Eve* (1916), one of her new sculptures included in the exhibit, builds upon her study of Cycladic, Egyptian, and African art and her engagement with the principles of cubist sculpture (see figure 6.11). A full-length female nude created in wood, it emphasizes the theme of fertility by presenting the female body as a series of geometric body parts: asymmetrical round breasts, long tubular torso, shapely arms, and muscular thighs. Together they form a spiral around a central axis through geometrical alignment and rotation of the figure. Orloff obscures the figure's lower right shin and foot with abstracted drapery that resembles a fragmented column with fluting. This technique was used by many of her colleagues like Archipenko and Zadkine associated with the "Puteaux Group" or "Section d'Or" (Golden Section), a collective of cubist artists active in Paris between 1911 and 1914. The Bernheim-Jeune exhibit placed this piece in dialogue with the work of Matisse, whose *Blue Nude* of 1907 engaged in similar formal strategies. As critic, collector, and art dealer, Fénéon likely appreciated how Orloff's piece offered an innovative rendition of these ideals in sculpture from a female perspective. The gallery did not yet represent the work of women artists, but later in the 1920s it showed the work of Suzanne Valadon, who painted defiant images of the female body.

Orloff's interest in blending figuration and geometric simplification also is apparent in *The Kiss (The Family)* (1916), one of the other pieces she exhibited at Bernheim-Jeune (see figure 6.12). Another early example of her visual interest in motherhood, here she portrays a family unit harmoniously joined in a single embrace. Her friend Ivanna Lemaître modeled for this piece, along with her husband, the fresco painter André-Hubert Lemaître, and their newborn son, Jean.

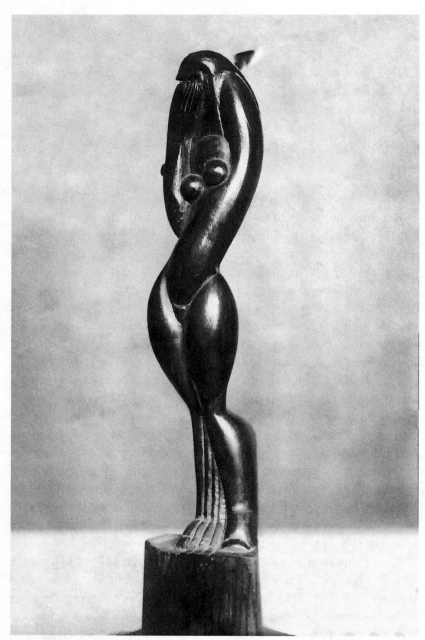

Figure 6.11. *Eve*, 1916. Wood.

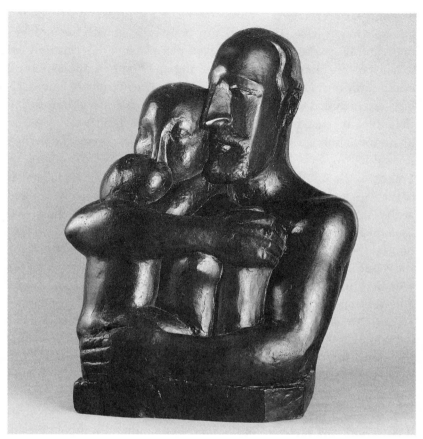

Figure 6.12. *The Kiss (The Family)*, 1916. Bronze.

The father figure protectively envelops the bodies of both mother and child in his extended muscular arms, holding them close to his chest as if merged in an interlocking unit. Surely Orloff was thinking about Brancusi's earlier and more abstract rendition of this theme (*The Kiss*, 1907–8), created in response to Rodin's (*The Kiss*, 1882). By adding the image of the child into the embrace, she shows her interest in representing themes of procreation and the nuclear family. In her piece there is a clear hierarchy of both scale and detail in contrast to Brancusi's abstracted forms. The father figure's head and torso are much larger than those of the mother. His protective gesture, angular facial features, and solemn expression convey strength and stability. In contrast, the

woman's face is reduced to barely delineated, expressionless eyes and a long, straight nose. The child's tiny body is fused with the mother's body. Orloff's participation in this well-placed exhibition certainly led to her growing reputation as an emerging contributor to the sculptural avant-garde during the years of World War I. The Bernheim-Jeune Gallery also included Orloff's work in six more group exhibitions during the interwar years, but never offered her a solo exhibition.[30]

André Salmon, a leading French poet and art critic of the period, invited her to show her work in an exhibit titled "L'Art moderne de France" at the Salon d'Antin, an important alternative venue for artists of the Parisian avant-garde to showcase their work. The salon was held at the Galerie Barbazanges from July 16–31, 1916, and was sponsored by Paul Poiret, the famous couturier, who owned the building that housed the gallery.[31] This particular salon is in fact famous for being the venue in which Picasso exhibited *Les Demoiselles d'Avignon* for the very first time to the public. The *Demoiselles* caused quite a scandal among critics that must have affected how the work of Orloff and other artists in the show was received. We do not know exactly which work(s) by Orloff were included in this exhibition. *Eve* (1916) (see figure 6.11) fit well within the context of cubist abstractions of the female form that offended particular critics. Orloff joined many of her colleagues in attending a series of public events that accompanied the exhibition, including poetry readings by her friends Max Jacob and Guillaume Apollinaire, and performances of the innovative musical compositions of Erik Satie, Igor Stravinsky, Georges Auric, and Darius Milhaud. These events were documented in a series of celebrated photographs by Jean Cocteau. Although the art market remained fairly inactive given the ongoing war, she positioned herself as an important contributor to the Parisian avant-garde. She was among a small minority of women—in this case Vassilieff and the French artist Valentine Hugo—who received invitations to take part in such important exhibitions during the war years in Paris.

BECOMING A MOTHER

Orloff continued working throughout her pregnancy, even though it was difficult with the war at its peak. The constant noise of explosions signaled the ever-presence of what Orloff referred to as "Big Bertha,"

a name commonly used by the Allied forces to describe a variety of large caliber guns and cannons used by the Germans. It was a challenging period for women to give birth in Paris, as laboring women were not the highest priority for receiving medical care. When the time came, given her husband's service, Orloff was admitted to the hospital affiliated with the American Red Cross. After making it through a fairly routine labor and delivery, she gave birth to a son. Élie-Alexander Justman, whom they called Didi, was born on January 4, 1918.

News of the baby's arrival was announced in the pages of *sic*. Shortly after they returned from the hospital to their Montparnasse home and studio, on what should have been a joyous occasion, Orloff and Justman were startled by the harsh sounds of an alarm. They acted quickly by putting the baby in a wooden box and going down to the basement of their apartment building to seek shelter. The alarms continued, sounding at frequent intervals throughout that night, signaling the ongoing siege. Even though the basement was dark, deserted, and full of mold, the three of them remained there for at least twenty-four hours. They took several short breaks when she ran nervously upstairs to fetch items required to tend to the baby's needs. She recalled, "Even in this basement, when death and bereavement raged above, I had hours of joy and happiness." Soon after giving birth, she continued to make art inspired by her personal experiences, including many drawings and sculpted portraits of her young son.

JUSTMAN'S UNTIMELY DEATH

After his son's birth, Justman was absent from home, as his work with the American Red Cross became more intense with the German siege on Paris between March and August 1918. Orloff fled to the South of France with Élie for five months, to the picturesque village of Bruniquel, near Toulouse. Bruniquel was known for its Châteaux, Gothic City Hall, and seemed like a good place to escape the dangers of wartime Paris. We do not know where she lived or if she had contacts there. She recalled observing some of the townspeople stealing from farmers, desperate during this time of severe food shortages and rationing. Fortunately, a young female farmer grew fond of Orloff and brought her food daily. This sustenance enabled her to continue nursing her son. She continued with her art practice even in these hard conditions. She

created a series of wood-carved portraits of local people in bas relief, as well as informal portraits of her son.

In the spring of 1918, Europe was attacked by the Spanish flu pandemic, the most devastating epidemic recorded in world history. They estimated that it infected over five hundred million people, and killed somewhere between twenty and fifty million people, more than the number of actual deaths from warfare. Parisians, already lacking in food and fuel, were overwhelmed by the outbreak and powerless to fight against it. Apollinaire succumbed to the Spanish flu on November 8, 1918, just three days before the Armistice, and two years after he was wounded fighting; Albert-Birot published an entire edition of *SIC* in his memory. Orloff, now back in Paris following her retreat to Bruniquel, recalled how her husband, who normally had a calm disposition, was overcome with fear as the virus spread among their friends and through the city. Initially she could not understand the depth of his trepidation, given her experience of his bravery and composure during the war, when he wandered the bombed streets to pick up the wounded. However, the usual fearless tone dissipates as she quickly came to terms with the gravity of the situation. In those months, she recalled that their street, the rue d'Assas, became

> the last and silent via dolorosa of the epidemic victims. This street led to the Montparnasse railway station, where the dead were brought to be buried outside the city. Disturbing scenes occurred in this street. Entire families were lying on the hearses, which often reminded us of the horror stories about the Black Death plague in the Middle Ages. You couldn't run away from such silent scenes of death. Thousands of watchful and demanding eyes saw death. The atmosphere in the street weighed heavily on us, the living ones.

During the second week of January in 1919, less than two months after the celebrations marking the signing of the Armistice and end of the war, Justman felt ill. Initially, she believed he would recover when he requested to eat. After taking his meal, he fell asleep. By midnight, however, he became ill again. Orloff called for a doctor to come to their home. After taking one look at him, he told her, "Your husband is very sick. You can't leave him here. Bring him to the hospital." When they

arrived at the hospital, they put him on a gurney in the corridor, since the hospital beds already were packed with both wounded soldiers and patients dying from the flu pandemic. His condition worsened, and two days later, on January 12, 1919, when he was just thirty years old, Ary Justman was dead.

Only eight days earlier, on January 4, Justman had celebrated his son's first birthday with Orloff and their friends in good health. Albert-Birot reflected on that birthday gathering in an obituary that appeared in the pages of *sic*: Justman, "poet-husband-father," his face "full of joy" as he passed out cigarettes and tartines, embraced his friends who had come together to celebrate this milestone. He read aloud two of his poems, one dedicated to Orloff, "La mère" (The mother), and the other to their young son, Élie. Albert-Birot concluded his obituary with the phrase "another poem unfinished," recognizing all the joy and potential in Justman's life with Orloff, their young son, and his ongoing writing projects.[32]

In the hospital, an administrator asked Orloff if she wanted to bury her husband as in a traditional Jewish funeral. She said yes, and a French rabbi came to see her, whom she described as "a genteel man who was attentive to my needs and understood me." However, on the day of the funeral, the speed of the procession and burial shocked her. In her native Ukrainian village, as well as in Palestine and in Le Marais, the Jewish Quarter of Paris, the funeral custom for Jews was to proceed on foot, out of respect for the dead. "We would lay the bier on a wagon, led by horses and covered in black. Friends and relatives would follow it slowly." But, given Ary's service in the American Red Cross, it was they who arranged for his funeral. The hospital where he died was far from the Suresnes American cemetery, where volunteers who died in the war were buried, located just outside of Paris. Following American burial customs, Justman's body was transported in a large, bare freight car from the hospital to the cemetery. Orloff stood by his coffin, as the car moved "with breakneck speed through the busy streets of Paris, a city that this genteel lyric poet loved dearly." Only a few came to pay their respects at the hospital, and even fewer traveled with her in the car to the cemetery. Those friends who were still healthy were terrified of being infected, and those who were sick were incapacitated and potentially on their own deathbeds.

Orloff recalled, my "sorrow because of my loss of this person, whom I loved and adored, the father of my baby, was mixed with astonishment and silent protest in the haste of the last goodbye to the deceased."[33] When she arrived at the cemetery, she appreciated the simplicity of the white gravestones, all uniform and shape, surrounded by well-kept lawns and surrounding trees. She recalled seeing only a few Jewish gravestones mixed with a majority that were decorated with Christian crosses. The interviews poignantly describe how her husband's gravestone embodied his triple identities: it was in the American cemetery, placed on French soil, and decorated with a Star of David. Justman's name was later engraved on the walls of the Panthéon in Paris, among the names of writers who were World War I victims, "as a badge of honor that is given by the French nation to every gifted poet who writes in the French language."[34]

WIDOW AND MOTHER

"I had accumulated several handicaps: foreigner, Jew, artist, woman, and now widow and mother."[35] Orloff, just thirty years of age, faced a new and unexpected challenge at the war's end: she had to raise by herself her one-year-old son. Adding to her already significant hardships, Élie became sick with polio around the time of his father's death from the flu pandemic, leaving him with physical disabilities. These included hemiplegia, or partial paralysis of the right side of his body, which resulted in difficulty walking and involuntary spasms of his muscles and limbs. Shortly after Justman's death, she visited the offices of the American Red Cross, as her husband had told her that his service would entitle her to insurance if he were to die. This route failed. Several friends recommended she look for a job teaching art, given her diploma from Arts Décos. This advice infuriated Orloff, as she had absolutely no desire to pursue a teaching career. Her goal was to keep making, exhibiting, and selling her art, and she was determined to build her clientele.

During this period, Orloff surrounded herself by nurturing women friends, most of them also Jewish émigrés with whom she could easily communicate in Yiddish and Russian. They included Pauline Lindelfeld, who temporarily moved into her apartment so that she could

help with caring for Élie while Orloff grieved; Sala Prussak, who also emigrated to Paris from Lodz and owned an art bookstore on the Boulevard de Montparnasse (Prussak was married to Orloff's friend and colleague, the writer and editor Jean Paulhan); and Ivanna Lemaître, a Russian painter who fled the Revolution in 1917. Orloff's friends from *SIC* were also ready to lend their support. In a note offering her condolences, Germaine Albert-Birot wrote: "I sense that your Russian women friends, with whom you are very close, are encircling you, and understand very well that you must have wanted them by your side at such a difficult time, that I am afraid of being indiscreet and of little help by disturbing this familiar perfume of the homeland."[36]

Given her resilience, it only took a few months before Orloff was back to work and entertaining friends and colleagues in her atelier. Since she had been successful with her graphic work in *SIC* and illustrations for Justman's book of poetry, she decided that she would try to continue publishing and selling her woodcuts and drawings. As she rebounded, Orloff created a powerful series of eleven large folio woodcut portraits of her women friends and colleagues who sustained her, bound as a softcover volume entitled *Bois gravés de Chana Orloff*. The volume was published in May 1919, just four months after Justman's death, by the editor D'Alignan in Paris in an edition of one hundred, with each print signed individually. Except for the one portrait of her infant son, the series portrayed only those women who were among her closest friends during this difficult period of grief. They included Lindelfeld, Prussak, and Lemaître, the actress Louise Marion from the *SIC* group (see figure 6.13), as well as the woman she had hired to help her care for her son, among others. This series included a haunting self-portrait as a veiled widow in which Orloff used the grain of the plank as part of the design (see figure 6.14). Her round face stands out amid a sea of black cloth covering her body and head. She does not portray herself looking like a stylish Parisian woman here, but a widow from the Ukrainian Jewish village. During this time of grief, Orloff returned to her roots, both in her self-portrait and in choosing to be with her Jewish émigré women friends.

A host of prominent critics praised the series of woodcuts and helped promote Orloff's reputation. The art critic Gustave Kahn wrote of the

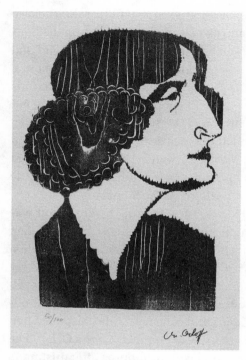

Figure 6.13.
*Portrait of Mlle Louise Marion,
Bois gravés de Chana Orloff*, 1919.
Woodcut.

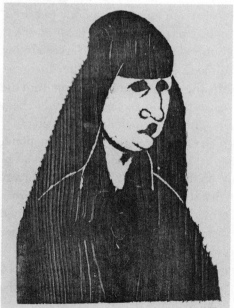

Figure 6.14.
*Self-Portrait, Bois gravés de
Chana Orloff*, 1919. Woodcut.

series: "Madame Orloff's drawing is expressive. She gives value to her woodcuts, which are very robust and do not leave out any unnecessary detail to capture the character of her models. They are desperate for truth."[37] The positive critical response to this series encouraged her to continue seeking commissions for graphic work and sculpted portraits of friends and colleagues. She sold some of her woodcuts at the modernist artist Eileen Gray's Parisian Galerie Jean Desert (217 rue du Faubourg Saint-Honoré) in 1923 and at other gallery showings. For now, she made it a priority to spend what little money she had to keep the nanny so she could continue working.

Only three months after Justman's death, Orloff also had another solo exhibition of her sculptures in April 1919 at Galerie des Beaux Arts, located near the Opéra (Palais Garnier). Her friend, the poet Jean Pellerin, wrote a glowing review in the daily French newspaper *La Lanterne*, in which he identified works like *Amazon*, *Eve*, and *Pregnant Woman* for their engagement with African, Egyptian, and Polynesian art, and *Torso* for its "mystical sensuality." He described *The Kiss (The Family)* eloquently as a "living embrace, of deep and calm joy, where the man's arm takes on such importance, and the woman's is not an added as an adornment, but an exquisite coronation."[38] Exhibiting her work *The Kiss (The Family)* must have been challenging in the wake of losing an integral member of her own new family. It is unclear whether she sold any works at this exhibition, but the review shows how Pellerin was one of her big supporters after Justman's death.

This was one of many small exhibitions in Paris that Orloff organized during the war years. For example, Parisian newspapers make mention of a small group of her sculptures on display in 1918 in the foyer of the Théâtre du Vieux Colombier near Luxembourg Garden, as well as another small gallery show in 1918 in which her work was paired with the French painter Marie Nivouliès.[39] She also had another small exhibit in 1920 with French painter Elisabeth de Groux (gallery "À L'Artisan," 22 rue Saint-Benoit, Paris). Orloff worked hard to make these connections, with gallerists and other artists with whom she could exhibit, given how determined she was to develop a clientele and earn a living as an artist.

ENTERING THE POSTWAR ART MARKET

Orloff's community continued to support her both emotionally and financially, leading to another commission, also in 1919. The same editor, D'Alignan, invited her to illustrate a limited-edition volume of drawings portraying forty-one prominent contemporary artists and writers, entitled *Figures d'aujourd'hui: dessins de Chana Orloff*, accompanied by texts by coeditors Jean Pellerin and novelist and literary scholar Gaston Picard. While Orloff created all the portraits for *Figures d'aujourd'hui* in 1919, the volume was not published until 1923 due to Pellerin's illness and death from tuberculosis before the completion of the project.

The list of artists who sat for their portraits for this volume include a real who's who of leading cultural figures in Paris during this period, including Pablo Picasso, Max Jacob, Jean Cocteau, Mikhail Larionov, Natalia Goncharova, and many more (see figure 6.15). Once her contract with the press was complete, Orloff sent out personal calling cards inviting all of those to be featured to contact her in order to schedule a studio visit to sit for their portrait. Everyone responded affirmatively. Max Jacob replied, "So, do you really believe that my bald head could adorn an album or interest anyone? I would like to think so . . . but truly, you'll have to put a lot of talent into that head to make it appear to have anything inside!"[40]

While some of the figures she portrayed were already close friends, the commission also provided her with the opportunity to expand her network and meet artists and intellectuals who she did not yet know personally. For example, Carlos Larronde, a Left-leaning poet and dramatist, who was then editor of a journal called *Arts* and became an active critic and voice in French radio, wrote to Orloff: "My friend Gaston Picard told me that you wish to feature me in an album of artists you are preparing. This touched me greatly as I hold your talent in high regard, and I will be at your disposition next Tuesday afternoon, at the place and hour of your choosing."[41] The French composer Georges Auric (one of the group known as Les Six, along with Jean Cocteau and Erik Satie) wrote to Orloff from his post at the office of the Ministry of War on June 18, 1919, to let her know of his availability to come to her studio and sit for his portrait.

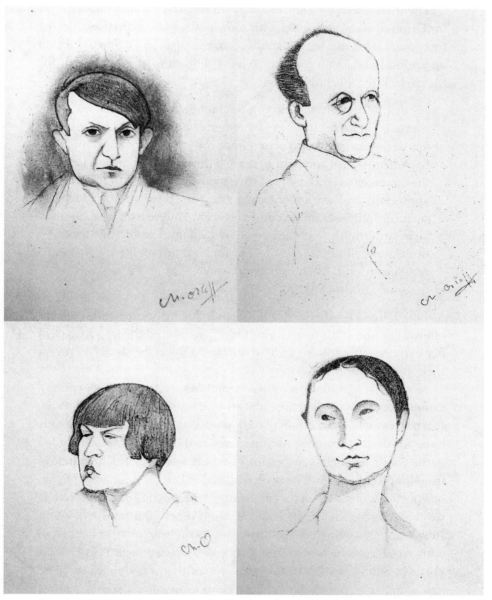

Figure 6.15. Pablo Picasso, Max Jacob, Henriette Sauret, Natalia Goncharova (*clockwise*), *Figures d'Aujourd'hui*, 1923. Paris, d'Alignan.

The studio visits for *Figures d'aujourd'hui* also provided an occasion for Orloff to exchange works with some of the featured artists. Almost forty years later, in a letter dated January 2, 1956, she wrote to Picasso and reminisced about his visit to her studio in 1919, when he sat for his portrait for this publication:

> My dear friend Picasso, do you remember in 1919, when you wanted to pose for me! Do you remember that after you chose a few of my drawings and prints from my portfolio, you promised to give me one of your works in exchange? While I always lacked the courage to remind you of this, today I did it and to tell you I appreciate your work more and more, even if you are jaded from such compliments, mine come sincerely. Your existence is, for me, an example of the courage we know with joy. I would like for my three grandchildren to know that their grandfather (Ary Justman) was your friend. I wish you a happy new year and a long life for the good of humanity.[42]

Although there is no evidence indicating that he ever followed up and offered her one of his own works, Orloff recognized the importance of her early encounter with Picasso and acted upon her desire to revisit their association.

As a whole, *Figures d'aujourd'hui* made a specific claim to forming a canon of contemporary artists, writers, and musicians working in Paris. It is unclear what role Orloff played in selecting the list of participants to be featured. Alexander Archipenko was the only sculptor included in the volume, which is surprising given the talent among her circle of friends and colleagues. The book featured only six women out of forty-one portraits included in the publication: the Russian painters Natalia Goncharova and Ivanna Lemaître; the French painter Jeanne Rij-Rousseau; Germaine Albert-Birot; and two French writers affiliated with *sic*, Henriette Sauret and Suzanne Sourioux-Picard. In Orloff's portrait, Sauret resembles the garçonne of the period, with cropped hair with bangs, pursed lips, and a serious expression. Sauret is known for her pacifist poetry written during World War I.[43] Likely because of the editors' choice and not Orloff's, the small percentage of women included in this canon of the Parisian cultural world is not surprising. Why were none of the other women artists involved with cubism

included, such as the painters Maria Blanchard, Alice Halicka, Marie Laurencin, or Marie Vassilieff? Even within progressive avant-garde circles, women artists consistently were marginalized. The volume provides a stark contrast to Orloff's decision to feature only women in her *Bois gravés de Chana Orloff* of 1919, a project that was more personal.

In contrast to the marginal representation of women artists in the volume, Orloff's own reputation was further solidified when *Figures d'aujourd'hui* was published in 1923 to critical acclaim.[44] One critic described her portraits as both "profound and subtle," focused not only on "physical aspects" but on "evoking a knowledgeable synthesis."[45] Eager to promote the publication, Orloff featured the entire suite of original drawings beside a selection of her sculptures in a solo exhibition at the Galerie Briand-Robert in 1923. We don't know how much money the editors paid her for her work on the commissioned project, nor what percentage of the proceeds she received from sales. However, Orloff's engagement with the *Figures d'aujourd'hui* project shows how despite the hardships she faced, she was well on her way to turning her life around. The work she produced during the years of World War I, particularly her graphic work for *sic* and the related sculptures, set the stage for her lifelong commitment to representing women and the female body as symbols of strength and resilience. The challenge she now faced was how to build a clientele in order to financially support herself and her young son while continuing to experiment in her artistic practice.

CHAPTER 7
Portraitist of Montparnasse,
1919–1925

As the French economy and art world very slowly recovered after the war, Orloff was determined to expand her professional opportunities. She continued to navigate her grief over the loss of her husband and concerns about Élie's health. Months passed before she could get any news of her family back in Palestine. When she finally received a letter, she learned that her eldest sister, Reina (Lutsky), along with her eldest surviving brother, Meir Dov, and their respective spouses all died of typhus during the epidemic that swept through the Ottoman Empire during the war. Despite her grief, Orloff remained focused on her own art practice in Paris. Orloff was a savvy professional who marketed her work through her artistic and cultural companions and their networks. Her primary goal was to attract new clientele by exhibiting her work as much as possible in a wide variety of venues.

She scraped together enough money from the sale of her sculptures and graphic work to hire a live-in childcare provider. This support was essential and allowed her to work long days in her studio, visiting with her son during mealtimes. In the late afternoons and evenings, she continued her habit of meeting with friends and colleagues at La Rotonde. Orloff regularly invited her friends to her studio and home, resuming the active social life that she and Justman had established during the war years. Among her inner circle of friends in the early 1920s were Edmond Fleg, a Swiss-born French writer, and his wife, Madeleine Fleg, and the designer Pierre Chareau, and his wife, Dottie.

She also socialized regularly with artist friends who lived nearby and had young children: Ivanna Lemaître, Mark Chagall, Moïse Kisling, Per Krohg, Edouard Georg, Marie Vassilieff, and Manuel Ortiz de Zárate.

Orloff's family members expressed concern that she could not support herself and her young son as an artist living in Paris. In 1920 her youngest brother, Abraham Orloff (1891–1981), known as Izzy, came to visit her from his home in Western Australia. He and their older brother Aaron were among many Jews living in Palestine who emigrated to Australia in the first decades of the twentieth century in search of employment. Izzy came to Paris in search of professional training in commercial photography so that he could launch a studio of his own in Australia. He arrived on the Ormonde, the first passenger vessel to sail from Freemantle to Europe after the war. Orloff housed her brother in her rue d'Assas apartment. She proudly used her connections to arrange for his instruction and employment at a friend's professional photography workshop, at the Éditions Photographiques Félix. Orloff was happy to support her brother in his professional goals; however, she understood that the real motivation for Izzy's visit was to "convince her to leave Paris" and move with him to Australia. She recalled how he complained about her lifestyle. In frustration one day, Izzy exclaimed: "You will never make it as an artist . . . artists are not well respected here. Hear me out and come with me to Australia. You have a teaching certificate for sewing. You will prosper on our continent. You will have a nice house with its own bathroom and you will live a peaceful life. It will also benefit your son." Such comments exasperated Orloff, who had full faith in her own ability to thrive as a professional sculptor in Paris. She had no interest whatsoever in giving up on her artistic ambitions in order to live a comfortable, bourgeois life as a sewing teacher in Australia.

One afternoon, a wealthy, unnamed Parisian patron of the arts, a woman who was herself a practicing artist, came to call upon Orloff at her studio. She was not at home, so Izzy answered the door. The woman explained to him who she was, and that she was interested in seeing Orloff's latest sculptures. He took her into the studio and removed the protective covering to show her some of Orloff's most recent unfinished works in wood. This incident offered proof to Orloff's skeptical brother that she had clients and could support herself as an artist.

Izzy eventually accepted her decision to stay in France. While he had her best interests in mind, he still saw his sister as the young woman he had known in Palestine. Even though she was confident in her ability to thrive and had a track record of success, he could not comprehend her adult achievements as a professional artist. Izzy said goodbye to Orloff and Élie in 1921, stopping in Palestine for an extended stay to visit family. Although he was the sibling with whom she had the most in common professionally, she did not remain in close contact with him after this visit. His departure marks a more definite split from her family. She was no longer "Chana, the seamstress," and she now had her own circle of close friends and colleagues in Paris.

MARKETING THROUGH PORTRAITURE

The genre of portraiture is rarely considered central in modernism, and sculpted portrait busts are less common than paintings. Yet Orloff and her circle of friends made portraits of one another as an essential means of forming identities and allegiances, while also supporting one another financially.[1] Of the approximately 500 documented sculptures Orloff created over the course of her career, 187 are portrait busts of friends, colleagues, and clients, and another 72 depict full-length or partial body portraits of identifiable individuals. Her friends must have realized that her sculpted portraits would help shape their reputation and public identity. During the interwar years, Orloff's portraits of friends and colleagues circulated widely in exhibitions and were re-produced in a many newspapers and magazines throughout Europe, the United States, and Palestine.

In the 1920s Orloff was building up a body of work for exhibition, and the press was starting to take notice. Many of Orloff's Russian and Jewish friends commissioned her to make busts of themselves or their spouses or children during those first years after the war.[2] She exhibited these works widely in the Parisian salons, which helped advance her reputation. Some of these works are among Orloff's best-known sculptures. For example, *Woman with a Fan* (1920) (see plate 4) is a regal three-quarter-length portrait in bronze of the painter Ivanna Lemaître, her close friend who fled the Russian Revolution in 1917. Orloff presents her as a stately figure whose masklike face suggests Orloff's continued interest in modernist primitivism. An ornate col-

lar and fan adorn the figure's long and sinuous neck and torso. Orloff engages with cubist principles of space in the undulation of the sitter's graceful fingers and the slats of the fan against her body. Orloff exhibited this piece in wood in Paris in 1920 at the Salon des Indépendants, followed by the Salon d'Automne later that year. It was reproduced in *Vanity Fair* in 1921 and widely featured as the cover image for many of her international exhibition catalogs.[3] The German-born Israeli artist Anna Ticho, another friend in Orloff's network, eventually purchased the first edition of this work in wood, and it is in the Israel Museum's permanent collection.

Marc Chagall, also a close friend of Orloff's, commissioned her to create a portrait of his daughter, Ida, age seven, in 1923 upon his return to Paris from Russia (see figure 7.1). Orloff portrayed the young girl in an uninhibited pose, standing nude with her abdomen jutting forward and small breast buds visible. An armature of thick, wavy hair frames her face, accentuated by the placement of her hands on top of her shoulders. Orloff's passion for Egyptian art is apparent in this work with the regal treatment of the girl's hair and stiff comportment.

Orloff created many such sculpted portraits of Russian friends and colleagues including Alexander Jacovleff (1921), a neoclassical painter and draftsman, and Ludmilla Pitoëff (1924), an actress in the Comédie Française. The most prominent piece from this group is Orloff's monumental *Man with a Pipe (Portrait of Widhopff)* (1924) (see figure 7.2), her portrait of her friend David Ossipovitch Widhopff.[4] Widhopff was a Ukrainian painter and graphic artist who emigrated to Paris from Odessa in 1887. Orloff met him through Vassilieff's academy, as he led the group of Russian artists known as the Société des Artistes Russes at the time. Represented by the prominent French art dealer Ambroise Vollard, he regularly contributed drawings of women of the Belle Époque to the daily Parisian newspaper *Le Courrier Français*. He was known for his fun-loving personality and organized an annual costume ball attended by members of the Parisian art world. They became good friends.

Orloff exhibited her portrait of Widhopff at the 1924 Salon d'Automne to great acclaim. Critics described this large and playful portrait as a standout, one of the "*clous* of the whole Salon," and said Orloff was "chief among the distinguished foreigners in the section

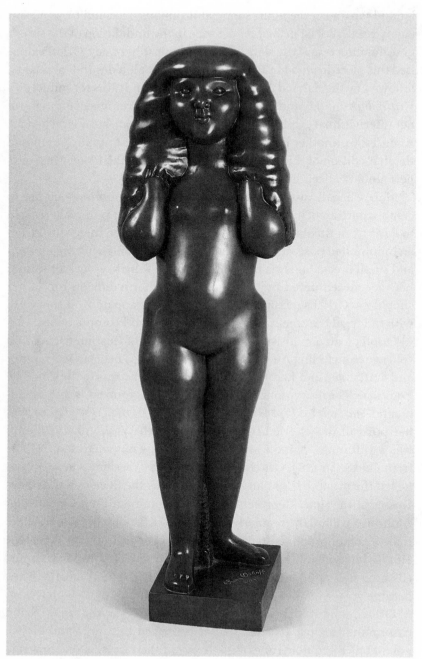

Figure 7.1. *Portrait of Ida Chagall*, 1923. Bronze.

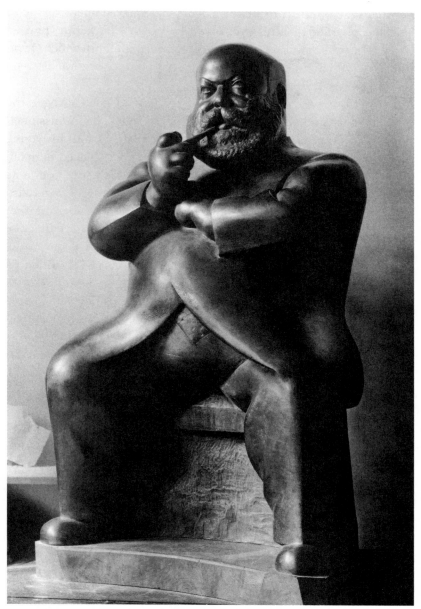

Figure 7.2. *Man with a Pipe (The Painter Widhopf)*, 1924.

devoted to sculpture."[5] Seated in a chair, legs splayed open, Widhopff smokes a pipe and folds his arms over a large belly. Many critics praised this work for its ambitious scale and the novel manner in which Orloff infused it with humor. They also noted a national connection between the two artists as Russians.

During this period Orloff met and befriended Lucien Vogel, the popular magazine and newspaper editor. In 1921 he commissioned portraits of himself, sporting a bow tie (see plate 5), and his young daughter, Nadine Vogel (see plate 6), her hair in a stylized ponytail atop her head. Orloff also sculpted a portrait of his wife, Cosette de Brunhoff, the founding editor of French *Vogue*, in 1924.[6] Vogel also ran a small art gallery and exhibited Orloff's work in a solo exhibition there in 1922. He is best known for having later founded and edited the magazine *Vu* (1928–40), the popular weekly French pictorial magazine that was the precursor to *Life* and *Look*. Vogel was closely affiliated with several other international journals, including *Fémina*, *Vanity Fair*, and both the French and American editions of *Vogue*. He promoted Orloff's work in these prominent journals, including a spread in *Vanity Fair* in August 1926 that featured a number of Orloff's works accompanied by a drawing of the artist holding her son by Alexander Jacovleff (see figure 7.3).

Orloff exhibited the portraits of Widhopff and Vogel at the Salon d'Araignée, an annual exhibition of humorous works by Parisian artists that was founded in 1919. During this exhibition, the French government purchased the plaster portrait of Vogel, for the Musée du Luxembourg, the national museum of contemporary art, and displayed it in the new annex dedicated to contemporary art by foreign artists housed at the Musée du Jeu de Paume.[7] In response to the news, Vogel felt that the plaster material was too fragile, and he paid for Orloff to reproduce the piece in stone for the museum collection.[8] Orloff was among the first roster of foreign-born artists of the École de Paris whose works entered the state's collections that year. French art critic Louis Léon Martin, in his review of the Salon d'Araignée, responded to the news of the state's purchase, quipping ironically, "The funny thing is that someone is paying for Monsieur Vogel's head. . . . the wall label reads 'Acquired by the state.' Is this a joke?"[9] In addition to being humorous, Martin's comment also suggests surprise that Orloff's por-

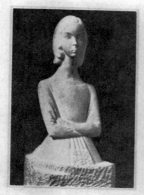

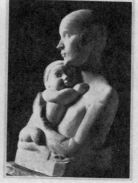

PORTRAIT OF A GIRL

Madame Orloff, the creator of the four portraits on this page, has been assuming of late a more and more commanding position among European sculptors. With the exception of Jeanne Poupelet, she is now the best known of the women sculptors in her adopted country

MOTHER AND CHILD

A plaster model for a bronze group which is now on view in the Salon at Paris. Very few of Madame Orloff's works are in bronze, most of them being in marble (as in the case of *Portrait of a Girl*) or in wood, a medium for which she has always shown a predilection

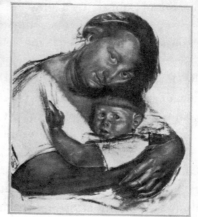

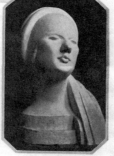

MADAME FARR

A recent marble by Madame Orloff. It should be explained that, in nearly all her marble busts, Madame Orloff gives to the stone an extraordinary lustre, an effect lost in reproduction

MADAME X

Photographed from the sculptor's informal and preliminary plaster sketch. As finally exhibited in Paris, in the now current summer Salon, this interesting anonymous bust was made in wood

CHANA ORLOFF

A very interesting portrait sketch of the artist herself by Alexandre Jacovleff, the Russian painter, who has become one of the chief ornaments of contemporary art in Paris. The portrait at the left shows Madame Orloff in her Paris studio, holding her young son in her arms

Some Recent Portrait Busts by Chana Orloff

The Russian Sculptress Who, for Ten Years, Has Been Living and Exhibiting in Paris

Figure 7.3. "Some Recent Busts by Chana Orloff," *Vanity Fair*, August 1926.

trait was acquired by the French government, even if it was placed in a museum of foreign artists.[10] Despite Orloff's critical acclaim, she was still considered to be outside the French art world, which in the 1920s was becoming increasingly focused on the clear separation between national "schools" of art.

Accordionist (Per Krohg) (1924) (see figure 7.4), one of Orloff's most celebrated sculptures, is emblematic of romanticized accounts of Montparnasse as a site of entertainment during "les années folles" (the crazy years).[11] It portrays her friend and colleague, the Norwegian painter and musician Per Krohg, legs sprawled apart, engaged in playing music for his friends. Orloff's sculpture was one of several representations of accordionists by Jewish émigré artists in Paris.[12] This piece stands out as an iconic symbol of the modernity of 1920s Paris and of how émigré artists transformed the city into an animated cosmopolitan center.[13] Orloff's *Accordionist* appealed to critics and collectors and helped launch her critical reputation as "portraitist of Montparnasse." More recent scholars like Kenneth Silver have noted how in this piece she "makes a popular art out of Cubism" by taking "a structural toughness from the Cubists—the powerful planar conception of form—and left to others, like Lipchitz, the movement's more intellectually challenging aspects."[14] While Silver argues that Orloff offered a "popular recasting of a difficult art," she chose to retain a figurative style as a way to market her work to as wide an audience as possible.[15] We recall her comment that she did not wish to become "one of them" (the cubists), and she resented colleagues who believed she was not up to the task because she was a woman. Keenly aware of trends in the art market and critical backlash against cubism, she wanted to create work that would have broad public appeal and produce significant revenue.

Orloff's reputation as "portraitist of Montparnasse" was further solidified when she was invited to have a gallery-sponsored solo exhibition of her work at the Galerie Briand-Robert in 1923. The exhibition featured her forty-three illustrated portraits from *Figures d'aujourd'hui* alongside a selection of her sculpted work. With her mounting success due to the sale of her portraits to colleagues, private collectors, and the French government, Orloff could now execute her sculptures in a variety of materials. Although wood carving remained her preferred technique, in the early 1920s she could engage, depend-

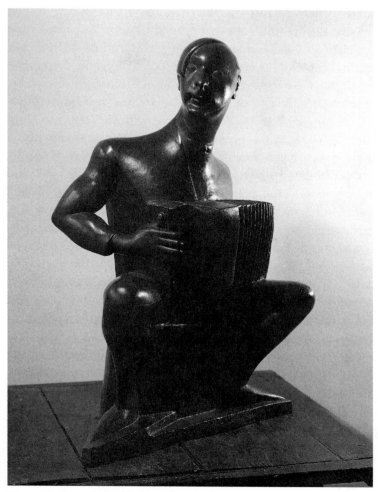

Figure 7.4. *Accordionist (Per Krogh)*, 1924. Bronze.

ing on her client's budget, in lost wax casting, otherwise known as *cire perdue*, a popular sculptural technique dating back to the third millennium BC. Orloff engaged the foundry of Eugène Rudier, who had cast Rodin's sculptures throughout his long career. After Orloff created her original sculptures in plaster, the foundry went through a multi-step process of creating a mold and using molten wax to cast the sculpture in bronze. Orloff's connection to this well-known foundry, used by Rodin, only added to her status as a leading professional sculptor.

"ÉCOLE DE PARIS" VERSUS "ÉCOLE FRANÇAISE"

After the war, the art world slowly resumed its activities. The Grand Palais, which functioned during the war as a military hospital, returned to its original function as an exhibition hall. The Salon d'Automne reopened there on November 1, 1919 (and ran through December 10, 1919). Four of Orloff's sculptures were selected for inclusion: *Maternity, Eve, Woman with Arms Crossed (Madonna)*, and *Woman's Head* (1912). Besides showcasing contemporary work, this exhibit featured a posthumous retrospective exhibition of Rodin, who had died in 1917. Some critics wondered which living artist would become his heir and create monumental French sculpture commemorating those fallen in the war.[16] In his review in *Le Crapouillot*, the widely read Parisian avant-garde satirical journal, the distinguished critic Claude Roger-Marx singled out the French sculptors Bourdelle, Despiau, and Maillol as the three most likely candidates.[17] While no single artist ultimately claimed the role of Rodin's successor, the names of these three native-born male sculptors circulated widely as leading the "French school" of sculpture.

Romy Golan has described how the phrase "École de Paris" was used loosely from the 1920s onward to distinguish "foreign" artists, especially Jews like Orloff, from the "genuinely" French artists of the "École Française."[18] For antisemitic critics like Camille Mauclair, the influx of Jewish artists in Paris in the first decades of the century was a serious threat to French cultural well-being. Several prominent art critics, some of whom were Jewish themselves (such as Louis Vauxcelles and Waldemar George), engaged in an intense critical debate about the sudden rise of Jewish émigré artists in the Parisian art market of the 1920s.[19] Works by Orloff and others in her circle signaled not only foreignness but also Jewishness. These works were perceived as a threat to the purity of the French artistic tradition, much in the same way that avant-garde artists were described by conservative critics as "boche"—a derogatory term used to describe German soldiers. As the percentage of Jews in the cultural sector grew rapidly during the period between the two world wars, the French art world became increasingly nationalist and antisemitic.

Considering the widespread antisemitic and xenophobic claims that the work of Jewish and foreign artists contributed to the decline of

French culture, many of the approximately 500 Jewish émigré art-
ists of the cosmopolitan École de Paris wished to distance themselves
from their Jewish identities. As immigrants to France, a condition of
their naturalization was the expectation that they disavow their ethnic,
cultural, and religious allegiances and embrace the French Republican
ethos. For some, this resulted in what has been described as "Jewish
self-hatred."[20] Orloff had different objectives. In addition to earning a
living and building a reputation as an important international sculp-
tor, she wished to develop her own practice of Jewish portraiture and
promote a positive representation of the Jewish body.

Orloff's interest in representing modern Jewish artistic identity is
related to her own experiences within the Parisian avant-garde. She
even encountered antisemitism while participating in the group known
as Mir Iskusstva (The World of Art), which aimed to educate the Rus-
sian public about new trends in Russian visual culture.[21] When Orloff
joined in Paris in 1920, many Russian artists (including the paint-
ers Natalia Goncharova and Mikhail Larionov) had just emigrated to
France. One day at a general assembly meeting, a non-Jewish colleague
made an antisemitic remark. Orloff proudly narrates how she "jumped
up furiously, banged the table powerfully, and yelled at him with the
full strength of [her] lungs: 'Don't you know I am a Jew?' . . . 'I am leav-
ing this group right now.'" Despite separating from the Mir Iskusstva
group, Orloff remained closely connected to several prominent artists
and art dealers associated with it. Her work was exhibited frequently in
shows devoted to the Russian avant-garde in Paris and internationally.

Art critics and salon organizers categorized her as a "Russian" artist
in the early 1920s because of increased nationalism and xenophobia in
the French art world. At the 1921 Salon d'Automne, six of her sculp-
tures were grouped with works by Russian artists connected to Mir
Iskusstva. The Paris-based Russian critic Natacha Liverska wrote in
the pages of *Le Crapouillot*: "This Russian hall, at the Salon d'Automne,
resembles a display of fireworks amid the often sad, unsophisticated
and embarrassing work of the young French painters. It comprises
two sculptors, one of whom is a woman, painters and artists especially
preoccupied with theater design."[22] Here, a Russian critic based in
Paris takes aim at her French colleagues and critiques their work as
less advanced than that of their Russian counterparts.

With nationality at the forefront of debate in the art world, in 1923 the Salon des Indépéndents, under its current president, neoimpressionist painter Paul Signac, voted to pass a measure to separate artists in its annual exhibitions by nationality rather than last name. This led to a public debate in the pages of the journal *Le bulletin de la vie artistique* known as the "Quarrel of the Indépendants." Many in the art world perceived this shift to be giving in to the demands of nationalist and xenophobic critics and against the spirit of this independent salon.[23] Orloff, along with many of her colleagues, including Lipchitz and Zadkine, stopped exhibiting with the Indépéndants shortly afterward, perhaps frustrated by the new policies.

Orloff's chose to include her work in several international exhibitions of Russian art in this period. She represented Russia in the Exposition Internationale d'Art Moderne in Geneva in 1921 with six sculptures and eighteen engravings, alongside the work of her colleagues Archipenko, Zadkine, Vassilieff, Goncharova, Larionov, and Jawlensky. She also was invited to send her *Amazon* (see figure 6.2), along with three other works, to London that same year for the "First Russian Exhibition of Art and Craft" at the Whitechapel Art Gallery. And in 1923 Orloff's *Woman with Arms Crossed (Madonna)* (see plate 3), then newly purchased by the American sculptor Malvina Hoffman, was featured in the "Russian Exhibition" at the Brooklyn Museum. It was reproduced in the *New York Times*, with a lengthy essay about Orloff as part of "a Russian Renaissance in Paris" and "a modernist of striking individuality."[24]

Orloff was also connected to prominent Russian art dealers in Paris during this period. In March 1922 Jacques Povolozky featured her work in a solo exhibition at his gallery in the Saint Germain Quarter (13 rue Bonaparte) to critical acclaim. Povolozky, an art dealer and bookseller, and his wife played an active role in the 1920s Parisian art world and were generous supporters of many Jewish émigré artists of the École de Paris, including Modigliani and Soutine. Orloff's connection to this gallery reinforced her association with the Russian avant-garde diaspora in Paris, a group that was highly esteemed by international art critics and audiences.

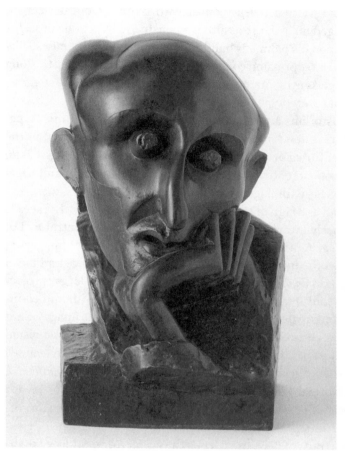

Figure 7.5. *The Jewish Painter*, 1920. Bronze.

MODERN JEWISH PORTRAITS

Sculpting portraits of Jewish cultural figures, Orloff strove to offer alternatives to the antisemitic stereotypes that permeated French culture. Her sculpted bust in bronze entitled *The Jewish Painter* (1920) (see figure 7.5) is emblematic of her work from the early 1920s.[25] The sculpture is usually identified as a depiction of the Yiddish writer Abraham Reisin. However, the title Orloff chose suggests it was a portrait of a "type," a Jewish émigré artist in diaspora in Paris, rather than a specific individual. Orloff exhibited *The Jewish Painter* at the Salon des Indépendants in Paris in 1921, along with five other works. It was

reproduced in several articles about her work throughout her career. The middle-aged male figure assumes a pensive, melancholic pose, his chin resting upon his palm, his hand graced by a fan of long, cubist-like fingers. His facial expression conveys weariness and resilience, the long nose, beaded glass eyes, furrowed brow, and receding hairline suggesting the popular stereotype of the Wandering Jew.

Cultural historians have historicized how the physiognomic "type" of the wandering Jew "underwent a series of metamorphoses" in the nineteenth century. For many, including the French neurologist Jean Martin Charcot, stereotyped features such as the long nose and nasal voice were psycho-pathologized. In the literature of eugenics, these features were read as a sign of the deformity of the entire Jewish "race."[26] Orloff was surely aware that the nose was "one of the central loci of difference in seeing the Jew" in both popular and medical imagery.[27] By focusing on the intensity of the figure's physical gesture and facial expression, her *Jewish Painter* contributes to the artist's larger project of Jewish portraiture, which often involved engaging with and countering such stereotypes. By creating a new and stronger image of her Jewish friends and colleagues, she promoted her own unique visual "types" to build a pantheon of Jewish artists, writers, and intellectuals with whom she associated. Orloff donated a bronze cast of *The Jewish Painter* to a special "jubilee" exhibition in 1926 to benefit the Jewish National Fund of France and saw it as evidence of her public commitment to Zionism.[28]

Orloff's portraits of her close friends the writer Edmond Fleg (1922) (see figure 7.6) and his wife, Madeleine Fleg (1920) (see figure 7.7), shed light on hybrid French and Jewish identities in Orloff's life and work. Edmond Fleg (Flegenheimer) was a Swiss-born French poet, essayist, dramatist, and theater critic whose outlook was deeply affected both by the Dreyfus Affair and the first three Zionist congresses in Europe (1897–99).[29] Fleg's works *Hear Israel* (Écoute Israël, 1913–21) and *Why I Am a Jew* (Pourquoi je suis juif, 1928) exemplify the philosophy of modern European Judaism in the pre-Holocaust era, which was rooted in the desire to forge connections between Jewish and Christian texts in "an expansive notion of ecumenism."[30]

Orloff became intimate friends with the Flegs in the teens and twenties and shared with Edmond a desire to become a French citizen in

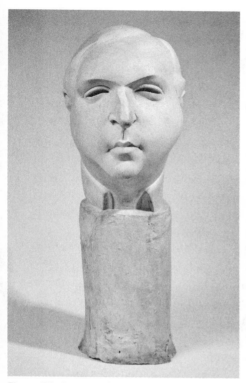

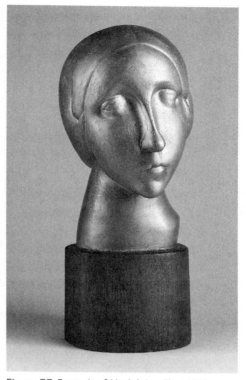

Figure 7.6. *Portrait of Edmond Fleg*, 1922. Plaster.

Figure 7.7. *Portrait of Madeleine Fleg*, 1920. Bronze.

compliance with the norms of the Third Republic. However, also like Fleg, she wished to incorporate her Jewish identity into her public persona as a French artist. Orloff's portrait in pencil of Edmond Fleg for *Figures d'aujourd'hui* (1923) was accompanied by a short biographical text by Gaston Picard celebrating the "duality" of Fleg's "double personalities": "the first is that of the Jew or rather Hebrew that is as unassimilated as possible. The second slowly separates itself from the first: it does not, however, substitute it. These two personalities continue to exist in parallel."[31] While Fleg's "second" personality is not described, Picard implies it is the opposite of his "unassimilated" Jewish identity—his assimilated French identity. Picard's last line reads: "I respect infinitely, myself a Christian, those elected from this race, born Jewish, who affirm their Jewishness."[32] This text shows how

Fleg and, by association, Orloff became proud and unashamed Jewish voices in certain progressive French literary circles of the early 1920s. Distinctions, however, were made between "foreign-born" Ukrainian and Russian Jews like Orloff and "French-born" (French Swiss Jews) like Fleg; this latter group often referred to themselves as "Israélites," the French word for "French-born Jews who tried to differentiate themselves from growing population of Eastern European émigrés by adhering to values of French gentile bourgeoisie."[33]

Orloff's portrait busts of both Edmond and Madeleine Fleg offer striking examples of her early bust portraits in which she distills the facial features to create an intimate portrait of two friends in her social circle. The portrait of Madeleine Fleg was widely reproduced in notable French art journals, appearing on the front page of the prominent critic Robert Rey's article on Orloff in *Art et Décoration* (1922),[34] and was mentioned in two short monographs published in Paris in 1927.[35] *Vanity Fair* introduced American audiences to the work in 1922 when they reproduced it with the following caption: "It is deemed, by some European critics, her best feminine portrait" by the "Russo-French Sculptress who is heading the recent revival of portrait carving in wood."[36] The exhibition and circulation of these portraits in the early 1920s helped shape Orloff's and the Flegs' public identities as *both* French and Jewish artists and intellectuals in Paris.

THE MODERN JEWISH WOMAN ARTIST

Orloff also moved in the circle of modern Parisian women artists during this period. In this body of work, Orloff created a pantheon of well-known Parisian women artists and writers who were themselves focused on the representation of modernity and sexual agency, and sometimes, Jewish identity. Edmond and Madeleine Fleg introduced her to the lesbian American expatriate writer and salon organizer Natalie Clifford Barney. Barney commissioned her own portrait, *The Amazon (Natalie Clifford Barney)* (1920) (see figure 7.8), along with that of her lover, the painter Romaine Brooks (1923), also an American expatriate (see figure 7.9).[37] Orloff also created sculpted portraits of the lesbian surrealist Claude Cahun (see figure 7.10), and many others who are celebrated today as modern women of the period. In each sculpted bust, Orloff offered recognizable facial portraits, yet distilled

Figure 7.8.
*The Amazon
(Portrait of
Natalie Clifford
Barney)*, 1920.
Wood relief.

her models' features down to highly stylized, abstracted forms in order to create the look of the modern woman.

Orloff incorporated her own experience in fashion design into some of these portraits. She represents Brooks (see figure 7.9) clad in a long cloak that resembles the sleek clothing worn by the women featured in Brooks's own painted portraits. Critics such as Léon Werth immediately picked up on the importance of fashion for the imagery of the modern woman. We can imagine that he is describing Orloff's *Portrait of Romaine Brooks* or her later *Portrait of a Woman in a Coat (Sonia)* (1926) (likely intended as a portrait of Sonia Delaunay) in the following passage: "Mme Chana Orloff realized that there are women of our time for whom the most enduring aspect of their character is expressed by their dress. Or by the long coats that envelop them, their expansive surfaces swaying and cutting against one another.... I know this woman much better than if she were naked, a knowledge neither anatomic nor sexual, but which captures the character in space and in society."[38] Werth's comments recognize the way Orloff used fashion

Figure 7.9. *Portrait of Romaine Brooks*, 1923. Bronze.

Figure 7.10. *Portrait of Claude Cahun*, 1921. Bronze.

choices to signify the boyish modernity associated with these "women of our time." His comment that the knowledge imparted by Orloff's sculptures is "neither anatomic nor sexual" speaks to the way clothing hides the bodies being represented. But it also alludes to the association of the modern woman with a lack of conventional femininity.

By looking closely at two of Orloff's sculpted portraits of modern women who were lesbians—*The Amazon* (*Natalie Clifford Barney*) (see figure 7.8) and *Claude Cahun* (see figure 7.10)—we can learn more about how she negotiated their relationships to gender and Jewish identity. Orloff created both plaster cast and wood portrait busts of Barney in 1920, and plaster, wood, and bronze portraits of Cahun in 1921. Cahun's portrait was exhibited at the Salon d'Automne that year, and both works were reproduced in the October 1922 edition of *Vanity Fair* in New York as well as the journal *Le Crapouillot*. Both women identified publicly as lesbians, and both were part Jewish, Barney on her mother's side, and Cahun on her father's side. Barney and Cahun had different relationships to their Jewish family backgrounds. Barney, who was profoundly antisemitic and supported the expulsion of Jews from Europe in the 1930s, may seem like an odd choice for Orloff to befriend and sculpt.[39] Despite her own family background and the fact that her sister was married to a Jewish man, Barney declared her intolerance of Jews and was in fact committed to the "solution" of a Zionist state. Perhaps Barney's stature as one of the most prominent modern expatriate women writers in Paris at the time overrode Orloff's interest in Jewish identity. In contrast, Cahun, who had changed her name from Lucy Schwob in 1918, identified strongly with the Jewish side of her father's family.[40] Cahun's father, Maurice Schwob, born Jewish, was an atheist who strongly opposed the church's involvement in government. Her mother was a Christian whose family was anti-semitic. The artist's chosen name, Cahun, a French version of Cohen, was her paternal grandmother's maiden name. She identified with her great-uncle Léon Cahun, curator at the Bibliothèque Mazarine, writer, and advocate of symbolist literature and art.

Orloff was friends with these radical women. She visited Barney, Brooks, and their mutual lover, the writer Elisabeth (Lily) de Gramont, Duchess of Clermont-Tonnerre, in the summer of 1921.[41] Barney included Orloff's name in her mazelike diagram of the colleagues,

friends, and lovers who regularly attended her Friday afternoon salons in Paris. Orloff, who identified as heterosexual, was included in this milieu having achieved a reputation as a worthy portraitist of this elite group of creative women we now refer to as the Women of the Left Bank. Barney commissioned Orloff to create a sculpted relief portrait that celebrated her alter ego, the *Amazon*, an identity she developed in a collection of poetry published that year entitled *Thoughts of an Amazon* (1920). We have already seen how Orloff produced an earlier piece entitled *The Amazon* in 1915 (see figure 6.2), a large, sculpted piece in wood portraying an abstracted and unnamed woman riding a horse. She chose to exhibit that piece at the Salon des Indépendants in 1920 (along with *The Jewish Painter* and her *Portrait of Madeleine Fleg*), the same year she created Barney's portrait. Unlike Barney and Brooks, however, Orloff was not affluent in 1920, so we must consider how her practice as a prolific portraitist of this elite group of Parisian women fit into the larger economic needs of her career.

During this same period, Claude Cahun commissioned Orloff to sculpt her portrait. Orloff entitled the work using Cahun's given name in the familiar, diminutive form, *Lucette Schwob* (Lucette being the nickname for Lucy). The two women were mutual friends of Pierre Albert-Birot (founder of *sic*). The strength of their friendship (which may have developed in the years Cahun posed for Orloff over the period 1920–21) is suggested by the fact that Cahun dedicated an essay entitled "Sappho" in her series *Heroïnes* (1925) to her.[42] As in the portrait of Barney, Orloff portrays Cahun's facial features as strong and angular, the prominent profile echoing Cahun's own photographic self-representation. Orloff represented her sitter's signature crewcut-style hair, a marker of her identity as a modern woman who was even more radical than the media image of the stylish Parisian garçonne. In both this work and her portrait of Barney, Orloff exaggerated the prominence of her sitters' noses as a marker of Jewish identity that would have been identifiable to her public. Many Jews engaged in rhinoplasty to reduce the size of their noses in response to widespread antisemitism. Perhaps in response to public desires to make Jews less visible, Orloff did just the opposite in her portraiture, amplifying the noses of her sitters, Barney and Cahun, to stress their shared identities as modern Jewish women artists.

In portraying Cahun's nose so prominently, Orloff drew on Cahun's own self-representation. Cahun herself wrote about what she called her "curlew" nose, and her first pseudonym was Claude Courlis, French for "curlew," the species of birds with long, slender, downturned bills. Orloff's sculpted portrait of Cahun resembles one of the images Cahun made with her lover Marcel Moore from circa 1928, the year of Cahun's father's death. In this photograph, Cahun posed in a corduroy jacket resembling one worn by her father and emphasized her own angular facial profile as an attempt to mimic a 1917 photograph of him in profile. Scholars have argued that Cahun was attempting to emulate her father's "masculine" and "Jewish" facial features and bodily identity.[43] By engaging in a dialogue with these specific features from Cahun's practice and then exhibiting the piece at the Parisian Salon d'Automne, Orloff shows her investment in shaping the public imagery of the modern Jewish woman artist.

Louise Weiss, a brilliant French journalist, politician, and champion of European union and women's rights, was yet another Jewish woman with whom Orloff had a lifelong friendship.[44] Weiss, whose descendants were from the Alsace region, came from an upper-middle-class family of mixed Protestant-Jewish backgrounds. By sculpting Weiss's portrait bust (see figure 7.11), Orloff inserted herself into a specific history of powerful activist women in France who strove for stronger roles for women in public life. Weiss was the founding editor (1918–34) of *L'Europe Nouvelle*, one of the most influential weekly Parisian magazines during the 1920s that advocated for pacifism and worldwide disarmament.[45] Among Weiss's many other accomplishments, she founded a hospital for wounded soldiers during World War I; she also founded *La Femme Nouvelle*, a movement promoting women's suffrage in the 1930s (1934–38), and played a leadership role during the resistance movement during World War II.[46] After the war, Weiss traveled extensively, wrote books, and produced documentary films about her experiences (1946–65); she also won the Literature Prize of the Académie Française (1947) and was elected to the European Parliament in 1979 at age eighty-six (1979–83). She was named "the grandmother of Europe" by then Chancellor of the German Republic Helmut Schmidt.

Figure 7.11. *Portrait of Louise Weiss*, 1928. Bronze.

Orloff's bronze portrait of Weiss, now in the Musée d'Arras, emphasizes her sitter's confident demeanor. Weiss tips her head back and bears a slight smile upon her lips, hinting at her sense of humor. She wears her short hair cropped tightly against her head, signaling the attributes of the modern woman, who in this case was widely recognized by the French public for her political acumen and strong feminist politics. When a bronze cast of the sculpture was exhibited at the Salon des Tuileries in 1927, Robert Rey described how "Orloff has perfectly captured the astonished expression, the brief burst of a playful expression of laughter that sometimes animates the face of Louise Weiss," and noted that "one of the most interesting and sympathetic figures of our time is portrayed here, by the sculptor who can highlight all there is of fresh humanity with so much knowledge and desire."[47] Rey's commentary suggests that Orloff's portrait communicated not only Weiss's "knowledge and desire" but also her personal familiarity with Weiss's mannerisms.

An early admirer of Orloff's work, Weiss reflected on their close friendship in an interview with Orloff's granddaughter, Ariane Justman Tamir, in 1972. Weiss described how she went to visit Orloff in her studio in the 1920s and they immediately became "wonderful friends who got along marvelously."[48] Weiss was committed to covering Orloff's exhibitions for L'Europe Nouvelle, and lamented that she only owned a few of Orloff's works: "If back in those days I had more money (I was a young journalist), I would have a whole collection of Chana's works!" Weiss kept the portrait bust, which is slightly larger-than-life in size, displayed prominently in her living room until her death.[49] Both women had lived through the brutalities of two world wars and had overcome significant obstacles to promote their ambitious professional goals. It is not surprising that Orloff and Weiss deeply respected one another. While Orloff did not publicly align herself with the feminist and women's suffrage movements championed by Weiss, her celebration of women's achievements through commemorative portraits like this one was a feminist act. In solidarity, Weiss honored Orloff following World War II by displaying her portrait prominently in her own home, surrounded by personally resonant objects that signify the power of women's ability to persist in the face of war and adversity.

LEGION OF HONOR AND CITIZENSHIP

On August 16, 1925, Chana Orloff had become so successful in the French and international art world that she was named Chevalier of the Legion of Honor. She was awarded this honor with one other artist, a musician named Wanda Landowska, a Polish Jew who founded the École de Musique Ancienne in Paris in 1925. The critic André Levinson called both women "Amazons" and "women who dared" in an article in *Les Nouvelles littéraires* when their awards were announced.[50] We think back to Orloff's self-identification with the Amazon theme, both in her 1916 *Amazon* and 1920 *Amazon (Natalie Clifford Barney)*. It was fitting that she was paired in receiving the award with Landowska, as two highly successful Jewish émigré women succeeding in their respective fields in Paris.

Orloff became a French citizen on April 7, 1926; Élie, then age eight, simultaneously became a citizen. Although he was born in France, because his mother was foreign born he would have had to wait until he reached the majority age of twenty-one had she otherwise been unable to naturalize. As a testament to her desire to assimilate, Orloff donated a sculpture for the "Patriotic Exhibition for the recovery of the franc," held at the Galerie Armand Drouant in Paris, with proceeds going to the national defense fund.[51] She recalled how thrilled she was on the day that she became a French citizen.[52] For the first time in her life, she felt a sense of belonging and identification with a homeland. Even though she had experienced antisemitism in France, once she was a citizen Orloff believed that the French government would "protect her son, and he will not know the fears and persecution she faced in her youth" as a Jew in Ukraine.[53] Despite the long history of entrenched attitudes toward Jews in France, she steadfastly believed in the notion of "redemptive citizenship" that emphasized community and inclusion. This illusory sense of security persisted right until the moment of the Occupation and Vichy collaboration.

CHAPTER 8
Villa Seurat
Building a Studio and a Community, 1926–1929

In the mid-1920s, Orloff decided that she had outgrown her rented studio space on the rue d'Assas. She wanted to upgrade to a larger combined home and studio in Montparnasse.[1] In these years, Orloff still had to live with the tension between her desire to assimilate to French culture and her long-term pride in her Jewish émigré identity. She also continued to navigate the friction between her public image as a modern woman and her role as devoted mother. Orloff's new home and studio, the Villa Seurat, became a site where she negotiated these seemingly oppositional identities and allegiances.[2] Her atelier became a vehicle to shape her identity by claiming Frenchness, attracting publicity and the media, as well as a social space where she enacted her cosmopolitan Jewish émigré identity. It served as a central meeting place for a wide circle of friends, which included prominent French and Jewish émigré writers, Zionist leaders, artists, and students who came from Palestine to Paris in the interwar years. Many of Orloff's friends and colleagues sat for their portraits there, recognizing the ability of her work to shape their own reputations and public identities.

The character of the neighborhood where Orloff lived and worked was changing quickly with the growing art market, and it became fashionable among commercially successful artists to commission the construction of combined studios and homes. Orloff's colleague, the painter Alice Halicka, reflected on this phenomenon with a bit of cynicism in her memoirs: "New streets sprang up in which the artists lived

in town houses in the style of Le Corbusier and Mallet-Stevens. The painters carried themselves like nouveaux-riches, talked lots about country properties, makes of cars, jewels, they'd given their wives. . . . Montparnasse was the cradle of the new over-optimism."[3] Given her commercial success, Orloff was able take out a loan from the bank and purchase land in one of these cul-de-sacs (known as "impasses" and "villas") that was being newly developed as live-work spaces for artists. The plots were on a small, quiet street called Villa Seurat, named after the famous pointillist painter, located off the rue de la Tombe Issoire, near the Parc Montsouris.

Orloff purchased two of the eight plots available on this street. She intended to build a combined home and studio at 7 bis Villa Seurat. Then, once she had more resources, she planned to construct a second home in the adjacent lot (7 Villa Seurat) to rent to supplement her income.[4] Faced with a choice of architects to design her new home and studio, Orloff realized the important implications for her own public image. She selected Auguste Perret (who partnered with his brother, Gustave Perret), the notable French (Swiss-born) architect whose portrait she had sculpted and exhibited in bronze at the Salon d'Automne in 1923 (see figure 8.1).[5] He was especially well-known for having co-designed (with Henry Van de Velde) the Théâtre des Champs-Élysées (1913), known as the first art deco building in Paris, and entirely built of reinforced concrete, a new architectural technology of the time. Perret's design of the exterior of Orloff's house (1926–29) (see plate 7) was decorative, with strips of concrete and brick placed in symmetrical rows that frame the large bay windows, accented by two "bull's-eye" windows strategically placed above.

Orloff chose an architect associated with French tradition. It was Perret's first frame house executed in reinforced concrete, and it was considered an experimental building. The critic Marcel Mayer remarked that the Orloff house "teaches them a lesson, functions as a call to order, to good sense, to good taste . . . it is frank, likable, robust, distinguished. Down-to-earth architecture, up-to-the-minute architecture, French architecture."[6] Mayer celebrates Perret as the arbiter of French taste and stability using the language of the postwar aesthetic *rappel à l'ordre* (return to order), a movement advocating for the return to tradition following the devastation of World War I.

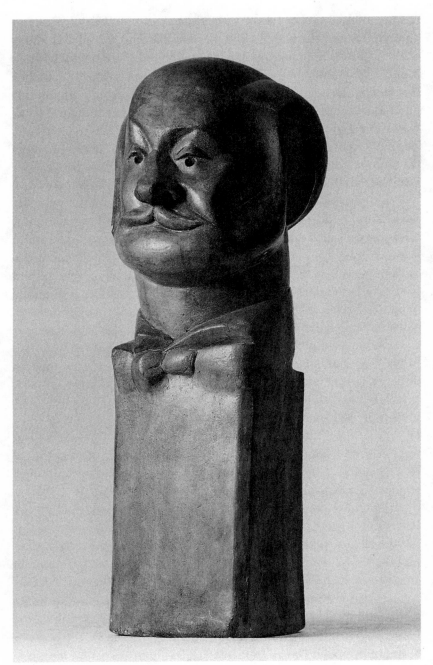

Figure 8.1. *Portrait of Auguste Perret*, 1923.

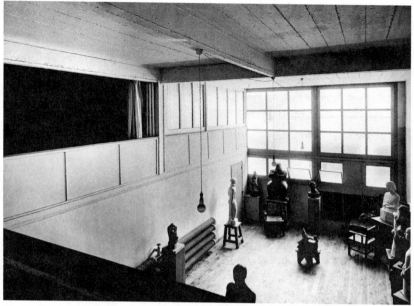

Figure 8.2. August Perret, Interior of Chana Orloff's studio, 7 bis Villa Seurat, Paris, 1926–1929.

By choosing Perret as her architect during the same year in which she got French citizenship, Orloff strategically showed her commitment to assimilation.[7] However, she also remained invested in celebrating her diaspora and cosmopolitan identities by making her new home a hub for émigré artists, international writers and intellectuals, and for those visiting from Palestine.

The spatial layout of Orloff's house was designed to effectively meet the combined needs of her personal and professional lives. Entering from the street, visitors first encountered two large studios on the ground floor. The larger, north-facing one with street frontage functioned as a gallery where she exhibited her work, met with clients, and entertained guests. One critic recalled, "She had a gallery of her own sculpture on the street, so that in effect she was in a continuous state of exhibition."[8] A photograph reproduced in the journal *L'Architecture* was taken from a mezzanine balcony that runs along two sides of this space (see figure 8.2). Orloff strategically placed some of her best-known works in prominent positions in the studio. Her bronze portrait

of Widhopff appears before the large bay windows, with *My Son* (1923) (see figure 8.6) standing on a pedestal in white cement adjacent to the wall, and *Woman with Arms Crossed (Madonna)* (1913) (see plate 3) in the corner. Visitors were encouraged to climb the stairs and view the sculptures from above.

After exploring her work on display in this street-front gallery, visitors entered the south-facing working studio. This was the heart of her workshop where Orloff hung tools on the wall for easy access and covered her works in progress with blankets. This is also where she stored stockpiles of clay, wood, and stone, along with bags of cement and plaster. Orloff held informal "open studio" exhibitions on both the ground floor and mezzanine levels. She advertised them in the popular press including *La Semaine de Paris*.[9] Her atelier thus served not only as a sculptural workshop attached to her home but also a public exhibition space that she carefully curated.

The living quarters of Orloff's house were compact and well-designed for separating her private and public lives. A small, partitioned area on the mezzanine level provided a secluded space for a live-in childcare provider. A second flight of stairs leads to the first floor, which includes a north-facing, combined living/dining room with large skylight windows on the ceiling, two small bedrooms with an adjoining terrace facing south, a small, sky-lit kitchen, and a bathroom.

Orloff commissioned two of her friends, Pierre Chareau and Francis Jourdain, to design these rooms tastefully but sparingly.[10] She explained her design aesthetic to Imbert, a journalist from the journal *L'Architecture*: "I don't like furniture; I prefer the walls to be furnished."[11] Orloff wanted to keep the aesthetic of her home clean and uncluttered, with shelving and storage built directly into the walls. Her predilection for simplicity is apparent in Chareau's designs of the two bedrooms. A built-in closet, cabinetry, and bookshelves in plain white suggest a minimalist aesthetic, the starkness stressed by the bold, geometric pattern of the bedspread and rug. Jourdain designed the north-facing living/dining room with a similarly functional but uncluttered aesthetic. Known for eliminating superficial adornments and focusing on comfort, Jourdain was among the first in France to attend to smaller domestic living conditions in homes and apartments. He once proclaimed, "We can decorate a room in a very luxurious way

by unfurnishing it rather than by furnishing it."[12] Doors between each section of Orloff's home provided added privacy and separation of the artist's private and public lives.

Orloff's friends and colleagues, as well as art critics and journalists, consistently described her new studio as an important meeting place for the international artists and writers associated with the École de Paris, a place where "one meets celebrities from many countries" and is generously welcomed with food and wine.[13] Orloff loved to entertain and hosted regular gatherings at her home on Sunday evenings. Among her frequent guests were many émigré friends and neighbors, including the sculptor Ossip Zadkine and his wife, the painter Valentine Prax; the artists Per and Lucy Krohg, Olga Sacharoff, and many more. She encouraged her friends to invite others whom she did not know to join these social gatherings. For example, Francis Jourdain once brought his close friend, the French art historian Dr. Élie Faure, with him as a guest.[14] Faure was so taken by Orloff's work and studio that he commissioned her to sculpt a portrait in plaster of Jourdain.[15] He later wrote in a letter to Orloff: "The bust of Francis salutes me with a mocking smile every time I return home . . . I await your news. . . . Please count me among your most fervent admirers."[16] Here, Orloff's portrait of Jourdain became symbolic of multiple friendships: between artist and sitter, artist and patron, and patron and sitter.

PROMINENT JEWISH VISITORS

Orloff was celebrated later in Israel for regularly having welcomed emerging Jewish artists and writers from Palestine to her home and studio on the Villa Seurat and having introduced them to the Parisian art world. Many of these friends and acquaintances from Palestine—artists, writers, and intellectuals—remarked later in their lives about how much they appreciated her generous hospitality. She produced sculpted portraits of some of them, which she exhibited. Orloff's portrait sculptures helped shape the reputations and public identities of artists who were early in their careers.

Reuven Rubin, the popular Romanian-Israeli artist who became a founder of what is today known as the "Eretz Israel" style of painting, visited Orloff's home.[17] Orloff's portrait of Rubin (1926) (see figure 8.3) was included in her solo show at Galerie Druet that year.[18] This work

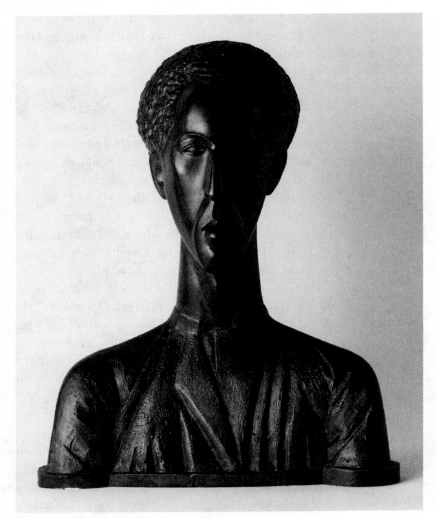

Figure 8.3. *Portrait of Reuven Rubin*, 1926. Bronze.

emphasizes an extremely elongated face and neck, refined features, and clothing that appears flat and linear. This neo-Byzantine style echoes Rubin's own Orientalizing treatment of his features in his own painted self-portraits. Orloff's bust recalls Rubin's use of Zionist figures of the "new Hebrew" or "new Jew" in his paintings. He often set this tan and muscular "type" in a local landscape among figures arranged like saints in a Christian altarpiece.[19]

In his memoir, Rubin describes his initial meeting with Orloff as his "first real introduction to the life of an artist in Paris."[20] He visited her at her rented studio on the rue d'Assas, just prior to her move to her new home. Whereas her professional and personal spaces were separated in the new space at the Villa Seurat, as Rubin notes, in her former studio everything was packed into one room: "One corner of her room was reserved for the kitchen, another corner, concealed by a curtain, served as a bedroom; the rest was the sculpture studio."[21] His vivid account of sitting for his portrait allows us to appreciate her use of domestic space as the site of art making, as well as the dramatic upgrade that Orloff's new studio space provided:

> Chana was young and full of energy. First she put a big pot of borscht on the stove and then started preparing the clay for my bust. She was a formidable worker and a remarkable person. She got the clay ready, then jumped up to see how the borscht was getting on. Occasionally she went behind the curtain, and I realized there was a child there who, as I later learned, was ill. But nothing seemed to depress Chana's spirit, which reminded me of Tel Aviv itself, vigorous and alive. She spoke fluent Hebrew and there was one particular song on her lips, "El Yivneh Hagalil" (God Will Build the Galilee). She worked furiously on the bust and by the afternoon I saw my head taking shape, looking like the Negus of Abyssinia. But it was a fine piece of work and I liked it from the start.[22]

Rubin's memoir gives us a glimpse of Orloff's great dynamism and busy daily routines as a working artist and mother of a child with disabilities. His observations suggest how she moved with ease between her professional and personal lives, including her maternal responsibilities, her cooking, and her art. The passage also stresses Rubin's strong identification with her as a Jewish émigré and Zionist from Palestine, while he lived temporarily in Paris. Rubin was so taken with Orloff's sculpted portrait bust of him that he kept it in his home in Tel Aviv for the rest of his life.[23]

In his memoir, Rubin recalls that Orloff helped him establish himself within the artistic culture of Montparnasse by introducing him to her friends in the Parisian Jewish community, including, among others,

Edmond and Madeleine Fleg.[24] She taught Rubin the protocols for mining such relationships and helped him secure his first contacts to exhibit and sell his work. Immediately after receiving the news of his upcoming exhibition at the prestigious Galerie André Scheller, Rubin called Orloff. She insisted that they go out to celebrate together at La Rotonde. While he credited her in his memoir for facilitating his entry into the French art world, Rubin later explained that he did not wish to fully assimilate: "I had a strong feeling that I must guard myself in case I be submerged in the sea of French art life. For in my ears, I again heard the calling of the Land of Israel and my father's singing of Hallelujah."[25] Orloff's sculpted portrait of Rubin stands as an important symbol of her influence on the early art world of the Yishuv. However, Rubin's words remind us of the ambivalence that Rubin and other Jewish artists and critics from Palestine would later express toward complete assimilation to French culture.[26]

When Hayim Nahman Bialik, "the father of Hebrew poetry," traveled from the United States to Palestine in 1926, he made a special stop to visit Orloff in her new home and studio and sit for his portrait (see figure 8.4).[27] Bialik was an influential figure in the history of Zionist and Israeli culture. His serious facial expression and crossed arms invest him with a commanding presence. With his bald head, angular features, furrowed brow, and deep creases connecting his mouth and nose, he is portrayed as a seasoned and influential public figure. Bialik's tailored suit and tie also demonstrate Orloff's continued interest in representing contemporary fashions.[28]

Orloff seized upon Bialik's Parisian visit to invite her community of French and Jewish émigré artists to the Villa Seurat studio for a celebration. The German writer Dr. Else von Hofmann published an article about this occasion that presents Orloff in the central role of salon organizer, and her studio as the site of cultural transmission.[29] A "crowd" of international artists (Austrian, French, Russian, and Polish) "gathered around" Orloff to celebrate Bialik's "visit to his honored friend" to "sit for his portrait." Several of Orloff's close friends were present: Leopold Gottlieb, a Polish Jewish painter who was active in Kraków, Vienna, and Paris, and who had lived in Jerusalem while teaching at Bezalel School of Art and Crafts; and Josef Floch and Viktor Tischler, both Austrian Jewish painters who emigrated to Paris from

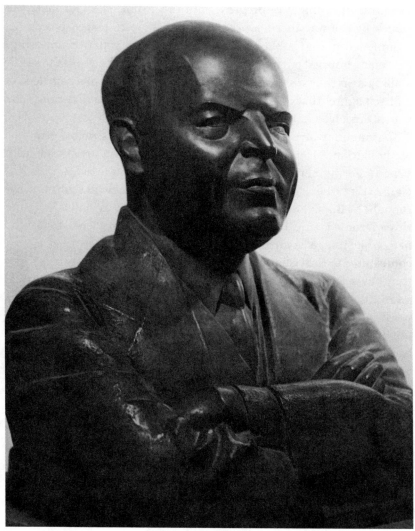

Figure 8.4. *Hayim Nahman Bialik*, 1926. Bronze.

Vienna in the 1920s and were active in the circle of émigré artists in Montparnasse.[30] A festive banquet ensued, during which guests alternated between lighthearted conversation and "passionate and original discussions about art." Was it really possible that Orloff did all the cooking for her extensive entertaining? For Hofmann, the "culmination" of the evening occurred when Orloff shared the clay studies of

her portrait of Bialik in progress with the group. The journalist was struck by the way these "works in progress" were placed beside her "completed plaster molds, arranged in rows, their power imposing." The many finished portrait busts lined the wooden shelves of the studio walls, just as they still do today. Cumulatively, they form a pantheon of cultural figures that offers physical evidence of the long roster of guests warmly received in this very space.

Throughout her life, Orloff emphasized Bialik's prominent role as the national Hebrew poet in cultivating her own artistic identity. When offering her own story about becoming an artist, Orloff told Gamzu that when, for the first time, she tried her hand at sculpture, she thought of Bialik and began kneading his portrait in clay.[31] Whether this anecdote is true, the narrative shows how Orloff wished to fashion her public image as an artist who, from the beginning of her career, contributed to the visual culture of Zionism. The two met socially many times over the years, and their correspondence reflects their mutual admiration. When Edouard des Courières's monograph on Orloff's work was published in 1927, Orloff sent a copy to Bialik with a dedication in Hebrew: "To H.N. Bialik, the great sculptor of words." He wrote back, thanking her and praising the volume: "All who came to my home and saw your book were amazed by your fingers' doing and blessed the *Birchot Hanehenin* (Blessings on Sights, Sounds and Smells). I've heard that your reputation is growing and that you are like a rushing river. Grow bigger and you will succeed!"[32] When Orloff and Bialik met again in person, later in Palestine at her brother Zvi's Chanukah party, he dedicated a book of his poetry to her: "I can speak / and create words / You go knead clay / and make statues. Hanukka gelt for Chana Orloff, from H.N. Bialik, Tel Aviv, Hanukka 5687."[33]

ARTISTIC REPUTATION AND MOTHERHOOD

We have seen how Orloff emphasized her ties to Jewish artists when fashioning her image as a contributor to the visual culture of Zionism. Looking at her critical reputation through the lens of international magazines, we also see Orloff actively cultivating a reputation as a professional woman artist and as a mother. In photographs taken throughout the 1920s, Orloff used the space of her studio-home as the symbolic setting for this self-fashioning. In 1924 Orloff appeared in a feature

story in *Vanity Fair*, promoting her work to an American audience. The article was illustrated with photographs by the American expatriate photojournalist Thérèse Bonney, who regularly photographed professional artists as modern women of the 1920s.[34] Orloff recognized that by marketing her work to a targeted readership of international women consumers, she could expand her clientele by connecting her sculptures to feminized forms of popular culture, such as fashion and shopping.[35] *Vanity Fair* was the perfect forum for both addressing women and proving her credentials as a modern artist. Throughout the 1920s the magazine featured the work of important avant-garde writers, including Aldous Huxley, T. S. Eliot, Gertrude Stein, and others, as well as reproductions of the art world by Picasso and Matisse. Orloff first met the editor of *Vanity Fair*, Frank Crowninshield, through Lucien Vogel.[36] Crowninshield, who was an organizer of the Armory Show in New York in 1913, transformed *Vanity Fair* from a monthly magazine that was heavy in fashion advertisements to an important literary and artistic journal. He visited Paris and saw Orloff in her studio. She wrote to him in 1922 in anticipation of one such visit: "I am working hard. I have many new things. Looking forward to showing you. Also photographs of them."[37]

Orloff's work appeared in nine different full-page spreads in *Vanity Fair* throughout the 1920s, showing how quickly her international reputation had grown since the end of World War I. One such story included a detail from Thérèse Bonney's series of photographs of the artist at age thirty-six in her Parisian studio, accompanied by this caption: "Madame Orloff has now become one of the most interesting figures in the artistic life of Paris, where her enchanting studio, her high talent as a sculptress, and her interesting circle of friends have made a notable position for her."[38] In Bonney's 1924 photograph, Orloff epitomizes the popular media image of this professional and economically independent, postwar woman: she is dressed in a simple sculptor's smock, with a scarf tied around her neck, and she sports the cropped hairstyle associated with modern women. However, rather than portraying the artist alone at work, Bonney featured Orloff holding her five-year-old son, Élie, with great tenderness, in her lap (see figure 8.5). Orloff's pose echoes two sculptures of mothers and children featured in the photograph behind her. A third piece, a sculpted bronze bust

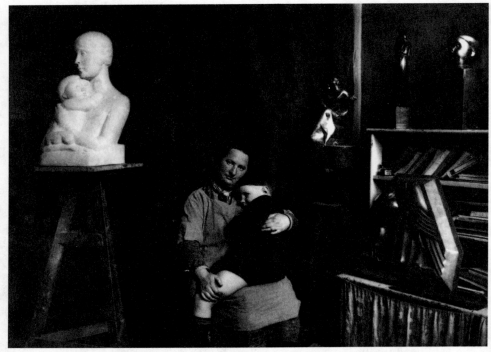

Figure 8.5. Thérèse Bonney, Chana Orloff and her son in her rue d'Assas studio, 1924.

portrait of her young son, created that same year (1924), is visible in
the upper right. In Bonney's photograph, Orloff presents herself as a
professional sculptor proud of her dual identities as a modern woman
artist and as a mother. She also makes clear that motherhood is an
important inspiration for her work.

Orloff created many sculpted portraits of her son, Élie, throughout
his boyhood, both as stylized busts, such as the playful bronze por-
trayed in the photograph, and a full-body portrait in stone in a sailor
suit purchased by the state for the museum in Grenoble in 1926 (see
figure 8.6).[39] In an interview published in *Le Petit Journal*, Orloff pub-
licly acknowledged the connection between her artistic practice and
her identity as a single mother devoted to raising her son. When asked
to comment on the challenges of becoming an artist, she responded by
citing the famous German dictum about the role of women in society:
Kinder, Küche, Kirche (Children, Kitchen, Church); Orloff claimed

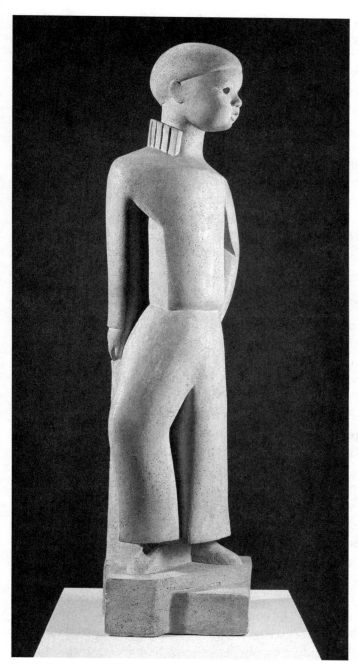

Figure 8.6. *My Son*, 1923. Cement.

that religion, cooking, and housework were, for her, secondary to the importance of raising children: "Anything to do with children, I believe, is truly the most essential thing, and what concerns me most, naturally, in my art."[40] She explained: "For me, a woman is especially and above all, a mother, and she does not live completely unless she experiences motherhood; also, I am convinced that for a woman creator [*créatrice*], maternity is necessary, because life is the most profound source of all art."[41] With this statement, Orloff asserts that motherhood is essential for any professional woman artist. Certainly, this position appealed to French (male) critics, many of whom subscribed to the state's rigid pronatalist agenda following the devastating loss of life and shocking drop in the birthrate that caused a major threat to population as a result of World War I.

Orloff's sculpted "modern madonnas" also held nationalistic appeal for many conservative art critics.[42] In response to the depopulation crisis caused by World War I, some of Orloff's French critics emphasized her classical representations of motherhood.[43] Popular postwar imagery that continued to circulate drew upon the maternal status of "Marianne," an allegorical figure who symbolized "Mother France" and hence the cohesive strength of the French Republic following the revolutionary period.[44] For many male and female artists seeking recognition in France, Marianne had both secular and religious connotations and implied a sense of national tradition.

As if in response to her efforts to focus upon maternal function, critics often described Orloff's work, such as *Reclining Maternity* (1923) (see plate 1), by referring to her ability to sculpt "maternally."[45] In this sculpture, Orloff portrays a reclining nude model with her ample body intimately wrapped around her offspring to show her viewers the intricacies of breastfeeding. In this work, we see the mother's physical and emotional attachment to the suckling child. Orloff frequently depicted nude women embracing their offspring and mothers nursing their young, as well as visibly pregnant nude women. In these works, Orloff imbues her figures with a sense of ease and pride in their embodiment and sexuality. The contemporary critic Adolphe Gottlieb from *L'Illustration Juive* described such works as "felt, lived and exteriorized from the depth of bodily sensations."[46] Given her own espousal of the importance of the biological experience of maternity for the

female artist, Orloff likely would have accepted this critic's remarks as a high compliment. These maternal sculptures rarely portray specific individuals, but stand more for universal themes of female sexuality, fertility, creativity, and reproduction.[47]

Many critics writing about Orloff during the early to mid-1920s infused their descriptions of the artist and her work with their own ambivalent attempts to reconcile the artist's diasporic and gender identities.[48] In an illustrated feature article that appeared in *Deutsche Kunst und Dekoration* in 1924, the German critic Pawel Barchan began by exclaiming: "Chana Orloff is a Jewess. She herself seems to place considerable weight on this. Yet the Semitism of the Russian Jew is a problematic matter. . . . One look at a photograph of Orloff suffices for the viewer to notice: 'There is a little Russian peasant mama!'"[49] Initially, negative stereotypes about working-class, Russian Jewish motherhood shaped the public's attitude about Orloff and her work by downplaying her professionalism as a successful Parisian artist. Yet further consideration of this text reveals Barchan's more complicated critical perspective; while "French schooling is also unmistakable in her," he focuses on two primary influences: "national primitive humor" linked to Russian folklore (evidenced by her facility in working with wood), and the pervasive influence of "motherhood" ("Of motherly thoughts conceived, of a motherly hand created"). Barchan describes Orloff's sculptures as "of a manly character," in contrast to widely held stereotypes about the work of women artists as "sentimental," "always imitation, always jarring," and concludes by complimenting the artist on her "motherly craftiness."[50]

While this review may support my idea that Orloff successfully devised an artistic strategy to make legible her identity as an artist and mother who is Russian, Jewish, and French, it also reveals an ongoing critical fascination that mixes gender stereotyping, philosemitism, and its apparent opposite, antisemitism, in response to her work of the 1920s. In contrast, in response to Picasso's painted and sculpted portraits of children and pregnant-looking female nudes created in the interwar years, critics did not excessively discuss his Spanishness, paternal status, or personal relationships with women.

Orloff's was not always portrayed as a "Russian peasant mama." Her acclaim extended to the popular press, where she often was described as a hybrid "Russo-French" sculptor and a glamorous modern

woman artist. The December 1926 edition of French *Vogue*—devoted to the themes of winter sports and luxurious automobiles—included a two-page tribute to Orloff. Entitled "In Search of the Expression of Style," the article alerted its readers of the upcoming exhibition of this "excellent" sculptor of prominence at Galerie Druet. The critic praised her portraits of well-known people, and how Orloff "adds her own commentary" to the notion of "likeness" by using a simplification of form to emphasize "dominant physiognomy."[51] Three of Orloff's sculpted portrait busts of young women are reproduced on the first page.[52] Each figure is dressed stylishly, one clad in a pleated skirt and another donning a fashionable turban on her head. Orloff primarily engaged Thérèse Bonney and the French photographer Marc Vaux to photograph her work that appeared in magazines, journals, and exhibition catalogs.[53] Vaux was a well-known photographer who documented the work of the Parisian avant-garde. The *Vogue* caption describes how the reflection of the light across the figure's face can be understood as a mark of "intelligence." With its strategic choice of imagery and language, this article helped foster Orloff's reputation as an elite portraitist of modern Parisian women for *Vogue's* readership.

Vanity Fair, too, sometimes portrayed the artist as an elite portraitist of modern Paris. As a testament to Orloff's celebrity status, *Vanity Fair* nominated her twice for its Hall of Fame, in December 1922 and December 1929, praising her prowess as a sculptor and the diversity of her artistic skills: "because she has studied dyes, color printing and ceramics."[54] In a similar vein, *Paris-Midi*, a daily French newspaper, ran a special survey ("enquête"), in which Orloff was interviewed beside the French actress and beauty queen Edmonde Guy.[55] Such coverage shows how Orloff, now midcareer at age forty, used her position as an illustrious personality in the media both in France and abroad to fashion identities appropriate to particular circumstances.

When she was interviewed or commissioned her own images, however, Orloff tied her success to the image of down-to-earth worker, in contrast to glamorous "femme artiste moderne."[56] When she spoke with critics, she strategically rejected the image of the woman artist as celebrity icon. Instead, she emphasized how her hard work, physical strength, and modest upbringing facilitated her success as a professional sculptor. She told a journalist from *Prager-Presse*, the state-

funded, leftist German newspaper published in the Czech Republic during the interwar years: "Women are rarely sculptors; but I don't see any secret reason behind this fact. In my opinion, it's a question of physical aptitude, of resistance. To become a sculptor is a very difficult career; you must stay standing up for long hours. A woman can't always support this. I am, thank God, in good health and solid."[57]

When writing about popular French sculptors in this period, critics often integrated the practices of artisans into descriptions of their work. André Levinson, the critic who celebrated Orloff as an "Amazon" upon the occasion of her Legion of Honor award, described her work as "robust" and said that she "kneads the heavy clay with the arms of a great giant."[58] This rhetoric of a "return to the soil," promoted by Orloff herself, was a means to show an artist's allegiance to French nationalism during the decade of Reconstruction following World War I.[59] In Orloff's case, however, even after she became a French citizen, art critics regularly linked her work to her Russian heritage to establish her authenticity as a sculptor, connecting her practice of wood carving to her Russian roots.[60]

By 1927 Orloff had become so well known in the French art world that she was featured in two short monographs, both published in Paris. The respective authors, Edouard des Courières and Léon Werth, reinforced her image as a professional woman sculptor in artisanal terms and reflected on her modernity and hybrid national identities.[61] Although Courières's book appeared as part of a new series on contemporary French sculpture, he claimed "the single most important influence on Orloff's work" was "the Orient," followed by that of "Russian music"; "It is logical that a Russian artist, who is closer, perhaps, to Asia than to Europe, would have deep roots in an ancient civilization with such strong originality."[62] Besides espousing such racialized language, he also alluded to her identity as a worker: "In sculpture, one cannot cheat with the material: it must be conquered. There are no sculptural half-truths. The masterpiece is made by the worker's hands."[63] Werth used similar rhetoric in his monograph on Orloff, describing sculpture as an art form that is "labor and manual work ('oeuvre ouvrière et manuelle')."[64]

The cover illustration for Courières's book features an engraving after a self-portrait drawing by Orloff that dramatizes her contradic-

Figure 8.7.
Cover of Edouard
des Courières,
Chana Orloff, 1927.
Paris, Gallimard/
Les Sculpteurs
Français Nouveau,
no. 6.

tory identities (see figure 8.7). She portrays herself wearing a headscarf, which recalls both Jewish traditional dress and the contemporary iconography of the Russian woman worker. Rodchenko's 1924 poster image of the writer Lilya Brik made this look famous. She was hand-to-mouth shouting "Books!" an image signaling the activism of women in the workforce and public sphere.[65] In contrast, Orloff, who was neither religious nor strongly identified with Soviet politics, only wore a headscarf while working in the studio, presumably to keep her hair out of her eyes and free of plaster. Note, however, that we can tell from her collar that she dons a sailor's shirt or "middy," a fashion made popular by Coco Chanel for stylish Parisian women of the 1920s. This combination of both traditional and modern dress in her self-portrait reproduced on the cover of the very first monograph focused on her work confirms her desire to fashion her public persona as both a serious maker/worker and a stylish modern woman.

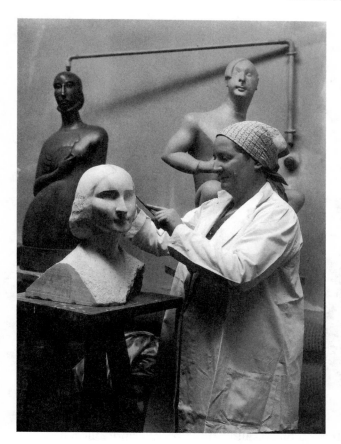

Figure 8.8.
Thérèse Bonney,
*Portrait of Chana
Orloff*, November
1929.

PHOTOGRAPHIC SELF-REPRESENTATION
IN HER NEW HOME

In 1929 Orloff commissioned Thérèse Bonney to take another series of photographs of her in the studio to promote her first trip to the United States. In one image, Orloff is engaged in chiseling a stone bust of an unnamed woman with classical features and chin-length, wavy hair (see figure 8.8).[66] The woman may very well be Esther Hirschbein, a Russian-born Canadian Yiddish poet and screenwriter,[67] recognized for her groundbreaking poems addressing pregnancy and motherhood. In Bonney's photograph, Orloff's full-body portraits of Ivanna Lemaître (*Woman with a Fan*) and Per Krohg (*Accordionist*) are identifiable in the background, framed by an exposed pipe against the studio wall.

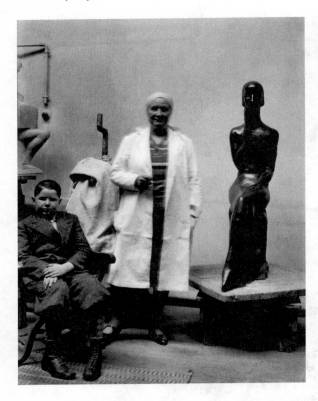

Figure 8.9.
Thérèse Bonney,
*Portrait of Chana
Orloff (with son, Elie
Justman)*. Taken in
Villa Seurat studio,
November 1929.

The composition of this photograph places Orloff in dialogue with her life-size sculptural subjects, all of them friends and colleagues, as if forming an international community of artists and writers in the Villa Seurat studio space.

In the other image, Orloff stands in a slightly different position in her workshop, cigarette in hand (see figure 8.9). Élie, age eleven, is seated to her left, clad in a tweed jacket and knickers. His feet awkwardly point inward—a result of the heavy metal leg braces that he wore daily, underneath his socks, to facilitate his movement. His presence reminds us of Orloff's daily life and routines as a mother and caregiver, as well as an artist and a worker. To her right is the life-size, full-bodied portrait of her friend Manya Harari, a Russian-born, British translator of Russian literature best known for her translation of Boris Pasternak's *Doctor Zhivago*.[68] Harari and her husband, Ralph Andrew Harari, a banker and art collector from a prominent Anglo-Jewish family in

Cairo, commissioned Orloff to create their portraits in 1925. In this portrait, Madame Harari's slender figure is emphasized by her long, formfitting dress and leisurely posture. With her legs crossed and one hand placed against her thigh and the other on her neck, she appears deep in thought. Harari's willowy stature and refinement appear even more exaggerated in juxtaposition to Orloff's physical comportment and dress. Although these two photographs taken by Bonney in 1929 appear not to have been published, they give us a glimpse into the multiple roles that Orloff played in her daily life in the studio.

THE PSYCHOANALYTIC CIRCLE

Orloff's work was influenced by her participation in another émigré social circle that included several prominent figures involved in the history of psychoanalysis. While sculpting busts of Dr. Otto Rank (1927) (see figure 8.10) and his wife, Beata (who went by Tola) Rank (1929) (see figure 8.11), Orloff was exposed to early psychoanalytic theories of subjectivity.[69] Otto Rank, a preeminent psychoanalyst from the Viennese school, is best known today for his break with Freud's model of psychoanalysis, which is grounded the idea that unconscious repression of the "Oedipus complex" is the source of all neurosis. Rank was the first to use the term "pre-Oedipal" in his writings, and developed a relational, "here-and-now" approach to psychotherapy, art, and creativity that is focused on attachment theory.[70] Orloff first met the Ranks in 1926 when they moved to Paris after Otto left the Viennese Psychoanalytic Society because of differences with Freud and his disciples.[71] During the decade in which they lived in Paris, Orloff regularly hosted them and their young daughter in her home, and developed a very close friendship with Tola. Tola was born Beata Minzer to a middle-class assimilated Jewish family from Kraków, and her first language was Polish. Like Otto, she also came from a family that was not religious, and she did not strongly identify as Jewish.[72]

Orloff's portrait of Otto Rank shows her appreciation for his innovative work in developing new theories of emotional experience and creativity.[73] His facial features and expression celebrate his identity as a visionary psychoanalyst and thinker. The furrowed brow suggests Rank's conviction, and the oversized eyes, protruding from his spectacles, signal the playful side of Orloff's work. His lips form a partial

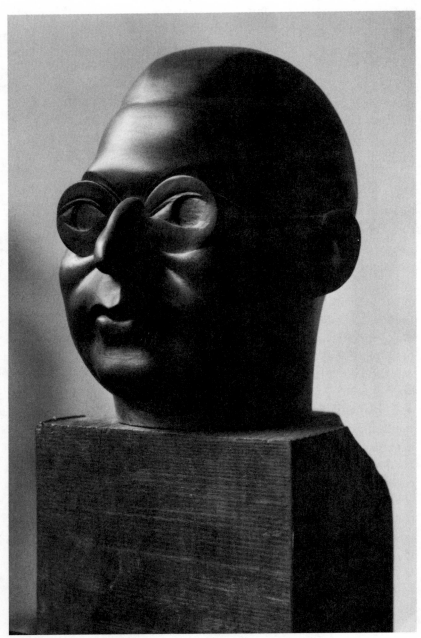

Figure 8.10. *Doctor Otto Rank*, 1927.

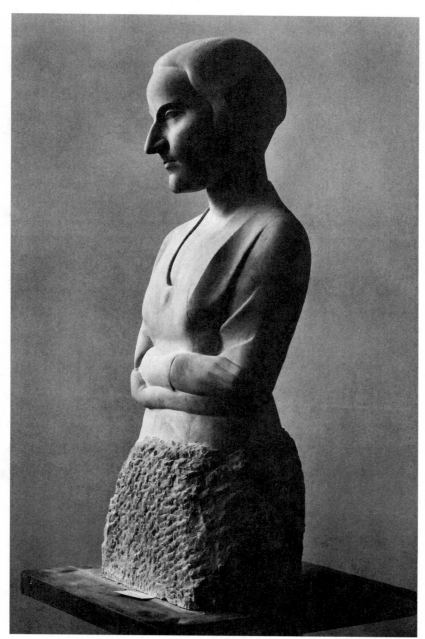

Figure 8.11. *Madame Beata Rank*, 1930. Stone.

smile, with prominent laugh lines stressed by pockets of flesh on ei-
ther side of his face. Although Orloff regularly engaged in the unusual
practice of representing the eyeglasses of her sitters who wore them,
Rank's eyes appear out of proportion to the eyeglass lenses. If he was
farsighted, a strong prescription lens could have made his eyes appear
magnified. By stressing both his sense of vision and capacity to express
humor, Orloff's portrait commemorates Rank's humanity and his abil-
ity to "see" into the human psyche.

Orloff's portrait busts, and the portrait of Rank in particular, are in
dialogue with some ideas expressed in Rank's *Art and Artist* (1932).
Published five years after she completed the bust, this text addresses
some of Rank's most influential theories with which Orloff was no
doubt familiar. In the first chapter, entitled "Creative Urge and Person-
ality Development," Rank takes up the seemingly paradoxical duality
between life and creation. He argues that an artist's creativity is mo-
tivated by a desire to distinguish between the transient experience of
one's actual life and the urge to immortalize life in art. Orloff exhibited
her portrait of Rank in the Salon d'Automne in 1927. By emphasizing
her appreciation of Rank's powers of vision and sense of humor, and
by publicly claiming her relationship to him, Orloff eternalizes her own
connection to the psychoanalyst and his work.

The Jewish art journal *L'Illustration Juive* illustrated Orloff's por-
trait of Rank beside Orloff's portrait of Rubin in 1927. It linked them as
Jewish subjects despite the fact that Rank had disavowed his Judaism
at a young age. Gottlieb also linked the Jewishness of the artist and her
sitters, remarking how she had overcome tremendous obstacles: "In
our day, to be a woman, Jewish, and a sculptor, is to bear a triple bur-
den—and to not succumb to it requires an unusual strength of spirit."[74]

In her sculpted portrait of Tola Rank, Orloff represents her friend in
stone from the waist upward. Her arms are folded against her midriff
in a self-reflexive pose that recalls that of Bialik (see figure 8.4), as well
as her earlier portrait of her friend Pauline Lindelfeld, *Woman with
Arms Crossed (Madonna)* (see plate 3). A well-known child analyst
who later became an important member of the Boston Psychoanalytic
Institute, Tola Rank has been understudied in the history of psycho-
analysis.[75] Well respected by Freud, she published a Polish translation
of his book *On Dreams* in 1923. She studied dream work in six-year-old

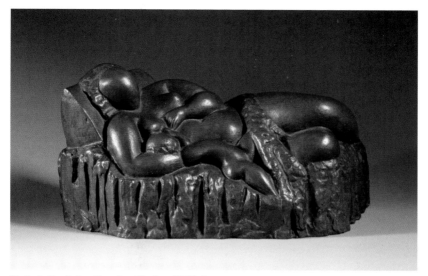

Plate 1. *Reclining Nursing Mother*, 1923. Bronze.

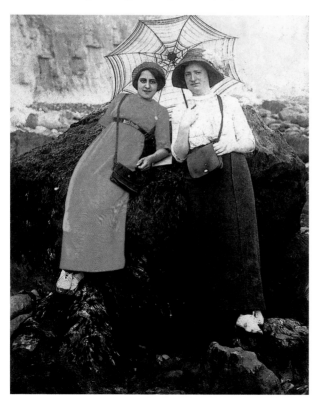

Plate 2.
Orloff (right)
with a friend in
Paris, 1911.

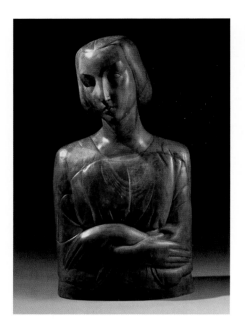

Plate 3.
Woman with Arms Crossed (Madonna),
1913. Bronze.

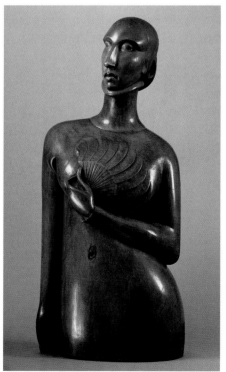

Plate 4.
Woman with a Fan,
1920. Bronze.

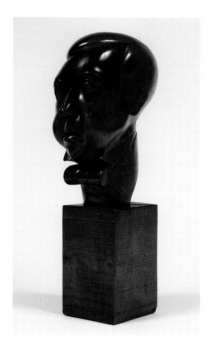

Plate 5. *Portrait of Lucien Vogel*, 1921. Bronze.

Plate 6. *Portrait of Nadine Vogel*, 1921. Wood.

Plate 7. Auguste Perret, Façade, Chana Orloff Studio and Home, 7 bis Villa Seurat, 1926–29.

Plate 8. *Large Crouching Woman*, 1925. Bronze.

Plate 9.
Georges Kars,
Self-Portrait,
1929. Oil on
canvas.

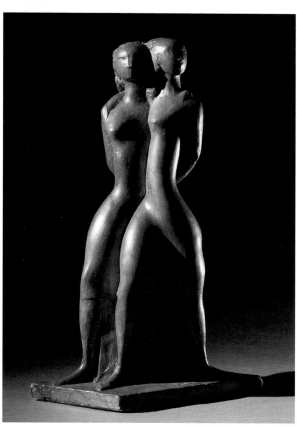

Plate 10.
Ruth and Noemi,
1928. Bronze.

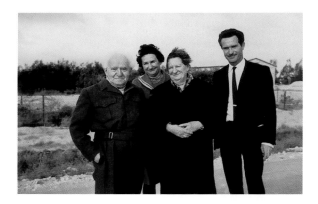

Plate 11. Orloff, Nechama Ofek and Pinhas Ofek with David Ben-Gurion, Sde Boker.

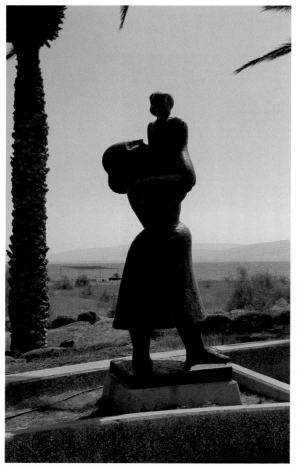

Plate 12. *Mother and Son* monument, 1952. Bronze. Kibbutz Ein Gev, Israel

Plate 13. Dov Gruner monument, 1952. Bronze. Ramat Gan, Israel

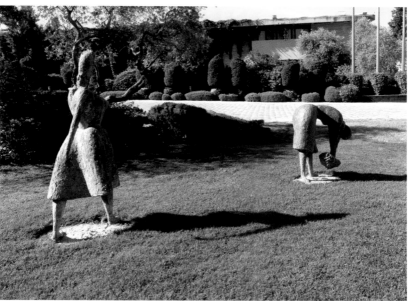

Plate 14. *Sower* (left) and *Gleaner* (right), 1955. Bronze.
Israeli Presidential residence, Beit Hannassi, Jerusalem.

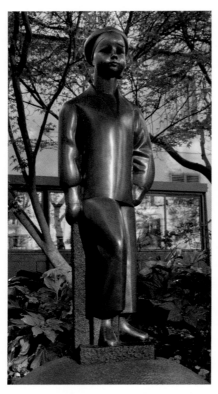

Plate 15. *My Son, Marine*, 1927. Bronze. Place des Droits des Enfants, Paris

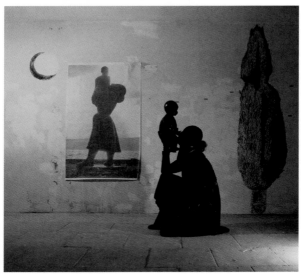

Plate 16. Noa Tavori, Sketch for placement and action in the studio of artist Noa Tavori (ahead of the exhibition *Still Alive after Chana Orloff*), 2017. Tel Aviv. Photograph by Dorit Figovitz Goddard.

schoolchildren. That year, she published a paper titled "The part played by women in the evolution of culture."[76] Orloff's portrait of Tola deliberately does not represent the pupils of Tola's eyes, in direct contrast to the exaggerated eyes and spectacles in Otto Rank's bust. This aesthetic choice, common in many of Orloff's portrait busts, is connected to a tradition of uncarved eyes in ancient Greek and Roman sculpture. This approach to sculpture was thought to remove the figure physically and intellectually from the quotidian world.[77] Orloff's portrait captures Tola in a private moment of retreat or contemplative self-reflection. Her modernity is signaled by her bobbed coiffure and fitted dress, reminding us that Orloff's sculpted bodies should reproduce actual people, and in this case a professional woman who became her lifelong confidante.

Perhaps because of her interest in female subjectivity, Tola purchased one of Orloff's marble sculptures of a mother and child soon after they met, and she owned more than a dozen of Orloff's works during her lifetime.[78] Although she did not see patients in private practice when she lived in Paris, Tola studied women's psychology and conducted research at the Bibliothèque Nationale on this subject, a continuation of her earlier paper on women published with the Viennese school. Through Tola Rank, Orloff was exposed to psychoanalytic theories; she also met and befriended Dr. Helene Deutsch and Dr. Mira Oberholzer, both prominent female psychoanalysts who had emigrated to the United States and commissioned portraits from Orloff.[79]

Orloff's obvious ease and comfort in representing the natural state of the female body, reproduction, motherhood, and childhood must have drawn these early female psychoanalysts to her work. We have seen how she frequently depicted anonymous nude female models embracing their offspring and mothers nursing their young, as well as visibly pregnant nude women. In these works, Orloff reveals her facility in engaging directly with the subject of female embodiment and maternal sexuality. In works such as *Me and My Son* (1927) (see figure 8.12), Élie, age nine, is presented as if he were part of Orloff's ample, seated body. His head rests against her left breast, nearly identical to it in shape and size, with his body leaning tenderly against her side.[80] Both of their heads appear small in proportion to the rest of their bodies, with their simplified, geometric facial features recalling Cycladic

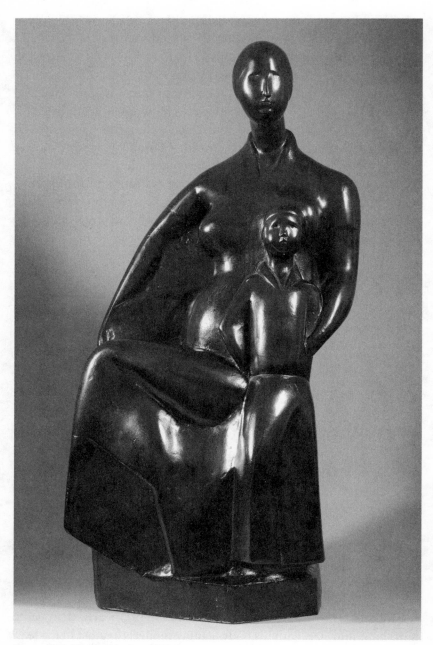

Figure 8.12. *Me and My Son*, 1927. Bronze.

statuary. Orloff's focus here is upon her own ample and curvaceous body, the full breasts, arms, and the rounded angles of her seated lower body fully enveloping her young son.

Orloff's celebration of the female form and embodiment in her work did make certain figures in her psychoanalytic circle uncomfortable. The writer Anaïs Nin, who became Otto's patient in 1933, and later his lover and a lay analyst herself, wrote in her diary about her first visit to meet Orloff at the Villa Seurat: "The studio was filled with statues of women. They were larger than nature and in all the various stages of pregnancy. It was oppressive!"[81] While the accuracy of Nin's writings has been questioned by Rank scholars, a closer look at her account suggests what might have made her feel so uncomfortable:

> Rank introduced me to a sculptress he admires, Chana Orloff.
> ... As he took me to visit her, he told me her story. Chana Orloff was always sculpting pregnant women. She loved to study what happened to women's bodies. Her feeling about motherhood was entirely confined to the image of carrying, holding, extending, and preserving. She made a wish at the time, that if she ever had a child, *he should need her*. She envisioned motherhood as nursing, protecting, serving. She did not say "need her forever." But she may have thought it. When she did have a child, a son, he was born crippled! He lived in a wheelchair. Chana Orloff was shattered with guilt. She felt it was her wish which had caused this. It was to deliver herself of this haunting guilt that she had visited Rank.[82]

There are no doubt inaccuracies in Nin's narrative. For example, we have no evidence or reason to believe that Orloff was Rank's patient. Élie did not live "in a wheelchair"; he typically walked with the help of a cane. It is clear from this passage, however, that the combination of Orloff's son's disability and the many large sculptures of pregnant women and mothers made Nin feel exceedingly uneasy. As a writer who was interested in erotica, Nin had different ideas and experiences from Orloff. Her account of Orloff's alleged guilt over Élie's condition in fact says more about Nin's own personal anxieties about reproduction and motherhood than it does about Orloff and her work.[83]

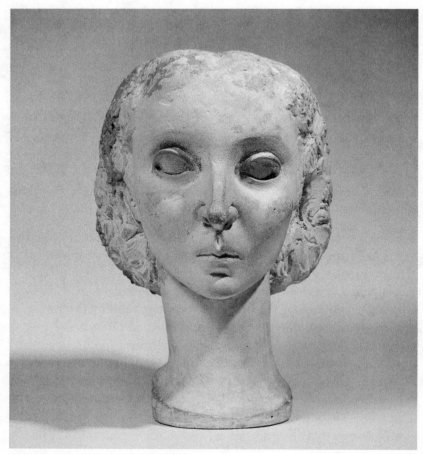

Figure 8.13. *Portrait of Anaïs Nin*, 1934. Plaster.

In this same passage in her diary, Nin also described sitting in Orloff's studio for her sculpted portrait, which was completed in 1934 in both plaster and bronze (see figure 8.13). The portrait emphasizes Nin's heart-shaped face, long neck, and classical features, with a small, pointy nose and chin. Orloff stressed her large, round, and deep-set eyes and prominent lids that suggest a startled expression, as if capturing her discomfort in posing in the studio beside Orloff's sculptures of pregnant women and mothers. In contrast to the smooth surfaces of her earlier work from the 1920s, Orloff represented the texture of Nin's hair as rough. Nin recalled that Rank purchased this portrait from

Orloff and installed it in his library when he moved permanently to New York in 1936.[84] Orloff's portraits of Nin, Otto, and Beata Rank, as well as her sculptures of mothers and children in this period, stand as a testament to her engagement with the early psychoanalytic movement.

By sculpting portraits of her international friends and colleagues in her newly designed home and studio, Orloff engaged in an ongoing process of identity formation that incorporated both her French and cosmopolitan Jewish émigré identities. The architectural environment that she created was deeply connected to her sense of self-creation at this moment in her career. She also crafted her own persona in the media as a hardworking artisan, a modern woman, and a devoted mother, friend, and colleague. Her Villa Seurat studio became a charged space, where her hospitality commingled her creation of a collection of portraits of friends and colleagues with powerful representations of the female body and motherhood. Her studio also served as a site for the curation and exhibition of her work to her community of friends and colleagues. Those who sat for their portraits—many of them emerging or already established artists, scholars, and public figures—also understood the power of this space in shaping their own public identities.

CHAPTER 9

Transatlantic Travel and Networks,

1929–1930

Financially successful and extraordinarily well-connected, Orloff made the momentous decision to travel to the United States for the first time in the late 1920s. Many people in the New York art world were already familiar with her work. She now had a following of affluent American collectors from New York, Boston, Philadelphia, Chicago, and other cities that regularly visited her Parisian studio when they traveled to France.

As she prepared to make her first transatlantic journey, she reached out to friends, colleagues, and clients who could help her succeed in the American art world. Elisabeth Chase, a young American artist who had studied sculpture in Paris, thought there was a market for Orloff's work in the United States; in fact, she claimed that the French-born American sculptor Gaston Lachaise was one of many who appeared to be "imitating" Orloff's original style.[1]

Orloff secured a contract for a solo exhibit at the prestigious Weyhe Gallery in New York for November 11–30, 1929. Known as a "shrine for modern art," it was one of the most important sites for avant-garde exhibitions, particularly focused on prints and drawings.[2] Erhard Weyhe, a publisher and print and book dealer originally from Germany, found the gallery. Carl Zigrosser, also a print dealer, served as director between 1919 and 1940.[3] In Midtown Manhattan at 794 Lexington Avenue, the gallery focused on modern and contemporary European art, and featured artists including Picasso, Matisse, and Diego Rivera.

It also exhibited and sold contemporary American art, including works by Rockwell Kent, Reginald Marsh, and John Sloan. Occasionally the gallery featured modern sculpture—including Picasso's famous cubist-inspired bronze bust of his romantic partner Fernande Olivier—making it an auspicious site for Orloff's first exhibition in the United States.[4]

Before her departure, Orloff invited her closest friends over for a party to celebrate the occasion of her first transatlantic journey. Imagine her, age forty-one, surrounded by the group of them, sitting around her dining table, enjoying lavish delicacies and bottles of wine. The discussion turned to the fact that Orloff did not speak any English. How would she manage in New York? they wondered. In fact, she admitted that she only knew how to say one word: "please." In response, her friends, "elated by the many drinks and hearty meal," played a little game with her, all in good fun. They created a written "questionnaire," as a kind of parody of a French-English dictionary or phrase book:

> To every question that I didn't understand, I answered with the only word I knew, "please," and as they translated it to French, they burst into hysterics. Among those questions were: "The president of the USA asks if you will do his likeness." "Please," was my curt reply. "Do you agree to a million-dollar fee for this sculpture?" "Please," I responded immediately. The "guys" read the "dictionary" out loud and we enjoyed it endlessly. We all felt young, bold, and successful, and the faraway America seemed in our imagination as a country full of money and sculpting opportunities.

This passage from the interviews shows Orloff's self-confidence as she anticipated both opportunities and challenges she might face during her upcoming trip.

After some deliberation, Orloff brought Élie, then age ten, with her to the United States. She believed that she "would be much calmer" if he joined her, rather than leaving him back in Paris to stay with friends. Élie was now thriving as a student at the École Alsacienne, a prestigious Protestant-run private school founded in Paris in 1871, known for its ambitious and modern curriculum. Traveling with a child with physical disabilities added certain challenges to her trip.

Just a few days prior to their scheduled departure date, the infamous

Wall Street stock market crash known as "Black Tuesday" occurred on October 29, 1929. It was the most devastating crash of the stock market in the history of the United States, and it directly followed the fall of the London Stock Exchange. Little did Orloff know that this moment marked the beginning of the Great Depression that affected all Western industrialized nations for the next twelve years. Given the economic crisis, her friends advised her to cancel her trip. She already had spent sizable sums of money in commissioning her foundry, Rudier, to create new bronze casts of her works and had arranged for their transport to New York. The exhibition was confirmed, but she wondered, would the art market come to a halt, with American collectors refraining from purchasing art? Used to taking chances, she was unwilling to pass up this opportunity in spite of the significant financial risks.[5]

Before the financial crisis, Orloff purchased two tickets for her and Élie to travel to New York on the ss *Île de France*, the first major ocean liner built after World War I. It was a large and luxurious ship that was known as one of the first "floating luxury hotels," and a big commercial successes of the French Line shipping company.[6] It also was the first ship ever to be designed entirely in a modern, art deco style. Viewed by many as a post–World War I "symbol of goodwill between France and the United States, sister republics," the ship had taken its maiden voyage two years earlier, in June 1927.[7] It attracted media attention in both Europe and the United States. One American passenger described the ship's interior to a *New York Times* reporter as "so far out of the ordinary" and said that "its general beauty is so colossal that it baffles one."[8] Many noted the splendor of the dining room, which seated six hundred passengers, the largest of any ocean liner, and had "a fountain of round gold and silver pipes, with a centre silver light," and mural paintings by noted French artists covering the walls.[9]

Imagine the thrill that Chana and Élie experienced as they boarded the *Île de France* in the port city of Le Havre that November morning. Elegantly dressed passengers filled the three-deck high main foyer, including "fashionable women holding feather fans and smoking cigarettes" and their well-wishers.[10] Chana and Élie likely traveled in second (cabin) class, a big step up from Chana's earlier days in steerage. She packed lightly, bringing "a couple of nice suits, a coat, and an elegant dress." Orloff carried onboard with her a large portfolio filled

with black-and-white professional photographs of her sculptures. She wanted to seize the opportunities that such a journey provided for identifying prospective patrons.

As sailing time approached, one of the many bellboys dressed in shiny uniforms approached Orloff's cabin to deliver a telegram. A group of her friends, identifying themselves as "Le Club des Amis," sent her a farewell message wishing her a safe passage and "success" in the United States.[11] Over the course of their weeklong journey at sea, Chana and Élie enjoyed the many luxurious amenities offered onboard, including a twenty-nine-foot bar, a model of a Parisian sidewalk café, an elaborate gymnasium, a shooting gallery, a film theater, and even a merry-go-round.

As the ship entered Ambrose Channel in the New York Harbor, the sight of the skyscrapers shocked her at first, with their massive "blocks of stone" recalling "the constructions of Egyptian Antiquity."[12] Initially, she and Élie stayed at the historic Shelton Hotel, located right near the Weyhe Gallery on Lexington Avenue. The hotel was known as one of the first skyscraper residential hotels, designed in 1923 by Arthur Loomis Harmon, an architect who later contributed to the design of the Empire State Building. A thirty-one-story building in Romanesque Revival style, the hotel was unlike any building Orloff had ever seen.[13] She later moved to one of the largest residence hotels in Manhattan, the Ansonia, on the Upper West Side at 2109 Broadway. Orloff later told a journalist from *L'Atlantique* that she was "received like a queen."[14] While she described the pace of life as "intense" and "feverish," with people moving at "top speed," she openly embraced the challenge of adapting to American culture.[15]

ARRIVAL IN NEW YORK: THE WEYHE GALLERY

On November 11, 1929, just a few days after her arrival in New York, Orloff's exhibition opened at the Weyhe Gallery. It featured twenty-five of her sculptures, primarily bronze casts with a variety of different color patinas, and two works carved in wood. The exhibit included several of her best-known portraits, sculptures of male and female nudes, maternities, biblical themes, and various animals.[16] She created a quick sketch for the gallery to use as a promotional image (see figure 9.1).[17]

Figure 9.1. Promotional image, Weyhe Gallery exhibition, New York, 1929.

It features a lone woman in profile, seated upright upon a horse. Presumably a self-portrait, based on the physical likeness, as "Amazon," Orloff took up a familiar theme that had great resonance throughout her career. The letters of her name, arranged vertically in all capitals (with the "N" drawn awkwardly in reverse), are superimposed over the faint pencil outline of a skyscraper on the right. Perhaps she was referring to the Shelton Hotel. Or it might represent the Chrysler Building, an icon of modern American architecture that was just months from completion at the time of her arrival. This self-promotional image

embraces the theme of the modern woman and signals Orloff's readiness to conquer the New York art world.[18]

A two-page brochure accompanied Orloff's exhibition at the Weyhe Gallery. It included a checklist and a short essay by Frank Crowninshield in which he speculated on her meteoric rise to fame over the past decade. He noted the novelty of her cubist-inspired sculptural style when she first began exhibiting in Paris and suggests her work initially was not fully understood.[19] That reaction was short lived, he claimed, and by 1929 the public appreciated her work for its "dignity, significant simplification and an unerringly true adjustment of weight to line, all of them qualities that are only to be found in great sculpture."[20] To those who accused her of engaging in "highly stylized caricatures" he replied, "These provocative people whom Madame Orloff has rendered: they are personages of the very first importance."[21] Given that the Weyhe Gallery was at the forefront of American modernism, this exhibition placed her among its elite roster of artists who engaged with the simplification of form in portraiture without abandoning figuration completely.

The Weyhe Gallery hosted a group exhibition of drawings by well-known American, French, and other international artists, including Matisse and Stuart Davies, to run concurrently with Orloff's sculpture show. Their names helped attract those unfamiliar with her work. Soon after the exhibition closed, Orloff gave Crowninshield two of her drawings as an expression of her gratitude for his support. In response, he sent her a telegram in which he expressed his appreciation, addressing her as "my dear genius benefactress artist and friend."[22]

Many American art critics described the Weyhe Gallery exhibit as Orloff's "first American one-man show." They almost always referred to solo exhibitions using this terminology, regardless of the gender of the artist, showing just how rare it was for female artists to have their own shows at this time.[23] As in France, some reviewers emphasized themes of motherhood and childhood as "natural" in her work based on her sex.[24] An unnamed critic from *Vanity Fair* described the artist as "probably the most important sculptress living today and in the first group of sculptors of either sex."[25]

The reviews of Orloff's exhibition in the American press also engaged with stereotypes of national and racial identity in her work similarly

to their French counterparts. Some tried to make sense of her hybrid national identities, first distinguishing her work from the French tradition of "Bourdelle's archaisms" and "Maillol's classic objectivity," and then asserting: "Curiously, for all her modern viewpoint, her sculpture has its roots deeply planted in Russian tradition. An exotic fantasy and a certain hieratic formalism hark back to the naïveté that no Russian artist entirely loses in his creative expression."[26] Such commentary reproduces the racialized language of French critics in which her "Russianness" is associated with primitivism rather than avant-gardism.

Other critics appreciated the manner in which Orloff integrated both professional and personal attributes of her sitters into her sculpted portraits. Ruth Green Harris of the *New York Times* noted, "What is sweet is corrected by a certain pungency; what is acrid is softened. Balance is not only of the spirit but of the body. No doubt it is this beautifully felt adjustment that gives all her works their sense of composure."[27] In response to *Accordionist*, Harris writes, "Enjoy for a moment only a detail of the figure, the shapely lump of hand corrected by a sensitive turned-back thumb."[28] This work was one of the most widely reproduced of Orloff's sculptures displayed on her first American tour, and the small, playful details such as the figure's active hand gesture did not go unnoticed.[29] The theme of *Accordionist* is important in Orloff's American debut. She was interested in how Americans embraced romantic views of Paris as cosmopolitan, and the accordion was an instrument familiar to many émigré artists from their home countries.[30] The piece also made links between music and the visual arts that she likely hoped would appeal to Americans immersed in jazz culture. New York's art world, however, was affected by the stock market crash, and fewer of Orloff's pieces sold than she had hoped.

CHICAGO

Following her debut in New York, Orloff's exhibition traveled to the Fine Arts Club of Chicago (January 3–17, 1930). The Arts Club was founded in 1916, following the success of the Armory Show, part of which had traveled from New York to Chicago in 1913, with a goal of bringing innovative modern art exhibitions to Chicago.[31] From 1922 through 1927, the club oversaw a gallery inside the Art Institute of Chicago. However, by the time of Orloff's exhibition, it had moved to

the Wrigley Building and took on ambitious international exhibitions. Marcel Duchamp organized a Brancusi exhibition there in 1927, and Modigliani's work was featured just one month before Orloff's.[32] In a letter to an Arts Club organizer, Carl Zigrosser of the Weyhe Gallery wrote to his colleagues in Chicago: "I can assure you that I think it is one of the most important shows of modern sculpture that has been assembled in this country and would create considerable interest in Chicago if it could be arranged to show Chana Orloff's work at the Arts Club."[33]

Orloff already had several American clients in Chicago that facilitated her showing her work there. Rue Winterbotham Carpenter (Mrs. John Alden Carpenter), cofounder and president of the Arts Club and a talented interior designer in her own right, organized all aspects of her exhibit in Chicago. Other local collectors included Mary Mitchell Blair, who commissioned a 1924 sculpture in marble of a mother and child;[34] Flora Schofield, a cubist-inspired painter and collector who was known as the "Dean of women artists in Chicago";[35] and Arthur Taylor Aldis, an influential member of the board of trustees at the Art Institute of Chicago credited for his role in bringing the Armory Show to Chicago.[36] The exhibition checklist remained largely the same, with some of these local collectors lending their works. In addition, Orloff brought with her a newly completed piece, a portrait of George S. Hellman (1929), an American author, editor, rare-book collector, and manuscript and art dealer. The Arts Club produced their own catalog and organized an afternoon tea opening reception for Orloff.

The exhibition received only a brief mention in the press. After it closed, Rue Carpenter donated Orloff's *Woman with a Basket* (1926) to the Art Institute of Chicago for its permanent collection from the Arts Club of Chicago.[37] Unfortunately the organizers reported that none of Orloff's works sold, likely due to the depressed economy. But Orloff did sell several works directly to local collectors in Chicago.[38] As expected, the stock market crash had an enormous adverse impact on the sale of Orloff's work in American art galleries. She did have some financial success while also enjoying the adventure and opportunity to become acquainted with many new patrons who later commissioned works.

Many of Orloff's new patrons were Jewish Americans, and some of them became lifelong friends. Dr. David M. Levy, a colleague of Tola

Rank's and pioneer in child psychiatry who was based in New York, and his wife, Adele Rosenwald Levy, became clients and close friends with whom Orloff corresponded regularly.[39] Reuven Rubin facilitated Orloff's introduction to Mrs. Mildred Otto, also of New York, a young, American collector who had just commissioned him to paint her portrait.[40] Mrs. Otto also introduced Orloff to her father, Mr. Alfred Stone, a wealthy entrepreneur who was an avid art collector with homes in Lake Placid, New York, and Palm Beach, Florida. When Orloff became ill with pleurisy while in Chicago, Mr. Stone invited her and Élie to sojourn for several weeks at his Florida home, prompting them to extend their stay in the United States. They escaped the cold winter weather and he kindly introduced her to more prospective clients. Orloff made sketches and studies in clay for Mr. Stone's portrait, and those of other new American clients and their children.

Adolph Oko, a scholar, philanthropist and librarian at Hebrew Union College in Cincinnati (and associate editor of *Menorah Journal*) invited Orloff to visit him in Cincinnati. He also tried to organize an exhibition for her there, which ultimately fell through. He purchased her bronze portrait bust of Bialik for the Hebrew Union College collection, and encouraged his friends to purchase one of her works.[41] Through her connections to American friends and colleagues, old and new, Orloff's exhibit continued to travel. After Chicago it went to the Worcester Art Museum in Worcester, Massachusetts. Following her stay in Florida, Orloff worked productively on ideas for new sculptures in a small, rented studio space on the Upper West Side of Manhattan.[42]

HELENA RUBINSTEIN:
AN AUSPICIOUS COLLECTOR

One of the most important collectors to promote Orloff's work to the American public was Helena Rubinstein, the Polish-born cosmetics entrepreneur.[43] An avid collector of modern art, Rubinstein purchased at least three sculptures by Orloff in the late 1920s.[44] At least two of these works were on display in Rubinstein's newly opened salons in New York and Chicago in 1928. They were part of an extensive collection of modern sculpture, painting, and African art acquired by Rubinstein over the course of her career. She regularly commissioned works by immigrant artists and designers for display both in her home and salons.

Although there are no records showing the provenance of Orloff's sculptures in Rubinstein's collection, or whether the two women ever met in person, it is possible that Rubinstein purchased Orloff's work from a Parisian art dealer or through a personal connection.[45]

Rubinstein featured Orloff's work, along with that of other artists from her collection, in her American salons to market both herself and her cosmetics to her clients by pairing them with modern art and art deco designs.[46] Her salons in fact served a hybrid function and have been described as "part museum, part fashion house, part department store."[47] In a 1928 article, *Good Furniture* magazine celebrated her Chicago store as "the most extensive example in Chicago of modern art interior decoration adapted to a commercial establishment." The article included several photographs of the interior of Rubinstein's Chicago store that highlight the juxtaposition of art deco furniture, African statuary, and works of modern art, including Orloff's sculptures.[48] The author explained: "One of Madame Rubinstein's chief reasons for planning her three beauty shops in the modern manner is to acquaint her patrons with distinguished examples of modern art. . . . She wishes to influence such women to give the young modernistic artists the encouragement and patronage which they need."[49]

Woman with Turban (Madame X) (1925) (see figure 9.2), one of Orloff's works in Rubinstein's collection, reinforces Orloff's connection to a community of successful Jewish women entrepreneurs in fashion and the arts.[50] It portrays the sculptor and designer Sarah Lipska, a Polish Jewish émigré artist active in Paris.[51] A regular collaborator with Rubinstein, in this portrait Lipska wears a chic turban neatly wrapped upon her head, with two small braids peeking out of one side.[52] With her delicate lips pursed and head tipped backward, her posture and facial expression convey self-confidence and introspection. That Rubinstein displayed this piece and others by Orloff in her home and salons suggest she identified with the artist as an ambitious woman and self-made Jewish émigré with a keen ability to market her work.[53]

Although the hybrid function of Orloff's home and studio differed from the more commercial focus of Rubinstein's beauty salons, both women successfully created spaces that combined art, architecture, and design to market themselves and their work while cultivating interest in their respective visions of modernity.[54] Given her endorsement by

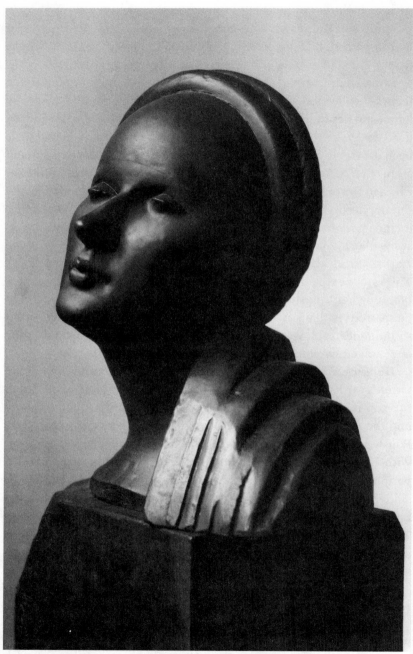

Figure 9.2. *Woman with Turban (Madame X)*, 1925. Bronze.

Rubinstein, along with the regular features in *Vanity Fair* and *Vogue*, Orloff was on her way to becoming a popular cultural icon by the time she arrived in the United States.

MARIA LANI

Orloff's *Portrait of Maria Lani (Shepherdess)* (1928) (see figure 9.3) is another work that raises interesting questions of modern subjectivity and the charged relationship between artist and model that piqued the interest of her American collectors. A group exhibition at the Brummer Gallery in New York featured it, entitled "Portraits of Maria Lani by Fifty-One Painters" (November 1–28, 1929). It ran concurrently with Orloff's solo exhibition at the Weyhe Gallery. The Maria Lani exhibit also traveled from New York to The Arts Club of Chicago, where it directly preceded the opening of Orloff's solo exhibition, before traveling to other cities in the US and Europe.[55]

Orloff met Maria Lani, a self-proclaimed silent-film star, when she arrived in Paris in 1928, allegedly from Berlin, to make a movie. Several prominent fashion designers dressed her, including Lanvin. Lani invited fifty-nine artists—including Orloff, Bonnard, Braque, Chagall, de Chirico, Robert Delaunay, Derain, van Dongen, Léger, Matisse, Man Ray, Ozenfant, Picabia, Rouault, Soutine, Valadon—to create her portrait. The only two artists to turn her down were reportedly Picasso and Marie Laurencin.[56] *Vanity Fair* ran a full-page story on the project of one model sitting for fifty-nine artists in a short time period while Orloff was in New York.[57] A decade and a half later, Thomas Mann coauthored a screenplay about Lani; Jean Renoir agreed to direct it, and Greta Garbo was to play the leading role. But Lani had disappeared. They did not produce the film. After she died in obscurity in 1954, a new story circulated. Lani was, in fact, a fraud. She was not an actress, but a stenographer from Prague, who took the portraits—which she did not own—to America and sold them for her own financial gain.[58]

Recent scholarship has challenged this story as an unsubstantiated rumor, positioning Lani less as an impostor than "as an impresario who inverted the traditionally passive role of the model."[59] We might think of figures like Kiki de Montparnasse, the quintessential muse of the Parisian art world who personified this type of self-promotional strategy. Many contemporary critics, however, saw the exhibit as less

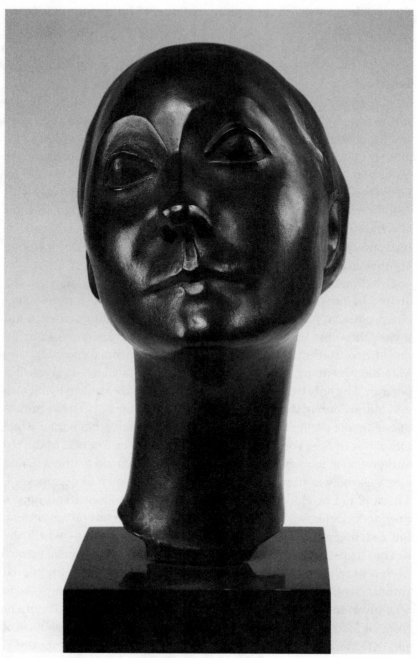

Figure 9.3. *Portrait of Maria Lani (Shepherdess)*, 1928. Bronze.

about Lani than as an opportunity for each artist to promote their own unique artistic agenda and personality. Some criticized the artists for failing to agree on Lani's actual physical appearance.[60] Several artists who took part in the exhibition offered several renditions of Lani, as if to stress her "virtuoso mutability," with Picabia even superimposing several faces into a single portrait.[61]

Although Orloff never commented publicly on her participation in the Maria Lani exhibition project, she produced several bronze casts from the same mold of the work and sold them to multiple American collectors, including Tola Rank and Elise Stern Haas, a prominent philanthropist from San Francisco, both of whom purchased their busts in 1929.[62] In her portrait of Lani, the figure's head tips backward, causing the pointy chin to jut forward prominently. Although we can interpret this posture as conveying self-importance and even haughtiness, other aspects of Orloff's portrait suggest contradictory qualities. For example, she tips the head slightly to one side. This evokes thoughtfulness and reflection. The delicately pursed lips, deep nostrils, and prominent philtrum add qualities of softness and vulnerability to the portrait, whereas the wide arches of the eyebrows, reminiscent of Orloff's earlier sculpted portrait busts, convey curiosity. Orloff may have related strongly to her subject of Maria Lani, as she, too, had many sides of her persona that she wished to convey to her public at different times, depending upon the context. That she circulated multiple editions of this bronze bust while on tour in the United States suggests she believed it was an evocative work that could play an important role in shaping her critical reputation.

COURTING A JEWISH AMERICAN AUDIENCE

Orloff's work gained recognition in the United States also through the promotion of her work in *Menorah Journal*, the leading English-language Jewish intellectual and literary magazine of the period. Founded and edited by Henry Hurwitz in 1915 as the print organ of the intercollegiate Menorah Society, the magazine enjoyed its peak in popularity in the 1920s and remained continuously in print until 1962. It aimed to foster a "Jewish Renaissance" by publishing essays, poetry, fiction, and political commentary.[63] The journal also promoted Jewish visual culture as part of its mission in shaping American Jewish

identity.[64] Artists and cultural critics regularly contributed articles aimed to promote both humanistic values within Judaism and secular Jewish culture to English-language readers.

Orloff was among a variety of contemporary Jewish artists whose works *Menorah Journal* reproduced regularly. Her friend, the writer Marvin Marx Lowenthal, invited her to contribute to the magazine. He was an American Zionist author who was an editor and regular contributor.[65] Lowenthal wanted to promote Orloff's work to a Jewish American audience and commissioned her to create his sculpted portrait while she was in the United States in 1929–30.[66] He also connected her with the journal founder, Henry Hurwitz, who greeted her warmly when she arrived in New York. Hurwitz, in turn, facilitated her introduction to a wide circle of "writers and artists, professors and students from various parts of the country" assembled for the National Menorah Convention held in New York on December 29, 1929.[67]

Orloff's work was featured in *Menorah Journal* five times over the course of its print run. It was first reproduced a few years before her visit, in June and July 1926, to supplement a two-page article by the French art critic André Salmon. An eight-page insert accompanied the article, with reproductions of a selection of Orloff's recent sculptures, printed on glossy paper in the magazine's interior.[68] Although it did not feature illustrated covers until 1937, *Menorah Journal* frequently reproduced the work of contemporary Jewish artists in such inserts of eight to ten pages, as well as in frontispieces that usually featured the work of a living artist, as well as occasional historical images. This was a strategy that enabled the editors to introduce its Jewish readership to the work of a wide variety of contemporary Jewish visual artists, while representing "an unbroken continuum of Jewish culture in which the reader could position himself."[69] Even though Salmon did not directly call out or discuss Orloff's Jewish identity in his 1926 text, he praised her work for its "humanity and noble spiritual ardor," a comment that evokes religious connotations.[70] He also expressed his appreciation of how her sculptures are "liberated from academicism, solicitous primarily about living art, yet not falling into the error of rejecting entirely the treasury of the past."[71]

The frontispiece for this month of the journal was a reproduction of the painter Emmanuel Mané-Katz's *Portrait of a Writer* (*Ilya*

Ehrenburg). By juxtaposing Orloff's work and feature article with Mané-Katz's image of the popular Russian Jewish writer, the editors of *Menorah Journal* situated her within a wider circle of Jewish émigré artists and writers that engage with representations of the Jewish past and present.[72] Given the increasingly hostile critical debates taking place in the French art press at this very moment on the question of "Jewish art," *Menorah Journal* was invested in creating a positive alternative narrative by establishing "an important link between Jewish artists and their Jewish audience."[73]

Menorah Journal reproduced Orloff's work a second time in 1926, when her *Portrait of Reuven Rubin* appeared as the frontispiece of the magazine. Here, they paired Orloff's portrait bust with an autobiographical article written by Rubin himself. Entitled "I Find Myself," Rubin describes his upbringing as a young aspiring artist in a Jewish shtetl in Romania. He then offers a classic Zionist narrative of his "discovery" of Palestine as an idealized site of both spiritual and artistic inspiration: "As the desert revives and blooms under the hands of the pioneer, so do I feel awakening in me all my latent energies."[74] The essay encouraged readers of the magazine to associate Rubin and his new Eretz Israel style of painting with the popular Zionist metaphor of the "desert blooming." The magazine had a history of situating Orloff in Paris as a center of Jewish diaspora culture. By drawing a connection between these two artists, the editors created a dialogue about contemporary Jewish art around the world that resonated with diverse Jewish American audiences.

Menorah Journal featured Orloff's work a third time two years later, when her *Portrait of Peretz Hirschbein* was the frontispiece in March 1928. Here, the journal linked Jewish art and popular literature in promoting Orloff's bust of this Yiddish playwright, novelist, journalist, travel writer, and theater director who had a strong following among Jewish Americans.[75] In January 1930 the editors of the magazine seized upon the occasion of Orloff's visit to the US to illustrate her work a fourth time; they featured a reproduction of her bronze sculpture *Mother and Child* (1925). In the "Notes on Contributors" section of the journal, the editors took credit for introducing Orloff's work to the Jewish American public: "Chana Orloff is among the best of France's contemporary sculptors. *Menorah Journal* was instrumental

in introducing her work to the American public, first publishing an insert of her sculpture in its June–July 1926 issue."[76]

Menorah Journal reproduced Orloff's work a fifth time years later, after World War II, when Orloff returned to the United States in 1947 to exhibit her work in San Francisco at the de Young Museum, among other venues. The editors reproduced her sculptural image of the biblical figure Rachel on the cover of the magazine, accompanied by another eight-page insert featuring her glossy images of her work. The selection of works reproduced included many sculptures of the artist's Jewish American clients, such as the musician Louise Maas Mendelsohn of San Francisco, or specifically works containing Jewish and Old Testament themes. Orloff's work thus was a vital part of the magazine's postwar project that encouraged readers to feel "part of a vital, creative visual culture" of Jewish art following the devastation of war.[77]

LESSONS FROM AMERICA

Although Orloff originally planned to stay in the United States for eight weeks, she extended the trip to last six months. Upon her return to Paris in April 1930, she described to the press how fascinated she was by the depth of knowledge and curiosity about French art among American collectors and museums.[78] When asked by an interviewer which works struck her the most, she replied: "Hold on, in New York, a private collection, the Havemeyer Collection, was donated to the Metropolitan Museum. There are works by Manet in this collection, totally unknown here, and of such beauty."[79] Similarly, in Chicago she described being "surprised and overjoyed to discover there the most magnificent canvases of Seurat, including *La Grande Jatte*." She visited some of the most important private collections of modern French art in the country, including in the Chester Dale and Lewisohn collections in New York, and the Barnes in Philadelphia. Financier Sam A. Lewisohn and his wife, educator Margaret Seligman Lewisohn, became supportive collectors of her work. Orloff reveled in the "artistic intuition and unimaginable sureness of taste" demonstrated by the American museum curators and private collectors who brought so many important Parisian artists to the US, including her forerunners, Degas, Gauguin, Renoir, Cezanne, Van Gogh, Courbet, Corot, and contemporaries, Modigliani, Matisse, Derain, de Segonzac, Pascin, and more.[80]

The American art world would shift radically after her departure and would move its focus from Paris to New York.

While she was in New York, Orloff met many new clients and art world professionals. Among her new American acquaintances was the powerful New York couple Eugene and Agnes E. Meyer, whom she visited at their castle-like estate near Mount Kisco, New York. Agnes was a journalist, philanthropist, civil rights activist, and arts patron with whom Orloff had many Parisian art world friends in common. She helped facilitate Orloff's introductions to other American art collectors. Eugene Meyer was then president of the Federal Reserve (1930–33) and was dealing with the financial crisis when Orloff met them.[81] In Orloff's portrait of the financier, exhibited at the 1931 Salon des Tuileries in Paris, she portrayed him in a classic power pose, with his arms folded behind his back, emphasizing the sleek lines of his elegantly fitted suit.[82]

Critical interest in Orloff's work grew over the duration of her time in the United States. Before leaving New York she began a professional relationship with Marie Sterner, the founder and director of Marie Sterner Gallery, at 210 East 57th Street (and later 9 East 57th Street), which operated from 1920 to 1950. Sterner was a successful art dealer who began her career at Knoedler & Company in 1912, before starting her own gallery. She represented many important sculptors in this period, including Elie Nadelman, Sandy Calder, and Isamu Noguchi, and took a strong interest in Orloff's work. Correspondence between Sterner and Orloff from 1930 suggests there was significant interest in her work on display in the gallery, but the depressed economy impacted sales.[83]

Sterner organized an important exhibition of Orloff's and Noguchi's sculptures together (along with a selection of Noguchi's drawings) for the Albright Gallery in Buffalo, that opened after Orloff's return to France, in late 1930 (December 24, 1930–January 25, 1931).[84] The exhibit then traveled to the Memorial Art Gallery of Rochester (1931) and the Art Gallery of Toronto (1931).[85] By pairing her with Noguchi, another transnational sculptor whose work asked questions about identity and place, Sterner played an important role in promoting Orloff's cosmopolitan reputation in North America. Noguchi also spent time in Paris where he worked with Brancusi, and Orloff may have met

him there. Curated by the Albright's director, William Hekking, the exhibition brochure emphasized the "outsider" and émigré status of both artists as part of their appeal: "two talented young sculptors, Chana Orloff, a Russian, and Isamu Noguchi, a Japanese American. Both of these artists possess a vitality and an original point of view which has made their work outstanding almost from their first introduction to the public."[86] Hekking's language suggests his belief that both national and racial identities are apparent in their work. For example, he describes Orloff's work as being "firmly rooted in the Russian tradition" despite her modernity. Of particular note, Hekking commends Orloff for her "rare ability to depict both the personal and racial characteristics in her subjects." He goes on to describe her as "perhaps the most outstanding woman sculptor and ranks high among all living sculptors." As for Noguchi, Hekking writes, "In his sculpture, the subjects are Occidental in their exterior form, but Asiatic in their feeling." Recent scholarship shows how Noguchi's critical reputation was shaped by these types of racialized readings that linked whiteness to Americanness, and positioned artists like Noguchi and Orloff as "other."[87]

Orloff's traveling joint exhibition with Noguchi shows how her work was implicated in a larger movement to define ideas about race and national identity in early to mid-twentieth-century American culture. The American public was fascinated with both her works and her artistic persona. Although the Depression impacted her sales, Orloff leveraged her strong interpersonal skills to cultivate new relationships with collectors, curators, and gallerists. Ultimately, her first trip to America propelled her career and led to invitations for a second American tour in 1938.

From Paris to Tel Aviv

The Jewish Art World in the Pre-State, 1930s

When Orloff and Élie returned to Paris from New York in April 1930, the effects of the Great Depression had not yet hit the French economy. Although the crash had affected her gallery sales abroad, she received new commissions for sculpted portraits from American clients for at least fifteen sculptures. Soon after her return, Orloff purchased a Fiat 524, a small automobile popular in France. Cars were just becoming a popular commodity. As news of her purchase spread, Orloff's friends, especially those visiting from Palestine (where there were far fewer vehicles than in France), were eager for her to drive them around the bustling Parisian boulevards. Nachum Gutman, the notable Israeli painter and longtime friend from their early days in the Yishuv, included a whimsical drawing of Orloff in the driver's seat of the small car in the body of a handwritten letter to his father in 1931 (see figure 10.1).[1] He was living in Paris at the time with his new wife, Dora.[2]

In the drawing, Orloff is dressed in a fur cloak, her hair pulled back in a bun emphasizing her strong profile. Bialik, who often collaborated with Gutman on publications, is seated beside Orloff in the front passenger seat. He gesticulates with his hands toward Gutman and Dora in the back seat. Although Gutman omits Orloff in the text of this letter to his father, the drawing stands as a testament to her prominence in his life in France. It also shows that she was an important link between the Parisian art world of the 1930s and that of Jewish artists and writers from the Yishuv.

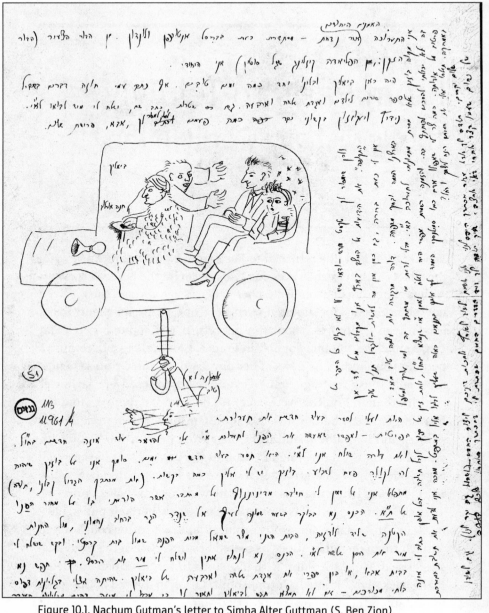

Figure 10.1. Nachum Gutman's letter to Simha Alter Guttman (S. Ben Zion),
February 5, 1931.

During the decade of the 1930s, Orloff came to full maturity as a sculptor in the Parisian and international art worlds, as well as in the emerging arts scene in Palestine. She continued with her perpetual migrations and did not fit neatly into one distinct art scene. Now an iconic figure in the Yishuv, she was part of a group that yearned to develop new Zionist traditions in the arts and also a sense of unified Jewish culture.

Orloff navigated her personal and professional life with great resolve during this decade in which antisemitic sentiments intensified. Hitler took control of the German government on January 30, 1933. Shortly afterward he ordered the Bauhaus art school in Germany to close its doors. The school prohibited many of its most prominent artists associated with the avant-garde from teaching or exhibiting their work in Germany, many of them not Jewish, including Wassily Kandinsky, László Moholy-Nagy, and Paul Klee. Orloff could no longer exhibit her work in Germany. By the mid-1930s the antisemitic press proliferated as a result of the "economic depression, mass migration, the emergence of the Popular Front, and the threat of war."[3] This fueled right-wing political groups like Action Française to target Jews and immigrants.[4] After two decades of proudly emphasizing her difference in the French public sphere, Orloff had to navigate her diverse identities and affiliations.

BUILDING A NEW HOUSE

Immediately following her return from America in 1930, Orloff immersed herself in the project of constructing a new house on the second plot of land she had purchased at 7 Villa Seurat.[5] Although this may seem like a rash decision in hindsight, she had the idea to build the second house before the 1929 crash while visiting Palestine in the summer of 1928. Reuven Rubin invited her to see a new house built by a young Palestinian architect, Zeev Rechter, for his client, their mutual friend, the poet Esther Raab. We know Rechter today as one of the founding fathers of Israeli architecture.[6] Orloff knew Raab from the early days when they both lived in Petah Tikvah. Raab's new house was on Hagalil Street (now Mapu Street), set amid the sand dunes leading to the beach in Tel Aviv.[7] Rechter's design engaged with the new international style of architecture, with clean, straight lines and absence of

arches and ornament. However, unlike the colorless Bauhaus-inspired houses that earned Tel Aviv the name of "the White City" in the 1930s, the walls of the house that Rechter designed for Raab were painted a warm pink color.[8] Known as "the Red Villa" on the dunes, Raab's house soon became the site of Tel Aviv's first literary salon. Whenever she visited Palestine from this point onward, Orloff enjoyed visiting the salon and engaging in dialogue with a host of international Jewish artists and writers.

Orloff was so taken by the modern design of Raab's new house that she asked to meet the architect. The twenty-nine-year-old Rechter was just beginning his architectural career in Palestine.[9] He escaped Ukraine in 1919 at twenty, just before completing his professional training. Upon their first meeting, Orloff explained that she owned two lots on a small street in Paris, and recently commissioned Auguste Perret to design her combined house and studio on one of them. She bluntly asked Rechter, "Will you come and build me a house on the second lot?"[10] Initially Rechter did not take her invitation seriously. Why would this successful international sculptor who had commissioned one of France's best-known contemporary architects want to bring an unknown architect just starting out his career in Palestine to design an adjacent structure in Paris, still considered an art capital at the time? He realized this was a serious request when a few months later Orloff wrote to formally offer Rechter the commission. She proposed he begin the work of designing her new house as soon as she returned from America.

It was unusual at the time for anyone on the periphery, let alone a Jewish architect from Palestine, to be commissioned to work in Paris, but Orloff had logical reasons for selecting Rechter for this project. Throughout her professional life, she showed a strong interest in supporting the development of Jewish émigré culture in Palestine and abroad. Many saw her as a "bridge" between Paris and Tel Aviv. One advantage was that it was much less expensive for her to bring Rechter to Paris and hire him for the job than to reengage Perret. Perhaps she also realized that, once completed, her two adjacent homes, with their complementary styles of architecture, would reflect her own hybrid allegiances to both France and Jewish Palestine. And through these two buildings, she was laying down more roots in Paris, while reaffirming

her connection to the new society of Zionist Jews. They were beginning a new art scene in Tel Aviv, and she identified with their pioneering Jewish spirit.

Rechter had a hard time deciding whether to accept Orloff's commission. It meant that he would have to move to Paris and leave his family behind in Palestine.[11] He and his wife, Paula Rechter, had two young children at the time. The family lived with his wife's parents in a tiny apartment on the border of Jaffa and Tel Aviv. Rechter was unemployed, and they lived on Paula's salary as a kindergarten teacher. Paula's sister had tuberculosis and the family managed her care. While Rechter was reluctant to leave, Paula encouraged him to accept Orloff's offer and go to Paris because of the opportunities it would bring. Besides income and professional recognition, the move would allow him to complete his professional degree in architecture and engineering at a reputable French school. There were no schools of architecture in Mandatory Palestine. He tried to complete his studies in Rome in 1926 at Scuola di Ingenieria but had to return to Tel Aviv when he ran out of funding. Once he accepted Orloff's commission, she paid for Rechter's travel to Paris and assisted him in finding suitable living arrangements.

Rechter's arrival in the summer of 1930 coincided roughly with Orloff and Élie's return from the United States. He rented a room in a shared apartment occupied by the Gutmans. He enrolled in classes toward a degree in architecture and engineering at the École Nationale des Ponts et Chausées. There he met Le Corbusier and was fully trained in the new international style of architecture. As he engaged in designing Orloff's house, Rechter also met Auguste Perret. Perret served as a professor at the school and was one of Le Corbusier's teachers. It was an important opportunity for Rechter to study with the architect who designed Orloff's first home in the adjacent lot, given his charge to design the new house.[12]

Paris offered Rechter many new opportunities, but he missed his family. After about six months, Paula and the children came to live with him in France. Orloff did what she could to help situate his family. Paula found a job teaching Hebrew to French students at a private Jewish school funded by the Rothschild family.[13] She did not speak French, and according to their youngest daughter, Tuti Sara Rechter, Orloff's "charismatic presence in their lives" apparently made her mother

uncomfortable.[14] While the two women eventually worked out their differences, relations between Orloff and Paula Rechter were described as "complex and emotionally charged."[15] Perhaps Paula was jealous of the close friendship and professional rapport that had developed between her husband and Orloff. Rechter's family lived with him in Paris for two years until he completed the design and construction of Orloff's house in 1932. During this time, Paula became pregnant with Tuti, their third child. The couple decided they preferred for Paula to give birth in Palestine, near her family. She returned to her parents' home with the two children three months before her husband. Rechter completed the house in early 1932 and stayed on several months longer to complete his architectural degree in the spring of 1932.[16]

After abandoning his first two proposals for various reasons, Rechter's ultimate design for the new house included three independent apartments on three separate floors, with a large studio space on the ground floor connecting to the Perret house and a garage.[17] The juxtaposition of the Perret and Rechter houses (see figure 10.2) shows Orloff's public persona as a modern Parisian artist who identified with both French- and international-style traditions. Whereas the facade of the Perret house emphasizes pattern and delicacy, that of the Rechter house appears solid, sculptural, and devoid of decoration. Its weight and mass suggest a building designed to protect those inside of it. In contrast, the Perret house, with its thin veil between indoors and outdoors, offers a more open and inviting space. The recessed windows on the first floor of the Rechter house, with their solid, asymmetrical surrounds, offer a modernist innovation that contrasts with Perret's smaller recessed windows at the same level. Just to the left of the front door of the Rechter house, the wall curves slightly, a detail that resonates with the more pronounced curvatures featured in the other houses on Villa Seurat. Most of them were designed by French architect and designer André Lurçat. Rechter would develop these concepts further in his future work developing Bauhaus-style homes and public buildings in Tel Aviv.[18] The Rechter home reinforced Orloff's personal and professional ties to Jewish Palestine, as well as her move between cultures.

After he completed both the house and his studies, Rechter returned to Palestine. He and Orloff continued to consult each other on a variety

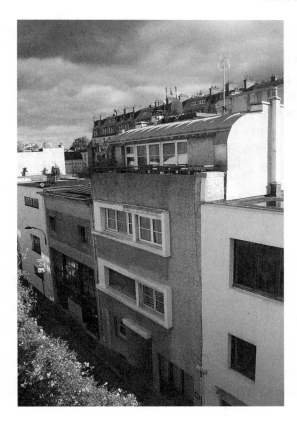

Figure 10.2.
Facades of Orloff's two homes, 7 and 7bis Villa Seurat, Paris. Auguste Perret (*left*) and Zeev Rechter (*right*).

of professional projects throughout the duration of their lives, and their families maintained close relations. That Orloff hired Rechter so early in his career is significant. She gave him one of his first commissions, in Paris no less. She had the foresight to recognize his talent, and sought to strengthen her own connection with her artist friends and colleagues in Tel Aviv and support the future cultural leaders of the Jewish state.

A NEW MUSEUM OF JEWISH ART

In an article published in *Ketuvim* (October 24, 1929), a weekly Hebrew art and literary journal published in Tel Aviv (1926–33), Orloff articulated her ideas on French, Jewish, and Zionist artistic traditions in the arts.[19] She likely had some help in writing this piece, since she was not a prolific writer and rarely wrote in Hebrew. It appeared following an exhibition entitled "The Palestine Painters Group," held at a gallery

on Allenby Street in Tel Aviv, that included a few of her sculptures, along with paintings by Gutman, Reuven Rubin, Sionah Tagger, among others. She opens the article by explaining French modern painting to the Hebrew audience, describing its complexity and diversity. Orloff notes how many Jewish artists living in France, like Chagall, "are perceived as Russian," but that such a national identity is misleading: "Chagall is not a Russian artist. He has the amiability and kindness of Jewish domesticity, the humor, cleverness and creativity of a Jewish street. . . . He is Jewish to the core even when he does not focus on national subjects."[20] She laments how critics often pigeonhole artists based on their country of national origin.

Orloff continues in this piece to describe her own sculptural practice similarly, as implicitly "Jewish" and outside of a single fixed national identity:

I do not intend to sculpt Jews and do not deliberately choose national subjects. I do not believe in creating national art on purpose. We express art and nationality in a subtle and implicit manner, shimmering through every drawing, every dot. The [Jewish] perception, temper, way of seeing and doing are all hidden in the human soul, and expressed in art, even when I sculpt a fish, dog, portrait, girl, or dancers.[21]

She grapples publicly with her own artistic identity as a cosmopolitan Jew and a Zionist, living in France and exhibiting her work in Palestine. Given how rarely she wrote, we note her concern about being typecast based on national identity, even though she believed her Jewish experience permeated all aspects of her art.

In the last paragraph of the article, Orloff expresses her ideas about the challenges of building a Zionist artistic tradition in Palestine: "I cannot introduce Zionist artists to Eretz Israel artists. I hardly know them." She notes that both Gutman's and Rubin's paintings offered an "impressive start" and the "first signs of live contact with the homeland."[22] According to Orloff, their works combined local motifs and modern style in an absence of any history of local artistic tradition.[23] She does not mention their relationship to the Bezalel artists, based in Jerusalem, who revived ancient Hebraic symbols and then synthesized them with local motifs and with elements from the style of art nouveau.

Orloff describes Gutman and Rubin as representative of a new school of modern artists of Tel Aviv that rejected association with past traditions. She stresses foremost the important influence from modern European art, and specifically the tradition of French landscape painting: "We do not have a grand tradition of the past, and art is like a pleasant flower that can blossom only through the light of affection."[24] Without a local history of art, she argues, painters needed to have direct contact with Europe, "the homeland of painting, to dive into the colors of Paris."[25]

Orloff's commentary in *Ketuvim* shows the tension that existed in the early art world in the Yishuv between the desire to turn to Europe for artistic inspiration and to generate a new national style. Art historian Dalia Manor, drawing from the work of Romy Golan, has demonstrated how painters like Rubin and Gutman appropriated a conservative modernist landscape art from Paris in the 1920s, that was associated with French nationalism following World War I, to signify Jewish nationalism.[26] Orloff's article shows that in 1929 she was already aware of these tensions between European/French and Jewish, Israeli, and Zionist identities and cultural influences in the emerging field of art in the Yishuv. She also wanted to help build up the art scene in Tel Aviv from her position as a French and Parisian artist. Once again, she wants to be "both" or "between" Paris and Tel Aviv, as she identifies strongly with both lands and cultures. She also sees herself in a unique position of being a conduit between them.

Besides writing about early formation of Zionist art, Orloff played an important role as an adviser in the formation of the Tel Aviv Museum of Art. She viewed the establishment of the museum to support the larger goal of building a history of Jewish art in Palestine. The museum first opened to the public in 1932 in the private home of mayor Meir Dizengoff. The home was converted into a museum by the architect Dov Hershkowitz, who added two rooms on the second floor, along with an international-style facade. There has been much speculation on the question of who first came up with the original idea of converting Dizengoff's home in Tel Aviv into a museum of Jewish art, given the number of prominent stakeholders in this conversation.[27] Dizengoff acknowledged in his personal journal the need to build institutions of culture in the new city following the construction of a "movie-picture theater," "a hospital, a synagogue, a slaughterhouse, bathhouses, and

so forth"; "we felt the need to foster beauty."[28] Orloff had sound ideas about the need for such a museum and center for cultural life in Tel Aviv, and yet her name is rarely associated with the founding of the museum.

Orloff first discussed the proposition of building a new museum of Jewish art with Dizengoff and his wife, Zina, in her Parisian studio in 1928.[29] Zina, a powerful advocate of the arts in the early days of Tel Aviv, recently had been diagnosed with cancer. The couple traveled to Paris seeking treatment, which included an operation to remove a tumor. During this period, Orloff spent time with the Dizengoffs and suggested the idea of building the new museum in their private home. Gabriel Talphir, the prominent Israeli art critic and editor (also a poet, publisher, and translator), described Orloff as a pivotal figure in influencing the Dizengoffs to consider transforming their own home into a museum: "Many guests from Eretz Israel came to visit her [Orloff], among them Mrs. Zina Dizengoff. 'What should I do with my home' she asked, 'museum!' Orloff answered shortly. Orloff also stood by the side of Meir Dizengoff in his efforts to form the Tel Aviv Museum."[30]

Initially, some stakeholders, such as Reuven Rubin, were not supportive of the idea—if it originated with Orloff—of locating the museum within the Dizengoff home. Rubin recalled: "I told him that he could not sleep and eat in a museum. Dizengoff replied he would relinquish his apartment on the second floor (the first floor was occupied by a bank) and move to a room on the roof, and so he did."[31] Dizengoff was persistent in moving ahead with plans for building the museum in his private residence, perhaps expedited by his wife's illness and his desire for her to see the project come to fruition. After years of struggling with her health, Zina Dizengoff died in February 1930, two years before they fully realized the museum project.

Four months after his wife's death, Orloff received Meir Dizengoff in her Villa Seurat studio with the goal of continuing their discussions of next steps in planning for the new museum to open inside his home. Presumably they discussed curatorial strategies, considered which artists to include, and articulated a vision for the new national museum. Following this visit, Dizengoff wrote a letter to Orloff in Hebrew from the ship on his way back to Palestine that attests to her active role in the project.[32] Addressing her familiarly and with fondness, as "Chanale," he

asked her if she could help him persuade Marc Chagall, who was then also living in Paris, to come to Palestine in order to assist him with planning the museum.[33] The letter outlines terms that Dizengoff discussed with Orloff. He was ready to offer Chagall access to two rooms in his house, including utilities, "for one or two months and free," as well as travel and daily expenses while he traveled to Haifa, Jerusalem, and Tiberias, as long as he agreed to return to Palestine to teach. Dizengoff urged Orloff to assist him in laying the groundwork before sending Chagall "a formal invitation in the name of the museum board."[34] Given the gendered hierarchies of pre-state Israel and its early art world, it is not surprising that Dizengoff wished to extend this honorable invitation to Chagall rather than to Orloff herself. Their correspondence shows how the mayor respected her and recognized her influence on Chagall as necessary to the success of the museum project.[35]

Even though Dizengoff selected Chagall as his primary public adviser, Orloff maintained significant influence in the museum project. Since she was on familiar terms with both men and had ideas of her own about a home for cultural life in Jewish Palestine, Orloff used her sway to encourage Chagall to accept Dizengoff's invitation. She helped the mayor negotiate the terms of their agreement, since she knew what Chagall would deem acceptable. Chagall in fact already was considering traveling to Palestine to execute a commission by his Parisian publisher, the gallerist Ambroise Vollard, on a new series on the Old Testament. In an interview in Jerusalem, Chagall strategically put himself at the center of the discourse of building the new museum: "As Herzel came to Baron Rothschild, asking for help to build the Land [of Israel]—so Mr. Dizengoff came to me in Paris, asking for help in building a museum."[36] Chagall was not modest. His commentary reveals his strong ego, in comparison with Orloff, who acted as a go-between.

Chagall eventually accepted Dizengoff's invitation, and in spring of 1931 he traveled to Palestine from Paris with his wife, Bella, and their fifteen-year-old daughter, Ida.[37] Orloff's close friends—the French Zionist writer Edmond Fleg and his wife, Madeleine Fleg, and Bialik, whom Chagall had met in Berlin in 1922—were passengers on the same ship that departed from Marseilles. During the journey they discussed ideas for a new museum of Jewish art. Chagall had been interested for many years in establishing such a museum in Vilna.[38] Once he arrived,

the mayor went to great lengths to welcome Chagall and his family to the Yishuv, including greeting them at the head of a fire brigade as they arrived at the Tel Aviv railroad station. Dizengoff even organized horse races on the seashore, as well as an exhibition of Palestinian artists to honor Chagall. He treated Chagall as a great artist, which is not how he treated "Chanale."

Orloff remained integrally involved in the museum project. Dizengoff invited her, along with Edmond Fleg, to join an "artistic committee," chaired by Chagall. Dizengoff charged the committee with advising him on plans for the new museum in the first Jewish city. The group of three friends, all based in Paris, met regularly and responded to Dizengoff's proposals as they developed. They suggested names of artists whose works they believed the museum should display, as well as who they should consult. They viewed themselves as integral to building the identity of the new museum focused on Jewish art. Their positions, however, were sometimes at odds with Dizengoff's. For example, in one letter to the mayor, Chagall writes: "Today, Fleg, Chana Orloff, and I discussed your Memorandum. It is very good as is, but some concrete points are somewhat changed and the list of artists should not be published for the time being."[39] Chagall described how the three of them proposed that Dizengoff consider the formation of committees of "Friends of the Tel Aviv Museum," to be established in several countries. The committee questioned Dizengoff's judgment and wanted reassurance that he would respect their standards for selecting artists and curators for the museum space. Chagall wrote to the mayor: "I foresee an ideal museum if you trust in the jury and will not impose on our taste. I will be happy if you create not only the first Jewish city, but if you also build the first truly Jewish museum. Let us get to work!"[40]

Chagall's letter points to some fundamental differences between Dizengoff's vision for the new museum and that of the three-person "jury" that comprised Chagall, Orloff, and Fleg. Dizengoff envisioned the museum full of art from all different historical periods, especially art on "biblical themes." He also was open to collecting reproductions and even purchased cheap plaster copies of Michelangelo's *Moses* and Bernini's *David* statues in Italy to display them in the new museum. The mayor placed the copy of *Moses* at the center of the museum and

exclaimed: "Nu, praise the Lord, we finally have a museum. Could there be a Tel Aviv Museum without a Moshe Rabeynu [Moses]?"[41] Dizengoff's vision also included a hall of portraits of "famous Jews." Ultimately, Chagall became furious about what he viewed as the mayor's lack of respect for contemporary artists, namely himself, Orloff, and Fleg as "the artistic committee." If Dizengoff did not give them full responsibility for curatorial selections and decisions, Chagall threatened to withdraw from the project. In a 1931 interview with a journalist from Palestine, Chagall exclaimed: "They want to flood this museum with plaster casts, copies—who needs it? Why do you need this moldy junk? . . . one has to know even how to reject a gift, if it contradicts the designed artistic plan. . . . Either-or, either the organizers trust us, or let them act accordingly to their own taste, but in that case I cannot allow any committee to use my name as a cover—it must not even be mentioned!"[42] Chagall ultimately disengaged completely from the museum project when he felt the mayor did not defer to the artistic committee on all acquisitions and curatorial decisions.[43]

Although she did not publicly express her own position on the matter, Orloff presumably agreed with Chagall since Dizengoff's actions were not in concert with their collective goals as an artistic committee. In a letter from Dizengoff to Chagall (but addressed "Dear Friends") (November 11, 1931), Dizengoff attempts to summarize his understanding of the reasons for his falling out with Chagall, and presumably the rest of the committee that includes Orloff and Fleg. One of three points Dizengoff mentions in the letter as a source of conflict is a misunderstanding over the purchase of several of Orloff's works for the new museum. It seems Dizengoff promised to purchase a certain number of works from contemporary artists, including Orloff, for the permanent collection. "The committee" apparently accused him of not following through on this: "That I promised to buy a certain number of paintings from painters; I had visited with Madame Orloff and did not keep that promise and did not give them any response. Now, here are the facts: a) I bought two statues from Mrs. Orloff and paid for them in advance; b) I bought a painting from Kissling [*sic*] which I paid for immediately."[44]

Orloff in fact sent a letter to Dizengoff in which she confirms receipt of his check for 13,000 francs for the advance purchase of two of her

sculptures—*Portrait of Madame Harari* and an unnamed sculpture of "a pioneer"—for the permanent collection of the new museum.[45] She indicates that she would like to create even more works for the museum if she had more funding: "If I had 100,000f [francs] basalt, and with help from the Muse [Museum], I would create wonderful works, better than any painter could do. The price of the pieces is 5,000f, or three thousand if you want fewer pieces. Get me the money and I will deal with it."[46] Orloff does not state how many additional works she hoped the museum would commission, but her language shows her shrewd style of business negotiations. She wrote a second letter to Dizengoff a few weeks later that is difficult to decipher (she acknowledged her spelling and grammatical mistakes): "After a great deal of talking I finally agree to sell a piece but I want Scolptura for the muse [*sic* museum?] and he promise me to send me the money but went without it."[47] She is likely referring to a specific brand of sculptural material; while it is unclear exactly what transpired, it seems there was a misunderstanding regarding commissioning her work for the museum that left Orloff (and Chagall) disappointed.

Despite these differences with his colleagues, Dizengoff forged ahead with his plans and inaugurated the museum on April 2, 1932. He worked with architects to convert bedrooms into three galleries and add additional sections to the back of the house. After these additions, the building consisted of fifteen exhibition spaces and a concert and lecture hall. The inaugural exhibit included Orloff's and Chagall's works that Dizengoff acquired for the new permanent collection, along with others by Modigliani, Mané-Katz, and Lesser Ury. It also included pieces on loan from thirty-four local artists (including Reuven Rubin, Sionah Tagger, Yosef Zaritsky, Aharon Avni, David Handler, Anna Ticho, Batia Lichansky, Avraham Melnikov, and Avigdor Stematsky). Although the opening exhibit included replicas by artists like Michelangelo and Bernini depicting biblical figures, Dizengoff eventually was convinced to abandon his plan for a special Bible Gallery. The museum ran without a director or chief curator in its first year.

In a dedication ceremony two years later, the mayor recalled his motivation to commemorate his late wife by turning their house into a museum that would bear her name.[48] The museum ultimately did not bear Zina's name—it was rather Dizengoff Square that was named

after her when it was inaugurated later that year. He acknowledged her support of local artists, as well as her passion for visiting the museums of Europe and collecting photographs and souvenirs of European "masterpieces." Although it is unclear whether Orloff attended either the inauguration or dedication ceremonies for the new museum, she clearly played an important role in its planning. She used her strong relationships in the international Jewish art world to assist Dizengoff in essential networking to move the project forward. In her role on the advisory committee with Chagall and Fleg, she suggested which contemporary artists they should include in the new museum. Finally, she negotiated the inclusion of her own works, and she pushed for even more works than were ultimately accepted. Her actions were crucial to the successful launch of this institution that became the foundation of Israeli art and culture. She did not demand public credit for her actions like Chagall, and to this day she has not been properly recognized for her important efforts in this project of opening a new national museum.

FIRST SOLO EXHIBITION
AT THE TEL AVIV MUSEUM OF ART

Orloff's efforts to promote her own work and provide institutional support for Jewish artists working in Palestine through the development of the new Tel Aviv Museum of Art were well appreciated by those who yearned to cultivate new traditions and a sense of unified Jewish culture in the Yishuv. Dr. Karl Schwartz, appointed by Dizengoff as the first director of the museum in June 1933, invited Orloff to hold her first solo exhibition there in February 1935.[49] During the period leading up to this exhibition, the museum was planning an architectural expansion to the original building. They hired the architect Carl Rubin to redesign the mayor's house as a "symmetrical, modernist building with no decorative elements," influenced by the "white cube" style of museum architecture.[50] Although the redesign was not completed in time for Orloff's exhibition, it was an exciting time of growth for the young art institution.

To prepare for Orloff's arrival and exhibition opening, Esther Raab wrote to Gabriel Talphir, encouraging him to orchestrate an appropriate welcome for her. She also urged him to consider devoting a special

edition of *Gazith* (Tel Aviv, 1932–82)—the journal that he founded and edited dedicated to Jewish art and culture—to her work to coincide with her museum exhibition: "I wanted to inform you that Chana Orloff is coming to Eretz Yisrael and the country should welcome her as befits a Jewish artist of her caliber. . . . You should publish a special issue of *Gazith* dedicated to her work, as you did for Chagall and Menkes. Go and visit her. . . . She is such an honest, amiable person, and she has an earthly quality about her. . . . My advice to you is to become friends with her. You would probably like that."[51] It is no coincidence that Raab, a woman and a friend of Orloff's, is the one who suggests honoring her.

Talphir did not in fact publish a special issue dedicated to Orloff's work in the journal until over a decade later, to coincide with her second solo exhibition there, held in 1949, one year after the birth of the Israeli state (chapter 11). In its first decade, *Gazith* frequently promoted the work of Jewish artists in Paris, including Chagall and the Polish-born painter Zygmunt Menkes, as role models for artists in Palestine, yet the work of women artists was absent from this narrative.[52] Why did it take ten years for *Gazith* to run a special issue on Orloff? Although the press covered female artists and writers significantly less than they did their male counterparts in this period, Orloff was one of the few women they featured consistently during the period of the Yishuv and the early years of the state.[53] Raab's insistence that Talphir orchestrate a welcome for her "befitting a Jewish artist of her caliber" was still nothing like the fire brigade and race horses Dizengoff had planned for Chagall's arrival in Palestine. Although that was Chagall's first visit, and Orloff, of course, had a long history in the land, Raab wished to rally significant institutional support for her from the Jewish art world.

As the date of her solo exhibition approached, Orloff selected eighteen sculptures from her Parisian studio to ship to the Tel Aviv Museum of Art. Her curatorial choices support the argument that she wished to construct a specific image for herself as a modern Jewish and Zionist artist who was invested in building a pantheon of modern Jewish leaders in the arts. The works were displayed with the two sculptures Dizengoff had already acquired for the museum's permanent collection: the bronze *Portrait of Madame Harari* and *The Pioneer*, in plaster, along with many drawings. Orloff's choice of which works to feature

was strategic, as she wanted the exhibition to resonate with the Jewish audience in Palestine. As the artist of these Jewish notables in Palestine, she had a special role to play. Rubin noted that Orloff highlighted specific portraits of prominent Jewish figures, from his own portrait, to that of *The Jewish Painter (Reisin)* (see figure 7.5), to Bialik's portrait made in 1926 (see figure 8.4). At the time of her exhibition in February 1935, local inhabitants were still mourning Bialik's recent death (the summer of 1934), from complications following a gallstone operation. Orloff's portrait of him was so well-received that she left it in Palestine following the exhibition, as a gift, to include in the future museum at Beit Bialik.

Besides her works honoring the "fathers" of Hebrew poetry and art, Orloff included portraits of Jewish American patrons and writers like George Hellmann, Peretz Hirschbein, and Shalom Asch, as well as women writers like Manya Harari; the mysterious "Maria Lani"; nudes; sculptures of anonymous mothers and children, biblical figures, and animals, executed in a range of materials (wood, bronze, cement); along with a selection of drawings. One critic noted that expensive shipping costs prompted Orloff to leave her largest pieces back home in Paris, "yet we are thankful for what she has brought. The choice was discriminating that one can get a good idea of her genius from the 20 pieces on the exhibit. The scale of her medium of expression is phenomenally broad. She handles everything, nude, portrait or animal, with the same masterful hand."[54]

When she was in Tel Aviv for the exhibition, Orloff began work on several new pieces that furthered her aim of contributing to a visual history of notable figures in Palestine, including politicians, artists, poets, and so on. She was an original chronicler of the Yishuv, a kind of historian in sculpture of early cultural figures in Jewish Palestine. These included a bronze bust of the prominent Russian Zionist activist and rabbi Shmaryahu Levin (1935),[55] and a portrait carved in wood of Habima actress Chana Rovina (1935) (see figure 10.3), widely known as the "first lady of Hebrew theater." Rovina is featured in a three-quarters' pose, her hands clasped at her midriff as if she were amid delivering a monologue on stage. The piece was not completed in time for Orloff's first exhibition at the museum in 1935, but it was later acquired by the Tel Aviv Museum of Art for its permanent collection and featured

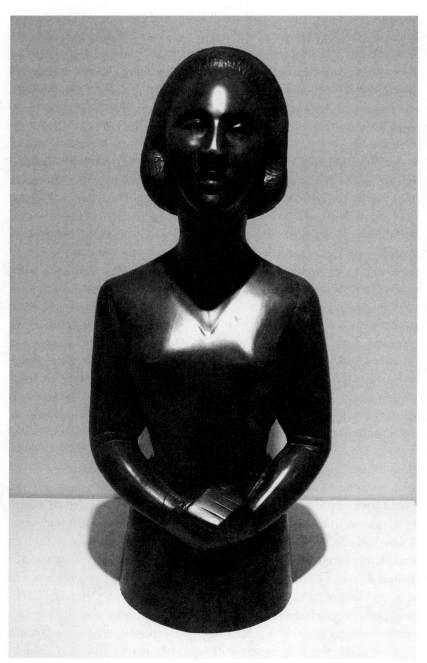

Figure 10.3. *Chana Rovina*, 1935. Bronze.

Figure 10.4. Orloff (*second from left*) outside the Tel Aviv Museum of Art, 1935.

alongside the portraits of Rubin and Bialik in Orloff's later solo exhibitions (1949; 1969). By carving Rovina's likeness, Orloff added to her practice of sculpted portraiture a veritable who's who in Jewish art and culture at that moment in Palestine.

Newspapers reported that seven thousand visitors attended Orloff's 1935 exhibition at the Tel Aviv Museum of Art in only fifteen days, a huge number in those days, attesting to her popularity and the great interest in and demand for cultural events in Mandatory Palestine.[56] A photograph taken on the opening day (February 1, 1935) shows Orloff standing just outside the front doors of the museum, surrounded by her closest friends (see figure 10.4). She is dressed in a long, light-colored linen dress with a flared skirt, highlighted by a decorative pendant and stylish hat. Reuven Rubin gestures amicably toward her from his position seated on the ground; behind him his wife, Esther, beams at the camera. Orloff and Rubin were clearly among the best-known artists of the day, and this was a special occasion for the Jewish cultural world in Palestine. An anonymous journalist from *Doar Hayom*, the earli-

est daily Hebrew newspaper under British military rule (Jerusalem, 1919–36), noted that "the artistic crème de la crème of Tel Aviv—writers, theater people, painters, sculptors, teachers and more" attended Orloff's opening.[57]

Dizengoff, who still lived on the floor above the museum and had been ill for months, received applause from the crowd when he came downstairs to say a few words about his friend Orloff. His speech shows how throughout her career, Orloff's critics and supporters, first in the Yishuv and later Israel, attempted to determine whether she should be considered as a Jewish, Israeli, or French artist. They appropriated these different facets of her national and ethnic identity in order to promote their own ideological positions, and read her works in accordance to their perceptions about the "ideal" nature of pre-state Israeli art and the role of culture in the Zionist project. An excerpt of Dizengoff's speech was reprinted in the article in *Doar Hayom*:

> Celebrating the exhibition of the sculptor Chana Orloff. The name of Chana Orloff, who has mastered and succeeded all over the world, is very well-known and famous. She, who has been awarded the highest merit of the French government, the Legion of Honour, will bring the beauty of Yefet into the tents of Shem.[58] I do not need to introduce to you Chana Orloff. She came from our people and made a name for herself in the world. . . .
>
> We want art to grow in this country, and educate the next generations. My aspiration and hope are that Chana Orloff will stay with us, in this country. Even though she has presented her work around the world's capitals, such as London, Paris, New York and more, I am confident she will especially remember this exhibition in Tel Aviv. . . . France awarded her the ribbon of its order of chivalry: the Legion d'Honneur. We do not have a ribbon, we have appreciation. I take the honor of appointing her our honorary knight.[59]

Dizengoff viewed Orloff as a pivotal figure in the construction of a history of Jewish culture in Palestine. Like many critics and cultural figures from the Yishuv, he claims she "came from our people" while

celebrating her highly revered reputation in France and on a global scale. His language reveals the tensions between her being French and living in Paris, and yet being from the Yishuv, while still an outsider in Tel Aviv and Israel. Throughout her career, Israeli critics perceived her as belonging to the big world outside, and yet they longed for her to make Israel her permanent home.

In response to the 1935 exhibition, art critics in Palestine were fairly consistent in their desire to appropriate her work to support the Zionist project. Mordechai Narkiss, a Polish-born Israeli curator and art historian, claimed that "Chana Orloff really belongs to the artists of Eretz-Israel, even though she is not living in Israel."[60] Eugen Kolb declared that "Orloff is one of the greatest sculptors of our time. She is also one of our own, our own flesh and blood."[61] Even Reuven Rubin, in his own review of Orloff's 1935 exhibition, lauded her as "one of our own" and described the opening as a "true artistic holiday" in Tel Aviv: "The legend of this Petah-Tikvah girl who went to Paris to learn dress-designing and became the greatest living sculptress of our time and one of the few glories of the École de Paris is well known."[62] Rubin described his own impression that Dizengoff's address "gave the many friends of art who were assembled there a feeling that a new era was starting for the development of art in Palestine."[63] He also recalled how he first posed for Orloff in 1925, and then later observed her at work in her new Villa Seurat studio: "She is the same Orloff, working hard, singing and telling a story, always ready to receive genially every visitor. Palestinian artists especially always knew the way to Orloff's studio."[64] Such commentary reinforces how her identity was complicated in Israel. She was a prominent public figure, with local roots, who helped construct a Zionist history of art; however, she also was perceived as different and more worldly. Although she was a pivotal link to the Parisian art world for younger artists just starting out in Palestine, there was a constant questioning of her belonging and moving between Paris and Tel Aviv.

Still, other art critics in the Yishuv resisted the common cultural Zionists' attempts to create new Jewish art forms, free from "negative diaspora influences." They promoted the notion of Orloff as standing outside the social structures and therefore free to express her unique

artistic identity without prejudice or limitations. For example, the journalist Miriam Bernstein-Cohen claimed in 1925, a full decade before the Tel Aviv Museum exhibition, that Orloff's work was worth appreciation even though it did not express Jewish motifs: "One could not trace her Jewish origin in her works. She is not an original Hebrew (or Jew). However, the aesthetic value of her work is too high, without needing to bond it to a specific national identity or tendency, in order to recognize its absolute value."[65] These divergent interpretations of Orloff's art in the Israeli artistic discourse continued following future solo exhibitions at the Tel Aviv Museum of Art in 1949 and 1969 (Chapter 11). They reveal the tension between those who wished to view her as a "modern" artist, apart from biographical and social contexts, and those who, like Dizengoff and Rubin, appropriated the work of a renowned Parisian artist as part of the young pre-state art scene.[66] She also was pressured regularly to move to Palestine and later Israel in order to truly belong.

Besides emphasizing Orloff's commitment to the country, Jewish art critics from the Yishuv resolved their discomfort about her refusal to settle down in Palestine by claiming that her decision stemmed from the requirements of her career. For example, a review published by an anonymous critic in 1935 stated: "Chana Orloff came back to us, to see her family and homeland. . . . And she must return to Israel. The greatest tragedy of Israel's noteworthy artists is that their country is calling them, leading them to return, but, their second homeland—the homeland of the professional art world—is also beckoning."[67]

Orloff's 1935 exhibition traveled from Tel Aviv to Steimatsky Gallery in Jerusalem, where it opened on March 1, 1935. The gallery associated with the flagship Steimatsky bookstore in the Mamilla neighborhood, and was one of the few places one could view art in Jerusalem. Critics praised the exhibition opening as "the artistic sensation of year" and continued to appropriate Orloff as "one of [their] own," regularly noting her masterful handling of different themes.[68] Although their intentions were not at all religious, several writers engaged with biblical metaphors to convey her strength and determination: "she never takes the easy road, but always struggles like Jacob and the Angels"; "Channa Orloff went to Paris to become a fashion artist. Like Saul, who was looking for his father's animals—so have you gone out, Channa

Orloff—but what you have brought back? A Kingdom."⁶⁹ When asked by an interviewer to describe the reception she received to her first solo exhibitions in Palestine, she responded:

> I have never seen such a crowd. It's amazing and exciting. I didn't think they'd come out to see my work because I used to live in Petah Tikvah. They are, I think, hungry for sculpture, painting, music. Palestine must be and will become an artistic center. We see factories opening up everywhere, houses are proliferating, and yet we do not have art galleries. Art is more important than boutiques that sell clothing. Jerusalem must have an art gallery that features paintings and sculptures by Jewish artists dispersed around the world.⁷⁰

Orloff expressed her concerns that her upbringing in Petah Tikvah would be viewed as provincial and perhaps would not be taken seriously by the cultural elite of the new city of Tel Aviv. When asked by this same interviewer why she had returned to Palestine in 1935, Orloff responded, "I wanted to see Palestine again and I was attracted to the idea of doing sculptures on biblical themes. I was sure that I would find the stimulus I was looking for here." Here we sense her desire to express publicly her love of the land and to engage in artistic studies of Old Testament themes on behalf of Jewish and Zionist audiences. Orloff's commentary on the exhibit provides another example of her state of constant migration. Her choice of language is rich regarding issues of belonging, of claiming and appropriating the land and culture. At the same time, she commands respect for her success "out there," in Paris. Her descriptions of her work and motivations consistently point to the tensions between those, and in Palestine and later Israel, the need to feel that she has a place.

While Orloff was in Palestine for her these two exhibitions, she also tended to her mother, Rachel Orloff, then age eighty-one, who was very ill. Rachel had recently suffered from gangrene, and one of her legs had to be amputated following complications from diabetes. As she neared her death, Orloff's mother could express her pride in seeing her youngest daughter's tremendous success. Orloff also took the opportunity while in Palestine to create many portraits of her family members.

MORE INTERNATIONAL NETWORKS

After her mother passed away, Orloff traveled to Egypt at the invitation of Baron Félix de Menasce, a banker and ardent Zionist who led the Jewish community in Alexandria. The *Palestine Post* reported on her travels: "Madame Chana Orloff, having concluded her exhibition in Jerusalem, is leaving for Alexandria this morning to carry out several commissions, among them the bust of Baron Felix de Menasce and Mr. Raphael Toriel."[71] Menasce was from a prominent Sephardic family that arrived in Egypt in the eighteenth century. His grandfather started the banking firm of J. L. Menasce and was one of the earliest entrepreneurs in Egypt to develop trade with Europe. He and his wife, Rosette, who was French, hosted Orloff at their home. They were known for putting on lavish concerts, theatrical performances, and exhibitions of the family's vast art collections that included Chinese porcelain, Roman and Syrian class, colored diamonds, jeweled watches, Greek tapestries and Turkish embroideries, Fabergé, and more. Menasce commissioned Orloff to create his portrait bust and also purchased other works from her. She carved the bust in wood and then created a plaster cast from which she made several bronze casts collected by various members of the Menasce family. Given their strong ties to Palestine, the family later donated a bust in bronze to the Tel Aviv Museum of Art.

While in Alexandria, Orloff sent a photograph of herself, age forty-seven, posing proudly before the camera, to her close friend Tola Rank, a child analyst in Cambridge, Massachusetts. On the back of the photograph, she wrote in French: "In Egypt, on a sweltering day." Orloff's enduring friendship with Rank is yet another example of her cosmopolitanism and vast international networks.

During the mid-1930s, Charles Corm, the prolific Lebanese writer, industrialist, and philanthropist, invited Orloff to exhibit her work in Beirut.[72] Corm led the Phoenicianism movement, a form of Lebanese nationalism, and edited a journal, *La Revue Phénicienne*, in which he wrote in French. He and Orloff traveled in similar social circles, and she may have met Corm when he was in Paris decades earlier at the start of their respective careers. Beginning in 1934, Corm inaugurated and hosted in his home the Amitiés Libanaises cultural salons, described by historian Franck Salameh as "a trendy and much coveted weekly 'gathering of the minds,' to which flocked a number of eminent local

and international political, cultural and intellectual figures" (including Paul Valéry, F. Scott Fitzgerald, and many others).[73] Corm regularly invited scholars and intellectuals from the Yishuv to Beirut to attend these gatherings, including Bialik and the author and educator Rachel Ben Zvi. In a series of letters between Corm and Eliahu Epstein, a representative of the Jewish Agency who had a "second home" in Lebanon, Orloff's name is mentioned along with the Jewish archaeologist Nahum Slouschz. Epstein and Corm propose that Orloff and Slouschz present their respective work at the Amitiés Libanaises and at several other Beirut venues.[74] Corm and/or Epstein may have seen Orloff's 1935 exhibition at the Tel Aviv Museum of Art and admired her work and connections to the international art world.

Although there is no record that Orloff traveled to Beirut, such an invitation shows the extent of her interactions among diverse communities throughout the Eastern Mediterranean. Franck Salameh makes the important point that such invitations took place "at a time where the (barbed) borders of the Middle Eastern state system had not been finalized, and brewing animosities between Muslims and Jews had not yet reached their pinnacle."[75] Her cosmopolitanism allowed for these types of cultural exchanges that "reached across borders and bypassed ethnic, religious and political barriers."[76]

Orloff's reputation was not limited to Paris and Tel Aviv, or even the greater Eastern Mediterranean. Besides her travels in the United States, in 1931 she took part in a group exhibition of contemporary international art in the Zürich Kunsthaus, where her work was exhibited alongside that of Jacques Lipchitz, Ossip Zadkine, Henri Laurens, and Henry Moore, among others. In his preface to the exhibition catalog, curator Dr. Wilhelm Wartmann described the "return to order" or return to figuration in which many artists previously associated with cubism had abandoned it for a more conservative aesthetic following World War I. Orloff also had a successful solo exhibition in Amsterdam at Kunstzaal Van Lier in November 1932, when she exhibited thirty-five sculptures created between 1914 and 1932.

Early in 1936 Orloff had a solo show at Leicester Galleries in London. Her friend, the American librarian Dorothy Kuhn Oko, who was living in England, assisted Orloff with preparations for this exhibit and hosted her at her home in the town of Farnham, in Surrey, fifty-eight

kilometers southwest of London.[77] The critic H. K. wrote a glowing review in the British *Art Notes* emphasizing Orloff's "international reputation, having exhibited in America, Norway, Japan, Russia and Palestine." The article stressed Orloff's worldliness and her modernity. Ruth Green Harris of the *New York Times* also reported on the London exhibit of "a Chana Orloff strengthened since her last appearance in New York."[78]

Back in Paris, we have seen how Orloff "belonged" to many diverse circles, from the avant-garde, to men of letters, to Jewish artists, to women artists. Among this latter group, she was part of the social circle around the formidable Berthe Weill, an important Jewish woman gallery owner in Paris who played a central role in promoting the careers of many modern artists of the period.[79] Weill was a tremendous supporter of women artists, as we saw earlier in the case of Natalie Clifford Barney and her salon. Weill represented painters in Orloff's circle including Suzanne Valadon, Emilie Charmy, Olga Sacharoff, Hermine David, and others, besides Picasso, Matisse, and Modigliani. In December 1931 Orloff was photographed attending a celebration of the thirtieth anniversary of the Galerie Berthe Weill in festive costume.[80] Although Orloff chose not to have one single dealer represent her, she was a vital part of this group that convened regularly around Weill to celebrate the milestones of her friends' and colleagues' lives and careers. The photograph reflects Orloff's place in a vast network of prominent women in the Parisian art world of the 1920s and 1930s, including other powerful Jewish women like Weill.

In 1932 she joined the Société des Femmes Artistes Modernes (Society of Modern Women Artists, known by its initials FAM), an organization of over one hundred international women artists who exhibited their work together in prominent Parisian galleries and public venues between 1931 and 1938.[81] These included the prestigious Durand Ruel, where she previously showed her sculptures in group shows, and the exhibition pavilion at the Esplanade des Invalides. Founded in 1930 by the French painter Marie-Anne Camax-Zoegger, the goal of FAM was to organize annual exhibitions in Paris. It also collaborated with other feminist groups on two important international women's art exhibitions in the 1930s in which Orloff took part. Over the course of eight years, FAM's annual exhibits featured the work of over one

hundred female artists from different generations, backgrounds, and stylistic movements, many of whom were recent immigrants to Paris from countries as diverse as Argentina, Australia, Poland, Russia, and Turkey. FAM published annual exhibition catalogs and its exhibitions were widely reviewed and photographed by the press. As an institution, it was supported by an all-male honorary committee, many of whom held prominent positions in government and culture. Although Orloff already was a prominent international figure when she joined this group, her participation in it only added to her broad recognition from multiple facets of the French art world, from the avant-garde to more academic and conservative sectors.[82]

Orloff was among the best-known female artists of the day in Paris to take part in FAM—along with the painters Suzanne Valadon, Marie Laurencin, and Tamara de Lempicka. She was one of only a few sculptors who participated annually; Anna Bass, Anna Quinquaud, and Yvonne Serruys also were regular participants. FAM also staged retrospective exhibitions of prominent deceased women artists, including the sculptors Camille Claudel and Jane Poupelet. In staging such retrospectives, FAM sought to construct and transmit its own history of women artists that featured a diverse range of women's experiences and interests. By participating in FAM, Orloff joined an institution committed to establishing a history of women in the arts and also placed her work within a history of French women sculptors.

Orloff took part in two other important international exhibitions promoting the work of women artists that were connected to FAM. In 1937 she was invited to take part in FAM's collaborative exhibition with the Circle of Czech Women Artists at the historic Obecnídom in Prague. That same year, through her affiliation with FAM her work was included in *Les Femmes artistes d'Europe exposent au Jeu de Paume*, the first international exhibition devoted to women artists.[83] This exhibit was held in Paris at the Musée du Jeu de Paume, the state's Musée des Ecoles étrangères (Museum of Foreign Schools). Orloff was selected to represent France in the Sculpture category, along with Germaine Richier and Yvonne Serruys (along with ten painters).[84] Of the thirteen women representing France in the exhibit, Orloff and the painter Mela Muter were the only two Jewish artists, and the only two who were not born in France. Orloff's participation in these Parisian women's art

exhibitions shows how she was appreciated as a "French woman artist" and also a vital member of a small lineage of French women sculptors.

Orloff took part in a third important art exhibition in 1937 entitled *Maîtres de l'Art Indépendent, Peintures et Sculpteurs, 1835–1937* (Masters of Independent Art), held at the Petit Palais Museum in Paris. Connected to the last of the Parisian World's Fairs (L'Exposition Internationale des Arts et Techniques), the exhibit was one of three large art exhibits showcasing French art for the international audience attending the fair.[85] Organized by the Municipality of Paris, it focused on "independent art" or "l'art vivant" of the first three decades of the twentieth century, emphasizing the international artists of the École de Paris. As one of the leading "independent" sculptors working in Paris, Orloff was given her own room (Room 37) in this exhibition that featured twenty-five of her sculptures. The only other female sculptor represented was Jane Poupelet, who had only five sculptures on display. Other sculptors included were Rodin, Maillol, and Despiau, each displaying over fifty works; Bourdelle, fifteen; Lipchitz, thirty-six; Zadkine, forty-seven; Henri Laurens and Pablo Gargallo: thirty-three each; Mateo Hernandez: twenty-six; Léon Drivier: one. Orloff had exceptional visibility in this line-up of contemporary French sculptors, most of whom were born in France. Her work was understood as part of a so-called "independent" Parisian art movement that perpetuated the French tradition.

Through this exhibition, Orloff's sculptural practice was absorbed into this idea of Paris and France as a "cosmopolitan crucible" where foreign-born artists were recognized as part of the French tradition. Scholars have shown how the 1937 Exposition was a way to position France as more individualistic and non-conformist compared to its totalitarian rivals.[86] Thinking back to how Zionist critics appropriated Orloff's work in response to her 1935 solo exhibition at the Tel Aviv Museum of Art, in *Maîtres de l'Art Indépendent*, Orloff's work becomes a vehicle for those wishing to show the rich diversity of French national identity.

At the same time as her work was featured in the Exposition International in Paris, Hitler's curatorial team, led by Adolf Ziegler and the Nazi Party, staged the Degenerate Art Exhibit and adjacent exhibition of "Great German Art" in Munich (July 19–November 30, 1937). Much

has been written about these exhibits, which showed in counterpoint how Nazi leaders sought to control Germany culturally as well as politically.[87] The Degenerate Art Exhibition presented six hundred fifty works of modern art confiscated from German museums, while the Great German Art Exhibit promoted more realist and classical styles of painting, sculpture, and architecture favored by Hitler. As early as 1933, Nazi officials began opening "chambers of horrors" and "exhibitions of shame" that mocked modern art as containing "Jewish" and "Bolshevik" influences that could "endanger public security and order." Curators across Germany began removing avant-garde works from museums. Mayor Dizengoff reached out to Chagall in Paris upon learning in September 1933 that Chagall's painting *The Rabbi* "was destroyed by a rampaging mob of Nazis who burned it" in Mannheim, Germany.[88]

Orloff became increasingly alarmed as antisemitism increased in France following the election of Léon Blum, the Jewish prime minister of the Popular Front government in 1936–37. Newspapers regularly published the work of conservative writers, such as Paul Morand, Marcel Jouhandeau, and Charles Maurras, leader of Action Française, denouncing Jews. One of the most offensive of this group was Louis-Ferdinand Céline, who published two antisemitic pamphlets, *Bagatelles pour un massacre* (1937) and *Ecoles des cadavres* (1938), in which he viciously repeated arguments that Jews are the enemy of the French and must be eliminated.[89]

As the rise of fascism became more and more pronounced in France, Orloff made a momentous decision to travel to the United States in 1938. Marie Sterner, the New York art dealer who promoted Orloff's work during her first visit to the US, invited Orloff to have a solo exhibition in her Manhattan gallery. Eager for a respite from the antisemitism raging across Europe, Orloff accepted. Her friends from the Jewish psychoanalytic circle, including Tola Rank, Dr. Mira Oberholzer, and Adele Rosenwald Levy, now all in the United States, were increasingly concerned for her safety and well-being. They wrote letters regularly and encouraged Orloff to consider returning to the US indefinitely. They also commissioned portraits as a means to offer financial support during this moment of political uncertainty and fear for Jews in Europe.[90]

Orloff made the trip to New York in the winter of 1938, this time without her son. Élie was now an independent university student and

wished to pursue his studies in mathematics in Paris. With Europe on the cusp of war, Orloff traveled to New York for the opening of her exhibition at Marie Sterner Gallery. The exhibit included thirty works in a mix of bronze, wood, and cement, as well as a mix of portraits, maternities, nudes, and sculptures of animals. Several works were lent by local collectors, including one in the personal collection of Marie Sterner herself. Sterner is one of several women art dealers who would champion Orloff's work over the course of her career.

Orloff received several positive press reviews of her show at Marie Sterner Gallery. Edward Alden Jewell, a critic from the *New York Times*, described Orloff's "one-man show" as "an event not to be missed" and "a plenitude of power and plastic beauty and finesse of insight."[91] An anonymous critic took his praise a step further: "Risking the charge of feminism, rashness or impetuosity, this critic would like to be recorded as believing that Chana Orloff, the Russian-born sculptress, is among the world's greatest living sculptors. Maillol, Epstein, and Zadkine are no greater. Despiau and Brancusi, themselves considered giants, are inferior."[92] This critic noted how impressive it was that "she had a special display to herself" at the International Exhibition in Paris the year before, "which we considered one of the high spots of the Independents presentation."[93] Although we do not know who wrote this piece and for which newspaper, the author takes a feminist stance in positioning Orloff's talent above her male peers, in a league of her own: "It is extraordinary that her work isn't better known here."

Following her gallery show in New York, Orloff traveled to Boston and exhibited her work at the Museum of Fine Arts, Boston (February 18–March 6, 1938). Boston-based art critic and lecturer Dorothy Adlow wrote a short preface to the exhibition catalog, praising Orloff for "expressing herself in a distinguished manner, with wit, boldness, and solemnity. She is a sculptor in possession of a rare endowment—ideas." As the daughter of Jewish immigrants from Eastern Europe and a strong female voice in the art world, Adlow likely identified with Orloff.[94] Orloff's Boston-based collector friends, including Jewish philanthropists David R. Pokross and Muriel Kohn Pokross, lent several works to the show.[95] In Boston, Orloff was reunited with Tola Rank. Her portrait of Otto Rank was reproduced in an exhibition review in the *Boston Globe*. Critic A. J. Philpott praised the work as a

"masterpiece of character building up," with special appreciation for her subtle sculptural treatment of her sitter's eyeglasses.[96] The exhibit then traveled to the nearby Farnsworth Museum at Wellesley College just outside of Boston.

At this point Orloff was well known in American art circles. In 1936 the Brooklyn Museum acquired her bronze *Portrait of Reuven Rubin* (see figure 8.3) and *Young American* from the bequest of her friend, the psychiatrist and author Dr. Frankwood E. Williams.[97] This same museum had featured her work in several group exhibits throughout the 1920s and 1930s. The Philadelphia Museum of Art purchased her bronze *Dancers (Sailor and Sweetheart)* (1923) (cast in 1929) in 1937.[98] This piece offers a whimsical image of a couple tightly clasping one another in a dance move, the man dressed in a sailor's uniform and the woman in a long dress. Some critics speculated that the dancing that took place in Parisian costume balls in the 1920s inspired her. Friends and collectors widely celebrated Orloff during this second trip to the United States. The worsening political situation in Europe was looming in the background of her travels.

While she was in New York, Orloff was among 130 artists, "almost all of them well-known to New York gallery goers," who sent works of art to an exhibition and sale arranged by the Joint Distribution Committee, the leading Jewish humanitarian organization founded during World War I to help Jews suffering in Palestine.[99] The goal of the exhibit was "to aid in raising funds for the committee's relief work among the oppressed and needy Jews overseas who have been the victims of the political situation in various parts of Europe."[100] Among the other well-known artists, both Americans and European émigrés, to take part were Isabel Bishop, Mané-Katz, Georg Grosz, John Sloan, William Zorach, and Thomas Hart Benton. Still in New York during the spring of 1938, Orloff was warned by her American friends not to return to Paris. While she knew that she was putting herself at risk given the rapid rise of fascism and antisemitism across Europe, she forged ahead with her plans to return to her Montparnasse home and studio. She longed to be reunited with her son and truly believed that the French government would protect them from harm.

CHAPTER 11
Occupation and Escape,
1938–1942

RETURN FROM NEW YORK

One day in the mid-1970s, a visitor to the *Marché aux Puces*, the biggest flea market in Paris, purchased this small portrait bust of a woman in plaster, measuring only seventeen centimeters high (see figure 11.1). Signed "Ch. Orloff" and dated 1940, the work was later confirmed as an authentic self-portrait. The bust eventually landed in the hands of the artist's granddaughter, who provided a context for how this piece fit into Orloff's life and work. She suspected it was one of many works that the Nazis pillaged from her grandmother's studio during World War II. Orloff had made it during the years of the Nazi Occupation in France, when she was among the many French and foreign-born Jews banned from public spaces, forced to observe a curfew and wear the yellow badge with the Star of David and the word *Juif* written on it. Professionally stifled and prohibited from exhibiting or selling her work, Orloff strategically created what she called *sculptures de poches* (pocket sculptures), works so small that they could easily fit in her pocket. She wanted them to be easily transportable so she could sell them for income during the war. She later told the art critic André Warnod, "They were, I assure you, very useful, and helped me survive."[1] This self-portrait bust—intentionally signed and dated—is among a dozen such works emblematic of Orloff's migrant experience. Her strong profile and stoic facial expression give dignity to a nearly untenable situation. It shows Orloff's desire as an established, fifty-two-year-old artist to document the traumatic experience of being uprooted yet again.

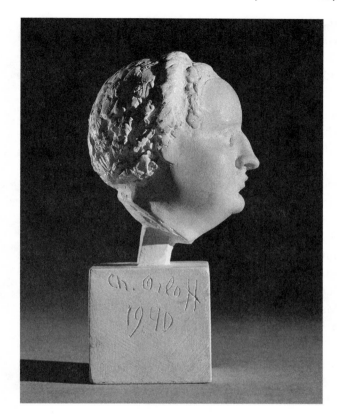

Figure 11.1.
Self-Portrait, 1940.
Plaster.

Orloff created this "pocket-sized" self-portrait in the difficult period following her second trip to the United States. Thrilled to reunite with her son, she returned to Paris in May 1938. Élie, now age twenty, was thriving as a student of mathematics and preparing to begin his university studies. Immediately, she set to work on the many new commissions she had received from her friends and clients in the United States.

By the time she settled back home, the European art world had largely shut down. Among the few exhibitions that were taking place, there were clear signs that Nazi ideologies and policies were affecting French culture. For example, when Orloff's friend Jacques Lipchitz, a Jewish émigré originally from Lithuania, exhibited his expressionistic sculpture *Prometheus Strangling the Vulture* in Paris in 1938, a journalist in *Le Matin* described it as "a gigantic pile of garbage" and an insult

to French culture, and demanded its removal.[2] Lipchitz, like many of Orloff's artist friends, including the Chagalls and Rubins, ultimately fled Europe for New York and other locations.

Just as she had used her art to support Jews in need while in New York, Orloff took part in a sale exhibition of Jewish artists in Paris to benefit the Zionist organization Keren Kayemeth L'Israel (Jewish National Fund).[3] It was part of a larger Palestine exhibition at the Palmarium du Jardin d'Acclimatation that lasted only a few days in June 1939. She joined artist friends—including Chagall, along with other Russian colleagues such as Isaachar Ber Ryback, Zygmunt Menkes, Mané-Katz, Jacques Chapiro, Nina Brodsky, Wladimir Segalowitsch, Rahel Szalit, and S. Rachumowski—in their support of Jewish emigration to Palestine during this highly vulnerable time. Orloff likely attended the opening on June 17, which featured a concert with Hebrew, Yiddish, and Ladino songs, followed by dancing. In his review of the exhibit in the German-Jewish newspaper *Jüdische Welt-Rundschau*, German critic Max Osborne noted the "artistic subtlety" of Orloff's wooden sculpture depicting the Habima actress Chana Rovina.[4] Other critics writing in both French and Yiddish reported on the exhibition, attesting to the vitality of the cosmopolitan Jewish arts community in Paris on the verge of World War II.[5]

Even though very few exhibits were taking place, Orloff received an invitation to take part in a large traveling European exhibition of French sculpture, entitled *One Hundred Years of French Sculpture, 1833–1939*. She sent three sculptures to be included in this show, which originated at the Stedelijk Museum in Amsterdam (July 8–October 8, 1939): *Man with a Pipe*, and two more recent bronze sculptures of animals, an Afghan dog and an ostrich. The curators displayed her work beside those considered the great masters of French sculpture: Rodin, Bourdelle, and Maillol. *Ostrich No. 1* merges the wings with the bird's compact body, its thin legs and tiny feet balancing precariously upon a small square pedestal (see figure 11.2). Known for its long, slender neck and short wings, the Old Testament (Book of Isaiah) describes the ostrich repeatedly as a "wild beast of the desert" that cannot fly. Orloff's sculpture suggests her predicament at this moment, trapped in an environment that was becoming increasingly hostile toward Jews and non-native-born citizens.

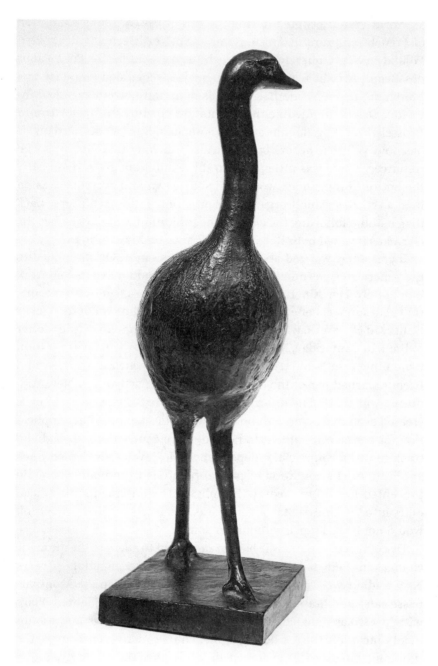

Figure 11.2. *Ostrich No. 1*, 1939. Bronze.

World War II erupted during the run of this traveling exhibition of French sculpture in Amsterdam, when Nazi Germany decimated Poland in September 1939. The exhibit traveled to the Petit Palais des Beaux-Arts in Brussels and opened as scheduled (January 27–March 26, 1940). While Belgium was neutral, the country risked invasion. Orloff attended neither exhibition opening in Amsterdam or Brussels. Traveling alone as a Jewish woman in Europe was too dangerous now. With the onset of war, she also was mindful of her financial resources. There was little press on this exhibition, given that nearly the entire European art world had shut down and everyone was on high alert. The exhibit organizers sent Orloff's three sculptures back to her studio following the close of the exhibition, just days before the Germans invaded both Belgium and France on May 10, 1940.

Increasingly worried about her and Élie's safety, Orloff applied to the American government for visas, so they could move to New York indefinitely. Her American friends and colleagues, led by Tola Rank, rallied to support her efforts. Carl Zigrosser, still director of the Weyhe Gallery in New York, where Orloff had exhibited in 1929, wrote a letter to Rank in Cambridge, Massachusetts, on July 10, 1940, inviting Orloff for another exhibition.[6] Although encouraged by such support, several friends warned her of the difficulties of selling artwork in New York during war years. The influx of European artists living there in exile created even more competition. US authorities approved her application for a visa, a testament to her extensive connections abroad and track record for financial independence. However, they denied Élie's application. His condition of partial paralysis from polio as a child prevented him from meeting the physical requirements for official entry into the United States. There was absolutely no question: Orloff would not leave France without her son.

Discouraged, she and Élie had no choice but to adapt to the dramatic changes in their daily lives during the German occupation of Paris. Nazi soldiers were visible all over the city, including in the Montparnasse cafés and brasseries that she and her friends frequented. Flags with swastikas dangled from classical French buildings and monuments, including the Arc de Triomphe. The Germans even changed the time zone in France. They forced all residents of the city to live under curfew from 9:00 p.m. to 5:00 a.m., during which time the city streets

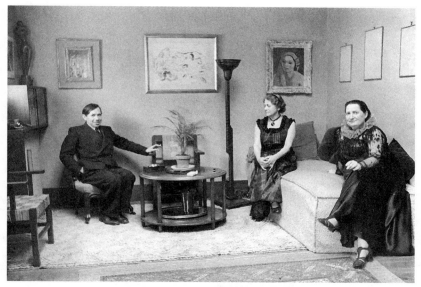

Figure 11.3. Chaim Soutine, Olga Sacharoff, and Orloff, ca. 1939.

were dark. Orloff no longer made her weekly Sunday excursions to the Louvre; the director of the Musées Nationaux, Jacques Jaujard, had the foresight to move the collections to various châteaux in the provinces in August 1939. The museum closed until September 29, 1940, at which point only statues and classical sculptures were on display, and the paintings galleries remained closed.

Confined to her home and studio, Orloff invited only her closest friends to visit with regularity. Soutine recently had moved into a house on the Villa Seurat and visited her daily during this tough period.[7] A contemporary photograph shows Orloff, dressed in a festive costume with an ornate collar, sitting in her living room with Soutine and the painter Olga Sacharoff (see figure 11.3). As a joke, Orloff explained, "Soutine demanded a worldly disguise from the ladies."[8] The artist friends regularly listened to newscasts from the Allied forces even though the French press and radio only broadcast German propaganda.

Despite the worsening political climate, Orloff continued to work most mornings in her studio. During this period of increasing isolation, she could not work on portrait commissions. Instead she continued to focus on sculptures and drawings of animal figures, some of them

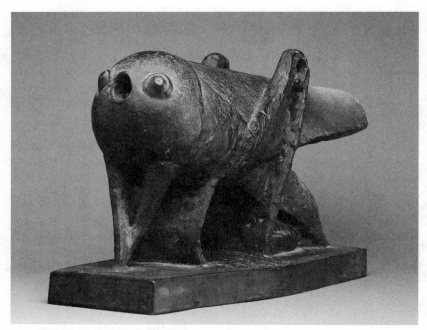

Figure 11.4. *Grasshopper*, 1939. Bronze.

laden with multivalent symbolism. For example, *Grasshopper* (1939) (see figure 11.4), cast in bronze, represents a much-larger-than-life insect with both biblical and political resonance. Throughout the Old Testament, grasshoppers transform into migratory locusts that represent God's armies and protectors of the Jewish people. The Nazis also appropriated the locust as part of their antisemitic propaganda, which regularly likened Jews to certain undesirable animals and insects.[9] Ernst Hiemer aligned Jews with locusts and described them as "the scourge of God" in his antisemitic German children's book *Der Pudelmopsdachelpinscher* (The poodle-pug-dachshund-pincher), published by Der Stermer in 1940. Hiemer also associated Jews with chameleons ("the great deceiver"), bedbugs ("bloodsucker"), and tapeworms ("parasite of humanity"), and so on, ultimately likening them to deadly bacteria that threaten humanity.

Orloff's bronze cast of the grasshopper, with its angular bodice, wings, and prominent round eyes, in fact resembles a Nazi tank or machinery of war from the period.[10] The shape of the insect's wings

also calls to mind the Wolfsangel, a German symbol of wolf traps that was the initial symbol of the Nazi Party before the swastika and was used by German SS armored infantry divisions.[11] Orloff's sculpture speaks to the locust's dual symbolism as both protector of the Jewish people and fascist threat.

As the political situation in Europe worsened, Orloff received a letter from André Dezarrois, then curator of the Musée du Jeu de Paume, which was then the state-run museum of "foreign" contemporary art.[12] Dézarrois had been trying for years to acquire her *Large Crouching Woman (Seated Nude)* (1925) (see plate 8) for the museum's permanent collection. He described his surprise upon learning from Eugène Rudier, director of the foundry that cast Orloff's sculptures, that the matter was still "in process." Dézarrois appealed to his boss, Georges Huisman, then director of fine arts for the French government. Huisman replied that while "in principle" he approved of the purchase, her asking price was too high. Dézarrois encouraged Orloff: "There is no reason that we should not represent you in our collections . . . it's been over fifteen years that I have been trying to acquire your work. . . . I will continue!"[13] Even though the French government purchased her *Portrait of Lucien Vogel* back in 1925 for the Musée du Jeu de Paume, Orloff's Jewish identity may have been a hindrance in her further acceptance into the French national collections. The national museums purchased the sculpture later in 1939; we do not have documentation on the ultimate price negotiated between Orloff and the French government. Just as the Nazi Party was strengthening its hold and spread of fascism and virulent antisemitism across Europe, including France, Orloff's second work had finally entered the French national collections.

As stories of German arrests and pillages proliferated, a state of panic erupted across Europe. Parisians adjusted to strict rationing on food, tobacco, coal, and clothing. After failing to secure the visas necessary for their relocation to the United States, Orloff strategized on other ways of navigating their escape. Just a few weeks following the German occupation of Paris, in early July 1940, she and Élie, accompanied by her friend Sala Prusac Paulhan, joined thousands from Paris and northern parts of France and Belgium, the Netherlands, and Luxembourg in the Exodus of 1940.[14] They quickly packed up Orloff's car two days before Élie was to take his final exams, fleeing to the "free

zone" in the South of France. Prusac was ill (she lost one of her arms a decade earlier, following an accident), and Orloff was taking certain risks in including her in their plan of escape if she needed medical care. Not knowing how long they would be away from home, Orloff brought a suitcase with clothing and other bare essentials, perhaps including a few of her pocket sculptures.

Once they set out on their route, they moved at a slow pace. The roads were gridlocked with traffic, as panicked Parisians struggled to make their way out of the city. The summer heat and stillness of the air made the conditions on the road particularly uncomfortable. They drove as far south as the town of Royan, the French Atlantic coastal resort town in the southwestern Nouvelle-Aquitaine region, before German troops stopped them. After showing their passports, the officers instructed Orloff to drive to the nearby town of Saujon. They stayed there for several weeks until the officers issued her an official permit to cross the demarcation line and return to Paris.

Orloff sent several letters to Tola Rank from Saujon, expressing her despair: "They cut us off from the rest of the world, and news from you would do us much good. Write quickly. My financial resources are dwindling bit by bit, but right now I am not asking for your help. . . . The days pass without joy. We hope we will soon see the end of this nightmare."[15] Two weeks later, still in Saujon, Orloff sent an update to Rank: "our health is fine" . . . "we are used to the occupation," despite "boredom" in being "unable to work. . . . We don't miss music," she writes, as "the soldiers sing every morning. It's hideous!"[16] Eventually Orloff received the document known as a *laissez passer* in French, or *ausweis* in German, dated July 24, 1940, allowing their return to Paris by car. Dejected and tired, they had no choice but to drive home. The challenges continued, as Orloff wrote to Rank yet again from the road, this time in Poitiers: they ran out of gas and could not return to Paris for another week.[17]

By autumn of 1940 the systemic persecution of French Jews had exploded, driven both by the Nazi Party and collaborating French governments. A German ordinance on September 21, 1940, forced all Jewish citizens in the occupied zone to register their name and address at a police station. Officers stamped Jewish citizens' identity cards with the

word *Juif,* a prelude to deporting Jews to concentration camps. Orloff and Élie were among the first of nearly one hundred fifty thousand people who registered in the department of the Seine, which included Paris and its immediate suburbs. Élie later recalled their initial optimism: "[We] loved life, work, friends, books, excellent food, the arts and laughter. We registered as Jews on the very first day of the German ordinance because we had confidence in humanity."[18] How could the country that had given Orloff so much, persecute them?

Orloff was so confident that the French government would protect established émigré artists, that following her own registration as a Jew, she accompanied Soutine to the police station to do the same. She waited outside while he entered the building. When it was Soutine's turn to present himself, the police officer stamped the document with an unsteady hand. "Look," Soutine told Orloff outside the station, "they have smudged my Jew."[19] Over twenty years later, Orloff wrote that Soutine tried many times to get a visa to America, but failed because he lacked proper documentation.[20] She probably meant that he was missing his original identity papers from Russia.

Only one month after their inscription as Jews, the German occupation authorities passed the Ordonnance d'Aryanisation, an antisemitic decree barring Jews from certain professions, including commerce and industry.[21] Orloff could no longer exhibit or sell her work, nor was she able to ship any completed commissions to her clients abroad. The collaborationist Vichy regime, led by Marshal Philippe Pétain, put forth its own antisemitic legislation that stripped Jews of their civil rights. Barely a month after taking office, Pétain passed a denaturalization law.[22] A committee reviewed five hundred thousand naturalizations given since 1927—resulting in fifteen thousand people having their French nationality revoked, of which 40 percent were Jews. Orloff had become a citizen only two years prior. The Statut des Juifs followed, a series of laws approved by the Vichy government that deprived Jews of the right to hold public office, designated them as lower-class citizens, and deprived them of citizenship. These anti-Jewish laws took effect in two stages: on October 3, 1940, the first law excluded Jews from the army, press, commercial and industrial activities, and civil service. In June 1941 the second law required the registration of Jewish businesses

and excluded Jews from any profession, commercial or industrial. Élie somehow secured an internship at an insurance agency despite this political climate of intense antisemitism.

During the Occupation, several propagandist exhibitions opened in Paris that officially sanctioned antisemitism.[23] The Vichy government and Institute of Studies on Jewish Questions opened *Le Juif et la France* (The Jew and France) at the Palais Berlitz in September 1941. It featured Charles Perron's thirty-foot-high sculpture *France Liberating Itself from the Jews* (see figure 11.5).[24] This monumental sculpture, which dominated the main rotunda of the multimedia exhibition, features a classical depiction of a young, muscular woman holding her child up in one arm, while she fends off two repulsive older Jewish male figures, one by using her knees, and the other by using her free hand. The piece speaks to Nazi appropriation of caricatures of Shylock, the Venetian Jewish money-lending protagonist from Shakespeare's *Merchant of Venice*. Orloff must have seen this work, either in person or reproduced in the newspaper. We can imagine that Perron's juxtaposition of motherhood—one of Orloff's favorite subjects in sculpture—and viciously antisemitic caricatures of the Jewish body, offended her. The exhibition's welcome banner exaggerates Perron's fascist and racist imagery even further. The monstrous-looking Jewish figure claws maliciously at the globe, signaling greed and desire for financial and political domination of France and the world.

As the antisemitic propaganda and laws multiplied, it reminded Orloff of the vicious pogroms of Ukraine during her youth. She and Élie began noticing that some neighbors looked at them differently. Others avoided them altogether in the streets; or were they imagining it, they wondered? By the summer of 1942, the German military commander in France ordered all Jews over the age of six to wear, on the left side of the chest, a yellow star the size of a person's palm, with the word *Juif* written inside. They banned Jews from all major streets, movie theaters, libraries, parks, gardens, restaurants, cafés, and other public places. The laws required that they ride on the last car of metro trains. Orloff rarely left her home. In an interview after the war, she recalled, "I felt like a fly bitten by a spider. . . . I was absolutely paralyzed."[25] It upset Élie that he could not go to the cinema, which was one of his favorite pastimes. Soon the anti-Jewish laws included "the exclusion

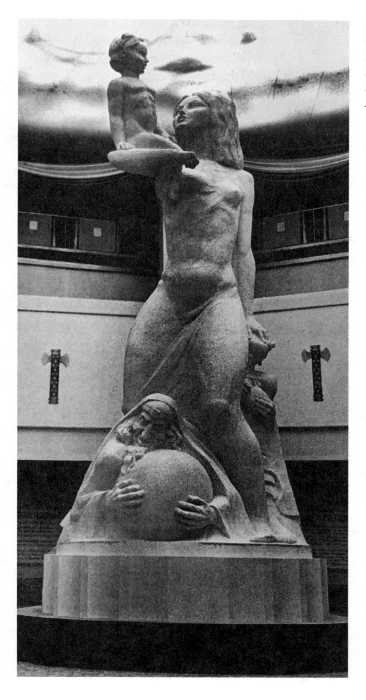

Figure 11.5.
Charles Clement
Francis Perron,
*France Liberating
Itself from the
Jews*, 1941.

of Jewish students," and he could no longer attend university, where he had begun studying mathematics. Devastated, Élie noted with irony that the French government had engraved his émigré poet father's name on the walls of the Panthéon. How could this same government now betray them?

ESCAPE FROM PARIS: LYON, GRENOBLE, GENEVA (JULY–DECEMBER 1942)

Early in the summer of 1942, Orloff began making plans for the third time for her and Élie's escape from Paris. She closed down her studio and moved some of her most valuable works in bronze to the homes of non-Jewish friends for protection. Wanting to ensure that she could cast her sculptures after the war, she asked Rudier to keep some molds on-site at his foundry and assist her with hiding others. She and Élie split up to make it more difficult for Nazi authorities to locate them. They each stayed in the homes of different local Parisian friends. Orloff went to the apartment of Dagny Bjørnson Sautreau, an affluent friend and client whose portrait she sculpted in 1939.[26] Élie stayed with a family friend named Ladislas Starévich (Starewicz), a Polish-Russian filmmaker who lived in the eastern suburbs of Paris, in the Fontenay-sous-Bois neighborhood. After spending some time in the Starévich residence, Élie moved to the apartment of another family friend, Madame Rappaport, who lived in a building located just southwest of the Porte d'Orléans. She was the mother of Élie's friend Joseph Kessel, son of the decorated French writer and journalist of the same name.

While they were in hiding, Rudier learned from a friend who was an official in the French police department that Orloff and Élie's names were on a list for the imminent mass arrest of Jews in Paris the very next day. The Vélodrome d'Hiver (or Vél d'Hiv) Roundup was a Nazi-directed raid by the French police that resulted in the arrest of thirteen thousand Jewish residents of Paris, including over four thousand children.[27] They deported most of those arrested to Auschwitz. Realizing that Orloff was in imminent danger, Rudier, with help from their mutual friend Jean Paulhan, who knew where she was in hiding, shared the news of the impending raid with her: "You are on the list. Get out of here. I give you two hours."[28] Paulhan, a literary critic and book editor,

was a pivotal figure in the intellectual resistance and a cofounder of *Les Lettres Françaises*, a clandestine newspaper published by writers during the war. There was just enough time for Orloff and Élie to grab any belongings they wished to take with them and complete their plans to leave Paris imminently. Initially scheduled to take place July 13–15, 1942, French authorities decided at the last minute to postpone the roundup to July 16–17, to avoid a public outcry on Bastille Day (July 14). French people could not celebrate the French national holiday in the occupied zone. This gave Orloff a few extra days to prepare for their escape.

Not knowing how long they would be away, once again, she packed a few of her pocket sculptures, along with a set of photographs of her work. She also took with her a copy of the monograph the French art critic Léon Werth had published about her work in 1927, and rolled-up drawings and watercolors made by Parisian artist friends that she hoped to sell if money got tight. This time, she entrusted the keys, care, and protection of her home and studio to a woman named Madame Cardinaun and her daughter. We know little about this woman and what led Orloff to delegate this important responsibility to her. Orloff returned to her hiding place at the home of Madame Sautreau and completed plans for their exodus.

A short, unpublished reflection by Frédéric Paulhan, the son of Jean Paulhan and Sala Prusac Paulhan and a close friend of Élie's since childhood, offers a vivid account of Orloff's and Élie's experience during the last weeks leading up to their exodus from Paris. Demobilized from the French army for a few months, Frédéric, age twenty-three, was then working at the Musée des Arts et Traditions Populaires. A few days after the Vél d'Hiv Roundup, Orloff telephoned him from her hiding place with an urgent question. Was he willing to go to her house on the Villa Seurat later that same night to retrieve a dossier? Frédéric, a loyal friend who later became involved in the Resistance, agreed without hesitation. Orloff gave him explicit instructions, which he would follow with exactitude. That night, in the pouring rain, he set out from his home near the Porte de Chatillon after dark, and walked to Orloff's neighborhood off the rue de la Tombe Issoire. He identified an unnamed woman, "a young Russian émigré" whom he had met in the street and "did not know at all," to keep watch over the house

while he looked for the dossier. As instructed, Frédéric entered Orloff's studio through a window leading to a secret passageway connecting the street-facing studios of the two adjacent homes. While they locked the doors and windows of each house, he could easily access this small passageway through a wooden door.

Once inside, the darkness and silence were palpable. Frédéric entered the western house (7 bis Villa Seurat, built by Perret) and climbed the stairs from the ground-floor studio up to the living quarters. He easily located the room with the enormous desk that Orloff had described, as he knew the house and its nooks and crannies well from his regular visits since childhood. It surprised Frédéric to find not one but two dossiers set out on the wooden desktop. He grabbed the folder that best fit her description in its color and weight, and stashed it under his coat.

Before exiting the house, however, Frédéric heard a car pull onto the small street. The police stopped the unnamed woman who had agreed to keep watch. Little did either of them know that a neighbor had been watching her from a window. This neighbor apparently did not see Frédéric enter Orloff's house. When Frédéric eventually exited Orloff's home and returned to the street, the woman had disappeared. The police from a nearby station had taken her away for questioning. While Frédéric described her as a "Russian émigré," he did not say whether she may have been Jewish. Perhaps he did not know. He was, however, clear that he had not shared with the young woman his name, address, workplace, or any other details about what he did that night on the Villa Seurat. As a result, she did not put him or Orloff at risk, but the German military may have kept her under surveillance. Frédéric realized his efforts to save Orloff and Élie had deep implications for this young woman whom he did not even know, who put herself in danger to help others.

Once outside, Frédéric hustled in the dark toward the Porte d'Orléans. For the moment, he put aside his worries about the woman, whom he referred to as his volunteer "watch-guard." On a mission to deliver the dossier to Élie at the Rappaport home, as instructed, Frédéric tried to blend in with the crowd as he passed the metro station. When he arrived at the front door of the second-floor apartment, he rang the bell. He could just make out Élie looking at him through the peephole,

Élie's body nervously pressed against the door. Élie had been anxiously awaiting Frédéric's arrival for half an hour, fearing that the Gestapo would arrive first and arrest him. The apartment was in a state of disarray, and Frédéric speculated that the police recently raided it. The elderly Madame Rappaport lay supine on her bed, drenched in sweat and appearing ill. She was in such terrible shape that the Gestapo could not transport her. The two friends hardly spoke. Frédéric handed Élie the dossier. After taking a quick glance at its contents, Élie grew pale, his hand trembling. He then wrapped the dossier in a napkin and left the room. The dossier likely contained Élie's false identity papers and Orloff's ausweis, the German document required to cross the demarcation line to the free zone without suspicion. Frédéric assured Élie that he had not inspected the papers himself. He then quickly left the apartment, having only stayed for a few minutes. Frédéric recalled feeling intense gratitude at that very moment; he could walk away from the scene "as a free person, out in public," in clear contrast to his dear friends, who had become refugees in their own country of citizenship. The fate of the unknown woman who volunteered to help him also must have weighed heavily on his mind that night.

Approximately one week later, Orloff still in hiding at Madame Sautreau's, called Frédéric again. This time, she asked him to meet her at a café near the Gare d'Austerlitz. Once he arrived, she explained that she and Élie must leave the city by train the next evening. She asked Frédéric to rent a room for her and Élie in his own name at a hotel near the train station. Orloff handed him enough cash to cover the expense. She and Élie stayed together in the hotel room for the one night before their respective departures the next day on separate trains headed for the *zone libre*. Frédéric recalled how Élie, trying to remain inconspicuous until the exact hour of his exodus, pretended to be part of a procession of handicapped children walking through the neighborhood near the train station. Significantly older than the children in this group, Élie exaggerated the limp that paralyzed one side of his body, and the tremors he regularly experienced. He usually refused to let his disability get in his way of walking, running, or even playing ping-pong with the support of a cane. This time, however, Élie embellished his condition to "pass" as a non-Jewish disabled child. Frédéric recalled how the two friends exchanged knowing glances. He nearly burst out

laughing upon seeing Élie's exaggerated gestures as the group passed him in the street.

That evening, during the first week of August 1942, Orloff and Élie each left Paris from the Gare d'Austerlitz on separate trains heading south.[29] Through a contact at the Red Cross, they got false identity papers—the papers that Frédéric had retrieved from their home. Élie traveled with a fake French passport, under the fictitious name of Edouard Justin (a play on his last name, Justman). Orloff did not change her name, but got a fake ausweis.

Orloff and Élie carefully planned each leg of their journey to ensure that Élie could move safely given his physical disabilities. Élie took the train directly to Lyon. Once he arrived, he rented a hotel room for one night before meeting up with Orloff in Grenoble in two days. Accustomed to staying in elegant lodging from his experience traveling internationally with his famous mother, Élie ironically stayed at the same hotel where the Gestapo lived in Lyon. While he did not realize this at first, it was a location where he was safe from police raids.

Orloff took a more circuitous route south and farther east, toward Grenoble. A friend of Élie's, a math professor who was of Basque origin, connected her with a *filière* or *passeur*, a Resistance worker familiar with the circuitous routes through the mountains. Orloff had to walk for hours through the mountainous region. Even though she could handle the challenging terrain, the trip exhausted Orloff. Two days later, mother and son reunited at the home of Léonce Bernheim, Madeleine Fleg's brother, who lived in Grenoble. Orloff had visited the Bernheim home several times over the years, including in 1926, when Mr. Bernheim commissioned her to sculpt his portrait. Once she arrived, she sent a letter to Tola Rank, confirming their safe arrival: "Dearest, finally I'm with Didi among my friends. I would like to join you as soon as possible. It depends on you, hurry. . . . We are in good health. . . . I have so much to tell you I don't know where to start. But maybe we will meet again soon."[30]

Their initial plan was to stay in Grenoble as long as they were safe. Given how close they were to the Swiss border, it is unclear why they did not travel directly on to Switzerland. Unable to stay at the Bernheims' indefinitely, Orloff found lodging in a *pension de famille*, where they lived in close quarters for three months. Restless and unsure how

long the war would last, Élie was desperate to continue his education and develop professional skills that used his strong abilities in math. Unsure of his status as a Jewish student, he learned that he was eligible to take courses at a vocational school, the Institut d'Actuaires, in Lyon. Given the grave dangers they faced daily, it is surprising that Orloff agreed with his plan to backtrack away from the Swiss border to Lyon for the sake of Élie's education. Lyon, however, was a major center of Resistance in the free zone, with powerful connections to Geneva, and that likely was another attraction.

Orloff and Élie met up in Lyon with her friend, the painter Georges Kars, and his wife, Nora. A Jewish émigré originally from Kralupy, a town near Prague, Kars had arrived in Paris a few years before Orloff in 1908 and traveled in similar artistic circles.[31] Kars exhibited his work in the Galerie Berthe Weill in 1928, among many other venues. A recipient of the French Legion of Honor (1938), Kars was a close friend of the late Pascin, and Chagall. He had enjoyed an active career painting landscapes and psychologically probing portraits in the style of his *Self-Portrait* (1929) (see plate 9). Orloff sculpted his portrait bust, bearing a similar facial expression to his self-portrait and exhibited the piece at the Salon des Tuileries in 1931 (see figure 11.6). Kars had spent the years of World War I on the Galician Front in Russian captivity and was anxious about living through another war in exile. He suffered from depression and anxiety, along with a heart condition that made him weak and prone to illness. He remained active as an artist in Lyon following the German occupation and would hold exhibitions of his work there in 1941 and 1942.[32]

Orloff rented a room in a hotel near Élie's school in Lyon and began strategizing with Georges and Nora Kars on a plan of escape. Their financial resources dwindling, she walked from door to door in their Lyon neighborhood selling the watercolors she had transported from Paris, by the popular French artist André Dunoyer de Segonzac. Segonzac was one of a small group of French artists who willingly identified with the Germans and French collaborators during the war.[33] They barely had enough to eat, subsisting on turnips that their friends managed to smuggle in to them.[34] She reached out to Jewish agencies and received funds every three months from the American Joint Distribution Committee, the primary benefactor for Jewish emigration and

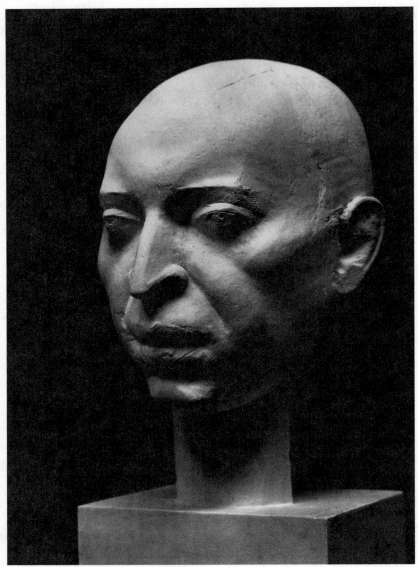
Figure 11.6. *Georges Kars*, 1931. Plaster.

rescue attempts from Nazi-controlled territories during World War II. Tola Rank continued to write regularly with offers of financial support, and Orloff's relatives back in Palestine also sent funds.

During this tough period in Lyon, Orloff became dejected. She could not create art and lost all motivation. Élie reflected on his mother's experience in an interview: "For the first time in her life, Chana, depressed, seems to give up and contemplate suicide. It was her love for her son that saved her."[35] While she herself did not describe her emotions during this low point directly in interviews, she must have drawn strength from her memories of overcoming struggles against virulent antisemitism during the pogroms of her youth in Ukraine. In another reflection on this period, Élie likened his mother to "a wild and strong horse, hindered in flight by a fragile foal."[36] His commentary suggests his awe in her resilience and that he personally grappled with fears that his physical disabilities could impede their escape.

By November 1942 Orloff and Élie realized they could no longer stay in Lyon. German forces had violated the Armistice by invading Vichy and the zone libre, in retaliation for the Allied forces' invasion of French North Africa. The zone libre now became the *zone sud* (south zone), and the occupied zone became known as the *zone nord* (north zone). The German military administration in France ruled both zones, with the Vichy regime only nominally in charge. Orloff recalled: "When the Germans arrived, we looked to leave for Switzerland. It was nearly impossible, but die, or die . . . But not with the *boches* [derogatory term for German soldiers]."[37] She likely meant that she would rather risk her life by facing the harsh physical conditions of the journey than be killed by the Nazis. Many artists and writers were taking refuge in Switzerland during the war years, and they knew this was their only option. Kars's sister, Elsa Werflové, lived in Zürich, and he could stay with her. Both Orloff and Kars had many personal and professional connections there. Since his wife, Nora, was not Jewish, they made the tough decision that she would stay behind in Lyon because of the costs and risks associated with crossing the border illegally. And so, Orloff made detailed plans for yet another harrowing escape.

Because of Élie's partial paralysis and difficulties walking, they had to plan the least physically challenging route across the border. They arranged their secret crossing through a connection that Kars had to

an art aficionado named Jacques Duclos, who was a French police commissioner. In December 1942 certain members of the Vichy Police were still willing to help Jewish émigrés escape from the newly occupied zone sud. However, if caught, they risked being sent to the Drancy concentration camp. Through this police commissioner, they met Louis Jacques, a prominent Swiss passeur, who helped Jews and others in exile pass the border illegally for no fee. His house, known as Maison Jacques, was in the village of Archamps, just above the national route 206. Louis Jacques and his daughter, Florentine, helped guide war fugitives traveling by foot to cross the border illegally into Switzerland near the Landesy border station.[38] This escape route was Orloff, Élie, and Kars's best option, because it allowed them to avoid treacherous mountainous terrain. Orloff received detailed instructions for each leg of their journey, from their hotel in Lyon all the way to Maison Jacques.

Several hours before dawn on the morning of December 17, 1942, Orloff, Élie, and Kars awoke in the dark. After Kars said a tearful goodbye to his wife, the three of them quietly departed by foot and headed to the train station. They left their suitcases and most of their belongings behind with Nora, who eventually would send everything back to Paris. Orloff carried a large cloth sack containing a few items of clothing for herself and Élie, along with money and some provisions for their journey. She also took a collection of photographs of her sculptures, and the small paperback monograph of her work published fifteen years earlier that she had brought from home. She knew that such documentation would be important in helping her reestablish her professional life in Geneva.

Kars carried a large satchel that contained a men's gabardine coat, some of his valuables stuffed into the pockets, an extra pair of shoes, and an umbrella. He planned to sell the coat for income in Switzerland. Eventually the three of them boarded a local train headed east toward the Alps, that stopped in the town of Artemare (about one hundred twenty kilometers east of Lyon). When they arrived at the small station, they noticed several police officers clearly looking at them. They were easily identifiable as refugees. The officers first made eye contact, then looked the other way, pretending not to notice them. From there they walked along the train tracks toward another small station. After waiting there for several hours, they boarded a bus that took them along a

windy road headed northeast about sixty-five kilometers further into the mountains, to the town of Collonge-sous-Salève, a small commune in the Haute-Savoie department in the Auvergne-Rhône-Alpes region, very close to the Swiss border. With the elevation increasing along their journey, they noticed snowbanks on either side of the road. At some point along the way, the bus broke down. They worried about having to hike through the snow. After some time, the driver was able to get the engine going again. Once they arrived at Collonge and exited the bus, a German soldier saluted them. Orloff recounted in an interview, "You don't know how afraid I was when he looked at us. My heart stopped! He said to us, 'Good evening!'"[39] Such a gesture, from a Nazi-affiliated soldier, shows that there was a level of resistance even among those tasked with monitoring border crossings. From the bus stop, Orloff, Élie, and Kars walked through the snow for three kilometers and arrived at the tiny village of Archamps.

When they finally reached Louis Jacques's house, Jacques and his daughter, Florentine, greeted them and offered a warm place for rest, food, and drink. Once they had recouped some of their energy, it was time to set out again on the last leg of their journey. Jacques explained that the most difficult obstacle they would face was crossing the border via a shallow river, the Arande, through a tunnel that passed under a bridge known as the Pont de Combe. A map of the area shows the escape route, the arrows leading from the Maison Jacques, on the French side of the border, across the river, to private Swiss property (see figure 11.7). Several refugees, assisted by the Jacques family and a pastor named de Pury, escaped Occupied France to Switzerland at this exact spot in the fall and winter of 1942.[40]

Orloff naturally was full of fear and anxiety. Now age fifty-four, she was not agile, even though she was still vigorous. She was especially concerned about Élie's health and safety under challenging physical circumstances. Kars's angst also must have affected her. By the time they left the Jacques house, night had fallen. They walked a short distance through the steep terrain, navigating their way around rocks, tree branches, and mounds of snow. They descended under the road and reached the river. Jacques had alerted them to look for the landmark of the bridge, which had a guard on duty. They knew the exact hour at which the guard took a break. They waited in a wooded area and

Figure 11.7. Maurice Baudrion, drawing, La Salévienne. Pont de Combe, Archamps, France.

kept watch in the cold, dark silence. When the moment arrived and they saw the guard walk away from his post, they scrambled down to the river's edge. Directly under the bridge, the water passed through a tunnel, closed off at each end by a barbed wire gate. Louis Jacques had cut the wire and left the gate ajar so that fugitives could take this passage, which led them directly onto Swiss soil via private property.[41]

They had no choice but to plunge their feet into the icy water as they crossed the river. Orloff's feet tingled, and she feared frostbite. Her eyes remained fixed on Élie as she walked carefully behind him, prepared to catch him if he fell. Exhausted from the journey, it was in fact Orloff who lost her balance. While uninjured, she got wet and momentarily lost a hold of the sack she was carrying. Devastated, she watched the precious package that contained photographs of her work, money, and other personal items get taken away in the strong current. She got up and kept walking. Once they reached the other side, she miraculously found her bag stuck to a branch; its contents remaining inside were wet. Orloff hoped that she could salvage the photographs and the rest of her few, precious belongings. Somewhere along their

route that night, Kars also lost most of his own personal items that he was carrying with him.

After crossing the river, they walked through muddy terrain for several more hours in the dark. The cold air was still, and it became difficult to find their way. Élie somehow found the strength to endure such a journey despite his physical condition. Exhausted, cold, and hungry, they grew weary. They were unsure whether they were walking in the right direction toward Geneva. After traveling for nearly twenty-four hours straight since they had first set off from Lyon in the middle of the night on December 17, 1942, two Swiss soldiers stopped them at eleven o'clock at night in La Croix de Rozon, a village in the canton of Geneva. Their energy depleted, they anxiously awaited their fate. Would the Swiss authorities admit them, allowing them to begin a new chapter as Jewish refugees?

CHAPTER 12
Exile and Return,
1942–1948

Orloff, Élie, and Kars identified themselves to the Swiss soldiers as Jewish refugees who had crossed the border illegally. The soldiers transported them to a police station near Geneva, where they were arrested at three o'clock in the morning and placed under military control.[1] Orloff told the police that they had been wandering for two hours just south of the city, without knowing exactly where they were. Only one hour earlier, another group of people—which included Dora Benjamin, the sister of the German-Jewish writer Walter Benjamin—had crossed the border in this same place, with help from a different well-known Swiss passeur, Louis Pache.[2] It is possible that Orloff, Élie, and Kars had encountered this group on the same route.

Following their arrest, the officers collected their passports and identity cards. The red "J" stamps, adhered when they first registered as Jews in Paris, were visible. Dr. Heinrich Rothmund, head of the Swiss Police Division, was in fact the first to propose this initiative to mark the passports of German Jews following the German annexation of Austria. Other countries then followed suit.[3] The Swiss government kept a file for all refugees who successfully entered the country, tracking the details of their immigration and related official paperwork.[4] Orloff, Élie, and Kars were among twenty-two thousand five hundred Jews who emigrated to Switzerland between 1938 and 1944.[5]

Reputed to be welcoming of immigrants during this time given its neutrality, Switzerland in fact had a long history of anti-Jewish immigration policies dating back to the late nineteenth century.[6] During the

interwar years, the Swiss government developed policies grounded in nationalism and institutionalized antisemitism. The primary goal was to protect the nation from foreign infiltration. They targeted Jewish immigrants from Russia and Poland in particular. At the direction of Rothmund, Switzerland closed its borders completely on two occasions during the war: in 1938, when the Austrian Jews tried to escape during the Anschluss of Austria to the German Reich, and in 1942–43, when Jews from France, Belgium, and Holland were being deported to the death camps in Poland. The Swiss government denied entrance to over thirty thousand Jewish refugees in 1942 alone, leaving them under control of the Nazis.[7] In an infamous speech, Federal Counselor Eduard von Steiger declared, "Our lifeboat is full."[8] The Swiss defended this decision by pointing to their small population of roughly four million and to the fact that Nazi troops and nations geographically surrounded them. In an interview after the war, Orloff described the intense fear of being turned away at the border; she, Élie, and Kars waited while the soldiers who stopped them called police headquarters in Bern: "Admitted, they admitted us!"[9]

Following their arrest, an officer interviewed Orloff and asked her to complete a fifteen-page handwritten questionnaire required of all who entered the country. The Swiss authorities then typed up an official one-page summary of that document, known as the "Declaration," which she signed. She used her married name, "Justman," in legal documents, reserving "Orloff" for professional and personal use. She noted her parents' names and her place of birth, and described herself as a sculptor and a widow. Sometimes the language in the official Swiss document departed from that of Orloff's in the questionnaire. She described her nationality as French, whereas the Swiss pronounced her "French by alliance." The Swiss also designated her and Élie as "Israélites," the word used by the French to describe Jews, whereas she wrote "Juive." Orloff said her health was "good," and recorded Élie's "infirmity because of childhood illness." Under "means of existence," she wrote that she had "access to a fortune in America that she could receive immediately following a telegram." She recognized the importance of being able to justify her financial independence as a Jewish refugee during wartime.

The questionnaire asked Orloff to provide names of any Swiss

friends and acquaintances. She listed Emilie Gourd, a feminist suf-
fragist and journalist known for her activism in Geneva. She also cited
the Nordmann family of Fribourg, prominent leaders in the Jewish
community of Switzerland. While she did not include their names, she
also was in touch with Albert Kundig, a Swiss artist, art book printer,
and publisher who lived in Geneva. Kundig's nephew, Georges Moos,
was another important contact; he was a successful Jewish art dealer
who had organized a solo exhibition of Kars's work at his gallery in
Geneva a decade earlier.[10] Orloff alerted these contacts and others to
her situation and that she might need help in securing accommoda-
tions and commissions in Geneva.

Immediately following their arrest, the Swiss border patrol took
Orloff, Élie, and Kars to a reception camp called Charmilles. It was
at the site of an old primary school in central Geneva. We know little
about the Swiss system of wartime camps, where thousands of Jewish
refugees from France and other parts of Europe landed upon arrival
into the country. They forced many to move from reception camps on
to labor camps, organized by the Central Directorate of Work Camps.[11]
In a controversial report published by the Simon Wiesenthal Cen-
ter in 1988, Dr. Alan Morris Schom identified sixty-two such camps
by name, and described the many human rights violations that took
place in them.[12] They expected men up to age sixty to do manual labor
from dawn to dusk. The type of work varied; some worked in facto-
ries making canteens and other gear sold to the Germans, and others
wore striped uniforms and worked in the field, roads, and forests with
shovels and pickaxes, in summer and winter. They sent women and
girls to institutions and private residencies to perform menial labor.
According to Schom, Switzerland maintained a "two-track policy" for
Jewish and Christian refugees throughout the war. The Swiss govern-
ment supported Christian refugees, whereas the small Swiss Jewish
community sustained Jewish refugees, along with American Jewish
relief organizations like the Joint Distribution Committee.[13]

Living conditions were primitive in the Swiss reception and labor
camps. When Orloff, Élie, and Kars arrived at Charmilles in mid-
December, they had to sleep in unheated barracks on piles of straw
rather than actual mattresses. They crowded the camp, with one hun-

dred fifty people, including young children, filling a single room.[14] Officers evaluated each refugee for their readiness to work. Élie's health condition excused him from any work responsibilities; Orloff, also, was excused from "women's work," in her role as Élie's caretaker. After one tough night in the camp, she demanded to see the director. She exclaimed, "Let me go to Geneva, I can earn a living." "How?" the camp director replied. She then took out her collection of photographs of her sculptures, still damp from her fall in the stream, to prove her livelihood.[15] They released Orloff and Élie from the reception camp that same day, eager to start a new life in Geneva.

They found lodging in a small room in the Pension Florinetti, located centrally at 9 rue Ferdinand Hodler. They paid 300 Swiss francs per month for housing and food combined. The heating in their room was minimal, and they were often cold during that first winter.[16] Because of the hard living conditions, they moved three times over the course of their two and a half years in Geneva. They had to visit their local police station regularly for check-ins as part of living under military control. In addition, they could not travel legally within the country without written approval from the government office of immigration. The most challenging restriction for Orloff was that she could not work legally. As an artist, this meant that she could not exhibit, sell, or even donate her work. Given this, we might wonder whether the director of the Swiss reception camp, in releasing her after seeing photographs of her work, was in fact quietly encouraging her to work clandestinely. Orloff later told a journalist: "From 1939, I lived in anguish. This anguish disappeared as if by magic. I could finally send news to my family. No one knew what had happened to me. There were even obituaries in American newspapers!"[17]

Orloff persevered and began rebuilding her life, which included returning to her sculpture. With her connections, resources, and determination, she quickly navigated ways around such restrictions. She found old friends from Paris, including sculptors Alberto Giacometti and Germaine Richier, who lived in Zürich with her husband, the Swiss sculptor Otto Bänninger. In a letter dated a few weeks after her arrival, Richier wrote to Orloff, "You would not believe how much knowing you are here in Switzerland warms my heart, and we can communicate

with affection both our joys and our sadness."[18] Orloff also reunited with the Zionist leader Marc Jarblum, whom she had seen regularly in Lyon, where he was active in the Resistance.

Orloff also forged many new connections in both the Swiss art world and Jewish community. Kundig introduced her to a woman named Karin Lievin, a Swiss printmaker who came from a bourgeois Jewish family. Lievin offered the use of her studio space soon after Orloff's arrival; eventually, she lodged Orloff and Élie in her apartment, their third and final address in Geneva.[19] Soon she found tools for sculpting and purchased a regular supply of plasticine, an oil-based, nondrying modeling clay that contains wax. It would become her preferred material during this period of exile, reminiscent of her early years as an art student in Paris. Only a week after getting settled, Orloff began working on a small sculptural bust of an unnamed woman with an intense and determined facial expression. She later told the Parisian art critic André Warnod, "It's the first sculpture that I made in Switzerland. It was in Geneva, on Christmas Eve. It brought me back to life. Never will I forget that Christmas Eve in Geneva."[20]

A small expressive *Self-Portrait* from this period (1943) (see figure 12.1) marks her desire to begin a new chapter in her life. An update to her 1940 sculpture de poche, her face appears rounder and the angles of her features are much softer than in the earlier piece. She sculpted her own likeness many times throughout her career to capture her observations of her own aging process, both physically and emotionally.[21]

Orloff drew upon her experience of resilience to get through this challenging period of exile. She was creative in identifying ways to earn income, even though she could not work legally. Kundig commissioned her to make his own sculpted portrait and introduced her to other collectors willing to work with her.[22] She quietly began selling her sculptures to her friends, old and new. We can assume that she sold her work in plaster "under the table," collecting cash directly from her clients, without sharing documentation of her sales. Orloff and Élie befriended Dr. René Mach, a nephrologist and professor of medicine at the University in Geneva, and his wife and son, Evelyn and Bernard Mach, as well as the family of a Polish-born physician and professor named Zychlinski, among others. Many of these new friends, some of

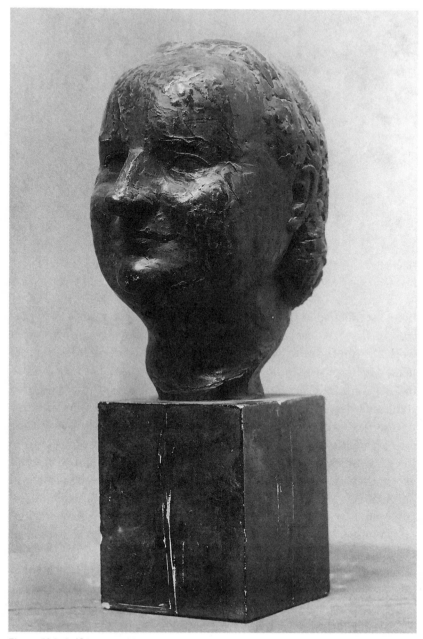

Figure 12.1. *Self Portrait*, 1943. Bronze.

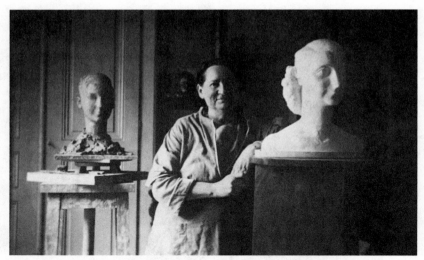

Figure 12.2. Orloff in her studio in Geneva in front of *Portrait of Bernard Mach*, 1943 (*left*) and *Portrait of Madame Dr. Mach*, 1943 (*right*).

them established in the Swiss Jewish community, commissioned portrait busts of themselves and their family members, along with other works, from nudes to sculptures of birds. She sent a photograph of herself in her Swiss studio, surrounded by portraits of her new friends, to Tola Rank in Cambridge (see figure 12.2). It must have reassured Rank that despite the hardships, Orloff was thriving in Geneva.[23]

Georges Kars experienced more difficulties than Orloff in settling into a new life as a refugee in Switzerland. He was not excused from the Charmilles reception camp so quickly. One week following their arrest, they moved him to a work camp called Champel, in a different part of Geneva.[24] Age sixty, he was forced to execute repetitive manual labor and live under despicable conditions. They then transferred him on December 23, 1942, to a third camp, in the village of Girenbad, near to where his sister lived in Zürich. He sent a letter from the camp to immigration authorities in Bern, urging them to search for the belongings he had lost while crossing the border: a Barclay's men's gabardine jacket, its pockets filled with belongings, one shoe, and an umbrella.[25] Two weeks later, he wrote to Orloff that he was finally about to leave the camp and move to his sister's home in Zürich: "It was 7 arduous weeks for me and I've finally reached the end. I'm thrilled to learn that

you are working and Didi can continue with his studies."[26] Dr. Rudolf Kopecky, a Czech government official and longtime friend of Kars, wrote to the head of the Swiss Police requesting Kars's release from the camp so he can live "outside, under military control."[27] Fortunately, the letter facilitated his release.

Kars wrote frequently to Orloff from his sister's house in Zürich. His letters, often several pages long, reveal both his physical and psychological struggles while living as refugee apart from his wife. While Orloff's letters to Kars are missing, those that he sent to her reveal how the two artist friends supported one another during this tough time. Five weeks after his release from the work camp, he wrote, "I just had the pleasure of speaking to our friend Kundig who told me how well you are doing and passed on the letter from Nora . . . he is a representative of our good God in Switzerland," in reference to his Jewish identity.[28] Kars's letters often expressed his despair, self-doubt, and frustration: "If I had money—I would buy colors and materials necessary for painting—like this I can't do anything; I'm not talented enough to ask anyone for anything; anyway, I'm not able to work outside, or rent a studio or hire a model—so what can I do? But it cheers me up to hear that you are working so much."[29]

After seven months in Zürich, Kars reported that he was finally doing better: "I have awoken from the nightmare that was detention in the camp," he wrote to Orloff.[30] "If you came to my home today, you would see a significant change. I created a studio in a *chambre de bonne* [maid's room] at my sister's house, and it's teeming with my work: drawings, about twelve paintings, three sculptures, I will be so happy to show you."[31] Kars made many drawings and paintings in this period featuring destitute-looking refugees seeking shelter (see figure 12.3). He often concluded his letters with pessimism: "But what do you want, we cannot escape from this upheaval, which, alas, still awaits us."[32]

Orloff presumably expressed her own anxieties to Kars. In response to one of her letters, he wrote, "I regret to hear that you are not in a good mood—that you even speak of feeling depressed—especially for material reasons. I refuse to believe you and have faith that your strength will help you get over these minor obstacles. I have every confidence in you."[33] When Orloff asked Kars why his wife, Nora, would not come and join him in Zürich, he lamented, "You think it's so easy, well it just

Figure 12.3. Georges Kars, *Mother with her Children*, 1943.
Pencil on paper. 35 × 50 cm.

became even more complicated today, and I can't take the initiative and force her into an adventure if she's not up for it."[34] Kars also struggled with his physical health. At one point, he was sick with an infection and hospitalized for seven weeks. After his release, he reported that he was readmitted to the hospital ten days later.[35]

Kars remained preoccupied with wanting to recover his lost belongings. In one letter, written nine months after their arrival in Switzerland, he urged Orloff to place an ad in the newspaper on his behalf, reading: "Lost somewhere between Collonge and Geneva in December 1942 by a refugee: a men's gabardine coat (label Barclay London) beige color with red ribbon, a double-felt shoe and an umbrella."[36] And then a month later, he wrote: "Have you placed the ad yet, for the coat?"[37] Kars's perseverance speaks to the trauma and desperation experienced by so many displaced Jewish refugees.

While there was a small underground market for her work, Orloff continued to struggle financially to support herself and Élie. She received funds every three months from the American Joint Distribution Committee, the primary benefactor for Jewish emigration and rescue

attempts from Nazi-controlled territories during the war. Tola Rank sent many messages offering financial help and expressing concern that Orloff had not received money she sent: "Telegram if you have received the $300 sent last spring. We continue if we can."[38] Swiss officials refused to convert the American dollars that Rank wired into Swiss francs.[39] Orloff tried repeatedly to borrow funds from Swiss banks, but they turned her down each time.[40]

Family members in Palestine sent money when they could, along with letters offering moral support. Her brother Zvi Nishri wrote to acknowledge her letter confirming receipt of his transfer of funds.[41] He added, "We all wait, with your agreement, for the auspicious moment when you can rejoin us in our country."[42] A few months later, it became more difficult to send funds from Palestine. Orloff's sister- and brother-in-law, Masha and Dov Skibin, wrote asking her to arrange for the British ambassador to send them a certificate attesting to her financial need.[43] In another letter, they confirmed having sent money through Barclays Bank, but were limited to a small sum of thirty-five pounds.[44] They would try again in a few months. At a certain point, it also became impossible for Orloff to receive funds from her family in Palestine.

An important figure in the Zionist movement, Orloff's brother-in-law, Dov Skibin, tried to help her and other Jewish refugees in Switzerland emigrate to Palestine. He wrote a letter to the leaders of Vaad Ha-Hatzalah, the relief agency of American Orthodox Jewry, on July 7, 1944:

> You are probably well aware of the fact that 40,000 Jewish refugees, who escaped from France and other countries, are currently residing in Switzerland. I am wondering if you can bring them to Israel and rescue them before it will be too late, as it was with the Jews of Hungary. My request holds national interest, as a Jew, and a personal interest, since my sister-in-law, the sculptor Chana Orloff, currently resides there, after escaping from Paris to Geneva.
>
> I suggest you publish a campaign for fundraising in the Israeli press, aiming to all the people in Israel who have relatives in Switzerland. They will definitely be eager to rescue their relatives

and Jews. I myself am willing to donate a considerable amount for the purpose of bringing to Israel some of the Jewish refugees, including the sculptor.[45]

While such efforts ultimately were unsuccessful, Skibin helped raise awareness in Palestine, and in the United States and Canada, of the plight of Jewish refugees in Switzerland.

Orloff and Élie required official written authorization each time they wished to travel within Switzerland as a condition of living under military control. While some Jewish émigrés could transition to the less stringent civil control, it is unclear why Orloff and Élie did not gain more freedoms. They could take their first brief trip during the winter of 1943. Jean Nordmann, a leader in the Swiss Jewish community, invited Orloff and Élie to spend a few days at his family home in Fribourg. The visit inspired Orloff to create a delicate portrait bust in plaster of the Nordmanns' young son.[46] She maintained a deep connection to this family, and Nordmann later described his memory of her renewing her commitment to her work during that visit.[47]

Later that summer, after completing his first semester as a full-time student at the University of Geneva, Élie wrote to the Swiss Police requesting permission to take a vacation with Orloff: "Monsieur Police Officer, having been in Geneva since December 1942 and having succeeded in seventeen exams in Mathematics and Economics, I would like to be able to take a vacation, along with my mother, during the summer at Begnins (Vaud) in the pension of Madame Champ-Renaud. Would you be kind enough to give me a favorable or an unfavorable answer?"[48] The official promptly denied Élie's polite request, without explanation. Apparently, even a brief summer holiday was not possible for a disabled Jewish student living under military control in wartime Geneva. The following year, Orloff was more strategic in planning a brief trip. Her friend, the French painter Adolphe Milich, encouraged her and Élie to visit him and his wife in Lugano.[49] This time, she solicited a letter from a Swiss physician, Dr. Charlie Saloz, to accompany her request. The letter stated that Orloff was being treated for "chronic bronchitis, surely caused by the poor hygienic conditions of living in a glacial apartment without sunlight."[50] The physician stated that Élie's fragile health condition was exacerbated by his working so hard in his

studies. While not "vital," he concluded, their desired holiday is "neces-sary," and "only entails costs for the interested parties."[51] This time the officials approved the request.

After living in Geneva for less than a year, Orloff established a relationship with a local foundry named Pastori, where Giacometti and Richier also cast their work. Her friend, the art dealer Georges Moos, was eager to sell her works in bronze, even though doing so was illegal. Moos's sales records show that the gallery took five bronze sculptures by Orloff on consignment from an entity listed as "Orloff-Salmanowitz" in November 1943.[52] One of these pieces, *Ophèlie* (1943), sold four months later to R. Junot, for 800 Swiss francs. Orloff's name is omitted from the sales record, and the creditor is listed simply as Mr. Salmanowitz. Jacques Salmanowitz was an avid Swiss art collector and wealthy Jewish entrepreneur based in Geneva.[53] Instrumental in bringing Jewish refugees into Switzerland from Occupied countries during the war, he was one of many who advocated for Orloff to sell her work. As a workaround to her legal situation, perhaps Salmanowitz commissioned the bronze casting of the works and paid Orloff in cash for them, and then placed them for sale with Moos at his Gallery.[54]

Others advocated more publicly for Orloff's legal right to exhibit and sell her work. Most prominent among them was Louis Gielly, profes-sor of art history at the University of Geneva, curator at the Musée d'Art et d'Histoire, and editor in chief of *Le Genevois*, the organ of the Swiss Radical Party.[55] Gielly wrote several letters to Rothmund, chief of police, and other government officials, in which he challenged the immigration laws prohibiting Orloff from working in Switzerland:

> Chana Orloff is a reputable artist, of an undeniable talent;
> she has been awarded the Chevalier of the Legion of Honor;
> a great number of museums in Europe and America have been
> keen to acquire her works.
>
> A refugee in Switzerland, she does not have the right to sell
> her work.
>
> I have asked you if it would be possible to make an exception to
> the rule in her favor. She is responsible for a disabled son. But the
> point upon which I must insist is that the Swiss artists of Chana

Orloff's caliber are pleased when they are invited abroad to exhibit and sell their work, and it seems legitimate to me to use reciprocity towards their colleagues from other countries. Protectionism in the artistic field seems to me singularly disagreeable, and one risks it one day working against us.[56]

In response, Gielly received curt replies from the government officials in Bern rejecting his request. Outraged by their lack of humanity, he published a front-page editorial in *Le Genevois* under the headline "Displaced Protectionism." In it, Gielly calls out Swiss governmental policies toward refugee artists:

Einstein's theory, is it false because Einstein was Jewish? If we discovered a cure for cancer, would you refuse to use it because the person who discovered it was a German, or an Englishman, or a Russian, following your personal distaste? . . . But, for the sectarians, there is only religion, race or nationality; there are political appearances. Have you ever worried, while contemplating the *Mona Lisa*, whether Leonardo da Vinci was republican or monarchist?

. . .

Why is it that a virtuoso is not able to perform? Painters and sculptors do not have the right to exhibit, sell, or even donate their works? We allow them to work secretly in their studios, if they have resources; if they do not, we intern them in a camp.

Gielly's editorial openly confronts the Swiss immigration policies as nationalist, xenophobic, and antisemitic. Orloff clearly fell into the former group of socially privileged artists, working clandestinely to support herself and her son during this difficult period. Gielly firmly but respectfully urged that such laws be reconsidered:

Undoubtedly, Switzerland fulfills its duties of hospitality towards the unfortunate. But there are certain cases where we do so without sensitivity, flexibility, understanding and generosity. We do not criticize the offices that only apply the laws; at most, we can blame them for being heavy-handed. But what must be said, and very loudly, is that the law is poorly designed, poorly implemented, and that it does us no honor, quite the contrary.[57]

Gielly's editorial exposed the Swiss government's treatment of refugee artists unjustly exiled from their own home countries as both dogmatic and inhumane. Ultimately, he suggested, this position harms the country's international reputation.

Rothmund responded to the piece by thanking Gielly for his "candor" and offering to meet with him in person to discuss this "delicate matter."[58] Nonetheless he failed to budge or offer any compassion in Orloff's case. His argument was that they should not allow refugee artists to take any work or opportunities away from Swiss artists: "Because of the smallness of our country, our artists have limited possibilities to earn a living, and at a time when many foreign artists have been forced to leave their country, and Swiss artists have had to return to our country and stay, the authorities cannot ignore the issue."[59] In spite of the Swiss government's nationalist and xenophobic position, Gielly's advocacy eventually helped Orloff by calling public attention to the issue. She wanted more than anything to have a solo exhibition of her work in Geneva before returning to France.

A few months after Gielly published his editorial, the Allied forces descended on the beaches of Normandy in June 1944. Nazi defeat was now within reach. Orloff wanted to return to Paris immediately, but her friends encouraged her to wait. In the meantime, the Swiss became more lenient in their policies toward refugee artists. Seeing an opportunity, she strategized with Moos on plans to open a solo exhibition of her work before returning home. They each wrote to government officials endorsing the plan, and solicited the Swiss artist Alexandre Mairet, president of the Geneva chapter of the Society of Swiss Painters, Sculptors and Architects, to do the same. Their letters eventually reached Rothmund in Bern.[60] Finally, the Swiss government agreed that Orloff could exhibit her work.

Orloff opened her solo exhibition at the Galerie Georges Moos in Geneva on February 17, 1945. It was open for just over two weeks, through March 3, 1945. An installation photograph reveals the scale of the show (see figure 12.4). Thirty-three sculptures, portrait busts, figural nudes, and animals in plaster, bronze, and wood, placed upon pedestals, were spaced equidistantly throughout the gallery. Among the portraits were busts of her many new friends; some of them, like M. Antonioz, a young friend of Élie's, were involved in the Resistance efforts in Geneva.[61]

Figure 12.4. Installation photograph, February 1945. Moos Gallery, Geneva.

A selection of her framed figural drawings, in both ink and pencil, lined the gallery walls. The exhibit included most of the work Orloff produced during her two years living in exile. Works like *Nude in an Armchair* (1943) (see figure 12.5) show the artist's continued fascination with the smooth and compact forms and curves of the seated female body. More naturalistic than Orloff's stylized sculpted nudes from the 1920s, this work shows how her approach developed. She worked in a smaller scale in Geneva than in Paris, due to space and financial constraints. Another work, *Paix* (1944), features a dove as the classic symbol of peace at the war's end.

Many Swiss art critics reviewed Orloff's exhibition at Galerie Georges Moos.[62] Among them, Albert Rheinwald of the *Journal de Genève* and Dorette Berthoud of *La Suisse* described her bronze rendition of the Old Testament subject of Eve, visible on the far left of the installation photograph. The female form appears nude in the classic pose associated with Eve's expulsion from Eden.[63] A reworking of Orloff's 1928 (see figure 12.6) and 1940 renditions of this theme, *Eve* (1944) takes on a particular poignancy in the context of her personal journey as a Jewish woman artist living in exile during the war. Berthoud writes:

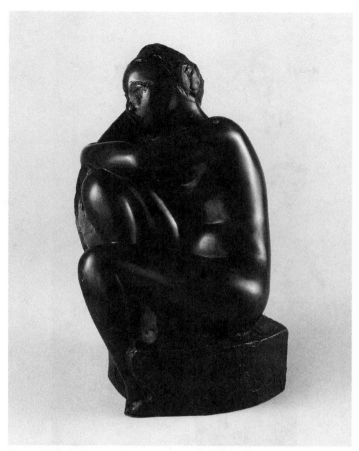

Figure 12.5. *Nude in an Armchair*, 1943. Bronze.

Chana Orloff is not interested in representing the nude in the manner of the Greeks, but to express, through the forms and lines of the body, the profundity of life. Nothing is more striking, in this regard than her Eve—Eve after the act—who, with one hand covering her powerful belly and the other, her face. Not out of shame, of course, but to the contrary, to experience fully the power of what she has accomplished.[64]

Berthoud reads Orloff's *Eve* as self-possessed and confident—rather than ashamed or humiliated—traits she observes throughout the article

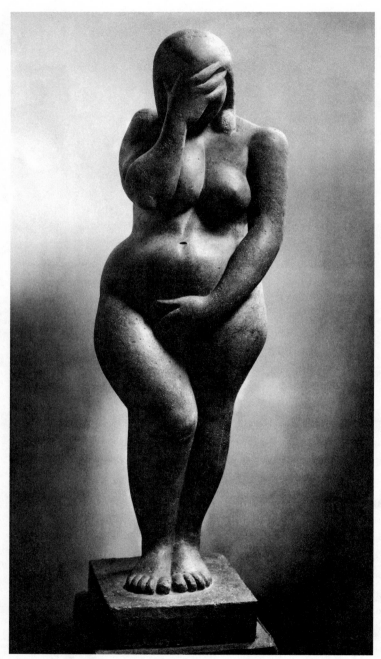

Figure 12.6. *Eve*, 1928.

in the artist's own remarkable personal story of struggle and resilience. When she first met Orloff at the gallery, the journalist recalled how the artist proudly handed her the monograph by Léon Werth that survived Orloff's harrowing escape and river crossing. With its "warped pages, peeled off," the critic described the small paperback book as "the most moving testimony of climbing through barbed wire, by this woman, whom age weighs down . . . a winter night's journey of terror."[65]

While other Swiss critics focused on Orloff's international reputation and place within a lineage of French sculpture, Berthoud emphasized the challenges faced by so many refugee artists living quietly among Swiss citizens during the war:

> The Swiss public is not aware of all the high-quality refugees that escaped from the Nazi persecutions that surround us. In the shadows, with makeshift means, some have set to work. The work allowed them momentary escape from their terror and suffering; it served as a consolation or outlet; it gave them a reason for living. If outside of their environment, stripped of their renown, obliged to silence, these artists have experienced an awakening of interest, aroused enthusiasm, they will return home strengthened, the authenticity of their genius confirmed. It will be their revenge. I thought about this the other day when visiting the exhibition of Chana Orloff generously started by M. Georges Moos.[66]

The warm critical reception of her work invigorated Orloff as she prepared to return home to Paris. Several of her Swiss friends purchased works from Moos following the exhibit, suggesting that restrictions finally loosened.[67]

Just as Orloff was preparing to open her exhibit, Georges Kars contacted her. Because they both lived under military control in separate cities, the two visited each other infrequently over the course of their exile. They spoke and exchanged letters regularly. Kars told Orloff that he received a letter from the Swiss government authorizing his return to France in early February. With the Allies in control and the end of the war in sight, the Swiss arranged transportation for thousands of refugees to return to their home countries. Orloff obtained official permission to postpone her and Élie's scheduled departure by several months because of her exhibition. When she met Kars at the Geneva

train station, he must have looked particularly fragile. At age sixty-two, the difficulties of the past two years in exile had taken a toll on him. From the train station, Orloff led him to a nearby hotel where she had reserved a room for him. Soon after getting settled, Kars visited a Jewish agency in Geneva, where he learned that the Nazis murdered his brother, sister-in-law, and nephew, all of whom were deported near the beginning of the war in Lodz, Poland. Devastated by this news and the horror of the death camps, Kars was inconsolable. He ended his own life by jumping from the window of his fifth-floor hotel room in Geneva.[68] He died just hours before he was scheduled to board a train headed back to Lyon to reunite with Nora.

When she first saw Kars's limp body, Orloff decided to bring supplies over to create his *masque mortuaire* (death mask), a long artistic tradition of creating a relief sculpture of the face of the deceased. She created drawings and two different molds of his face, using plasticine from her studio.[69] Kars's sister retrieved his body and buried him in Zürich. Once Orloff arranged for her and Élie's return to Paris, Nora Kars wrote: "Please, be sure to remember to bring the two mortuary masks back with you."[70] Years later, in 1949, Nora arranged for his remains to be returned and buried in the family tomb in the New Jewish Cemetery in Prague.[71]

"THE RETURN": PARIS, 1945–1948

Orloff and Élie returned to Paris on May 2 to find that Nazi officers had ransacked her Villa Seurat home and studio. Nora arrived a few weeks ahead of them and sent a letter describing the scene at the house. The front door was forced open, and most of the furniture was gone. All the electric outlet covers and doorknobs had been stripped and pilfered, and the electricity was cut off. The Nazis stole much of Orloff's artwork and brutally vandalized what they left behind.[72] Sculptures in plaster, stone, and wood were broken, decapitated, and mutilated. The original plaster cast of *Jewish Adolescent*, her very first male nude from 1912, was shattered. The *Portrait of Madame Blocq-Serruys* also was demolished, the head detached and suspended by a wire. Orloff declared that the Nazis had either stolen or vandalized nearly one hundred of her sculptures, including some original plaster molds that

could never be recreated. The Nazis also stole the furniture she commissioned in the 1920s by her dear friend Pierre Chareau, upholstered in fabrics designed by another friend, Madeleine Vionnet. The house was occupied part of the time by Dr. Roger Gatte, a French physician who was a friend of one of Orloff's neighbors. Now uninhabitable, it would take time and scarce resources before she and Élie could live there again. Nora arranged for them to stay temporarily with friends of hers while they made the repairs.

Following her return from Geneva, Orloff abruptly severed her ties with the Rudier foundry that cast all of her works in bronze before the war. Although Eugène Rudier had forewarned her of the Vél d'Hiv Roundup and had saved the molds and casts for about ninety of her sculptures during the war years, she rejected him as a Nazi collaborator. During the Occupation of Paris, Rudier accepted a large commission from the Third Reich on behalf of the German artist Arno Breker, Hitler's friend and favorite artist, to cast a rendition of Rodin's *Gates of Hell*.[73] Curator Pierre Laval included the piece in a large retrospective of Breker's work at the Orangerie in May 1942. Unwilling to maintain professional ties with Rudier because of his work on this project, Orloff switched over to his chief competitor, the Susse Frères foundry, which also had a long history and dated back to 1839. She maintained a close relationship with this foundry for the rest of her career, and to this day they produce posthumous casts of her work in Paris.

Although her family tried to convince her to move to Palestine, Orloff wanted to rebuild her career in France following the liberation. Once back in the house and studio, she retrieved many of her sculptures from their hiding places with friends. She also reclaimed the many hidden works of art by her friends and colleagues that had once adorned her walls: drawings by Modigliani, Chagall, Foujita, Pascin, and Max Jacob; paintings by Mela Muter, Georg, Sigrist, Hermine David, Olga Sacharoff, George Kars, Yacovleff, Kremègne, Diego Rivera, Reuven Rubin, and others. When her friend, the art critic André Warnod, came to visit her for the first time since her return, she exclaimed, "What happened to all of our friends who used to meet up? I can't find anyone!"[74]

Orloff could not work for many months. As for so many Jewish artists and writers, creating art in the aftermath of the Shoah was dif-

Figure 12.7. *The Return*, 1945. Bronze.

ficult.[75] Eventually, she sculpted *The Return* (1945) (see figure 12.7), a piece documenting this difficult period. Orloff captures the dejected facial and bodily expression of a seated, emaciated male figure who has returned "from there." Her use of the classic Rodin "thinker" pose recalls that of her earlier *Jewish Painter* (1920) (see figure 7.5). She used a sculptural style that is much looser, more textured and expressionistic than her earlier works created at the height of her fame in the interwar years. This style would become typical of her work created after the war.

Orloff sculpted *The Return* after creating dozens of drawings of concentration camp survivors confronting the horrors of war and dis-

Figure 12.8. Studies for *The Return*, 1944.

location of the Jewish people (see figure 12.8). She made this body
of work during the war in Geneva as well as upon her own "return."
For this series, she studied survivors who had just returned from the
Buchenwald concentration camp near Weimar, whom she encountered
both in Geneva and Paris. In one drawing, Orloff captures the angst in
her sitter's gaunt facial expression, cheeks hollowed and eyes sunken
into his sockets. In the other, the grimacing figure takes up the seated
"thinker" pose that inspired Orloff's sculpture, his hands and fingers
appearing skeletal. His wrist and hand function like a pedestal, sup-
porting his head as if it were one of Orloff's earlier portrait busts.
Orloff's drawings of survivors contribute to a vast body of artistic work
documenting the horrors of the Shoah and its aftermath. While making
such work was cathartic for those artists who survived the ordeal, it
also serves as an important testimony of the Nazis' vicious ravage of
both body and spirit.

In her postwar interview with André Warnod, Orloff asked: "How
do we express visually the drama of our time, the horrors of war, of
prisons, death camps. Will we be able to achieve this by direct, realistic
means? Perhaps we would better achieve the goal by non-figurative

means . . . the allusion of the truth is often truer than reality itself."[76] She recounted how while living in exile in Geneva, she chose to sculpt her sitters "smiling," as a reprieve to the trauma. She reiterated her gratitude to the Swiss for taking her in and offering support: "No one can emphasize enough how admirable the Swiss were. And not only to the French, but for France."[77] While her drawings of Holocaust survivors express the horror and terror of those years, Orloff never mentioned the difficulties of living as a Jewish refugee under military control in Switzerland, from the required check-ins, to harsh living conditions, travel restrictions, and the battle to sell her work legally. Instead, she focused on the positives, the kind people of Geneva who secretly helped her support herself and her son through her art practice.

As Orloff resumed her work, cultural life in Paris recovered very slowly. A hard winter resulted in fuel and food shortages following the liberation. The economy would not recover until the Marshall Plan took effect, in the period of the late 1940s and early 1950s.[78] Orloff had a solo exhibition at the Parisian Galerie de France, February 7–March 2, 1946. It was her first solo exhibition in France since 1926 at Galerie Druet; since that time, she had focused her career on international exhibitions (the United States, the Netherlands, Palestine, the United Kingdom, etc.). She exhibited twenty-seven sculptures, most of them created during the period of Occupation and in Geneva, along with the series of drawings of haunted faces of those returning from persecution.[79] Her friend Francis Jourdain, artist, writer, and political activist, wrote a brief reflection for the catalog.[80] His text stresses how "solemn" her work has become during this period, a visual narrative of "the torment of the dark years."[81] He described her drawings of survivors as both "magnificent" and "terrible". . . "Go see these faces, inhabited by distress and dread, ravaged by memory, by the survival of terror."[82] The exhibit attracted extensive press coverage, with more than a dozen Parisian newspapers publishing reviews championing her work as a testament to her resilience.[83]

Orloff chose not to include her sculpture *The Return* (*Le Retour*) in this exhibition. In fact, she kept it hidden under a sheet in the back of her Parisian studio for seventeen years, before exhibiting it for the first time in 1962 at the Parisian Galerie Katia Granoff. She did, however, show the piece privately to a few critics who visited her at her studio

following her return to Paris. After looking through Orloff's drawings, art critic Marianne Colin recalls her encounter with *The Return*, "a sculpture in plaster that [Orloff] did not wish to exhibit this time. We don't know if it's the horror that takes a vaguely human form, or if it's the flesh of existence that returns to the clay. It is painful to look at."[84] Colin relates the piece to Orloff's "obsession" with the poignant figures in her drawings; "it is difficult to give them artistic expression. These are the tragic faces of victims of the German fury, their anguish."[85] Orloff told Colin, "It's a revulsion, a void that I constantly carry inside of myself. Imagine sculpting a void. And that's what I must do to liberate myself. Are you able to find words for Auschwitz?"[86]

During this period of anguish, Orloff tried in vain to obtain restitution from the French government for her losses of both works of art and furniture from her Parisian home and studio. Once word got out that she and her son had returned to Paris safely from Geneva, care packages arrived on a nearly daily basis from her friends in the United States, filled with precious goods of which she was deprived during the war such as coffee and chocolate. She noted the arrival of each package in her appointment book, continuing until the end of 1946.

Élie completed his studies and found work as an actuary after the war. He also met and fell in love with a French woman named Andrée Marie. When he shared with his mother his intention to propose marriage to Andrée, Orloff had a heart-to-heart talk with her future daughter-in-law. She advised Andrée to consider first living with Élie before committing to marriage. This was Orloff's way of protecting her son from any more devastating losses; she wanted to be sure that his future wife understood what it means to live day-to-day with a partner with physical disabilities that sometimes lead to debilitating flares. Orloff invited the couple to move into the living quarters above her studio in the Perret house, where Élie was raised. She moved into the first-floor apartment of the Rechter house next door, which previously she rented out to tenants. An interior door connecting the two homes allowed for easy access to her studio and shared meals, and the beginning of a new chapter for all.

In the spring of 1947, Orloff was invited to exhibit her work at the prestigious Wildenstein Gallery in New York.[87] She seized the opportunity for her third trip to the United States and a chance to reunite with

her friends there, including Tola Rank. She showed primarily the same selection of works as she did in the 1946 Parisian Galerie de France exhibition, a mix of works from both before and after World War II, including her harrowing drawings of concentration camp survivors. Orloff's *Woman in an Arm Chair* was reproduced in the *New York Times*, and several works, including a self-portrait from the war years, were reproduced in *Menorah Journal*.[88] For her American audience, Orloff's works offered stark evidence of the horrors of war as well as demonstrating the artist's tenacity. Alfred Frankfurter, editor in chief of *Art News*, described the profound impact of these traumatic years on Orloff's artistic practice in the exhibition brochure, as well as in a review he authored: "The War years—in France the hideous years of occupation and persecution—were for Chana Orloff . . . a time of clarification and realization. Direct carving in wood became a necessity and, at the same time, a sharpening, enlivening experience."[89] Frankfurter lauded her as "one of the foremost naturalistic sculptors today," with her resilience and "deep human sympathy" as key traits of her work.

Orloff appreciated the cosmopolitan atmosphere in New York, where the American art scene was burgeoning. She reunited with European émigré artists and critics who had spent the war years there. She also reconnected with her friends from the Jewish American community and psychoanalytic circle, some of whom lent works to the Wildenstein exhibition. The French-German poet Yvan Goll wrote a tribute in response to Orloff's exhibit that shows how critics continued to use gendered language in response to her work: "What a joy to rediscover, in New York, at Wildenstein's Gallery, this powerful artist whose face is so familiar to Montparnassiens. Her vigor and male strength, her deep femininity imbues her characters with loving tenderness, innate to mothers. What a wonderful mother of humanity, Chana. . . every time she looks at a human face, the suffering of mankind."[90] Across continents and cosmopolitan cities, from Paris to Tel Aviv to New York, critics engaged similarly with gendered rhetoric that names both "masculine" and "feminine" traits in response to her work. Such language offered a strategy for critics to reckon with her identity as an ambitious, independent and prolific Jewish woman sculptor. In this case, Goll links Orloff's identity as a mother to her expression of compassion

toward the figures she represents, particularly during the vulnerable wartime years.

Orloff's American friends and collectors helped her secure additional venues for her American tour. She made her first visit to the West Coast, with a solo exhibition at the de Young Museum in San Francisco.[91] Orloff's local collectors and longtime friends Elise Haas and Cora Koshland, both of whose husbands managed Levi Strauss & Co., each lent several sculptures to the de Young Museum exhibition. Louise Maas Mendelsohn and Hilda Thompson (Mrs. Joseph Thompson) were San Francisco–based collectors who also lent works to the exhibit. This shows the extent to which Orloff was well-connected in the United States, particularly among wealthy Jewish American women who were patrons of the arts. She got to know her clients well, and took an active part in nurturing these relationships over many years. Her networking skills facilitated exhibition planning, since she could call on her collectors for loans.

In her press release for the de Young Museum exhibition, art critic Patricia Coleman lauded Orloff's "one-man show," and noted the moving drawings "representing the return of inmates of concentration camps."[92] Coleman also engaged in the familiar gendered language we have seen in both French and Israeli criticism of her work: "Blazing her own trail and never subscribing to any academic forms or fads—Chana Orloff's personality breathes of strength with an almost masculine virility—her life alive with growth; a record of challenges met; a record of achievement realized. Her early struggles and privations during two wars would have been sufficient to have destroyed the ambitions of a less sturdy soul. Instead to Chana Orloff—they were a spur."[93] By emphasizing Orloff's grit and perseverance, Coleman validated the artist's own desired self-presentation.

Tola Rank joined Orloff on her visit to the West Coast, including a stop in Los Angeles. There she was able to widen the scope of her Jewish American patrons. Tola's daughter Helena, who had grown up in Paris as Élie's contemporary, was now married and living in San Francisco. She had just given birth, and Orloff, always ready to roll up her sleeves, was very happy to assist her with housework and childcare. She stayed in the United States for a total of thirteen months, returning

Figure 12.9.
Marc Vaux, *Portrait of Chana Orloff holding her granddaughter Ariane*, 1949.

to Paris in June 1948. Élie and Andrée married during the year in which Orloff was in the United States; she did not return for the wedding. A few months after her homecoming, she became a grandmother, with the birth of Élie and Andrée's first child, Ariane, in September 1948. This marked the beginning of a new period in her life as a grandmother (see figure 12.9).

In the meantime, Orloff closely followed the dramatic political changes in Palestine. Many of her family members were directly involved in the events leading to the end of the British Mandate and the birth of a new state. She was eager to reconnect with them and think about how she could leverage her skills and international reputation to help construct an artistic identity in Israel.

"Israeli Artist of the École de Paris,"
1948–1968

Chana Orloff was bound to Israel by a thousand threads. Even before the founding of the State of Israel, her house was an Israeli island in the heart of the City of Lights. All Israelis—the leaders of the Zionist movement, students, and ordinary Israeli art-lovers— used to come to her house.[1]

Just months after her death, the Israeli critic, curator, and museum director Chaim Gamzu, who organized a retrospective exhibition of Orloff's work at the Tel Aviv Museum of Art, made this statement. In this excerpt from the exhibition catalog, Gamzu shows his appreciation of Orloff's career through the lens of her transnationalism. It also shows how Orloff's Parisian credentials gave her particular clout in the emerging Israeli art world. He believed her strong reputation in France and internationally would help elevate cultural life in the new state of Israel.

French critics also saw her as one of "their own." In 1961 the French curator Jean Cassou, writing in French about Orloff for an exhibition catalog of her work in Israel, called her an "Israeli artist of the École de Paris," suggesting her belonging in both places.[2] Cassou describes how her trajectory differed from other Jewish artists of the École de Paris in that she spent five years in Palestine before joining the "wonderful cornucopia of foreign and indigenous artists who are elevating modern

French art." He writes, "She stays in France, assured of her Frenchness, and at the same time, she feels at ease in a joyful country to which she also belongs, truly her own. Chana Orloff can claim to be as much a Jew of France as she is a Jew of Israel."

As much as Orloff was deeply connected to Israel, we have seen how throughout her life, viewed France as her home. She was a French citizen and among the first to register as a Jew in Paris following the German ordinance of September 1940. She believed her high stature in the French art world would protect her. Even though her family urged her to relocate to Palestine after the end of the war, she made yet another active choice to reclaim her Parisian home—which was ransacked by the Nazis and inhabited by French collaborators. Throughout her life, Israeli journalists asked of her, "Where is your home?" or "When are you moving here?" Orloff never fully answered these questions. She expressed her pride in her multiple identities and allegiances: "Whenever I am in Paris I long for Tel Aviv, and vice versa. Such is life."[3]

Orloff's experiences as an émigré artist in Paris took on a unique dimension in May 1948. Following decades of conflict between two groups indigenous to the same land—Palestinian Arabs and Palestinian Jews—the United Nations (UN) Special Committee on Palestine recommended unanimously that the British terminate their mandate for Palestine and Zionist leaders issued the Israeli Declaration of Independence on May 31, 1948.[4] Orloff must have been pleased by their choice to sign the official document at the Tel Aviv Museum of Art, the national museum she helped establish. In 1935, she was the first woman to show her work there in a well-attended retrospective exhibition. Finally an insider at age sixty, Orloff was eager as an established international Jewish artist to play a leadership role in the construction of a new national artistic culture.[5]

When asked by the Israeli journalist Raphael Bashan, from the daily newspaper *Maariv*, if she was interested in politics, Orloff replied, "God forbid! I only care about our country's situation."[6] Though there was much political conflict around Israeli statehood, she did not comment publicly on it, but readily accepted commissions following the founding of the state to create monuments to fallen men and women, and sculpted portraits of prominent political and cultural figures. Her

work was celebrated in many exhibitions, including two more major retrospective exhibitions at the Tel Aviv Museum of Art (1949 and 1969). By the time of her death in 1968, Orloff was a widely known artist in the history of the young state.

Even though she identified as a binational artist, Orloff never officially obtained Israeli citizenship. She traveled back and forth between Paris and Tel Aviv frequently, and purchased an apartment in Tel Aviv (35 Rechov Keren Ha-Kayemet) in 1949. Nonetheless she always chose to complete her work in Paris, in her Montparnasse studio, and at the Susse Frères foundry. Even after the French collaboration with the Nazis and the devastation of World War II, Orloff remained loyal to the nation that first gave her entrée to the Parisian art world and accorded her the Legion of Honor. She had no intention to relinquish her Frenchness, and struggled with the French government for restitution for the loss of her work and contents of her home during the Occupation.

Examining a selection of works, monuments, and exhibitions from the final decades of her life, with particular attention to her representations of women, raises interesting questions. How do attitudes about gender and nationalism expressed in response to her work engage with Israel's own identity as a new nation-state? How did she navigate her hybridity and simultaneous allegiance to both Israeli and French culture in her final decades?

RETROSPECTIVE EXHIBITION AT TEL AVIV MUSEUM OF ART, APRIL 1949

Just prior to the opening of her second retrospective exhibition at the Tel Aviv Museum of Art in April 1949, Orloff posed for the Israeli photographer Israel Zafrir before her newly completed portrait of her close friend *Zeev Rechter* (1949) (see figure 13.1), the architect who designed her second Parisian home nearly two decades earlier. Standing behind the larger-than-life bust, she places her fingers along the base as if measuring it and looking as if deep in concentration. The photograph documents the occasion of Orloff's retrospective in the newly formed state and stands as a testament to her central role in the emerging Israeli art world. The journalist Paula Apenshlak reproduced it in her review of the exhibit in the newspaper *Al HaMishmar*, attesting to

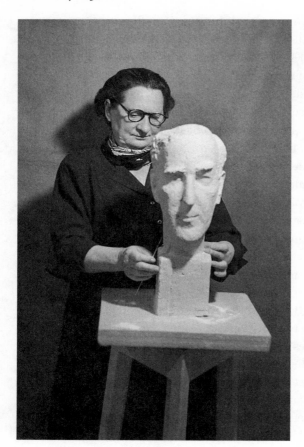

Figure 13.1.
Israel Zafrir, Portrait
of Chana Orloff
(before *Portrait of
Zeev Rechter*), 1949.

its role in shaping Orloff's public image.[7] With its elongated face and furrowed brow, her bust honored Rechter's prominent role in Israeli architecture. Another critic identified as S.W. from the *Palestine Post* noted the portrait's "psychological insight and feeling for the characteristics of a face which also mark her earlier portraits."[8] He or she lauded Orloff as "the leading woman sculptor of today," and positioned her retrospective as "an expression of solidarity with the year-old state. Although she has spent forty years in Paris, she still speaks Hebrew fluently and thinks of Israel as her second home."[9]

Orloff's 1949 retrospective exhibition, like the one after her death in 1969, was curated by Haim Gamzu, the notable art and theater critic who was also the museum's director.[10] He first approached Orloff about

the exhibit during the summer of 1947, just prior to Israeli statehood, while she was still in New York. He invited her to exhibit at the Tel Aviv Museum of Art "as soon as possible."[11] Orloff readily accepted and requested that he arrange for the visa required to exhibit her work in Palestine under the British Mandate.[12] Gamzu appealed to the British Consul: "You will certainly understand how important it is for us to show the works of a world-known sculptor such as Mrs. Chana Orloff to our artists and intellectuals here."[13] He reiterated these sentiments in a letter to the artist herself: "first rate artistic activities, such as a 'Chana Orloff Exhibition,'" will help achieve the goal of "raising the bar of artistic life in Palestine."[14]

Lauded by critics, Orloff's 1949 retrospective exhibit at the Tel Aviv Museum of Art was viewed as a homecoming of sorts, marking the artist's return to Israel "after a fourteen-year absence."[15] It included thirty-seven sculptures from different periods of her career, several of them owned by the Tel Aviv Museum of Art. Others were lent by her own local family members and private collectors residing in Israel. Orloff selected works she could ship from Paris and potentially sell to Israeli clients to offset her costs. She chose to highlight portraits of prominent cultural figures in Israel, as well as members of her own Zionist family. Her work itself was read as making an important contribution to the new state. Much like her prior retrospective at the museum in 1935, critics praised the show as a veritable who's who of influential figures in the history of art and culture in Israel: Rechter; Bialik, 1926, father of Hebrew poetry; Reuven Rubin, 1926, originator of the Eretz Israel style of painting; and Chana Rovina, 1935, "First Lady of Hebrew Theater," among others. Gamzu wrote in the exhibition catalog how Orloff's portrait of Rovina "penetrates the innermost recesses of the model's soul, revealing attributes to which we had no idea."[16] He also noted "a hint of playful lightheartedness" in her sculptural style in this portrait. Years later, in 1958, on the tenth anniversary of Israel's independence, Rovina was selected to read the Declaration of Independence at a reenactment of the state's founding ceremony. Orloff's portrait of Rovina captures the poise and self-confidence that she brought to that notable occasion. In the context of her exhibit in the new state, Orloff's selection of sculpted portraits of notable cultural figures showed her desire to articulate a canon of Israeli art and culture.

Orloff also included portrait busts of her own family members in the 1949 retrospective, acknowledging their deep involvement in the Zionist project as part of the Second Aliyah. These included her sister Masha Skibin (1935); her brother Zvi Nishri (1935), pioneer in modern physical education; and his son, her late nephew, David Nishri (1936), who was killed at age nineteen in a conflict with Arabs near Motza during the British Mandate period. Orloff also paid tribute to her late nephew in a life-size, full-bodied monument, commissioned by Nishri for the sports training facility he helped found south of Netanya that is the precursor to the Wingate Institute. By including family portraits in the exhibition, Orloff called attention to their high political status as a prominent Zionist family in the new state. Her retrospective became a way for her to acknowledge their work on behalf of Israel alongside prominent cultural and political figures.

In addition, Orloff included several recent sculptures of her family members back in France. Among them are two full-bodied sculptures of her daughter-in-law, Andrée Justman, while pregnant and nursing her newborn daughter Ariane, the first of Orloff's three grandchildren.[17] Orloff's imagery of the maternal body could be interpreted in the context of this exhibit as representing a Zionist vision of the future state, but it should be noted that her grandchildren were all born and raised in France to a French mother who was not Jewish. The artist's new role as grandmother certainly contributed to her desire to maintain her primary residence in Paris. In the context of this exhibit, Orloff's family portraits reinforce the artist's hybridity as a French-Israeli sculptor.

Orloff's 1949 exhibit also featured the theme of empowered Jewish women from the Old Testament. *Deborah, Poetess* (1940) (see figure 13.2) offers the artist's interpretation of the Hebrew prophetesses in a contemplative seated pose, signaling her identity as the sole female judge and maternal protector. Orloff later told an Israeli journalist that "the Bible was for me a constant source of inspiration."[18] This piece adds to the artist's long history of representing strong biblical women, including her numerous sculptures of Eve, as symbols of fertility and empowerment. She was repeatedly drawn to the figure of Ruth, with whom she first identified in her self-portrait as a young veiled widow (see figure 6.14). In another work, Orloff portrayed Ruth as a woman

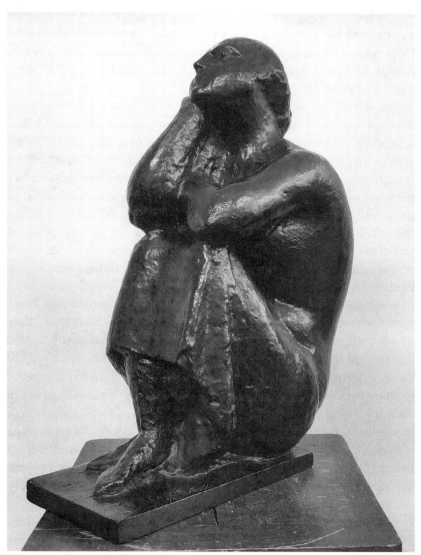

Figure 13.2. *Deborah, Poetess*, 1940. Bronze.

who is bound to her mother-in-law, Naomi (in French, Noémie), like a conjoined twin sister (1928) (see plate 10). Collectively, the works Orloff chose to feature in the 1949 retrospective show her desire to contribute to a new national visual culture of female strength, resilience, and creativity.

Orloff's identities as a female artist in both French and Israeli national and cultural contexts were directly relevant to her long history of representing women's bodies in her sculptures. In multiple interviews with both French and Israeli critics, she encouraged essentialized interpretations of her work on the basis of gender by highlighting her personal experiences as a woman, mother, and widow as integral to her work. For example, we recall her 1935 interview published in the French *Le Petit Journal* in which she stated that "for a woman creator [*créatrice*], maternity is necessary, because life is the most profound source of all art" (chapter 8).[19] Orloff elaborated on this position in a later interview conducted by the Israeli journalist Yehudit Winkler in 1961 for the daily newspaper *Herut*, in which she claimed that there were essential differences between male and female sculptors: "Certain artworks are better done by a woman. I sculpted many female figures: a pregnant woman, a widow, a mother and child, etc. Why [are these sculptures better than those made by male sculptors]? Because a woman feels all of this in her body, flesh and blood!"[20] However, in the same interview, Orloff acknowledged her frustrations with the problem of gender inequality in the art world and shared a personal experience where a potential client dismissed all female artists as "unreliable."[21] In the Israeli context, she was an exception as a female artist working in figurative sculpture in the new state at a time when there were very few others working in the field.[22]

Orloff's 1949 retrospective attracted a "massive audience" of visitors and solidified her public identity an artist committed to telling the story of the Jewish people and their new nation.[23] Eugen Kolb, who became director of the Tel Aviv Museum of Art in 1952, described how "the critics unanimously declared that Chana Orloff's exhibition is one of the main artistic events of our time." He praised the "aesthetic insight" of her work and commented upon the significance of "seeing Chana Orloff among us, in Israel (in her own country!)."[24] Kolb's commentary shows his strong desire to reclaim her as Israeli rather than French.

Like Kolb, many Israeli critics interpreted Orloff's work as being a vital contribution to the Zionist project. Such critics engaged in various rhetorical strategies to account for her French influence and diasporic status in the context of their common desire to represent her primary loyalty to Israel and Zionism.[25] Orloff's reception in Israel was based upon tension between two different Zionist ideologies. One promoted her work as representing continuity between Jewish cultural heritage and the new Hebrew/Israeli artistic language. The other saw her work as taking a stance of opposition to diaspora art by elevating the image of the *Sabra* (Israeli-born artist). An example of the former is Israeli art critic Lisetta Levy's claim that in spite of Orloff's high status in the European art world, she "bound her soul with the Hebrew culture" and "had a habit of singing one of Bialik's songs after completing a sculpture."[26] In a similar tone, Arie Lerner, an Israeli art critic and editor for the newspaper *Davar*, declared: "Ever since her family came to Israel, forty years ago, Chana Orloff has been tied to the Yishuv with every fiber of her being. . . . Therefore she came to us as a faithful daughter, who has been out in good company but later returned to her home."[27] Haim Gamzu wrote in a similar tone in his 1949 catalog essay on Orloff published for the exhibition: "Many wanted to claim her as their own. . . . But she always remained true to herself and to herself alone, meaning, she was one of our own, one of the Jewish people. . . . And wherever the wandering fate of the artist may lead her, she has always been a true daughter of Israel, who loves nothing more than to speak Hebrew."[28]

These critics were among many Israelis writing about Orloff after the birth of the state who attempted to reconcile the dominant Zionist ideology (wanting to "claim her as their own," "a true daughter of Israel") with her living abroad. They tried to resolve the fact she was not born in Israel and had only lived there for five years, before departing to Paris, by emphasizing her deep commitment to the new state, stemming from her Jewish identity. By demonstrating her love of poems by the national poet Bialik and her fluency in the Hebrew language, these descriptions show the popular perception of Orloff's loyalty to the new state, despite the fact that she did not fulfill the Zionist ideology by settling in Israel and becoming a citizen.

In contrast, other critics chose to emphasize what they described as

Orloff's Israeli-Sabra identity by attributing national characteristics to her persona as well as to the style and subject matter of her works. For example, in a 1949 interview, journalist Paula Apenshlak claimed that Orloff's "thoughts and mode of expression seem as if they were carved out of stone or marble: straightforward, without figurative language or insinuations, *Eretz-Israeli*, almost as a *Sabra*."[29] By linking the word *Sabra* with Orloff's artistic persona, naturalistic style, and use of materials, Apenshlak looks past Orloff's diaspora origins and primary location in Paris, and offers the artist a great compliment by linking her work to the culture of a new Zionist aesthetic. In particular, the critic points to the artist's use of "stone or marble" as evoking a directness and forthright quality she associates with the new nation.

For an example of a critic attributing national characteristics to both Orloff's life story and her choice of subject matter, the famous Israeli poet Jacob Fichman, in a review of her 1949 exhibition, described Orloff as "an embodiment of the Hebrew woman's Renaissance that grew from the soil of the homeland. There is nothing like the artistic creation of the Hebrew woman to attest to our nation! The vision of Zion finally has come true!"[30] For Fichman, Orloff's biography epitomized the narrative of the Zionist movement. Like the state of Israel, she, too, came into being "from the soil," overcame challenges, and achieved acclaim. In this case, the "Hebrew woman" becomes a symbol of national strength, resilience, and procreation. Without explicit mention, Orloff's lifelong artistic attraction to the theme of the female body—from maternities, to female nudes, to portraits of prominent Jewish women from the Old Testament and contemporary culture—is embedded in Fichman's critical commentary on the Zionist nature of her art.

Still, other Israeli art critics resolved their discomfort regarding Orloff's refusal to settle down in Israel by claiming that her decision was motivated by the requirements of her artistic profession, rather than her own will. For example, an anonymous critic writing in 1935 for the Jerusalem-based daily newspaper *Doar Hayom* (1919–40) wrote: "Chana Orloff came back to us, to see her family and homeland. . . . And she must return to Israel. The greatest tragedy of notable artists of Israel is that their country is calling them, leading them to return, but at the same time, their second homeland—the homeland of art—is also calling them."[31]

Orloff encouraged these interpretations that viewed her work through the overlapping lenses of her Jewish, Zionist, Israeli, and Sabra identities, and repeatedly stressed her deep commitment to the state of Israel and the promotion of Israeli culture. For example, in an interview, published in the daily newspaper *Maariv*, before the opening of her 1949 exhibition, she declared: "For 39 years I am living in Paris, but I still speak the Hebrew language. I have always tried to create a community of Israeli and Jewish artists in my house, whether they are residents of Paris, students or travelers on vacation. Some people even say that my home has become a sort of 'spiritual consulate of Israel,' years before the establishment of the state."[32] In response to the question "Why would you not settle down in Israel?" Orloff responded, "I am considering coming back. I do not want to be one of those Russian sculptors who are living in Paris."[33] Although it was unusual for Orloff to portray herself as a Russian artist in an Israeli context, it was common for her to mention her Jewish identity in the Israeli press.[34] We have seen how both French and American critics described Orloff as "a Russian artist"; her remarks here suggest that she rejected this critical label, as if it implied that she could never fully assimilate as French. It remains unclear from Orloff's statements, however, how she distinguished between her Jewish and Israeli identities, or in what way she viewed these identities as related to one other.

Israeli critics nonetheless also grounded their praise of Orloff by noting her international appeal, and often quoted from reviews written by French art critics such as Léon Werth, André Salmon, and Robert Rey. This was not unique to Orloff, but was part of a long-standing critical tendency in Israeli art criticism to focus on European art movements, whether directly, as the main subject of the article, or indirectly, as a reference point for discussion of Jewish and Israeli art. Orloff's immersion in the Jewish art world of Paris made her a desirable figure for Israeli audiences that wanted to establish their own artistic heritage in Palestine.[35] During the period of the Yishuv and the early years of the state, most work made by female artists was overlooked and marginalized by Israeli art critics. Orloff alone was glorified as one of the greatest artists alive, and her work consistently received positive reviews.[36] This was probably due to the fact that she was successful in Paris, which validated her in the emerging art world of Israel. Art crit-

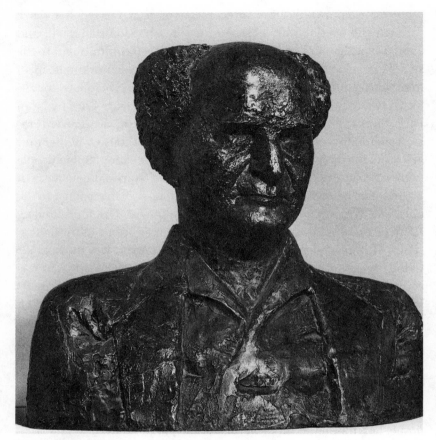

Figure 13.3. *David Ben-Gurion*, 1949. Bronze.

ics and journalists reported every visit she made to Israel, championed her Legion of Honor status, and portrayed her as a great artist.

Following her 1949 exhibition, Orloff received numerous commissions to create portrait busts of important Israeli political and military figures who contributed to the public representation of national building efforts. Three key political subjects included founding prime minister David Ben-Gurion (1949) (see figure 13.3); Yitzhak Sadeh (1951), the commander of the Palmach and one of the founders of the official army of the state, the Israeli Defense Forces (IDF); and prime minister Levi Eshkol (1968). Through her strong critical reputation,

as well as her family connections, she cultivated relationships with these top officials in the new Israeli government.[37] In addition to her brother Zvi Nishri, Orloff's brother-in-law (her sister Miriam's husband) Eliyahu Eitan was one of the founders of Hashomer, a Jewish defense organization founded in Palestine in 1909, a precursor to the Haganah. The Haganah was the main paramilitary organization of the Jewish population in Mandatory Palestine from 1920 to 1948, when it became the IDF. Orloff's nephew, Rafael Eitan (Miriam and Eliyahu's son), went on to become a well-known Israeli general and was former chief of staff of the IDF and later a politician, Knesset member, and government minister, showing just how deep the family's ties to political Zionism were.

Resorting to traditional styles of commemoration that prioritize realism over the more playful stylization of her works from the 1920s and 1930s, Orloff's sculpted naturalistic facial portrait busts in bronze of these political figures emphasized heroism associated with Zionist constructions of the new Jew.[38] Her larger-than-life portrait of Ben-Gurion conveys the patriarchal authority of the legendary leader by expressing the intensity of his facial expression and furrowed brow (similar to that in the Rechter portrait), connoting seriousness and perseverance. The sturdy weight of his shoulders echoes this vision of strength and solidity associated with Zionism. Orloff arranged for Ben-Gurion to sit for the portrait on several occasions at Rechter's apartment on Zamenhof Street in Tel Aviv, where she had usually stayed before purchasing a place of her own. First, she made preparatory drawings and then a plaster model. Then she cast the work in bronze in Paris, at the Susse Frères foundry. Rechter's daughter, Tuti, a young girl at the time, recalled the commission in an interview much later in life: "She used my room as her studio and made there the sculpture of David Ben-Gurion. He sat there and posed for her and there were all kinds of anecdotes. His wife Paula would call and say that Ben-Gurion should return home to eat, or to rest. She wouldn't let anyone watch her during her working process except me."[39] This description confirms prior observations of how Orloff regularly engaged with domestic space as a site of art making.

Orloff saved a press clipping from a French publication featuring a photograph of herself with Rubin next to her bust of Ben-Gurion

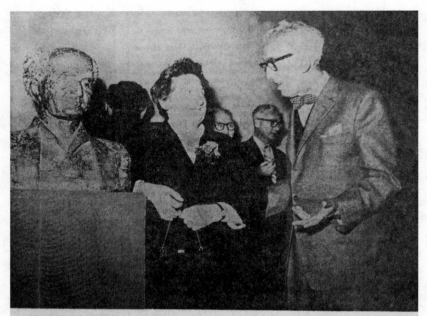

Hanna Orloff le célèbre sculpteur israélien établi à Paris depuis de nombreuses années est venue faire un séjour de quelques mois dans le pays. Sur notre cliché l'artiste en compagnie du peintre Reouven Rubin, près du buste de M. Ben Gourion que Mme Orloff vient d'achever.

Figure 13.4. Chana Orloff presenting Ben-Gurion's portrait.

(see figure 13.4).[40] The photograph may have been taken at a public unveiling of the work shortly after completion, but it more likely was from the 1952 touring exhibit of her work entitled *Again in Israel*, organized by the Museum Association of Israel. The exhibit opened at the Helena Rubinstein Pavilion in Tel Aviv, and then traveled to Jerusalem and Haifa, allowing her work to reach a broad public residing in different parts of the new state. Orloff maintained her connection to Ben-Gurion, and visited him at his home at kibbutz Sde Boker (see plate 11), where he lived in the center of the Negev Desert in southern Israel following his resignation in 1953. This photograph shows her familiarity with the senior leadership of the new state. Orloff is pictured beside Ben-Gurion, accompanied by her niece, Nechama Ofek, and her niece's husband, Ofer Ofek.[41] Such contact with top political and military leaders by a woman artist who was not an Israeli citizen was unusual, and shows Orloff's unique stature in the Israeli cultural sphere at the time.

As a Jewish diaspora artist aligned with the Zionist project, Orloff was sought out by both governmental and communal groups to design and build some of the new state's earliest official and commemorative monuments related to the war that gave birth to the new state. Given her personal history and life experiences, she was in a unique position to humanize pivotal moments in Israeli history from a female perspective. Over the course of her career, she created six war memorials that were erected at different locations in Israel.

On May 28, 1952, Israeli photographer Naftali Oppenheim photographed Orloff, age sixty-four, upon the occasion of the inauguration of her *Mother and Son* monument at kibbutz Ein Gev (see figure 13.5).[42] Orloff poses before the camera, her body activated with her left hand on her hip. Wearing sunglasses and a modern black V-neck dress, Orloff looks youthful and confident as she tilts her head back and gazes assertively up at the monumental bronze statue. An archetypal maternal figure holds her child above her head, toward the sky in the direction of Lake Kinneret (Sea of Galilee), along a shared border with Syria. Orloff's upward gaze mimics that of the sculpted maternal figure toward the child. A prominent shadow directly follows her sight line, forming a diagonal line against the memorial wall backdrop.

The statue, which measures thirty feet high and weighs three tons, commemorates the kibbutz members' victory in the 1948 Arab-Israeli War. It also pays tribute to their fallen, which included five men and one woman.[43] Adjacent to the statue, a biblical inscription from the Book of Nehemiah 4:18 (KJV) reads: "For the builders, every one had his sword girded by his side, and so builded [*sic*]. And he that sounded the trumpet, was by me." The Zionist resonance of both the monument and passage spoke to kibbutz members' self-sacrifice in the simultaneous acts of both defending and building a new nation. In the context of Oppenheim's photograph, Orloff appears as an active and engaged creator and participant in this Zionist narrative. She took a special interest in the Ein Gev commission because it provided her with an opportunity to highlight the role of women and their service to the new nation.

She was recommended to the kibbutz members by the Israeli architect Benjamin Chelnov, whom they hired to design a memorial space in which the statue would be installed. His plans suggested his desire

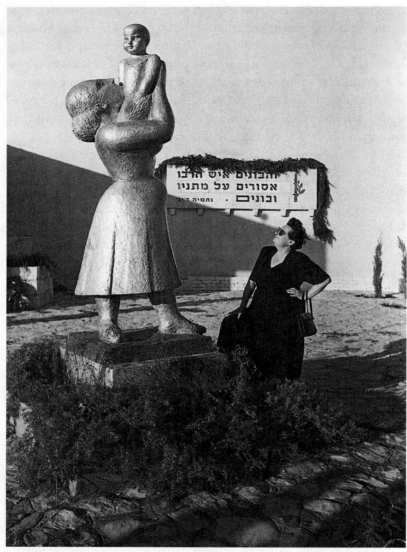

Figure 13.5. Naftali Oppenheim, Chana Orloff, Inauguration of Orloff's *Mother and Son* monument, Kibbutz Ein Gev, May 1952.

to create a sacred space and included a commemorative room, archive, and wall with a biblical inscription (he chose the passage from the Book of Nehemiah) and a concrete yard he called "Azara," a reference to the Temple's Court.[44] Following Chelnov's suggestion, Teddy Kollek, one of the founders of kibbutz Ein Gev (and a close ally of Ben-Gurion and future mayor of Jerusalem, 1965–93), invited Orloff to visit the kibbutz. When Orloff first accepted the commission, she would have been aware that when the IDF was founded with the establishment of the state in May 1948, all personnel were expected to serve as combat members, regardless of gender. This was not a standard practice in most nations at the time. Ben-Gurion believed "security will not exist if our nation's women do not know how to fight."[45] He advocated for "the women who are protecting their children at home" to "know how to use a weapon."[46] Israeli women thus engaged in frontline combat in the 1948 War.[47]

When Orloff arrived at the kibbutz, community members presented her with an illustrated "communal book," in which residents shared testimonies of their wartime experiences and quotes from some of those lost.[48] The words of one of the fallen resonated with her as she contemplated the iconography for the sculpture: "If one day a great artist will arise, who will have the power to give expression to the war of the Jews—I think that he [*sic*] will have to choose one figure: a Jewish woman, a mother in Israel, defending with her weapon her children and homeland."[49] This maternal figure was a symbol not only of those who died defending the kibbutz, but also of all Jewish lives lost in the 1948 War. It also offered the promise of an offspring symbolizing a prosperous future. These words stuck with Orloff in light of her decades-long history of representing the theme of motherhood along with her own life experience.

Orloff also was inspired by a photograph pasted into one of the pages of the memorial book presented to her by the kibbutz members. A joyous mother holds her infant son up high in her outstretched arms before a backdrop of lush foliage (see figure 13.6). She gazes affectionately up at her child, who smiles directly at the photographer. The mother was Hanna Tuchman Alderstein, a thirty-one-year-old woman from Ein Gev who died in 1948 in frontline combat with the Syrians. Moved by this story of a young Jewish mother of two children, pregnant

Figure 13.6.
Hanna Tuchman
Alderstein and her son,
Kibbutz Ein Gev.

with her third, who fell in combat, Orloff utilized this image in her monument design. She must have related to Alderstein on a personal level, given her own identity as a devoted mother of a son, and also as a Jewish woman influenced by socialist notions of gender equality from her early days in Palestine.

By the time Orloff set to work on this project, Israeli women were excluded from frontline combat. While she did not comment on this, it seems to contradict the very notion of gender equality that likely drew her to Alderstein's story. According to a later report from a kibbutz member: "She [Orloff] was deeply impressed by the [memorial] book, and especially by the fact that female members fought shoulder to shoulder with the male members in repelling Syrian attacks on the settlement."[50] As a member of a long-standing Zionist family, Orloff subscribed to the Zionist ethos in which heroism was defined as dedication and self-sacrifice for the Jewish resettlement of the ancient

homeland. She also would have been aware of women's important roles in the war effort, including providing medical aid, establishing refugee centers, and more.[51]

Orloff's chosen iconography was unique in that it focused on memorializing a female soldier in the form of a maternal figure as the symbol of hope and nationhood. According to historian Esther Levinger, most of the Jewish artists who created memorials commemorating the Zionist state in the 1950s, both male and female, depicted women in traditional roles: as a mother mourning her sons, a nurse healing the wounded, or, most commonly, as an allegorical figure of the nation itself, incorporating symbols of European nationalism.[52] Nathan Rappaport's *Memorial to the Defenders of Kibbutz Negba* (1949–53) is one such classic work in which three muscular figures—two men and a woman—stand erect and look toward the horizon, signaling their nationalism, heroism, and self-sacrifice. Rappaport inserted agricultural symbols—olives, grapes, wheat, and barley—behind the figures as symbolic of their pioneering ethos. In addition, many monuments used the depiction of a woman as an emblem of grief and mourning itself. In fact, there are very few monuments that depict a semirealistic representation of a woman and child, as Orloff did at Ein Gev, making her monument engage more actively with women's wartime experiences.

Moved by the commission, Orloff offered her services on the project free of charge, asking that the kibbutz only cover the cost of materials, including bronze casting, and shipment of the monument from Paris to Israel.[53] She first created several maquettes of the monument in her Parisian studio in wood and plaster, before sculpting the large plaster mold from which the statue was cast in bronze at the Susse Frères foundry. The monument echoes Alderstein's gesture in the photograph but does not make direct reference to her service as a position commander on the front lines of the war. It stands instead as a symbol of a mother who sacrificed her life in defense of the nation-state, and who was devoted to the development of future Israeli citizens through maternity. However, the iconography Orloff chose does not reference the figure's combat role and fallen soldier status. At the official memorial site of the Golani Brigade, in which Alderstein enlisted in 1948, she is identified as private soldier number 4393, who "received defensive training and participated in guarding and defense."[54] There is a gap

Figure 13.7. The Nazi German and Soviet Union Pavilions, 1937 International Exposition, Paris.

between Orloff's finding the story so inspirational and the fact that she leaves out all traces of the figure's combat experience, making the work conform to a maternal stereotype. The slight bulge of the figure's midriff recalls Orloff's many sculptures of pregnant women, further enhancing the monument's Zionist symbolism of procreation.

Orloff's design for the Ein Gev monument follows a long European allegorical tradition of "nation-as-mother," such as Marianne in France and similar imagery in German and Britain, as well as in Soviet memorials commemorating what Russians called the Great Patriotic War (1941–45). In thinking about how to represent the Zionist ethos through the theme of female self-sacrifice, Orloff would have been familiar with the Soviet Pavilion at the 1937 Paris International Exposition, dedicated to Art and Technology in Modern Life. The Russian monument, with its seventy-five-foot statue by Vera Mukhina entitled *Worker and Kolkhoz Woman* (*Rabochiy i Kolkhoznitsa*) (see figure 13.7), established what is described today as the Soviet socialist-

realist style of commemoration.[55] It was viewed in contrast to the Nazi Pavilion that faced it on the opposite side of the Trocadéro fountain, crowned with a stylized eagle and a swastika to communicate a more overtly militaristic image of national pride for the newly powerful National Socialist German state.

Like the Soviet monument, Orloff's *Mother and Son* monument shows the strength and heroism of those who dedicate themselves to the Zionist project. She replaced the hammer and sickle with a young child as the symbol of national strength and resilience, and the "peasant woman," a mother, stands alone. As a Ukrainian-born artist, Orloff may have related to the Russian context and its socialist ideal as a key source for her image of the new Israeli state. The maternal body in Orloff's sculpture is more compact and solid than that of the female figure in Mukhina's piece, with thick, squat calves emerging from a solid, geometrically shaped skirt. Orloff's figure also lacks detail such as facial features and folds of drapery in contrast to the Soviet example, making the figure all the more symbolic of all women who sacrificed their lives for the Zionist cause. Whereas the female figure in the Russian sculpture is defined in the context of her male counterpart and her presumed role in the nuclear family, Orloff's statue at Ein Gev focuses exclusively on this joyful encounter between mother and child. In short, it seems less like a monument to war than it does a forecasting of renewal and how the war allowed citizens to move on with their lives within the new state.

In thinking about Orloff's choice of iconography, we might also think back to Charles Perron's thirty-foot-high sculpture *France Liberating Itself from the Jews* (see figure 11.5), discussed previously as the centerpiece of the fascist, antisemitic exhibition "The Jew and France," held at the Palais Berlitz in Paris in September 1941. Orloff's *Mother and Son*, as a symbol of the Zionist ethos through the theme of childbirth and family propagation, provides a powerful counterpoint to Perron's juxtaposition of motherhood and viciously antisemitic caricatures. By isolating the mother and child, and locating the statue outdoors at kibbutz Ein Gev, overlooking Lake Kinneret and the Syrian border with Israel, Orloff's rendition of the Jewish "nation-as-mother" takes on new meaning.

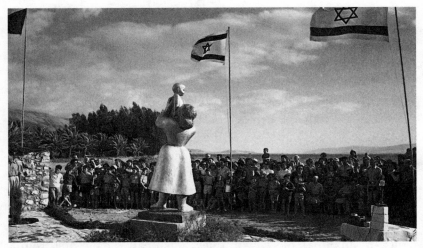

Figure 13.8. Naftali Oppenheim, Inauguration of Orloff's *Mother and Son* monument, Kibbutz Ein Gev, May 1952.

A second photograph by Naftali Oppenheim of the official unveiling ceremony of Orloff's *Mother and Son* in May 1952 (see figure 13.8) creates strong Zionist symbolism.[56] The statue is centered within the memorial site, framed by two Israeli flags billowing in the wind. The young child's head is bathed in sunlight against the backdrop of the cloudy sky, as if he were peering out over the crowd of onlookers at the Kinneret, a symbol of hope and regeneration in the new nation. Orloff attended the dedication ceremony, which was a local event for kibbutz members and families of the fallen. A kibbutz member delivered a speech for the occasion, highlighting the role of women in defending the settlements as a particular source of pride: "In the history of peoples and wars, revolutions and struggles for national liberation there were also cases where a woman played an important role, but these were few and far between."[57] Another kibbutz member later reflected on this perspective:

> [Orloff's] statue articulates the awareness that became prevalent among us during the war regarding the role of the female-member (or comrade) in the battle. . . . In her statue the artist commemorates the Jewish mother defending her child. . . . And therefore it seems to me that with the exception of the stand of

the few against the many, the active participation of the woman is the thing that symbolizes the special character of the War of Liberation.[58]

During the inauguration of the memorial, a squad of active (male) soldiers from the kibbutz presented their weapons as a sign of respect.

To this day, members of the kibbutz Ein Gev engage in an annual ritual of gathering together in front of Orloff's *Mother and Son* on Yom HaZikaron, the official national Remembrance Day, which always takes place the day before Israeli Independence Day. The event is understood as a means of reminding kibbutz members of the connection between the devotion of their own local fallen men and women and the establishment of the state.

Following the inauguration, prime minister David Ben-Gurion sent a congratulatory telegram heralding Orloff's statue for its "spirit of heroism that forever beats in the hears of Ein Gev builders and defenders."[59] Israeli and European critics alike praised Orloff's monument as a powerful symbol of the Zionist vision. Barnet Litvinoff, a London-based critic for the *Jewish Chronicle*, wrote, "This time, the child symbolizes the young defenders of Israel who died in their war of survival."[60] To me a more convincing interpretation is that of an Ein Gev kibbutz member: "the healthy baby—the symbol of our young state, a symbol of the young generation."[61] In this reading, it is the mother who, like Alderstein, sacrificed her own life for that of her child, who stands for the nation's future.[62]

Orloff later requested that the kibbutz members move the *Mother and Son* statue from the memorial site closer to the shoreline, providing a serene backdrop (see plate 12). When interviewed about the monument later in her life, Orloff responded: "For this subject, we need a woman's hands, and the entire spirit of a Jewish woman marked by the past and the present of her people. I can only ask myself if I am the 'chosen one,' worthy of this historic task, worthy of this poem of love and tenderness. This Jewish woman, I see her here, like a tree."[63] This statement links back to the original text quoted in the "communal book" that inspired Orloff to depict "a mother in Israel" as a symbol of the nation. By asking if she is the 'chosen one,' Orloff identifies as the "great artist" who received the commission. In retrospect, we can read

both this quote from Orloff and the monument itself as challenging the ways in which Israeli memorial discourse has marginalized the role of women and women's combat service in defending the land. It was without precedent that the kibbutz members chose to commission a female artist to commemorate what they agreed was a woman's sacrifice of her own life for Israel's independence and the future of her child. The classicizing portrayal of the theme of motherhood that had once been Orloff's ticket to acceptance in the increasingly antisemitic French art world of the 1930s had now become a Zionist symbol of hope, health, and regeneration in the early Israeli state, when procreation was deemed essential to the survival of the Jewish people and the new nation. As progressive as Orloff's monument was at the time, however, it still conforms to maternal stereotypes without focusing on the full realities of Alderstein's own life, including her combat experience, and what she sacrificed.

HISTADRUT MONUMENT

Following the success of her monument at Ein Gev, Orloff was commissioned in 1955 by the Executive Committee of the Histadrut, Israel's national trade union (the General Organization of Workers in Israel), to design a monument to the bravery of Jewish pioneer women, or what the organization called the "Hebrew working woman." The work was to be placed directly in front of their headquarters on Arlozorov Street in Tel Aviv as a means to commemorate women's labor in the founding of the new state. Eager for another opportunity to create a public work of art celebrating the role of women in Zionism, Orloff set to work on the project in her Parisian studio. She prepared four maquettes in plaster, from which she asked the committee to select their preferred piece for bronze casting on a large scale. Each sculpture featured the full body of a woman engaged in a different type of agricultural labor performed regularly by Jewish women pioneers in Palestine. These included gleaning, sowing, and carrying baskets of produce and building materials. The series resonated with Orloff's early days growing up in Petah Tikvah, along with her lifelong interest in the Book of Ruth, the story of the loyal and aspirational Jewish widow who was a migrant and converted to Judaism, and who developed a close relationship to the agricultural world and the Jewish nation.[64]

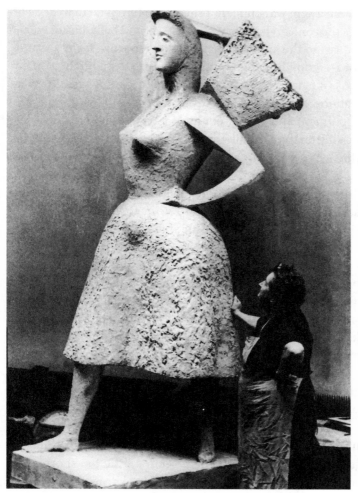

Figure 13.9. Orloff and *Woman with a Basket*, 1955.

The committee selected Orloff's *Woman with a Basket* (see figure 13.9) as the piece they wished to commission in bronze for the exterior of the Histadrut building. Executed in a more roughly textured social-realist style than her Ein Gev monument, the statue features a peasant woman carrying a large gravel-filled basket over her right shoulder. She rests the basket upon her upper back, and holds onto her left hip for balance. The woman appears as if in mid-stride, with one foot planted firmly forward and the other pushing off from the base. A formfitting

dress with such a slim waistline that she would have had to wear a corset enhances the conical shape of her breasts, round belly, buttocks, and hips, in contrast to the angular treatment of her arms, facial features, and the basket. Orloff intended for the sculpture to highlight women's contributions to nation-building through labor and production. This work also reinforced her interest in using biblical models to represent female embodiment and gender equity as part of the Zionist project.

After working on the commission for several months in her Parisian studio, Orloff's close friend, the painter Reuven Rubin, who was living in Tel Aviv at the time, wrote telling her that he was in fact on the Histadrut's sculpture committee. They planned to create and send a papier-mâché model of *Woman with a Basket* to Tel Aviv for temporary installation in front of the building; before moving forward with bronze casting, they wanted to ensure that the piece, which measured three meters high, was suitable for the site.[65] They must also have been curious about the public response to the sculpture, before finalizing the commission. After the model was installed, Rubin wrote again sharing some of the committee's concerns. While "they greatly admire your work," he wrote, "there is a small concession they request for your sculpture; they would like you to make the figure's bottom 'less round,' and for "'the woman's legs to be a bit longer.'"[66] Given the lack of precedent for representing the female body in Israeli sculpture, the committee was uncomfortable with certain aspects of Orloff's work. Rubin reassured her, "I went to see the plaster model in front of the building and looked at it from all angles. This will be truly magnificent for the Histadrut, but it's true, the legs seem a little too short if one looks at the sculpture from afar."[67] He agreed that she might adjust the bodily proportions, but he did not comment on their remarks regarding the shape of figure's buttocks. Orloff's naturalistic representation of female embodiment, including the buttocks, wide hips, and perhaps also the prominent breasts, may have bothered certain Histadrut committee members or members of the public on religious grounds who were uncomfortable with such bodily exposure.

Unfortunately, there is no record of the official correspondence between Orloff and the Histadrut committee. Ultimately, they rejected her piece and withdrew their commission.[68] We do not have clear documentation as to why, so we can only speculate. In an article

published shortly after the artist's death, entitled "The Story of the Uninstalled Statue," in the daily newspaper *Al HaMishmar*, Israeli journalist Nechama Genosar shared details of the story gleaned from a prior interview with Orloff. According to Genosar, the Histadrut's Executive Committee "canceled their invitation, because the religious people in Tel Aviv refused to install a statue (of a woman?)" in front of their building. The journalist described the unfolding of events as "a story that could only happen in Israel":

> I studied the image of the pioneer: a stunning figure, tight shirt over proud young breasts (not naked, heaven forbid), long skirt and a basket of gravel on her head. Chana Orloff wanted to commemorate the figure of the female pioneer, who worked during the establishment of Tel Aviv. Back then, she, as the figure of her statue, earned her livelihood from manual labor and it never occurred to her that one day someone would protest against a statue of a female pioneer.[69]

It appears that some of the committee members were religious Jews who objected to Orloff's sculpture as pushing the limits of what was acceptable artistic representation. Perhaps they viewed *Woman with a Basket* as violating the second commandment, "thou shalt not make unto thee any graven image" and risk idolatry. This mandate has been interpreted in a variety of ways since the Middle Ages; a common explanation prohibits the creation of sculptures of people, animals, or plants with the intention of worshipping them. The Histadrut's rejection of Orloff's sculpture might have been due to an objection to any representation of the female body. They also may have refused to accept imagery of a woman working outside of the domestic and traditional role of women in the home and in Judaism. Obviously, it was not at all Orloff's intention to invite the public to "worship" her statue of a pioneer woman. In contrast, we might think back to her *Mother and Son* monument at Ein Gev. In the context of kibbutz memorial culture, motherhood was viewed as a more acceptable and less threatening form of female embodiment that could be tied to the Zionist project. We must also take into account the different local audience for each work.

David Giladi of *Maariv* was another Israeli journalist who lamented

the suppression of Orloff's proposed "working woman" monument. "The powerful figure stands tall in a graceful posture," he wrote.[70] "One can find qualities of a great work of art, from every angle of the statue, full of rhythm and movement, the movement of a young woman walking powerfully and faithfully, toward her mission. It represents the mission of a working woman."[71] According to Giladi, it was a transition in the Histadrut's leadership that caused their rejection of the work. Mordechai Namir, the Israeli politician who commissioned it and served as the organization's general secretary from 1950 to 1956 (and was mayor of Tel Aviv from 1960 to 1969), remained enthusiastic about the project; however, his successor, Pinhas Lavon, took issue with the sculpture.[72] According to Giladi, Lavon shared his opinion that the figure portrayed in Orloff's sculpture possessed the figure and facial features "of a gentile, rather than that of an Israeli female pioneer."[73] The journalist did not elaborate on whether Lavon pointed to specific facial or bodily traits; more likely, religious committee members and/or the local religious community itself pressured him to reject the piece. Giladi concluded, "The artistic debate between the former and current chairmen naturally saddens the famous artist, and is a great insult to her art."[74]

Needless to say, Orloff's experience with the Histadrut commission was quite different from that with the members of kibbutz Ein Gev, from whom she had received a warm reception for her work honoring women who contributed to Zionism. Over the course of several years, Reuven Rubin repeatedly encouraged Orloff not to give up on the Histadrut commission. In a letter dated December 7, 1959, he reported on an exchange he had with a Histadrut member, Abraham Polani, who offered to advocate on Orloff's behalf. Rubin wrote that "he would seriously look into it, but there are many difficulties, especially when one has a case of a committee with religious people on it who are against the sculpture."[75]

Following this disappointment, Orloff found new contexts in both Israel and France to exhibit her latest body of work paying tribute to the "Hebrew working woman." She featured two works from this series in two different group sculpture exhibitions held in Parisian museums in 1958 (one at the Musée Rodin, and the other at Musée d'Art Moderne de la Ville de Paris).[76] In France, works like *Woman with a Basket* and

The Sower took on new significance in positioning Orloff's allegiance with the new state of Israel in a French context. Like the French curator Jean Cassou, who later dubbed her as the "Israeli artist of the École de Paris," many of Orloff's French critics took special interest in understanding her relationship with Zionism as a French citizen.

Thinking back to Orloff's monument at Ein Gev, in conjunction with her planned monument to the "working woman" for the Histadrut, we can see that she came full circle in embracing Zionist attitudes about women and war, procreation and nationalism. Her career-long investment in representing the maternal and laboring female body served a new purpose in her work for Israel created after World War II and the 1948 War. With gender, demography, and reproduction as central concerns to those who created and sustained the early Israeli nation-state, Orloff embraced this opportunity to pay tribute to the contributions of early Israeli women in art and politics.[77]

DOV GRUNER MONUMENT

In addition to her work celebrating the role of women, Orloff created a number of Zionist monuments commemorating men who sacrificed their lives in support of the founding of the state of Israel. The most controversial of these works memorializes Dov Gruner (1952) (see plate 13), a Hungarian-born Irgun Zionist activist who was injured and captured in a raid on a British police station in Ramat Gan, on April 23, 1946, and then sentenced to death by a British military court.[78] The monument also commemorates his three comrades of the Irgun Zionist underground—Israel Feinerman, Yaakov Zlotnick, and Yizhak Bilu—who were killed in the attack. Located on a main street in Ramat Gan, a small city located east of Tel Aviv, the monument features a mature lion, symbolizing the British Empire, wrestling a young cub, who symbolizes the Yishuv. Orloff's monument stands as a testament to the turbulent political environment of the final days of Zionist struggle against the British Mandate rule in Palestine.

In this well-known raid described by legal historian Shimon-Erez Blum as being "straight out of a Hollywood action movie,"[79] the four men, disguised as British sergeants and Arab prisoners, approached the Ramat Gan Police Station in a stolen British truck with a goal of taking over the weapons stored there. Their motive was also to hu-

miliate the British government. Gruner was severely injured in the course of the raid and was taken prisoner by the British. All three of his comrades, as well as an Arab police officer, were killed. Gruner was put on military trial by the British and sentenced to death. In response, the Irgun abducted senior British officials, and the British threatened to impose martial law on the Yishuv. A lengthy legal battle ensued, attracting international media attention. The affair ended on April 16, 1947, when Gruner and three other Irgun members were executed in Acre prison, "under a cloud of secrecy."[80]

Six years later, in 1953, Orloff was commissioned to create a monument to commemorate Gruner and his fallen colleagues in front of the Ramat Gan Police Station by an Israeli group known as Shelah, or Liberation of Freedom Fighters (LFF). In 1948, after the state of Israel declared its independence and the British departed, Shelah believed that the Mapai party ("Workers" Party), a democratic socialist party in Israel and rival of the Revisionists, presented the 1948 War and statehood project solely as achievements of the Haganah, and marginalized the contributions of the Irgun and other underground right-wing Revisionist Zionist groups from national memory.[81] Many organizations at the time, including the United Nations, the British and American governments, and the 1946 Zionist Congress, viewed the Irgun as a terrorist organization.[82] In light of the conflicts between different political organizations, Shelah turned to Abraham Krinitzi, the mayor of Ramat Gan, who was a well-known Revisionist. While Krinitzi supported the project, Shelah's request led to bitter conflicts and ideological disputes within the municipality. Among the topics that caused conflict were individual versus shared memorialization, as well as controversies over the violent nature of Irgun's and Gruner's actions. Eventually, Shelah's request was granted, and they turned to Chana Orloff, perhaps because her family was affiliated with the Revisionist party, and invited her to design and erect the monument. It took her two years to complete the project, and Orloff was paid 1.125,000 francs (which increased some with time). Correspondence between Orloff and the Shelah management reveals an ongoing dispute regarding the payments and schedule, and attests to her shrewd behavior in business transactions.

According to interviews published in the local press, Orloff's original design for the monument featured a unicorn fighting a lion. Tradition-

ally, the lion and the unicorn appear in the Royal coat of arms of the British Empire, the lion standing for England, and the unicorn for Scotland. In choosing this symbolism, Orloff drew from traditional legend and nursery rhymes that posed the two animals as rivals, and aligned the Yishuv with Scotland.[83] Dissatisfied, Shelah members came back to her requesting she change her design to show a lion fighting a cub, because the unicorn was perceived as not "Jewish" enough. In her final design, figured in the maquette (see figure 13.10), the big lion symbolizes the British Empire, and the cub the Yishuv. The Yishuv liked to see itself as young and vital, as well as strong and brave, characteristics needed for taking on a bigger opponent. Lions have a long history of symbolism associated with Zionist ideas of the "new Jew," and were a powerful symbol of the tribe of Judah and the emblem of the House of David. The Jewish community in Palestine associated lions with masculinity, bravery, victory, and military prowess.

Orloff and the Shelah members working with her on the commission must have been familiar with Israeli sculptor Avraham Melnikov's famous monument at Tel Hai, *Judah Is a Lion's Whelp* (1928–34). Known popularly as the "Roaring Lion," it features a symbolic crouching lion in granite, standing almost four meters high. It stands as a memorial to the women and men, led by Josef Trumpeldor, cofounder of the Jewish Legion, who fell in March 1920 while defending a small Jewish settlement in the Upper Galilee.[84] Even though Melnikov's sculpture faced initial skepticism, due to conflicting political factions, it has since come to symbolize "the rebirth of the historical Hebrew nation" and is a "national icon," according to art historian Yigal Zalmona.[85] Familiar with this and other memorial projects in Palestine where the Yishuv is symbolized as a lion, Orloff agreed to Shelah's request to adapt her original design. Her experience working on the Dov Gruner memorial project predated that of the Histadrut's commission for the "Hebrew working woman" monument, where she was not given a chance to respond to critique or consider making revisions.

The unveiling ceremony for Orloff's monument to Dov Gruner took place in Ramat Gan on June 6, 1954. Newspapers estimated that between thirty thousand to fifty thousand people attended from all over the world. Bouquets of flowers were placed at the foot of the monument. Orloff sat at the center of the stage beside Menachem Begin

Figure 13.10. Orloff with Dov Gruner monument maquette, Tel Aviv.

(then head of Irgun and the Herut party), Professor Joseph Klausner (who supported Revisionist Zionism), and Ramat Gan mayor Abraham Krinitzi. Among the audience members were the representatives of Swedish and Brazilian embassies in Israel. Several Irgun members who survived death row held torches and threw handfuls of dirt onto the monument. The ceremony opened with a eulogy to David Raziel, one of the founders of Irgun, and continued with a singing of Irgun's and Betar's (Revisionist Zionist youth movement) oaths; it concluded with speeches by Klausner, Krinitzi, Begin, and Rafael Kotlowitz (Shelah's chairman).

In retrospect we might ask: Why did Orloff, who did not publicly discuss politics or directly align herself with any of the political factions involved in the case of Dov Gruner, accept this controversial commission? Perhaps she viewed her role in executing the project as a gift to her family, a way of endorsing their own work in building the new nation. Given that she came from a politically conservative Zionist family that was affiliated with the right-wing Revisionist party, she likely embraced this and other Zionist memorial projects as a means of expressing her allegiance to them.

Orloff remained a celebrated figure in both the Israeli and French art worlds of the 1950s and 1960s. The Museum Association of Israel honored her fifty-year-long career by organizing a traveling solo exhibition that opened at the Tel Aviv Museum of Art, Helena Rubinstein Pavilion, in 1961. Organized by Jean Cassou, chief curator of the Musée National d'Art Moderne in Paris, the catalog was printed in both French and Hebrew. It was here that Cassou dubbed her the "Israeli artist of the École de Paris." The exhibit toured to museums in Jerusalem, Haifa, and Ein Harod, giving people across the country an opportunity to get to know her work. In 1964 she was awarded the prestigious Miriam Talphir Prize, attesting to her reputation for outstanding achievement in Israel's young arts scene.[86]

In Paris, Orloff's sculptures were featured regularly in salons and group shows at the Musée Rodin, Musée Galliéra, and other prominent French museums and galleries. Katia Granoff, an important French art dealer, Russian émigré, and strong advocate of women artists, organized three successful solo exhibitions of Orloff's work (1957; 1959; 1962–63). Among her latest works were a series of sculpted portraits

of young Israeli artists who came to visit her regularly in her Parisian studio: Lea Nikel, Sionah Tagger, David Lan-Bar, Moshe Mokady, Aharon Kahana, Yosef Zaritsky, and others.

The tension between her proud Jewish/Zionist/Israeli identities and her assimilated French identity persisted throughout Orloff's life and career. We have seen how critics in Israel appropriated her as Israeli in order to promote their respective ideological agendas. We also have seen how her work in this period supports a positive and forward-thinking version of the new state, to which her own family had deep ties, in the wake of war. In particular, Orloff offered her own representations of women and the empowered female body as part of the Israeli future.

CHAPTER 14
Conclusion
Legacy in Israel and France

In 1968 the Tel Aviv Museum of Art invited Orloff to have a "jubilee" exhibition on the occasion of her eightieth birthday. She traveled from Paris to Tel Aviv a full year before the proposed opening to begin the planning process. Haim Gamzu, head curator and museum director, reported that as the opening date approached, Orloff "was in great health; full of energy, she took care of everything, and thought of the smallest details."[1] However, when she arrived at Ben-Gurion airport following her flight from Paris, she fell ill. She was taken immediately to Tel HaShomer hospital in Ramat Gan. A few days later, on December 18, 1968, Chana Orloff died at age eighty.

Enormous crowds who came to honor her attended her funeral, including Miriam Eshkol, the prime minister's wife, and Mordechai Namir, then mayor of Tel Aviv. Before the ceremonial burial service, they placed her casket for two hours in the Helena Rubinstein Pavilion for Contemporary Art (the Tel Aviv Museum of Art at the time), accompanied by an honor guard (see figure 14.1).[2] Members of the public could visit the museum to pay their respects. All this, the kind of fanfare normally reserved for men, attests to Orloff's stature and ability to overcome gender stereotypes.

The museum postponed her retrospective exhibition to follow her funeral by several months; it opened on March 2, 1969. It included one hundred twenty sculptures, primarily in bronze, created over fifty years, and sixty drawings and works on paper. The exhibit filled multiple galleries of the museum. Installation photographs suggest it was curated

Figure 14.1. Orloff's funeral, lying in state. Helena Rubinstein Pavilion, Tel Aviv Museum of Art, December 1968.

somewhat thematically (see figure 14.2). For example, portraits, nudes, dancers, maternities, and sculptures of animals created during different points in her career similarly are grouped together. Newspapers reported that over twenty-five thousand people attended the exhibit.[3] This significantly exceeded the usual attendance figures for Israeli art exhibitions. People came not only to admire her work but also to pay homage to Orloff as an important leader in the cultural world of the new state.

In the exhibition catalog, Gamzu described "the story of Orloff's life" as "a legend": a young woman from a small Ukrainian town becomes "among the most prominent sculptors of her time." He acknowledged her "lively critical instinct," rejection of the academy, and independent spirit: "As she came to new approaches or unconventional ideas, she did not become enslaved by them, but adapted them to the character of her work—adapted, and did not become adapted."[4] Gamzu's catalog essay addressed how Orloff was intent upon defining her own aesthetic over the long arc of her career. Although full of praise, it also perpetuated certain gendered myths about her as a female artist. For example, he

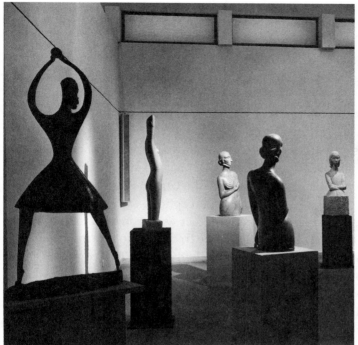

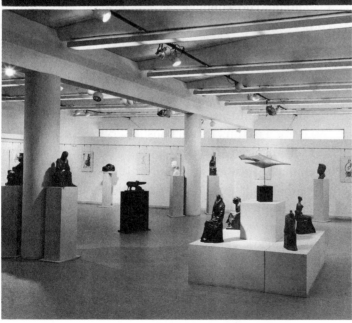

Figure 14.2. Israel Zafrir, Installation photographs from *Chana Orloff (1888–1968): Exposition Retrospective*. Tel Aviv Museum of Art, March 2–April 12, 1969.

claimed: "Through her husband, she met all the great Jewish artists of the Paris School—Modigliani, Soutine, Pascin, Zadkine and Jacques Lipchitz, as well as Marc Chagall. Until then, the dreamy girl had never dreamt that she would be an artist."[5] Orloff already was a professional artist when she met her husband. She forged relationships with her colleagues independently. We have seen that she was not a "dreamy girl," but a fiercely determined and ambitious young woman who overcame obstacles and created professional opportunities for herself at every turn. This type of positioning of women artists as naive and dependent upon a male artist partner is typical of mid-twentieth-century art-historical writing in Israel, France, the United States, and elsewhere.

Gamzu's essay contributes to perceptions of Orloff's placeless or "in-between" status by positioning her as a woman and an outsider who was also "one of us": "She came from time to time to present her work to us, as if to tell us how far we had come."[6] This comment shows how Orloff's national identity was not fixed. It also reveals how Israeli art critics and curators looked to the work of Jewish artists in Paris as a model for artists in Palestine and later Israel.[7] In 1952 Orloff made a sarcastic nod to this trend in an interview with an Israeli journalist when she said, "One could not conquer the Jews' hearts . . . not until all the goyim (Gentiles) spoke in praise of thee."[8] Using "thee," she played with biblical phrasing to emphasize the emerging Israeli art world's need for external validation from those already established in Europe.

Following her death, Orloff remained a well-recognized figure in the history of art in Israel. As new museums opened in Jerusalem, Haifa, Herzliya, and at kibbutz Ein Harod, her work entered a number collections across the small country. Israel's postal service featured a picture of her classically inspired *Mother and Child*, Ein Harod, and her Dov Gruner monument in postage stamps over the years, showing her stature as a national hero. However, solo exhibitions of Orloff's work have been rare in Israel since the time of her death. Hana Kofler's 1992 exhibit, *Chana Orloff—Line and Substance 1912–1968* at the Open Museum, Tefen Industrial Park, has been the most significant show since 1969. *Sower* and *Gleaner*, two of Orloff's "working woman" sculptures initially created for the failed Histadrut commission, were acquired by the museum for this exhibit. Afterward, they were moved to the

sculpture garden at Beit Hannassi, the home of the Israeli president in Jerusalem, where they are now on permanent display (see plate 14).[9]

In addition, Orloff's portraits of Bialik and Rubin, among her best-known works in Israel, are displayed prominently in the two neighboring museums dedicated to each figure in Tel Aviv. Bialik House and the Rubin Museum are located on Bialik Street, home to many art and architecture institutions in the heart of the "White City." Orloff's portraits, readily visible to busloads of international tourists who visit these iconic museums each year, show her role as an important chronicler of an early period in the formation of Israeli cultural identity.

In France, Orloff had a postmortem retrospective in Paris at the Musée Rodin.[10] The exhibition, which took place in 1971, featured ninety sculptures and over fifty drawings, primarily from French public and private collections and the artist's estate. On the occasion of Orloff's exhibition, the Rodin Museum's chief curator Cécile Goldscheider emphasized Orloff's role as an emissary for French art in Israel. She recalled Orloff's warm presence at the opening of a large Rodin retrospective at the Tel Aviv Museum of Art in 1967, remembering how Orloff had been moved by this opportunity to "transmit" the work of the "master" to this "distant land," her "second homeland" (*sa seconde patrie*). Such remarks situate Orloff as both a player in the Parisian art world and a propagator of French masters in Israel. French art critic and curator Raymond Cogniat notes in the catalog essay for Orloff's exhibition: "Since World War II she often takes up the theme of womanhood, in simple and familiar poses, with extreme sensitivity, a sort of tenderness that seems to signify an affectionate repose after long years of introspection."[11] Cogniat describes Orloff's postwar imagery of the female body, whether naked, clothed, maternal, at work, or biblical, as a place where she celebrates women's strength and resilience.

Critics and curators in both France and Israel remained interested in her work following her death, even as many of them grappled with how to categorize her contributions because her work embraced disparate cultural and geographical perspectives. Therefore, although Orloff strategically resisted pigeonholing based on nationality, this may have ultimately impacted her entry into art history. Stylistically, her body of work also resists categorization within the vari-

ous avant-garde movements that proliferated in both countries, from cubism, surrealism, and *art brut* in France, to social realism followed by abstraction in Israel. For many women artists like her, this lack of fitting in neatly to one artistic style or movement contributes to a sense of being placeless or in-between. Ultimately, Orloff shows us how it is possible to belong to multiple groups, and that many allegiances can coexist, if not complement each other, in an artist's oeuvre.

In the decades since her death, Orloff's life and work has often been overshadowed in both Israeli and French contexts by her more famous Jewish colleagues from the École de Paris: Modigliani, Chagall, Soutine, and Jules Pascin.[12] Her immersion in the Jewish art world of Paris made her a desirable figure for Israeli audiences that wanted to establish their own artistic heritage. Subsequent curators and critics in both countries positioned her as primarily a Parisian artist and focused on the importance of her contact with Jewish and Israeli culture for the work she produced in France. Although two exhibitions in 2021 at the Tel Aviv Museum of Art and the Musée d'Art et d'Histoire du Judaïsme in Paris acknowledged her important contributions to twentieth-century art, they did not delve into her unique position as a transnational woman artist whose sense of home and belonging was always in question.[13]

For the past several decades, Orloff's combined home and studio in Montparnasse has functioned as a private museum in Paris, the Ateliers-Musée Chana Orloff. Run by the artist's grandchildren, it features nearly two hundred sculptures on view in the light-filled studio designed to Orloff's specifications by French modernist architect Auguste Perret. Visitors can request a tour to take in the captivating place where Orloff lived and worked from 1926 until her death in 1968, with a nearly three-year interruption during the years of World War II. The museum offers special programming on the "Jours du Patrimoine" (European Heritage Days), a series of international events created in 1984 by the French Ministry of Culture with a goal of showing the richness of French heritage to as many people as possible.

As a testament to her family's efforts to ensure Orloff's inclusion in French cultural history, on the fiftieth anniversary of her death in 2018, they inaugurated *My Son, Marine* (1927) (see plate 15), as a public

statue at an intersection near her studio and home. It took ten years for the project to be approved and realized by the neighborhood culture commission. The family selected this sculpture featuring Orloff's nine-year-old son because of the resonance of the selected site, Place des Droits des Enfants (Children's Rights Square). As her granddaughter put it, "it seemed more than appropriate to have a sculpture of a child. Chana Orloff made many sculptures of her only son, Didi [Élie's nickname], which deeply show maternal love."[14] Orloff's combined home and studio also recently was designated as an official member of "iconichouses.org," demonstrating the family's efforts to elevate her status in France to join other marginalized women in modernism who are finally making history.

Another one of Orloff's sculptures of her son as a young boy is currently (as of 2021) at the center of two lawsuits, one in the Paris Judicial Court and the other in the Manhattan Supreme Court. The artist's family is claiming their right to restitution of the wooden statue titled *The Child Didi* (1921). The piece was stolen during one of several raids of Orloff's home and studio by Vichy collaborators, authorized by the Nazis during World War II. She created this work just two years after her husband's death, while navigating her life as a young artist and mother. The sculpture measures three feet high and is of great sentimental value to Orloff's grandchildren considering the persecution she and her son faced as Jews living under the Occupation of Paris. Orloff tried for many years to reclaim this work, along with other sculptures, paintings, furniture, and professional tools taken from her home and studio, but failed before her death in 1968. *The Child Didi* turned up at Christie's auction house in 2008 in New York, after the owner claimed to have purchased it the year before with no history or provenance. After Orloff's granddaughter, Ariane Justman Tamir, notified Christie's of the problematic history of the piece, Christie's withdrew it from auction. They have held it in a secure location since. In the meantime, several attempts to negotiate a settlement between 2008 and 2021 were unsuccessful. As we consider Orloff's legacy, it is crucial to acknowledge the decades-long struggle of families like hers to recover works like *The Child Didi* and have them returned, in order to evaluate the full arc of an artist's life and work.

Orloff's legacy also has become more visible in that contemporary artists and curators in Israel have explored her as a foremother of feminist art in Israel. Israeli curator Svetlana Reingold organized *Chana Orloff: Feminist Sculpture in Israel* at the Mané-Katz Museum in Haifa in 2017. The exhibit featured Orloff as "an early proponent of a personal, revolutionary approach to the female body."[15] Her nudes, maternities, biblical heroines, and pioneer women were paired with works by fifteen contemporary female Israeli sculptors, including Tali Navon, Ronit Baranga, and Orly Montag. According to Reingold, Orloff's legacy can be traced in these artists' engagement with themes of embodiment that include motherhood. In response to the exhibit, Israeli art critic Dana Gillerman critiqued Orloff as a conservative sculptor whose "classical" approach to the female nude and motherhood presents "a masculine view of nudity and beauty" with "no attempt to articulate a political statement."[16] I have argued the contrary. Orloff's imagery of the female body stands as a testament to her lived experience and effort to change the look and shape of Jewish female identity in the arts in France. She used similar visual strategies to contribute to the Zionist history of art in Israel from a female perspective. As a well-known member of the School of Paris who migrated between continents and forced exiles, she embraced disparate cultural and geographical perspectives as the basis of a complex identification not limited by the concept of a nation-state. Orloff was a politically engaged international artist who, through her practice of sculpture—portraiture, imagery of the female body, and later monuments—showed her commitment to a wide range of representations and critical attitudes about gender, Jewish identity, migration, and nationalism throughout her career.

To conclude this study of Chana Orloff's life and work, I wish to consider a recent installation by contemporary Israeli artist Noa Tavori, *Still Alive after Chana Orloff,* curated by Smadar Keren as part of the "Great Mother" exhibition at the Beit Uri and Rami Nehoshtan Museum, Kibbutz Ashdot Yaakov, Mehuad, Israel (2020) (see plate 16).[17] This piece shows explicitly how Orloff's lifelong inquiry into female embodiment and the mother-child relationship inspires and challenges contemporary feminist artists in Israel to think about their own place in the history of Israeli sculpture and the culture of commemoration

in the Zionist project. Tavori offers a powerful meditation on Orloff's *Mother and Son* monument at Ein Gev, a work of art with which Tavori has been fascinated for several years. She describes it as a "dybbuk," a term from Jewish folklore for when the soul of a deceased person enters a living body: "I was obsessed with this sculpture; Orloff, the artist, the woman she was memorializing, and myself, we were all combined."[18] The project began with Tavori responding to a large black-and-white photograph of the monument and its iconic silhouette on her studio wall. She wished to investigate the difference between a sculpture that is still, like a Greek caryatid, and something that is alive, using her own body. In contrast to the static monument, Tavori decided to "inhabit the figure of the statue, representing through her own body the mother as she carries her child."[19] Through drawing, photography, videography, and sculpture, we follow Tavori on her journey as the "silhouette" of the mother carrying her child. Dressed in all black, masked, and wearing heels, Tavori becomes the cosmopolitan version of Orloff's mother-statue, separated from its base. She leaves her Israeli studio, with its crescent moon and cactus garden backdrop, and wanders through various locations in Europe and Israel that include public gardens, bodies of water, and urban landscapes, as she holds her baby.

Tavori also stages "physical interactions" between herself, as the mother in Orloff's statue, and other monuments and statues in Europe and Israel, "alternating between mother and father figures—real and metaphoric—as if seeking a new place for the sculpture."[20] These include her physically climbing Yehiel Shemi's *Father and Son* (1954) (see figure 14.3), a monument created two years after Orloff's *Mother and Son*. Located at the entrance to kibbutz Hukkok overlooking Tiberias from the top of a mountain, Shemi's work commemorates Meir Hasman, who drowned in a flood in 1951 while on active duty. Here Tavori channels Orloff's tribute to Chana Tuchman Alderstein, also a parent-victim and a pregnant mother of two, killed while protecting members of her kibbutz from Syrian attack. Tavori's project examines the role of commemoration and the representation of women in Zionist art by asking "What came first: the figure of the symbolic mother in the work, or the private mother who served as a model for it?"[21] In her insightful analysis of the piece, Israeli critic Tali Tamir notes how

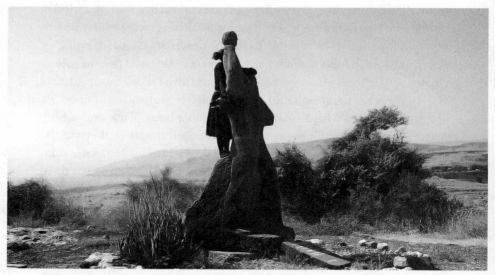

Figure 14.3. Video-still from the *Still Alive after Chana Orloff* project, an action by Noa Tavori, alongside the sculpture *Father & Son* by Yechiel Shemi in Hukok, Beit. Uri and Rami Nehoshtan Museum, 2020. Photograph by Dorit Figovitz Goddard.

"Orloff managed to break away from the Zionist project and create a new identity as a Parisian sculptor," whereas Tavori "also goes out into the world, masquerading as Orloff's statue," but is unlikely able to "separate herself from the Israeli project she grew up in."[22] Tavori writes that "'the longing to become a citizen of the world crashes against the other bank that ties me to Israel and to the local myth.'"[23] Described as "an alternative monument from the personal viewpoint of Tavori the artist—as a mother, a woman, and a sculptor,"[24] this project is but one example of how Chana Orloff's lifelong engagement with themes of gender, migration, nationalism, and cosmopolitanism leave an important legacy for a new generation of artists to ponder.

ACKNOWLEDGMENTS

This book has a long history, and it would not have been possible without the intellectual, personal, and financial support I have been fortunate to receive.

I am indebted to Chana Orloff's grandchildren, Ariane Justman Tamir and Éric Justman, for so generously opening up their home and family archives to me over many years and entrusting me to write her very first biography. They allowed me to spend as much time as I needed in the archives, answering questions and providing the rich documentation that made this project come to life.

Thanks to the team at Brandeis University Press—including former editor in chief Phyllis Deutsch for commissioning the book, and press director Sue Berger Ramin for her vision, enthusiasm, and confidence in the project. Sylvia Fuks Fried has been an ideal editor, full of patience, wisdom, and creativity. Anthony Lipscomb has provided constant support in finalizing permissions and shepherding the manuscript through the editorial process and production. I am grateful to Natalie Jones for her superb copyediting, to Richard Hendel for his inspiring design, and to the entire production team at Redwing Book Services for their exemplary work on the book.

I appreciate those institutions that provided generous financial support for the research, writing, and publication of the book: University of San Francisco, College of Arts and Sciences; Faculty Development Fund; and the Irwin Blitt Research Award, Hadassah-Brandeis Institute. I am honored that my book appears in the Hadassah-Brandeis Institute's Series on Jewish Women. I am also grateful to the Schusterman Center for Israel Studies at Brandeis University for supporting my research and teaching interests relating to this book.

This book simply would not be what it is without the help of Ayelet Carmi, who supported my research on Orloff's life and work in Israel. Ayelet's keen ability to track down the artist's descendants and friends in Israel, along with an array of archival materials and press reviews in

Hebrew, deeply enriched the project. Unless noted otherwise, Ayelet provided translations from Hebrew to English that appear in the text, including Orloff's unpublished interviews with Rivka Katznelson. Ayal Nistor translated part of Zvi Nishri's and Miriam Eitan's unpublished reflections from Hebrew to English. Translations from French to English are my own, unless noted otherwise.

I am grateful to the staff (too many to mention by name) that supported my research in a long list of museums, libraries, and archives in Israel, France, Switzerland, the United States, and other locations. I made a good-faith effort to track down the rights holder for every image under copyright that is represented in the book; for more information regarding permissions, please contact me. In certain cases, I have reproduced archival images of missing works of art, press clippings, and photographs that are essential to the book but that are not of the highest clarity.

I appreciate the following colleagues who generously shared their research, archival materials, and contacts with me and supported the project at various stages: Gannit Ankori, Maoz Azaryahu, Barbara Bauer, Claude Bernès, Sherry Buckberrough, Tal Dekel, Yves Chevrefils Desbiolles, Véronique Goncerut, Anita Halasz, Anne Grobot-Dreyfus, Ruth Fivaz-Silbermann, Lauren Jimerson, Claire Luchetta-Rentchnik, Camille Morineau, Marianne Le Morvan, Benoît Noël, Andrea Pappas, Lucia Pesapane, Pnina Peri, Guy Raz, Franck Salameh, Rebecca Shaykin, Amnon Tamir, Noa Tavori, Kerry Wallach, and Kenneth Wayne. I am also grateful to the following relatives and acquaintances of Chana Orloff interviewed for this project: Rina Avron, Rina Lutsky, Rina Shapira, and Moshe Zarhi. In addition, I am grateful to Binyamin Eisin, son of Rivka Katznelson, for granting me permission to draw from his late mother's unpublished interviews with Chana Orloff; Ruhama Veltfort and Zena Hitz, for sharing material from the Beata Rank Archive; Amnon Rechter, for sharing documentation from the Zeev Rechter Archives; and Tuti Sara Rechter, for sharing her memories of Chana Orloff.

I wouldn't have been able to finish this book without the constant support, encouragement, and editorial help of many friends, colleagues, and family members. Ruth E. Iskin generously provided feedback on countless drafts and hosted me on several research trips to Israel. Ruth recommended Ayelet Carmi, her doctoral student at the time, to

serve as my research assistant. My writers' group has been a constant source of support and feedback—especially Jennifer L. Shaw and Amy Lyford, my pandemic writing partners on Zoom, along with Kim Anno, Irene Cheng, Alla Efimova, Jeanne Finley, Tirza True Latimer, Jordana Moore Saggese, and Rachel Schreiber. Stacy Garfinkel also provided insightful feedback on early drafts. My daughter, Mariel Solomon, offered astute comments and provided essential help in formatting the illustration files for publication. Karen M. Offen helped me to refine the manuscript in the final stages. Her scholarship on feminism has greatly influenced my work.

Many colleagues and institutions invited me to give talks about Chana Orloff that helped me refine my ideas in the book. Tal Dekel invited me to give a keynote lecture for the 2017 conference "(Dis) Place: New Directions in the History of Art in Israel," sponsored by the Department of Art History, Tel Aviv University, in which I focused on themes of gender, migration, and transnationalism in Orloff's work. Tal also generously assisted with my research on Orloff's monuments in Israel and introduced me to artist Noa Tavori, whose inspiring work is featured in the conclusion. Students in my art history courses at the University of San Francisco have been a constant presence in the shaping of this project. I am grateful to my colleagues in the Department of Art + Architecture for their belief in me as a scholar and educator.

I want to above all thank my family and friends (too many to mention by name) for their encouragement over the years. My late mother, Barbara Birnbaum, loved learning about Chana Orloff and made me appreciate our own family lineage of strong Ukrainian Jewish women. My late father, Robert Birnbaum, and sisters, Carol and Margot Birnbaum, each in their own way has been a source of strength. Finally, I thank my children, Mariel and Jordan Solomon, and husband, Neil Solomon, whose love, support, patience, and humor have sustained me throughout the entire project.

At the time of this writing, we are in the third year of the novel coronavirus (COVID-19) pandemic, and the country of Ukraine is under siege. May Chana Orloff's personal experiences amid war and a global pandemic provide inspiration for all who persist in the face of trauma and displacement.

Paula Birnbaum, San Francisco, April 2022

NOTES

INTRODUCTION

1. The Ateliers-Musée Chana Orloff is a private museum in Paris run by the artist's descendants. One can visit by making an appointment at https://www .chana-orloff.org.

2. Ien Ang, "What Are Museums For? The Enduring Friction between Nationalism and Cosmopolitanism," *Identities* 1, no. 24 (2017): 4.

3. On the controversies surrounding the publication of Margueritte's novel, see Anne Marie Sohn, "La Garçonne face à l'opinion publique: Type littéraire ou type social des années 20?" *Mouvement social* 80 (1972); Mary Louise Roberts, *Civilization without Sexes: Reconstructing Gender in Postwar France, 1917–1927* (Chicago: University of Chicago Press, 1994), 46–62; Christine Bard, *Les Garçonnes; Modes et fantasmes des Années folles* (Paris: Flammarion, 1998) [French], 64–87.

4. On the role of head coverings in traditional religious Jewish culture, see Giza Frankel, "Notes on the Costume of the Jewish Woman in Eastern Europe," *Journal of Jewish Art* 7 (1980): 50–57. For analysis of women's clothing and head coverings in Russian/Soviet visual culture, see Valerie A. Kivelson and Joan Neuberger, eds., *Picturing Russia: Explorations in Visual Culture* (New Haven, CT: Yale University Press, 2008), 79, 119–23, 130, 162–67, 246.

5. Kenneth E. Silver and Romy Golan, eds., *The Circle of Montparnasse: Jewish Artists in Paris, 1905–1945* (New York: Universe Books/The Jewish Museum, 1985).

6. Jakob Eghold Feldt, *Transnationalism and the Jews: Culture, History and Prophecy* (London: Rowman & Littlefield, 2016), 7–11.

7. Romy Golan, "The 'École Français' vs. the 'École de Paris': The Debate about the Status of Jewish Artists in Paris between the Wars," in *Circle of Montparnasse*, 81–87; Golan, "From Fin de Siècle to Vichy: The Cultural Hygienics of Camille (Faust) Mauclair," in *The Jew in the Text*, eds. Linda Nochlin and Tamar Garb (London: Thames and Hudson, 1995), 156–73; and Matthew Affron, "Waldemar George: A Parisian Art Critic on Modernism and Fascism," in *Fascist Visions: Art and Ideology in France and Italy, eds.* Matthew Affron and Mark Antliff (Princeton, NJ: Princeton University Press, 1997), 171–204.

8. Arie Lerner, "A Great Artist Returns to the Homeland," *Devar* (March 6, 1949).

9. Sioma Baram, "Chana Orloff, Le Sculpteur Israèlien, est une Femme au Coeur Innombrable," *L'Arche* (November 1959), 47.

10. Sioma Baram, "Chana Orloff," 47.

11. Peggy Levitt, *Artifacts and Allegiances* (Berkeley: University of California Press, 2015), 5.

12. Silver and Golan, eds., *Circle of Montparnasse.*

13. Romy Golan, "The Last Seduction," *Paris in New York: French Jewish Artists in Private Collections*, ed. Susan Chevlowe (New York: The Jewish Museum, 2000), 10–21.

14. Pascale Samuel and Paul Salmona, *Chagall, Modigliani, Soutine: Paris pour école, 1905–1940* (RMN/Musée d'Art et d'Histoire du Judaïsme, Paris, 2020).

15. Two exhibitions focused on the life and legacy of international cosmetics entrepreneur Helena Rubinstein include works by Orloff in the context of Rubinstein's art patronage: Mason Klein, *Helena Rubinstein: Beauty Is Power* (New York: Jewish Museum, New York, 2014); and Hélène Joubert, *Helena Rubinstein: Madame's Collection* (Paris: Skira, 2019). A few of Orloff's works also have been included in recent exhibitions in Paris addressing the role of women in modernism, such as Camille Morineau, *elles@centrepompidou – Women Artists in the Collection of the Musée National d'Art Moderne, Centre de Création Industrielle* (Paris: Centre Pompidou, 2009); Catherine Grenier et al., eds., *Modernités plurielles 1905–1975* (Paris: Centre Pompidou, 2013) [French]; Paula J. Birnbaum, "L'artiste femme en amazon," *Pionnières, artistes d'un nouveau genre dans le Paris des années folles*, 147–55, eds. Camille Morineau and Lucia Pesapane (Paris: Réunion des musées nationaux, 2022) [French].

16. The late art dealer Félix Marcilhac's *Chana Orloff: Sculptures-Catalogue Raisonée* (Paris: Les Éditions De L'Amateur, 1991) [French] remains the most comprehensive publication in French on Orloff's life and work. Marcilhac championed the rediscovery of Orloff's work in France in the 1990s. His catalogue draws heavily from Germaine Coutard-Salmon, "Chana Orloff (1888–1968) et son Époque" (PhD diss., Université de Paris IV-Sorbonne, 1980) [French]. See also Cissy Grossman, "Restructuring and Rediscovering a Woman's Oeuvre: Chana Orloff, Sculptor in the School of Paris" (PhD diss., The City University of New York, 1998); Anne Grobot-Dreyfus "Sociabilités familiales, intellectuelles, artistiques et politiques autour d'une dessinatrice, illustratrice, graveuse et sculpteur: Chana Orloff (1888–1968), entre Paris, l'Amérique et Israël (1916–1968)" (PhD diss., University of Burgundy, Dijon, 2018) [French]. Rebecca Benhamou's *L'Horizon a pour elle dénoué sa ceinture* (Paris: Fayard, 2019) [French] is a work of historical fiction based on Orloff's life.

17. Chana Orloff and Rivka Katznelson, *Memoirs*, trans. Ayelet Carmi, 1957 [Hebrew]. Courtesy of Ateliers Chana Orloff.

18. Haim Gamzu, *Chana Orloff* (Tel Aviv: Massada, 1951), 57 [Hebrew].

19. Pierre Nora, "Between Memory and History: Les Lieux de Memoire," *Representations* 26 (Spring 1989): 21.

20. On theories of cumulative migration, see Sukanya Banerjee, Aims McGuiness, Steven C. McKay, eds., *New Routes for Diaspora Studies (21st Century Studies)* (Bloomington: Indiana University Press, 2012), 146.

21. On the question of women artists and biography, see Sarah E. Webb and Kristen Frederickson, eds., *Singular Women: Writing the Artist* (Berkeley: University of California Press, 2003).

22. Katy Siegel and Devika Singh, "Toward a Transnational Approach to American Art: Isamu Noguchi in India and Beyond," Terra Foundation, February 24, 2021. Online dialogue.

CHAPTER 1

1. Unless indicated otherwise, uncited biographical information is drawn from Chana Orloff's unpublished (and unpaginated) interviews: Orloff and Katznelson, *Memoirs*. Courtesy of Ateliers Chana Orloff. I also draw from the unpublished reflections by two of her siblings, Zvi Nishri and Miriam Eitan: Zvi Nishri, "From the Memories of Zvi Nishri," [Hebrew], trans. Ayal Nistor and Ayelet Carmi (n.d.), Courtesy of Ateliers Chana Orloff; Miriam Eitan, "Memories of Hanna. Written by Miriam Eitan (Orloff) in the years 1962–63, as Hanna Reached 75 Years," from the unpublished manuscript of Yael Eitan Gilad, trans. Ayal Nistor. Courtesy of Ateliers Chana Orloff.

2. Orloff was born the eighth of nine children, including four daughters and five sons. Her siblings were Shimshon Orloff (dates unknown), Meir Dov Orloff (1871–1916), Reina Lutsky (1876–1919), Zvi Arie Nishri (1878–1973), Aaron Orloff (1880–1929), Masha Skibin (1883–1861), Miriam Eitan (1887–1963), and Abraham (Izzy) Orloff (1891–1981).

3. Rokhel Luban (1898–1979), *Memoirs*, translated from Yiddish by Chaim Freedman (n.d.). http://kehilalinks.jewishgen.org/colonies_of_ukraine /memoirs_of_rokhel_luban.htm. Luban was born in 1889 in the neighboring Jewish colony of Trudolyubovka, which was also known to the Jews as Engels. In her memoir, Luban states that there were seventeen colonies in Yekaterinoslav, and that the names of the town, Tsaraconstantinovka and Kamenka, were in fact interchangeable. Note that in his unpublished memoir, Orloff's brother Zvi Nishri lists his birthplace as Tsaraconstantinovka, while Orloff refers to her place of birth in the unpublished Katznelson interviews as Kamenka. Kamenka was established as a Jewish agricultural colony of Kherson Guberniya in 1808: http://evkol.ucoz.com/colony_kherson_en.htm.

4. For a history of the Jewish colonies established in southeastern Ukraine, see Herman Rosenthal, "Agricultural Colonies in Russia," *Jewish Encyclopedia*, https://www.jewishencyclopedia.com/articles/908-agricultural-colonies -in-russia; David A. Chapin and Ben Weinstock, *The Road from Letichev: The History and Culture of a Forgotten Jewish Community in Eastern Europe,*

Volume 1 (Lincoln, NE: iUniverse, 2000); Chaim Freedman, "Introduction to the Study of the Jewish Agricultural Colonies in the Ukraine, Overview of the Shtetlinks site," Petah Tikvah, Israel, 2005, http://kehilalinks.jewishgen.org /Colonies_of_Ukraine/Chaim%27s%20Introduction.htm; and Isadore Singer and Cyrus Adler, *The Jewish Encyclopedia: A Descriptive Record of the History, Religion, Literature and Customs of the Jewish People from the Earliest Times to the Present Day*, Vol. I (New York: Funk & Wagnalls, 1912).

5. Jonathan Dekel-Chen and Israel Bartal, "Jewish Agrarianization," *Jewish History*, 21, no. 3–4 (2007): 239–47.

6. Rosenthal, "Agricultural Colonies in Russia."

7. For the census figures, see Список населенных мест Херсонской губернии и статистические данные о каждом поселении.—Х., 1896. Cited in http://evkol.ucoz.com/colony_kherson_en.htm.

8. Zvi Gitelman, *A Century of Ambivalence: The Jews of Russia and the Soviet Union, 1881 to the Present*, 2nd ed. (Bloomington: Indiana University Press, 2001), 1–58.

9. See Omelan Pritsak, "The Pogroms of 1881," *Harvard Ukrainian Studies* 11, no. 1–2 (June 1987): 8–43.

10. Chana Orloff grew up with an unnamed orphaned cousin, who was the daughter of her paternal uncle named Meir Dov.

11. Yohanan Petrovsky-Shtern, *The Golden Age Shtetl: A New History of Jewish Life in East Europe* (Princeton, NJ: Princeton University Press, 2014), 219–20.

12. Petrovsky-Shtern, *Golden Age Shtetl*, 219.

13. Mark Zborowski and Elizabeth Herzog, *Life Is with People: The Culture of the Shtetl* (New York: Schocken Books, 1952), 367; Sander Gilman, "Are You Just What You Eat? Ritual Slaughter and the Politics of National Identity," in *Revisioning Ritual: Jewish Traditions in Transition*, ed. Simon J. Bronner (Liverpool: Liverpool University Press, 2011), 349–51.

14. ChaeRan Y. Freeze and Jay M. Harris, eds., *Everyday Jewish Life in Imperial Russia: Select Documents, 1772–1914* (Waltham, MA: Brandeis University Press, 2013), 351–458.

15. According to the census of 1897, 99 percent of the Jews of the Pale of Settlement spoke Yiddish. Jewish literature and newspapers in Yiddish, Hebrew, Russian, and Polish circulated in many thousands of copies. "Modern Jewish History: The Pale of Settlement," *Modern Jewish History*, https://www.jewishvirtuallibrary.org/the-pale-of-settlement.

16. Zborowski and Herzog, *Life Is with People*, 313.

17. See "Among the Russian Jews: What Mr. Arnold White Learned," *New York Times*, June 13, 1892.

18. Monty Noam Penkower, "The Kishniev Pogrom of 1903: A Turning Point in Jewish History," *Modern Judaism* 24, no. 3 (October 2004): 187–225.

19. "Jewish Massacre Denounced," *New York Times*, April 28, 1903, 6.

20. "Troops Aid Infuriated Gomel Mob: Anti-Semites Receive Protection from Military," *San Francisco Call*, September 24, 1903; J. T. Loeb, "Outrage in Gomel Like That in Kishniev," *Washington Times*, September 28, 1903.

CHAPTER 2

1. וִיקסח ,יְמִמ, and Mimi Haskin. "Dancing Amidst Flames of Fire: The Hora Dance in the Hebrew Culture and Literature," *Jerusalem Studies in Hebrew Literature* (2013): 147–21.

2. Gur Alroey, *Unpromising Land: Jewish Migration to Palestine in the Early Twentieth Century* (Stanford, CA: Stanford University Press, 2014), 143. The price of the boat ticket was seventy-four rubles for the family, ninety rubles for the train ticket, and ten rubles for board and lodging. I rely heavily on Alroey's research on the details and conditions of immigration from Russia to Palestine throughout this section of the chapter.

3. Alroey, *Unpromising Land*, 128–30. While passports were not required in order to enter the US until after World War I, they were required to leave Russia legally and safely.

4. Alroey, *Unpromising Land*, 151.

5. Alroey, *Unpromising Land*, 139.

6. Robert Weinberg, "Workers, Pogroms and the 1905 Revolution in Odessa," *Russian Review* 46, no. 1 (1987): 53–75; Gerald Dennis Surh, "Russia's 1905 Era Pogroms Reexamined," *Canadian American Slavic Studies* 44, no. 3 (2010): 253–95.

7. Alroey, *Unpromising Land*, 154.

8. Ships logs with names of passengers are not available for this period from Russia to Palestine. While Miriam Eitan (Orloff) in her unpublished memories states that the Russian steamship that they took to Palestine was called the *Ruislan*, research shows that this ship did not exist until a later date.

9. Alroey, *Unpromising Land*, 152.

10. Alroey, *Unpromising Land*, 146–47.

11. Alroey, *Unpromising Land*, 146–47.

12. Among the many sources on the revival of the Hebrew language and two parallel strains, written-literary Hebrew and spoken Hebrew, see Daniel S. Breslauer, "Language as a Human Right: The Ideology of Eastern European Zionists in the Early Twentieth Century," *Hebrew Studies* 36 (1995): 55–71; and Ilan Stavans, *Resurrecting Hebrew* (Jewish Encounters Series) (New York: Schocken, 2008).

13. Orloff stated in her interviews that it was another famous Israeli poet, Nathan Alterman, who first read a poem of Bialik's aloud to her in this period before she left for Paris in 1910. This account is impossible, however, since Alterman was only first born in 1910 (in Warsaw, no less, and did not move to Tel Aviv until 1925). Perhaps Orloff confused him with another writer who may have read Bialik's poetry aloud to her in this early period of her life, or

else this story stands as a fictionalized narrative of her own shift in embracing the Hebrew language through the words and voices of two its national poets.

14. In her interviews, Orloff claims to have hired a yeshiva student to tutor her in Hebrew and Bible studies for a month one summer at her parents' house in Petah Tikvah, followed by a Zionist academic named Yitzhak Elazari-Volcani (who also went by Wilkanski or Vilkanski), who later became an Israeli agronomist and an active member of the Hapoel Hatzair party, in which Orloff also became involved. He represented the party at Zionist congresses and in Zionist institutions. In 1915 he published a book about the activities of Hapoel Hatzair, entitled *On the Way*. http://www.jewishvirtual library.org/yitzhak-elazari-volcani-wilkanski.

15. Haim Gamzu, "Chana Orloff Return to Israel," in *Chana Orloff* (Tel-Aviv: Massada Publishing, 1949) [Hebrew].

16. Ran Aaronsohn, *Rothschild and Early Jewish Colonization in Palestine* (Lanham, MD: Rowman & Littlefield Publishers & The Hebrew University Magnes Press, Jerusalem, 2000), 183–187.

17. "Letter from the Wife of Kalman Kantor, Zikhron Yaakov, October/ November 1889," cited in Ran Aaronsohn, "Through the Eyes of a Settler's Wife: Letters from the Moshava," in *Pioneers and Homemakers: Jewish Women in Pre-State Israel*, ed. Deborah S. Bernstein (Albany: State University Press of New York), 35; and Aaronsohn, *Rothschild and Early Jewish Colonization in Palestine*.

18. Soskin, like Orloff, emigrated to Palestine from Russia in 1905. He established the first photographic studio in Israel. His photographs document the development of Tel Aviv from its founding through the 1930s. He also documented some of the early Jewish settlements in Palestine.

19. The Orloff family was said to have purchased the plot of land from a Jewish man named Moses Marcus. Ayelet Carmi, interview with Rina Lutsky, Orloff's great niece, July 23, 2014, Petah Tikvah. Much of my account of the Orloff parents' lives in Petah Tikvah relies upon Zvi Nishri, "Old Workers in the Second Aliyah," in *The Book of the Second Aliyah*, ed. Bracha Habas, trans. Ayelet Carmi (Tel Aviv: Am Oved, 1947), 298–300 [Hebrew].

20. Nishri, "Old Workers in the Second Aliyah," 298–300.

21. Aaronsohn, *Rothschild and Early Jewish Colonization in Palestine, 188–209*; Baruch Oren, *Women of Valor in the Early Days of Em HaMoshavot* (Israel: n.p., 1973), 5–22.

22. Raphael Bashan, "Chana Orloff: Fifteen Hundred Sculptures," *Maariv: Days and Nights*, January 29, 1965.

23. Bashan, "Chana Orloff."

24. Rachel Arbel, *Blue and White in Color: Visual Images of Zionism 1897–1947* (Beth Hatefutsoth: The Nahum Goldmann Museum of the Jewish Diaspora, 1997), 59.

25. Margalit Shilo, "The Double or Multiple Image of the New Hebrew

Woman," in *Israeli Feminist Scholarship: Gender, Zionism, and Difference*, ed. Esther Fuchs (Austin: University of Texas Press, 2014), 67. See also Margalit Shilo, "Professional Women in the Yishuv in Mandatory Palestine: Shaping a New Society and a New Hebrew Woman," *Nashim* 34 (Spring 2019): 33–53; Shilo, "Second Aliyah: Women's Experience and Their Role in the Yishuv," *Jewish Women's Archive*, updated June 23, 2021, http://jwa.org/encyclopedia /article/second-aliyah-womens-experience-and-their-role-in-yishuv; Shilo, "The Transformation of the Role of Women in the First Aliyah, 1882–1903," *Jewish Social Studies, New Series* 2, no. 2 (1996): 64–86; Shilo, "Self-Sacrifice, National-Historical Identification and Self-Denial: Immigration as Experienced by Women of the 'Old Yishuv,'" *Women's History Review* 11, no. 2 (2002): 201–30; and Shilo, *Girls of Liberty: The Struggle for Suffrage in Mandatory Palestine* (Hanover, NH: University Press of New England for Brandeis University Press, 2016).

26. For an interesting exception, see Gerald M. Berg, "Zionism's Gender: Hannah Meisel and the Founding of the Agricultural Schools for Young Women," *Israel Studies* 6, no. 3 (Fall 2001): 135–65.

27. Deborah S. Bernstein, "Daughters of the Nation: Between the Public and Private Spheres in Pre-State Israel," in *Israeli Women's Studies: A Reader*, ed. Esther Fuchs (New Brunswick, NJ: Rutgers University Press, 2005), 79. For more on the role of women in the Yishuv, see n.30 and Bernstein, ed., *Pioneers and Homemakers*; Bernstein, *The Struggle for Equality: Urban Women Workers in Pre-State Israeli Society* (New York: Praeger, 1987); Bernstein, "Between Woman as Person and Woman as Housewife: Women and Family among Urban Jewish Laborers in the Yishuv Period," in *Israeli Society: Critical Aspects*, ed. Uri Ram (Tel Aviv: 1993), 83–103; Ruth Kark, Margalit Shilo, and Galit Hasan-Rokem, eds., *Jewish Women in Pre-State Israel, Life History, Politics, and Culture* (Waltham, MA: Brandeis University Press, 2008); Michael Berkowitz, "Transcending 'Tsimmes and Sweetness': Recovering the History of Zionist Women in Central and Western Europe," in *Active Voices: Women in Jewish Culture*, ed. Maurie Sacks (Urbana: University of Illinois Press, 1995), 41–62.

28. Nishri, "Old Workers in the Second Aliyah," 298–300.

29. Nishri, "Old Workers in the Second Aliyah," 298–300.

30. Boaz Lev Tov, "Leisure and Popular Culture Patterns of Jews in Eretz Israel in the Years 1882–1914 as a Reflection of Social Changes" (PhD diss., Tel Aviv University), 118–25 [Hebrew].

31. Haim Kaufman, "Jewish Sports in the Diaspora, Yishuv and Israel," *Israel Studies* 10, no. 20 (2005): 153.

32. *Yahud* is a classical Arabic term which comes from the Qur'an, where it is used eleven times to refer to descendants of Hud's community who had strayed into the worship Uzayir (Anosh Uthra) as the son of Allah. It is now ubiquitously used to refer to the plural of Jew.

33. Nishri, "Walid al-mut," in *The Book of the Second Aliyah*, 199–201.

34. Nishri, "Walid al-mut," in *The Book of the Second Aliyah*, 199–201.

35. Hannah Barnett-Trager, *Pioneers in Palestine: Stories of the First Settlers in Petach Tikvah* (London: George Routledge & Sons, 1923), 34–35.

36. Ehud Ben-Ezer, *Days of Gall and Honey: The Biography of the Poetess Esther Raab* (Tel Aviv: Am Oved Publishers, 1998) [Hebrew: Yamim shel La'anah u-Dvash], 55–59.

37. Ben-Ezer, *Days of Gall and Honey*.

38. Barnett-Trager, *Pioneers in Palestine*; see in particular Barnett-Trager's chapter on the "women's vote" relating to power of women in the moshava, 67–72.

39. Nishri, "Old Workers in the Second Aliyah," 298–300.

40. Nishri, "Old Workers in the Second Aliyah," 298–300.

41. Shilo, "Second Aliyah."

42. Shilo, "Double or Multiple Image," 71.

43. Sheinkin to Rivka Stein, March 26, 1907, Labor Archives, 104v, fol.2, cited in Shilo, "Double or Multiple Image," 71, n.24.

44. Sheinkin to Rivka Stein, cited in Shilo, "Double or Multiple Image," 71, n.24.

45. The first women's embroidery workshop took place in Jaffa in 1908, followed by the lace department at Bezalel School of Art and Crafts in 1911. Then she also established additional lace workshops in Tiberias and Safed in 1912. For more on Thon, see Dalia Manor, *Art in Zion: The Genesis of Modern National Art in Jewish Palestine* (New York: RoutledgeCurzon, 2005), 196, n.19.

46. See Sarah Thon, *Die Welt* 14 (1910): 1063. Cited in Shilo, "Second Aliyah."

CHAPTER 3

1. Barbara E. Mann, *A Place in History: Modernism, Tel Aviv, and the Creation of Jewish Urban Space* (Stanford, CA: Stanford University Press, 2006), 186.

2. Mann, *Place in History*. In addition to Agnon, the writers Devora Baron and Y. H. Brenner lived in Neve Tzedek in this period. For a description of intellectual life in Neve Tzedek in this period of 1905–10, see Haim Be'er, *Their Love and Their Hate: Agnon, Bialik, Brenner—Relations* (Tel Aviv: Am Oved, 1992) [Hebrew], and Nachum Gutman, *A Little Town and Few People in It* (Tel Aviv: Dvir, 1999 [1959]) [Hebrew].

3. Ben-Ezer, *Days of Gall and Honey*, 99–110.

4. Ben-Ezer, *Days of Gall and Honey*, 107–110.

5. Nirit Reichel, "The First Hebrew 'Gymnasiums' in Israel: Social Education as the Bridge between Ideological Gaps in Shaping the Image of the Desirable High School Graduate (1906–48)," *Israel Affairs* 17, no. 4 (October

2011): 604–20; Sergey R. Kravtsov, "Reconstruction of the Temple by Charles Chipiez and Its Application in Architecture," *Ars Judaica* 4 (2008), 36–42.

6. Orloff's younger brother Abraham worked as a stonemason on the new school. Nishri, "Old Workers in the Second Aliyah," 298–300.

7. Shilo, "Second Aliyah."

8. The average age of the students at the time the new Gymnasium building opened in 1909 was 13.5 to 15.5.

9. Shilo, "Double or Multiple Image," 71; Reichel, "First Hebrew 'Gymnasiums,'" 607.

10. "The Hebrew Gymnasium in Jaffa," *Hapo'el Hatza'ir*, Av 5671 (Summer 2011), 4th year, no. 20, p. 4 [Hebrew], cited in Shilo, "Double or Multiple Image," 72, n.29.

11. Shilo, "Double or Multiple Image," 72, n.30, Judith Harari, Bein ha-keramim.

12. Shilo, "Second Aliyah."

13. Reichel, "First Hebrew 'Gymnasiums,'" 609.

14. Lev Tov, "Leisure and Popular Culture Patterns," 99–103.

15. Lev Tov, "Leisure and Popular Culture Patterns," 99–103.

16. Freddie Rokem, "Hebrew Theater from 1888 to 1948," in *Theater in Israel*, ed. Linda Ben-Zvi (Ann Arbor: University of Michigan Press, 1996), 51–84; Emanuel Levy, *The Habima, Israel's National Theater, 1917–1977: A Study in Cultural Nationalism* (New York: Columbia University Press, 1979).

17. Lev Tov, "Leisure and Popular Culture Patterns," 155–56.

18. Lev Tov, "Leisure and Popular Culture Patterns," 99–103.

19. Kaufman, "Jewish Sports in the Diaspora, Yishuv and Israel," 151–52.

20. Lev Tov, "Leisure and Popular Culture Patterns," 99–103.

21. Shilo, "Double or Multiple Image," 73, n.39; Yair Galily, Haim Kaufman, and Ilan Tamir, "She Got Game!? Women, Sport and Society from an Israeli Perspective," *Israel Affairs* 21, no. 4 (2015): 559–84.

22. *Meels* is a Persian word, and British colonialists erroneously called them "Indian clubs." See Samuel T. Wheelwright, *A New System of Instruction in the Indian Club Exercise* (New York: E I Horsman, 1871); Edward B. Warman, *Indian Club Exercises* (Spalding's Athletic Library, 1909). For an extensive online bibliography on the history of Indian clubs or meels, see http://www.semlyen.net/cosmosjugglers/lib/bibcs.htm. For a recent study on the health benefits of swinging Indian clubs, see Melody L. Schoenfeld, "Increasing Strength and Power with Gada, Indian Clubs, Bulgarian Bags, and Other Tools of Concentric Strength," *Strength & Conditioning Journal* 39, no. 1 (February 2017): 48–56.

23. As a competitive sport, "club swinging" or meels involved the athlete standing erect with a club in each hand. Unlike juggling, the clubs do not leave the hands, but are swung very quickly around the body and head in a variety of patterns in a complicated routine. Judges award points based on

the routine, and the sport can be seen as a precursor to the modern Olympic rhythmic gymnastics discipline.

24. Competing clubs may have included the Bar Giora Club in Jerusalem, also founded in 1906, or the Shimshon Gymnastics Association, founded in 1910. Nishri also founded a popular annual sporting competition in Rehovot that predated the Maccabiah Games. See Lamartine P. Dacosta and Ana M. Miragaya, eds., *Worldwide Experiences and Trends in Sport for All* (Aachen: Meyer & Meyer Sport, 2002), 114; Kaufman, "Jewish Sports in the Diaspora, Yishuv and Israel," 151–52.

25. Nishri authored the very first physical education publications in Hebrew, and was the first person to establish specific terminology in Hebrew for physical education and sports. He enjoyed a prolific career as a teacher (for over forty years at the Gymnasia) and an author, and wrote publications on gymnastics, football, and other topics of interest in the field of physical education. In addition to founding the Maccabi movement (in which he coached gymnastics) and the Hebrew Scouts movement, Nishri was inducted as a member of the International Jewish Sports Hall of Fame in 1981, and the Wingate Institute established a prize in his honor. The Zvi Nishri Archives are located at Wingate Institute's Terner Pedagogical Centre. Nishri Zvi, *A Summary of the Physical Education History* (Tel Aviv: The Ministry for Education and Culture, The Department for Physical Training, 1953) [Hebrew].

26. Kaufman, "Jewish Sports in the Diaspora, Yishuv and Israel," 151–52.

27. Kaufman, "Jewish Sports in the Diaspora, Yishuv and Israel," 151–52.

28. Judith Eisenberg Harari, *Among the Vineyards* (1947), cited in Shilo, "Second Aliyah."

29. Sarah Thon, "On the Question of Female Farm Workers: Ha-Po'el ha-za'ir 1913," *Pirkei ha-Po'el ha-Za'ir* 3 (1935): 207, cited in Shilo, "Second Aliyah."

30. Sarah Glicklich Slouschz, "To Woman" (Jerusalem: 1919), cited in Shilo, "Second Aliyah."

31. Bat-Sheva Margalit Stern, "Rebels of Unimportance: The 1930s' Textile Strike in Tel Aviv and the Boundaries of Women's Self-Reliance," *Middle Eastern Studies* 38, no. 3 (2002): 171–94.

32. Lev Tov, "Leisure and Popular Culture Patterns," 89–99.

33. Lev Tov, "Leisure and Popular Culture Patterns," 89–99.

34. In Sara Malkin's letter to *Ha'poel Ha'tzair*, March 5, 1912, 14.

35. Fishman-Maimon, for example, became a member of the Hapoel Hatzair Central Committee in 1913, after having joined a youth movement associated with Hapoel Hatzair. She remained on the committee until 1920. In 1921 she was among the founders of the Women Workers' Movement, and served as its secretary until 1930. See Deborah Bernstein, "The Women

Workers Movement in Pre-State Israel, 1919–1939," *Signs* 12, no. 3 (Spring 1987): 454–70.

36. Miriam Eitan (Orloff), "Memories of Hannah."

37. Judith Cooper-Weill, "Early Hebrew Schools in Eretz-Israel," Jewish Virtual Library, https://www.jewishvirtuallibrary.org/early-hebrew-schools-in-eretz-israel.

38. Nishri, "Old Workers in the Second Aliyah," 298–300.

CHAPTER 4

1. Ariane Justman Tamir, "Chana Orloff: Une Vie de Legende," in Ariane Justman Tamir, Éric Justman, and Paula J. Birnbaum, *À la rencontre de Chana Orloff* (Paris: Àvivre Éditions, 2012), 20.

2. Esther Benbassa and M. B. DeBevoise, *The Jews of France: A History from Antiquity to the Present* (Princeton, NJ: Princeton University Press, 1999); Paula E. Hyman, *The Jews of Modern France* (Berkeley: University of California Press, 1998).

3. Reuven Lifshitz (Leaf) managed the metal and wood batik departments at Bezalel from 1912 to 1916 before moving to New York. See Manor, *Art in Zion*, 203–4, n.38.

4. There are some discrepancies in the accounts of where Orloff first lived when she arrived in Paris. Germaine Coutard-Salmon (followed by Felix Marchilhac) claimed that a family friend, a Russian émigré by the name of Madame Rosenblum, offered to lodge Orloff in her apartment at 43, rue Tournefort, in the heart of the Latin Quarter, near the rue Mouffetard. Coutard-Salmon, "Chana Orloff (1888–1968) et son Époque" (PhD diss., Université de Paris IV-Sorbonne, 1980), 14; Félix Marchilhac, *Chana Orloff*, 16. Orloff, however, does not mention living at this address in her interviews, and recalls renting a series of single rooms in this neighborhood, where she lived alone.

5. Orloff recalled in her interviews that Victor Hugo had once lived in a house on this street (during his childhood, between 1808 and 1813, he lived in the Couvent des Feuillantine), and the building where he lived had been converted into a school where Orloff took French language classes (now it is the Lycée Lucas de Nehou—Métiers des Arts du Verre et des Structures Verrières).

6. There were also training programs in floral design, along with porcelain, fan, and glass painting. See Tamar Garb, *Sisters of the Brush: Women's Artistic Culture in Late Nineteenth-Century Paris* (New Haven, CT: Yale University Press, 1994), 79; and Lucien Lambeau, ed., *L'Enseignement professionel à Paris, vol I, 1871–1896* (Paris: Imp. Municipale, 1898).

7. Coutard-Salmon, "Chana Orloff," 14.

8. Jan Glier Reeder, "Femmes de la Mode," in *Icons of Fashion:*

The Twentieth Century, ed. Gerda Buxbuam (Munich: Prestel, 2005), 22;
Glier Reeder, "The House of Paquin," *Textile and Text* 12 (1990): 10–18;
Glier Reeder, "Historical and Cultural References in Clothes from the House
of Paquin," *Textile and Text* 13 (1991): 15–22; Dominique Sirop, *Paquin*
(Paris: Adam Biro, 1989); Veronique Pouillard, "A Woman in International
Entrepreneurship: The Case of Jeanne Paquin," in *Entreprenørskap i
næringsliv og politikk. Festskrift til Even Lange*, eds. Knut Sogner, Einar Lie,
and Håvard Brede Aven (Oslo: Novus Forlag, 2016), 189–210; Valerie Steele,
Women of Fashion: Twentieth-Century Designers (New York: Rizzoli, 1991),
27–31; Nancy Troy, *Couture Culture* (Cambridge, MA: MIT Press, 2003),
129–33.

9. Emanuelle Drix, *Dressing the Decades: Twentieth-Century Vintage
Style* (New Haven, CT: Yale University Press, 2016), 27. See Ruth E. Iskin's
account of this painting in *Modern Women and Parisian Consumer Culture
in Impressionist Painting* (Cambridge: Cambridge University Press, 2007).

10. Drix, *Dressing the Decades*, 27.

11. Maude Bass-Krueger, email message to author, July 10, 2017; Archives,
Préfecture de Police, Paris; Pouillard, "A Woman in International Entrepre-
neurship," 210.

12. Maude Bass-Krueger, historian of fashion, email message to author,
July 10, 2017.

13. Baram, "Chana Orloff," 47.

14. In 1928 the Petite École changed its name to École supérierue des Arts
Décoratifs.

15. See Gillian Perry, *Women Artists and the Parisian Avant-Garde:
Modernism and "Feminine" Art, 1900 to the Late 1920s* (Manchester:
Manchester University Press, 1995), 16–19; and Catherine Gonnard and
Élisabeth Lebovici, Has Femmes/artistes, artistes femmes: Paris, de 1800
a nos.

16. Orloff continued this tradition of visiting the Louvre on Sundays most
of her adult life. Justman Tamir, "Chana Orloff," 20.

17. Green, *Art in France*, 49.

18. Félix Marcilhac, *Chana Orloff*, 14–15.

19. Baram, "Chana Orloff," 47.

20. Green, *Art in France*, 49; 189–190.

21. Silver and Golan, eds., *Circle of Montparnasse*.

22. Other friends from this period include Moïse Kisling (born in Kraków,
Poland, and moved to Paris in 1910); Jules Pascin (born Pinchas, in Vidin,
Bulgaria, and arrived in Paris in 1905); and Jacques Lipchitz (born in
Druskieniki, Lithuania, and arrived in Paris in 1909).

23. Previously the Musée du Montparnasse, the site of Vassilieff's home
and studio, 21 avenue du Maine, Paris, became Villa Vassilieff in 2015. Since

2001, the association AWARE (Archives of Women Artists, Research and Exhibitions) has occupied this historic space.

24. On Marie Vassilieff, see Claude Bernès et Benoît Noël, *Marie Vassilieff (1884–1957): L'œuvre artistique – L'académie de peinture – La cantine de Montparnasse* (Paris: Éditions BVR, 2017); Lauren Jimerson, "Defying Gender: Redefining the Nude: Female Artists and the Body in Early 20th century Paris" (PhD diss., Rutgers University, 2018); Lauren Jimerson, *Painting Her Pleasure: Three Women Artists and the Nude in Early Twentieth-Century Paris* (Manchester: University of Manchester, 2023); Marie Vassilieff, *La Bohème du XXe siècle*, (unpublished memoir), 1929, private collection, Claude Bernès; archives of Marie Vassilieff, private collection, Claude Bernès; "Dossier Vassilieff," Kandinsky Library, Centre Pompidou.

25. Vassilieff, *La Bohème du XXe siècle*, 25.

26. Anna Winestein, "Artists at Play: Natalia Erenburg, Iakov Tugendkhold, and the Exhibition of Russian Folk Art at the 'Salon d'Automne' of 1913," *Experiment* 25, no. 1 (September 2019): 328–45.

27. Norman Kleeblatt, ed., *The Dreyfus Affair: Art, Truth & Justice* (Berkeley: University of California Press, 1987); Linda Nochlin and Tamar Garb, eds., *The Jew in the Text: Modernity and the Construction of Identity* (London: Thames and Hudson, 1996).

28. Samuel J. Spinner, "Plausible Primitives: Kafka and Jewish Primitives," *German Quarterly* 89, no. 1 (Winter 2016): 17–35. See also Gabriela Safran and Steven J. Zipperstein, *The Worlds of S. An-sky: A Russian Jewish Intellectual at the Turn of the Century* (Stanford, CA: Stanford University Press, 2006); and Samuel Spinner, *Jewish Primitivism* (Redwood City, CA: Stanford University Press, 2021).

29. The French art critic Robert Rey described Orloff's *Woman with Arms Crossed (Madonna)* as portraying "a gentle and flat face, with divergent brows forming pointed or ogival arches, the form full of Florentine melancholy." Robert Rey, "Salon des Indépendants," *Le Crapouillot* (March 1, 1923), Ateliers Chana Orloff.

30. See Sieglinde Lemke, *Primitivist Modernism: Black Culture and the Origins of Transatlantic Modernism* (New York: Oxford University Press, 1998); Jack Flam and Miriam Deutsch, eds., *Primitivism and Twentieth-Century Art: A Documentary History* (Berkeley: University of California Press, 2003); and Victor Li, *The Neo-Primitivist Turn: Critical Reflections on Alterity, Culture and Modernity* (Toronto: University of Toronto Press, 2006).

31. Patricia Leighton, *The Liberation of Painting: Modernism and Anarchism in Avant-Guerre Paris* (Chicago: University of Chicago, 2015), 75–76.

32. See http://www.notredamedesion.org. The Congregation of our Lady of Sion still exists today with a wide variety of ministries worldwide. For a history of group in France during the period of World War I, see Audrey

Guilloteau, "Les Sœurs de Sion dans la Grande Guerre: 3 septembre 1916–28 juin," Maîtrise, Strasbourg II (2004).

33. Coutard-Salmon, "Chana Orloff," 30.

34. Two letters by Malvina Hoffman to Chana Orloff address her purchase of the piece: July 17, 1935, and September 15, 1935. Ateliers Chana Orloff.

35. See Marianne Kinkel, *Races of Mankind: The Sculptures of Malvina Hoffman* (Urbana: University of Illinois Press, 2011). On the recent reinstallation of Hoffman's work at the Field Museum, see https://www.fieldmuseum.org/exhibitions/looking-ourselves-rethinking-sculptures-malvina-hoffman.

CHAPTER 5

1. Billy Klüver and Julie Martin, *Kiki's Monparnasse: Artists and Lovers 1900–1930* (New York: Harry N. Abrams Inc., 1989), 64–65. Orloff's *Accordionist (Per Krohg)* was alternatively titled *Man with Accordion (Per Krohg)*.

2. Claudine Mitchell, "L'Horreur in face: Le travail féminine et l'art de la sculpture au lendemain de la Grande Guerre," in *Jane Poupelet (1874–1932)*, ed. Anne Riviere (Paris: Gallimard, 2005), 56–77; Claudine Mitchell, "Style/Ecriture: On the Classical Ethos, Women's Sculptural Practice and Pre-First World War Feminism," *Art History* 25, no. 1 (February 2002): 1–22.

3. The naturalization law of December 3, 1849, permitted the expulsion of all foreigners without having to specify motive. See Greg Burgess, *Refuge in the Land of Liberty: France and Its Refugees from the Revolution to the End of the Asylum, 1787–1939* (New York: Springer, 2008), 115; Peter Gatrell and Philippe Nivet, "Refugees and Exiles," in *The Cambridge History of the First World War*, ed. Jay Winter (Cambridge: Cambridge University Press, 2013), 3: 186–215; Panikos Panayi, "Minorities," in *The Cambridge History of the First World War*, 3: 216–41.

4. See Coutard-Salmon, "Chana Orloff," 23, n.39. Note that Coutard-Salmon states that Orloff "is in Bruniquel in the Tarn-et-Garonne region" in the "summer of 1914." Bruniquel is approximately eighty kilometers northeast of Toulouse, in southwestern France, and the artist's correspondence shows she traveled there in the summer of 1918, not 1914. In Orloff's interviews (chapter 34: My First Woodcarving, 1914), she describes being "ordered" to leave Paris in August 1914 "without money or an actual address," and states that she went to "a small village in northern France," without naming the town or region.

5. Orloff is quoted saying this in a 1960 interview in the following film: Jean-Marie Drot, producer, *Petite chronique du Montparnasse 14–18, Paris*, I.N.A/ La S.E.P.T, cop. 1987, 52:00 min. I am grateful to Barbara Bauer for sharing this reference with me. See also Jean-Marie Drot and Dominique Polad-Hardouin, *Les heures chaudes de Montparnasse* (Paris: Hazan, 1999), 51.

6. Klüver and Martin, *Kiki's Monparnasse*, 70–71. Vassilieff, *La Bohème du Xxe siècle*; Bernès et Noël, *Marie Vassilieff*.

7. Klüver and Martin, *Kiki's Monparnasse*, 70–71, from Gunnar Cederschiöld, *Efter levande modell* (Stockholm: Natur och Kultur, 1949), 170–71. Also cited in Meryle Secrest, *Modigliani: A Life* (New York: Knopf/Doubleday, 2011), 210–11.

8. Klüver and Martin, *Kiki's Monparnasse*, 70–71.

9. Klüver and Martin, *Kiki's Monparnasse*, 70.

10. See Albert-Birot, "Ary Justman," *SIC* 4, no. 41 (February 1919): 28.

11. See "Zeppelins Attack Paris," *International Herald Tribune*, March 21, 1915. On the history of all of the German attacks on Paris throughout World War I, see Earl H. Tilford Jr., "Air Warfare: Strategic Bombing," in Spencer C. Tucker, ed., *The European Powers in the First World War: An Encyclopedia* (New York: Garland Publishing, 1996) 13–15.

12. According to Germaine Coutard-Salmon's interview with Stanislas Fumet, a writer and art critic who was Orloff's friend and neighbor and lived beside her on the rue du Pot-de-Fer. Cited in Coutard-Salmon, "Chana Orloff," 23–24.

13. Lionna Baroi, "Entretien avec Chana Orloff," *L'Arche* (November 1959), Ateliers Chana Orloff.

14. My account of Orloff's relationship with Modigliani is based on Orloff's 1960 interview with film producer Jean-Marie Drot in *Petite chronique du Montparnasse* and her unpublished essay "La vie breve de Amedeo Modigliani et de Janette H," Ateliers Chana Orloff. Sections of this document have been published elsewhere, including Frederick S. Wight, "Recollections of Modigliani by Those Who Knew Him," *Italian Quarterly* 2, no. 1 (Spring 1958): 42–46.

15. Amedeo Modigliani, *Portrait of Ary Justman*, 1918 (drawing, Private Collection), Marcilhac, *Chana Orloff*, 33.

16. On Modigliani's relationship to his Jewish identity, see Kenneth Wayne, *Modigliani and the Artists of Montparnasse* (New York: Abrams, 2002), and Mason Klein, "Unmasking Modigliani," in *Modigliani Unmasked*, ed. Mason Klein (New Haven, CT: Yale University Press, 2017), 1–27.

17. Griselda Pollock, "Modigliani and the Bodies of Art," in *Modigliani: Beyond the Myth*, ed. Mason Klein (New Haven, CT: Yale University Press), 72.

18. Cathy Corbett, "Modigliani & the Salon d'Automne," *Modigliani*, eds. Simonetta Fraquelli and Nancy Ireson (New York: SkiraRizzoli/Tate Enterprises, 2017), 47–74.

19. Such as Modigliani, *Nude*, 1917, Guggenheim (INV 41.535).

20. Pollock, "Modigliani and the Bodies of Art," 72.

21. Frederick S. Wight, "Recollections of Modigliani," 42–46.

22. Wight, "Recollections of Modigliani," 45.

23. Wight, "Recollections of Modigliani," 45; Coutard-Salmon, "Chana Orloff," 18; and Haim Gamzu, *Chana Orloff: Memories of Chana Orloff of Modigliani, Pascin, Soutine and Georges Kars* (Tel Aviv: Massada, 1951).

24. See Marc Restellini, *Le silence éternel: Modigliani-Hébuterne 1916–1919* (Paris: Pinacothèque, 2008); Linda Lappin, "Missing Person in Montparnasse: The Case of Jeanne Hebuterne," *The Literary Review*, June 22, 2002.

25. Chana Orloff, "La vie breve de Amedeo Modigliani et de Janette H."

CHAPTER 6

1. Orloff's solo exhibition was announced in the pages of the journal *SIC* as the very first in the magazine's new initiative, *SIC Ambulant*, which translates as "Mobile SIC." The text reads: "Sunday, March 4, 3:00 pm, in the studio of sculptor Chana Orloff, 68 rue d'Assas (in the courtyard to the left, studio #7): A Few Sculptures—A Few Words on Sculpture—A Few Poems—A Little Music. All of the *SIC* are invited. Please present this edition of the journal as your invitation at the entrance. *SIC*, February 1917 (number 14)."

2. For information on *SIC*, see Debra Kelly, "Pierre Albert-Birot and SIC: The Avant-garde Review as Collective Adventure and Personal Poetics," in *La Revue: The Twentieth-Century Periodical in French*, eds. Charles Forsdick and Andy Stafford (Oxford: Peter Lang, 2013), 237–248; Debra Kelly, *Pierre Albert-Birot* (London: Associated University Presses, 1997), 58–122; Simon Dell, "After Apollinaire: SIC (1916–19); Nord-Sud (1917–18); and L'Esprit Nouveau (1920–5)," in *The Oxford Critical and Cultural History of Modernist Magazines*, eds. Peter Brooker, Sascha Bru, Andrew Thacker, and Christian Weikop (London: Oxford University Press, 2009), 142–59; Pierre Albert-Birot, "Naissance et Vie de 'SIC,'" *Les Lettres Nouvelles* 7 (Sept. 1953): 848–49; Arlette Albert-Birot, *SIC* (Paris: Editions Jean-Michel Place, 1980); Michel Sanouillet and Anne Sanouillet, *Dada in Paris* (Cambridge, MA: MIT Press, 2012), 48; and Stephen C. Foster, *Crisis and the Arts: Paris Dada, the Barbarians Storm the Gates* (New York: G.K. Hall, 2001), 8.

3. Laurent Véray, "La mobilisation des femmes," *Histoire par l'image* [en ligne], consulté le 29 juin 2021. http://histoire-image.org/fr/etudes/mobilisation-femmes.

4. Roberts, *Civilization without Sexes*, 91.

5. Amy Lyford, *Surrealist Masculinities: Gender Anxiety and the Aesthetics of Post-World War I Reconstruction in France* (Berkeley: University of California Press, 2007), 7.

6. The entire print-run of the *SIC* journal can be viewed online at http://sdrc.lib.uiowa.edu/dada/Sic/index.htm.

7. Simon Dell, "After Apollinaire: SIC (1916–19); Nord-Sud (1917–18)"; and L'Esprit Nouveau (1920–5)," 145.

8. Sanouillet and Sanouillet, *Dada in Paris*, 48.

9. Adrienne Mayer, *The Amazons: Lives and Legends of Warrior Women Across the Ancient World* (Princeton, NJ: Princeton University Press, 2014).

10. Kineton Parkes, "The Younger Sculptors of Central Europe," *The Studio* 91 (1926): 416.

11. Kelly, "Pierre Albert-Birot and SIC," 241–42.

12. Baram, "Chana Orloff," 47.

13. Marcel Millasseau to Chana Orloff, December 21, 1917. Ateliers Chana Orloff.

14. Gabrielle Buffet-Picabia, "Marie Laurencin," *Arts* (June 1923): 394.

15. Cited in Steegmuller, *Apollinaire: Poet Among the Painters* (New York: Farrar Straus, 1963), 158. See my discussion of Marie Laurencin in *Women Artists in Interwar France: Framing Femininities* (Farnham: Ashgate, 2011).

16. Apollinaire's play became the basis for Poulenc's 1947 opera *Les mamelles de Tirésias*. For a detailed analysis of the premiere of *Mamelles de Tirésias* in 1917, see Peter Read, *Apollinaire et Les Mamelles de Tirésias: la Revanche d'Éros* (Rennes: Presses Universitaires de Rennes, Collection Interférences, 2000). See also Willard Bohn, *Apollinaire on the Edge: Modern Art, Popular Culture and the Avant-Garde* (Amsterdam: Brill, 2010), 105–26.

17. Louise Marion, Marcel Herrand, and Edmond Vallée were the principal actors, and the chorus was directed by Max Jacob.

18. F. Laya, "Guillaume Apollinaire: Les Mamelles de Tirésias," *L'Eventail*, April 15, 1918. Repr. in *Que Vlo-Ve? Bulletin International des Etudes sur Guillaume Apollinaire*, 4th series, no. 4 (October–December 1998): 113; and Bohn, *Apollinaire on the Edge*, 121.

19. M. G. Rémon, *Le Radical*, June 27, 1917. Cited in *SIC*, n.19–20 Paris, July–August 1917, 1.

20. See Kelly, "Pierre Albert-Birot and SIC," 242. Kelly describes how Albert-Birot dedicated Issue 18 of *SIC* (June 1917) to various accounts of the staging of the play, and in the July–August issue of the same year (19–20), he excerpted several press reviews that emphasized the controversy it caused.

21. Albert-Birot claimed to have worked with him on the translations; however, he did not speak Polish, so this would have been challenging.

22. René Lalou, *Histoire de la littérature française contemporaine (1870 à nos jours)* (Paris: Les Presses Universitaires de France, 1922), 628.

23. *Nord-Sud: Revue littéraire* was another important literary magazine edited by Pierre Reverdy and published in Paris in sixteen numbers (fourteen issues) between March 1917 and October 1918.

24. Paul Reverdy, *Nord-Sud* no. 4–5 (June–July 1917).

25. Jacques Lipchitz, 1917, *L'homme à la mandoline*. Paris, Musée National d'Art Moderne, Centre Pompidou.

26. Kelly, *Pierre Albert-Birot*, 104–5.

27. Moussia Toulman, "Chana Orloff," *Formes et Couleurs* (1948–49), Ateliers Chana Orloff.

28. Birnbaum, *Women Artists in Interwar France*, 13–14; Sylvie Carlier

and Sylvie Buisson, *Suzanne Valadon, Jacqueline Marval, Emilie Charmy, Georgette Agutte: Les femmes peintres et l'avant-garde* (Paris: Somogy editions d'Art, 2006).

29. *Le XIX siècle*, June 20, 1916.

30. Grobot-Dreyfus, "Sociabilités familiales," vol. II, 74.

31. The Salon derived its name from the location of the gallery at 26 rue d'Antin. The 1916 exhibition was called "L'Art Moderne en France—le Salon d'Antin." Billy Klüver and Jean Cocteau, *A Day with Picasso* (Cambridge, MA: MIT Press, 1999), 65.

32. Albert-Birot, *SIC*, 4, no. 41 (February 28, 1919).

33. Orloff and Katznelson, *Memoirs*.

34. Nicolas Beaupré, "Du Bulletin des Ecrivains de 1914 à l'Association des Ecrivains Combattants (AEC): des combats à la mémoire, 1914–1927," in *La politique et la guerre. Pour comprendre le Xxe siècle européen, Hommage à Jean-Jacques Becker*, eds. Stéphane Audoin-Rouzeau, Annette Becker, Sophie Cœuré, Vincent Duclert, Frédéric Monier (Paris: Viénot, 2002), 301–15.

35. Justman Tamir, Justman, and Birnbaum, *À la rencontre*, 24.

36. Germaine Albert-Birot to Chana Orloff, January 15, 1919, Ateliers Chana Orloff, cited by Coutard-Salmon, "Chana Orloff," 30.

37. Gustave Kahn, "Chana Orloff," *Feuillets d'Art: Recueil de littérature et d'art contemporains* 5 (June–July 1922): 231–32.

38. Jean Pellerin, "La Quinzaine Artistique," *La Lanterne: Journal politique quotidien* (April 12, 1919).

39. *Lutetia: Revue artistique, littéraire, théâtrale* (January 1, 1918).

40. Max Jacob to Chana Orloff, April 14, 1919. Ateliers Chana Orloff.

41. Carlos Larronde to Chana Orloff, April 23, 1919. Ateliers Chana Orloff.

42. Chana Orloff to Pablo Picasso, January 2, 1956. Archives, Musée Picasso.

43. Nancy Sloan Goldberg, "Gender in French Poetry Against the Great War," *Minnesota Review* 32 (Spring 1989): 7–17; Nancy Sloan Goldberg, "'Qui donc fermera la porte entr'ouverte?': The Home and the Nation in Women's War Poetry," *Essays in French Literature and Culture* 51 (November 2014): 1–20.

44. Pellerin died before completion of the project, which delayed its completion and publication date to 1923.

45. Uncited document, dated 1923, Ateliers Chana Orloff.

CHAPTER 7

1. Wanda M. Corn and Tirza True Latimer, *Seeing Gertrude Stein: Five Stories* (Berkeley: University of California Press, 2011).

2. See letter from Claude-Lise Germak-Georg, daughter of the artist Edouard Georg who was Orloff's neighbor on the Villa Seurat, to Germaine

Coutard-Salmon, May 15, 1972, Ateliers Chana Orloff, on how Orloff sculpted her portrait at age three (1928) in exchange for a painting by Georg.

3. Orloff's *Woman with a Fan* was reproduced in Anonymous, "Sculptures in Bronze and Wood by Chana Orloff," *Vanity Fair* (September 1921), and Dorothy Adlow, *Chana Orloff* (Boston: School of the Museum of Fine Arts), February 18–March 6, 1938, which traveled to the Art Museum of Wellesley College, April 12–May 7, 1938.

4. Examples of *Man with a Pipe* (1924) can be viewed in the permanent collection of the Israel Museum in Jerusalem and the Musée National d'Art Moderne, Centre Pompidou, in Paris.

5. Allan Ross MacDougall, *Arts and Decoration* (March 1925): 21–22, 80.

6. See Chana Orloff, *Portrait of Cosette de Brunhoff*, 1924, cement and marble, Private Collections, M88. One of her brothers, Jean de Brunhoff, was the creator of the Barbar stories, and another brother, Michel de Brunhoff, followed her in becoming the third editor in chief of French *Vogue* in the 1930s.

7. Letter from Francis Jourdain, writer, critic, and then head of Salon d'Automne, to Orloff, telling her that her work was being considered for purchase by the state, Ateliers Chana Orloff, August 9, 1927.

8. Ateliers Chana Orloff.

9. Louis Léon Martin, "Salon d'Araignée," *L'Europe Nouvelle* (April 14, 1923).

10. Orloff's *Portrait of Lucien Vogel* (1920) is now located in the permanent collection of the Musée National d'Art Moderne, Centre Pompidou.

11. Ruth Green Harris, "Further Comment on Art Exhibitions in New York," *New York Times*, November 24, 1929.

12. Kenneth Silver, "Jewish Artists in Paris 1905–1945," in *Circle of Montparnasse*, 39–41.

13. Other examples include Jules Pascin, *Portrait of Pierre MacOrlan (The Accordionist)*, 1924, and Morice Lipsi, *Musical Group*, 1926. Ruth Green Harris, "Comment on Exhibitions of the Week," *New York Times*, November 17, 1929; Lina Goldschmidt, "From Rembrandt to Nolde," *New York Times*, May 25, 1930.

14. Silver, "Jewish Artists in Paris 1905–1945," 40.

15. Silver, "Jewish Artists in Paris 1905–1945," 40.

16. Rene Huyghe and Jean Rudel, *L'Art et le monde modern* (Paris: Larousse, 1978), cited in Coutard-Salmon, "Chana Orloff," 32.

17. Claude Roger-Marx, "Le Salon d'Automne," *Le Crapouillot* (1919): 11–12. Cited in Coutard-Salmon, "Chana Orloff," 32.

18. Golan, "'École Français,'" 81–87; see introduction, n.7.

19. Affron, "Waldemar George," 171–204.

20. Sander L. Gilman, *Jewish Self-Hatred: Antisemitism and the Hidden Language of the Jews* (Baltimore: Johns Hopkins University Press, 1986);

Paula J. Birnbaum, "Alice Halicka's Self-Effacement," in Diaspora and Modern Visual Culture: Representing Africans and Jews, ed. Nicholas Mirzoeff (London: Routledge, 1996).

21. Originally formed in 1898 in St. Petersburg by Leon Bakst and Serge Diaghilev of Ballet Russes fame, the group and the accompanying journal were originally aimed at educating the Russian public about Russian art. Anna Winestein, "Quiet Revolutionaries: The 'Mir Isskustva' Movement and Russian Design," *Journal of Design History* 21, no. 4 (2008): 315–33.

22. Natacha Liverska, "Le Salon d'Automne—Les Peintres Russes," *Le Crapouillot*, November, 16, 1921, p. 10.

23. Golan, *Modernity and Nostalgia*, 137–41; Éric Michaud, "Un certain antisémitisme mondain," in *L'école de Paris, 1904–1929: La part de l'autre*, eds. Suzanne Pagé, Jean-Louis Andral, Sophie Krebs (Paris: Association Paris-Musées, 2000), 407; Emilie Anne-Yvonne Luse, "'This Is the Future Liberals Want': The Crisis of Democracy and the Salon des Indépendants in Interwar France (1918–1939)," *Selva: A Journal of the History of Art* 2 (2020), https://selvajournal.org/article/this-is-the-future-liberals-want/.

24. "A World of Art: A War Monument and Other Sculptures," *New York Times*, January 21, 1923.

25. An example of *The Jewish Painter* (1920) is in the Collection of the Musée d'Art et d'Histoire du Judaïsme, Paris.

26. Jay Geller, "(G)nos(e)ology: The Cultural Construction of the Other," in *People of the Body: Jews and Judaism from an Embodied Perspective*, ed. Howard Eilberg-Schwartz (Albany: State University of New York Press, 1992), 255; Sander L. Gilman, *The Jew's Body* (New York: Routledge, 1991), 72–75.

27. Geller, "(G)nos(e)ology," 247.

28. "Les artistes juifs et Le Kéren Kayémeth Leisraël," *L'Univers Israélite* (November 26, 1926): 364.

29. Sally Charnow, *Edmond Fleg and Jewish-Minority Culture in Twentieth-Century France* (London: Routledge, 2021).

30. Charnow, *Edmond Fleg*; Nancy Robin Grey, "Edmond Fleg," in *Jewish Writers of the Twentieth Century*, ed. Sorrel Kerbel (New York: Fitzroy Dearborn, 2007).

31. Gaston Picard, *Figures d'aujourd'hui*, 64.

32. Picard, *Figures d'aujourd'hui*, 66.

33. Golan, "'École Français,'" 83–84.

34. Robert Rey, "Les Portraits Sculptés de Chana Orloff," *Art et Décoration* (Paris, 1922): 57–60.

35. Edouard des Courières, *Chana Orloff: Les sculpteurs français nouveaux* (Paris: Gallimard, 1927) [French]; Léon Werth, *Chana Orloff* (Paris: Editions G. Crès & Cie, 1927) [French].

36. *Vanity Fair*, October 1922, 52.

37. Orloff's portrait *Romaine Brooks*, 1923, bronze, 132 × 63.5 × 50 cm,

is in the Collection of the Musées de Boulogne-Billancourt / Musée des Années Trente, on loan from the Musée des Beaux-Arts de la Ville de Paris, Petit Palais, Inv. D2000.2.1.

38. Werth, *Chana Orloff*, 22.

39. Diana Souhami, *Wild Girls: Paris, Sappho and Art: The Lives and Loves of Natalie Barney and Romaine Brooks* (London: St. Martin's Press, 2005); Maren Tova Linett, *Modernism, Feminism, and Jewishness* (Cambridge: Cambridge University Press, 2007), 119–39.

40. François Leperlier, *Claude Cahun: L'exotisme intérieure* (Paris: Fayard, 2006); Viviana Gravano, "Explorations, Simulations: Claude Cahun and Self-Identity," *European Journal of Women's Studies* 16 (2009): 360; Jennifer L. Shaw, *Exist Otherwise: The Life and Works of Claude Cahun* (London: Reaktion, 2017).

41. See letter from Natalie Clifford Barney to Orloff, dated May 3, 1921, Ateliers Chana Orloff, arranging for her visit and telling Orloff the price of renting a room at the Hotel Palmiers (1,000 francs) presumably for the summer. Orloff also visited Barney and Brooks at their country home in Beauvallon (built in 1930 and destroyed in a fire in 1940).

42. Leperlier, *Claude Cahun*, 63.

43. Gravano, "Explorations."

44. For information on Louise Weiss, see Evelyne Winkler, *Louise Weiss: Une journaliste-voyageuse, au cœur de la construction européenne* (Paris: L'Harmattan, 2017); Michel Loetscher, *Louise Weiss: Une alsacienne au coeur de l'Europe* (Nancy: Editions Place Stanislas, 2009); Michele Fine, "A Passion for Action: The Political Crusades of Louise Weiss, 1915–1938" (PhD diss., University of California, Los Angeles, 1997); Célia Bertin, *Louise Weiss* (Paris: Albin Michel, 1999); "Louise Weiss, 1893–1983: Journaliste, féministe et femme politique française" (Paris: ENA, Centre de Documentation, 2016); Naomi Kershaw, *Forgotten Engagements: Women, Literature and the Left in 1930s France* (Amsterdam: Rodopi, 2007. See also Weiss's autobiography, *Mémoires d'une européenne*, vol. I (1893–1919), vol. II (1919–1934), and vol. III (1934–1939) (Paris: Payot, 1970).

45. Michele Fine describes *L'Europe Nouvelle* as "a journal which closely reflects the ideals and agenda of the League of Nations." Fine, "A Passion for Action," 6.

46. Weiss also was secretary-general of the Refugee Committee (1938–40) and editor of the Resistance gazette *La Nouvelle République* (1942–44).

47. Robert Rey, *L'Art Vivant* (May 1927), 343–44. Ateliers Chana Orloff.

48. Ariane Justman Tamir, interview with Louise Weiss, January 1972. Ateliers Chana Orloff.

49. Ariane Justman Tamir, interview with Louise Weiss, January 1972.

50. Coutard-Salmon, "Chana Orloff," 45.

51. "L'Exposition patriotique pour le redressement du franc." One thousand

works of art were donated by artists, with the proceeds going to "la Souscription nationale." The exhibit was held on November 27, 1926, at the Galerie Drouant, 66 rue de Rennes, Paris. Orloff donated one work. Her friend, the artist Gus Bofa, made the cover image for the exhibition catalog. http://gusbofa.com.

52. Coutard-Salmon, "Chana Orloff," 45; Ariane Justman Tamir, interview with the author, December 1, 2017.

53. Ariane Justman Tamir, interview with the author, December 1, 2017.

CHAPTER 8

1. Louise Campbell, "Perret and His Artist-Clients: Architecture in the Age of Gold," *Architectural History* 45 (2002): 412.

2. Louise Campbell, "'Un Bel Atelier Moderne': The Montparnasse Artist at Home," in *Designing the French Interior: The Modern Home and Mass Media*, eds. Anca I. Lasc, Georgina Downey, and Mark Taylor (London: Bloomsbury, 2015), 182; Campbell, "Perret and His Artist-Clients," 409–40.

3. Alice Halicka, *Hier (Souvenirs)* (Paris: Éditions du Pavois), 101. Cited in Silver and Golan, eds., *Circle of Montparnasse*, 45; and Campbell, "'Un Bel Atelier Moderne,'" 180; Campbell, "Perret and His Artist-Clients," 412.

4. Henry Miller described Orloff as "a very good friend of mine" in a letter to the writer Jean Giono, dated May 24, 1939. Miller recounted in this same letter that Soutine was "timid" and was frequently at Orloff's home. See Francis Segond and Jean-Pierre Weil, *Chaim Soutine* (Paris: Editions Faustroll, 2007). Miller wrote *Tropic of Cancer* in his home on this street in 1936. Dalí and his wife, Gala, were also thought to have lived in this same house for a short period during the 1930s.

5. Fonds Lurçat, "Journal des activités," 533 AP 450, IFA, reads "1925 juin. Paris. Commande de l'étude d'un maison particulier pour le sculpteur Chana Orloff." *Portrait of Auguste Perret*, 1923, M74; G74. In her interviews, Orloff claims that she sculpted Perret's portrait bust in plaster and bronze in exchange for his design and supervision of the building of her studio and home. She also stated that he paid for the bronze casting of his portrait himself.

6. Campbell, "Perret and His Artist-Clients," 414. Campbell translated the French from Marcel Mayer, "L'Architecture du béton armé: Une Oeuvre Classique," 268.

7. Campbell, "Perret and His Artist-Clients," 414.

8. Wight, "Recollections of Modigliani," 43.

9. For examples of announcements of "open studio" that Orloff published in various newspapers in this period, see *La Semaine de Paris*, March 4, 1927, 81, and *Comoedia*, June 15, 1932.

10. See Orloff's *Portrait of Francis Jourdain*, 1927 (M127; G128), Musée de Saint-Denis, France. For a biography of Francis Jourdain, see Gordon

Campbell, ed., *The Grove Encyclopedia of Decorative Arts* (Oxford: Oxford University Press, 2006), 532.

11. C. Imbert, "Le Quartier artistique de Montsouris, la cité Seurat, 101 rue la Tombe Issoire Paris," 111, cited in Campbell, "'Un Bel Atelier Moderne,'" 181; and Éric Justman, "De la Villa Seurat aux Ateliers Chana Orloff," in *À la rencontre de Chana Orloff*, 13.

12. Campbell, "Francis Jourdain," 532.

13. Uncited press article from 1938, New York, Ateliers Chana Orloff.

14. Coutard-Salmon, "Chana Orloff," 52.

15. Imbert, "Le Quartier artistique de Montsouris," 111.

16. Élie Faure to Chana Orloff, January 4, 1928, Ateliers Chana Orloff, cited in Coutard-Salmon, "Chana Orloff," 52.

17. For an important scholarly discussion of the work of Reuven Rubin, see Manor, *Art in Zion*, 75–110; Amitai Mendelsohn, *Prophets and Visionaries: Reuven Rubin's Early Years, 1914–23* (Jerusalem: The Israel Museum, 2006). Prominent themes in Rubin's work are the biblical landscape and folkloric imagery depicting Yemenite, Arab, and Hasidic Jewish peoples.

18. The bronze cast that Rubin owned of this portrait is now located in the Reuven Rubin Museum, Tel Aviv. Additional bronze casts are in the collections of the Musée d'Art et d'Histoire du Judaïsme, Paris, and the Brooklyn Museum.

19. For example, see Rubin's triptych *First Fruits*, 1923.

20. Reuven Rubin, *Reuven: An Autobiography and Selected Paintings*, with introductory text by Haim Gamzu (Givatayim: Massada, 1984), 157–60 [Hebrew]. The quotes are taken from the English translation: Reuven Rubin, *Rubin: My Life, My Art*, with introductory text by Haim Gamzu (New York: Funk & Wagnalls, 1974), 157–60.

21. Rubin, *Rubin: My Life, My Art*, 157–160.

22. Rubin, *Rubin: My Life, My Art*, 157–160.

23. The bronze cast is on permanent display now at the Rubin Museum, Tel Aviv. Other bronze casts of Orloff's sculpture are located in the Musée d'Art et d'Histoire du Judaïsme in Paris, and in the Brooklyn Museum in New York. Three years after Orloff created Rubin's portrait bust, Rubin painted an image of Orloff's bust into his own work. *The Zeppelin Over Tel Aviv*, 1929, Tel Aviv Museum of Art.

24. Rubin, *Rubin: My Life, My Art*, 160.

25. Rubin, *Rubin: My Life, My Art*, 161.

26. Dalia Manor, "Turning to Diaspora: The Jewish Discourse in the Art of Eretz-Israel during the 1930s," in *Israeli Exiles: Homeland and Exile in the Israeli Discourse, Studies in the Rebirth of Israel*, ed. Ofer Shiff (Sde Boker: Ben-Gurion University of the Negev Press, 2015): 13–52 [Hebrew]; Manor, "Pride and Prejudice: Recurrent Patterns in Israeli Art Historiography," *History and Theory, Bezalel: Parallel Lines* 1 (2005) [Hebrew].

27. *Portrait of Hayim Nahman Bialik*, 1926 (M128). A bronze cast of this work is now located in the Beit Bialik in Tel Aviv, and another bronze cast of Orloff's portrait of Bialik is located in the collection of the Skirball Cultural Center in Los Angeles.

28. When Orloff completed the plaster cast of his portrait, she sent a photograph of it taken by Marc Vaux to Bialik, with a handwritten inscription: "To the Great Bialik, with Love from Hanna." Archives, Beit Bialik, Tel Aviv. I am grateful to Shmuel Avneri, director of the Bialik Archives, Beit Bialik, for his assistance. Orloff exhibited the portrait at the 1926 Salon d'Automne, where it was received favorably by critics.

29. Dr. Else von Hofmann, "Die Pariser Bildhauerin Chana Orloff," Archives Atelier, 19–21, cited in Coutard-Salmon, "Chana Orloff," 52–53.

30. Orloff also sculpted Floch's portrait in 1926: *Portrait of Joseph Floch*, 1926 (M118). See http://www.joseffloch.com/en/; http://www.victortischler .com/en/; http://culture.pl/en/artist/leopold-gottlieb.

31. Gamzu, *Chana Orloff* (1951), 57.

32. The letter from Bialik to Orloff is dated June 28, 1927, and cited in Fishel Lahover, ed., *Hayim Nahman Bialik's Letters*, trans. Ayelet Carmi, Vol. 3 (Tel Aviv: Devir, 1939), 250 [Hebrew].

33. Bialik's dedication to Orloff was reproduced in *Haaretz*, Jan. 13, 1933, 5. Bialik also wrote to Orloff in June 1931 to ask for her help in acclimating his young friend, the Hebrew painter Haim Gliksberg, who was coming to Paris for a long stay. Bialik wrote, "I still have the wonderful taste of your Hamantashen in my mouth and the taste of your magnificent sculpture in my eyes." He continued by telling Orloff how when she returns to Palestine, he and his wife will "endow her with . . . honor and glory," because she is "one of us," likely implying a true Hebrew artist. See Lahover, ed., *Hayim Nahman Bialik's Letters*, 160.

34. Lisa Schlansker Kolosek, *The Invention of Chic: Thérèse Bonney and Paris Moderne* (New York: Thames and Hudson, 2002); Roberts, *Civilization without Sexes*. Orloff hired Bonney, along with the photographer, Marc Vaux, to photograph her in her studio at different points in her life. She also commissioned both Bonney and Vaux to photograph her body of work in several photography sessions at her studio so that she could distribute her work to the press, clients, galleries, museums, and other institutions. See Bauer, "L'oeuvre sculpté."

35. Elizabeth Majerus, "'Determined and Bigoted Feminists': Women, Magazines and Popular Modernism," in *Modernism*, eds. Vivian Liska and Ástráður Eysteinsson (Amsterdam: John Benjamins Publishing Company, 2007), 619–36.

36. See obituary, "F. Crowninshield is dead here at 75: Adviser to Conde Nast Firm, Introduced French Modernist Painters to this Country," *New York Times*, December 29, 1947; David Friend, "V.F.'s Jazz Age Canvas; Vanity Fair's

great pre-war editor, Frank Crowninshield, helped introduce modernist art to America as an organizer of 1913's breakthrough Armory Show," *Vanity Fair* 48, no. 12 (December 2006): 332.

37. Typewritten letter from Frank Crownishield to Chana Orloff, April 27, 1922, and draft of Orloff's handwritten reply to Crowninshield (n.d.), 1922. Ateliers Chana Orloff.

38. "A Group of Chana Orloff's Portrait Busts in Wood," *Vanity Fair*, June 1924, 55. Ateliers Chana Orloff. The article includes reproductions of four of her recently commissioned sculpted wood portrait busts of male friends and colleagues: the architect Auguste Perret, the writers Edmond Fleg and André Levinson, and Dr. Koninjy.

39. Marcilhac, cat. 130. Created in plaster, cement, and bronze. Private Collections.

40. Roumain, "'Toute femme a droit aux joies de la maternité,' soutient Mme Chana Orloff," *Petit Journal*, August 8, 1935.

41. Roumain, "'Toute femme'"; Michelle Coquillat, *La poétique du mâle* (Paris: Gallimard, 1982).

42. Kenneth Silver, *Esprit de Corps: The Art of the Parisian Avant-Garde and the First World War, 1914–1925* (Princeton, NJ: Princeton University Press, 1989), 191–92; Birnbaum, *Women Artists in Interwar France*; Paula J. Birnbaum, "Constructing a Matrilineal History of Art in Interwar France," *Aurora: The Journal of the History of Art* 4 (2003): 155–73; Paula J. Birnbaum, "Modern Madonnas and Working Mothers," in *Essays on Women's Artistic and Cultural Contributions, 1919–1939*, eds. Paula Birnbaum and Anna Novakov (Lewiston, NY: Edwin Mellen Press, 2009), 83–95.

43. Robert Rey, *Le Crapouillot*, April 1, 1925, cited in Coutard-Salmon, "Chana Orloff," 54.

44. Maurice Agulhon, *Marianne into Battle: Republican Imagery and Symbolism in France, 1789–1880*, trans. Janet Lloy (Cambridge: Cambridge University Press, 1981); Silver, *Esprit de Corps*, 13–24; Marilyn Yalom, *A History of the Breast* (New York: Alfred A. Knopf, 1997), 105–23.

45. Adolphe Gottlieb, "Chana Orloff," *L'Illustration Juive*, n.d. (circa 1927), Ateliers Chana Orloff.

46. Gottlieb, "Chana Orloff."

47. Orloff also represented the themes of sexuality, fertility, and creativity through the Jewish lens of Old Testament heroines in works such as *Eve*, *Ruth and Noémie*, and others. She exclaimed that "the Bible is a constant source of inspiration" in an interview in 1967. See Miriam Tal, "Hanna Orloff, Sculpteur Juif," n.p., 1967, 21–22. Ateliers Chana Orloff.

48. Birnbaum, *Women Artists in Interwar France*; Paula J. Birnbaum, "Chana Orloff: Sculpting as a Modern Jewish Mother," in *Reconciling Art and Motherhood*, ed. Rachel Epp Buller (Farnham: Ashgate, 2012).

49. Pawel Barchan, "Chana Orlowa," *Deutsche Kunst und Dekoration* (1924): 284–91.

50. Barchan, "Chana Orlowa."

51. M.A., "À La Recherche de l'Expression par le Style: L'Exposition Chana Orloff," *Vogue*, December 1, 1926, 34–35. See Brinda Kumar, "Likeness," in *Life Like: Sculpture, Color and the Body*, eds. Luke Syson, Sheena Wagstaff, Emerson Bowyer, and Brinda Kumar (New Haven, CT: Yale University Press, 2018), 107.

52. M.A., "À La Recherche," 34–35. The works reproduced on page 34 are *Portrait of Elisabeth Chase* (1926, pink stone), *Portrait de Femme (Mme X)* (1925, bronze), and untitled portrait bust of an unnamed woman (1925, bronze). Elisabeth Chase Geissbuhler was an American sculptor who was a friend and mentee of Orloff and had studied in the atelier of Bourdelle in Paris (as did her husband, Arnold E. Geissbuhler). She later became a scholar of Rodin. See http://www.tfaoi.com/aa/6aa/6aa277.htm. On page 35, the following works are reproduced: *Accordionist (Per Krohg)* (1924), *My Son* (1923), acquired by the Musée d'Art de Grenoble, and *Portrait of Reuven Rubin* (1926).

53. See Bauer, "L'oeuvre sculpté"; Jean-Paul Crespelle, *Montparnasse Vivant: Marc Vaux, 250,000 Peintures* (Paris: Editions Hachette, 1975).

54. Note that in Orloff's 1929 *Vanity Fair* Hall of Fame award, the editors also added the following text to an otherwise identical list of attributes: "because she is presently visiting the United States for the first time." See Majerus, "'Determined and Bigoted Feminists,'" 628.

55. Coutard-Salmon, "Chana Orloff," 48, and Campbell, "'Un Bel Atelier Moderne,'" 181.

56. According to Louise Campbell, Orloff "steered a judicious course between courting the publicity that artists attracted and maintaining the more anonymous role of artisan." Campbell, "'Un Bel Atelier Moderne,'" 182. See also Green, *Art in France*, 48–49.

57. "Ein Besuch bei Chana Orlowa zur Vernissage in ihren Ateliers in der Villa Seurat," *Prager-Presse* (June 19, 1932), Ateliers Chana Orloff. Cited in Coutard-Salmon, "Chana Orloff," 66.

58. André Levinson, *Les Nouvelles Littéraires*, August 29, 1925.

59. Romy Golan has argued that reactionary issues such as anti-urbanism, the return to the soil, and regionalism became central to cultural and art-historical discourse. Golan, *Modernity and Nostalgia*.

60. Parkes, "Younger Sculptors," 416.

61. Des Courières, *Chana Orloff*, 8, 9; Werth, *Chana Orloff*.

62. Des Courières, 4.

63. Des Courières, 5.

64. Des Courières, 4.

65. See introduction, n.4.

66. The finished work of 1930 is located in the collection of the Tel Aviv Museum of Art. Chana Orloff, *Head of a Woman*, 1930, marble (Inventory #1923), 43 × 23 × 15 cm, Tel Aviv Museum of Art.

67. Hirschbein is featured in a bronze portrait in the Jewish Museum of New York that greatly resembles this one. See *Portrait of Esther Hirschbein*, 1924, bronze, Jewish Museum, New York (M89) and *Portrait of Peretz Hirshbein*, 1924, bronze, Jewish Museum, New York (M90). These two portraits in bronze were first exhibited at the Weyhe Gallery in New York in 1929. https://thejewishmuseum.org/collection/20613-portrait-of-madame -peretz-hirshbein. See Faith Jones, "Esther Shumiatcher-Hirschbein," Jewish Women's Archive, retrieved April 6, 2018; "Guide to the Papers of Peretz Hirschbein," digital.cjh.org; Faith Jones, "Shumiatcher-Hirschbein, Esther," 2nd ed., *Encyclopaedia Judaica*, retrieved April 6, 2018; Myra Mniewski, "Esther Shumiatcher Hirschbein in Hospital," *Bridges* 11(1) (2006): 39; http://yiddishkayt.org/view/esther-shumiatcher/.

68. P.J.V. Rolo, "Harari, Manya, 1905–1969," *Oxford Dictionary of National Biography* (Oxford University Press, online edition, 2004). Orloff's *Portrait of Madame Harari* is in the Tel Aviv Museum of Art. See her memoir, Manya Harari, *Memoirs, 1906–1969* (London: Harvill Press, 1972).

69. Orloff first exhibited *Portrait of Dr. Otto Rank* (1927, bronze, figure 8.10), at the Salon d'Automne in Paris in 1928; she exhibited it in 1929 at the Weyhe Gallery, New York; 1937, Paris, Petit Palais (Maitres Indépendants); 1938 School of MFA Boston; 1947 de Young Museum; Israel (1952, 1961, 1969). Orloff first exhibited *Portrait of Beata Rank* (1929–30, stone, figure 8.11) in 1929 at the Weyhe Gallery in New York, and then it stayed in Rank's personal collection; it was exhibited again in 1975 at the Judah Magnes Museum, Berkeley, CA. Orloff also did a portrait of their daughter, *Mademoiselle Hélène Rank* (1928, stone, Paris, Musee d'Art Moderne de la Ville de Paris, purchased 1937).

70. See James E. Lieberman, *Acts of Will: The Life and Work of Otto Rank* (New York: The Free Press, 1985).

71. Otto Rank broke from Freud with the publication of his book *The Trauma of Birth* (1923, translated 1929), in which he ascribed the basis of neuroses as the initial psychological trauma of birth, rather than the Oedipus Complex.

72. Ruhama Veltfort, granddaughter of Otto and Tola Rank, interview with the author, San Francisco, April 9, 2018.

73. See in particular Otto Rank, *Myth of the Birth of the Hero* (1909, translated 1914); and Rank, *Art and Artist* (1932). Rank began his career by writing *The Artist* (1907), a text that used Freud's psychoanalytic principles from *The Interpretation of Dreams* to explain art and the creative process.

74. Gottlieb, "Chana Orloff."

75. Tola Rank died in 1967, only one year before Orloff. See Claudine

Geissman-Chambon and Pierre Geissman, *A History of Child Psychoanalysis* (London: Routledge, 1998), 134–37; and Paul Roazen, *The Historiography of Psychoanalysis* (New Brunswick, NJ: Transaction Publishers, 2001), 205–15.

76. Geissman-Chambon and Geissman, *History of Child Psychoanalysis*; and Roazen, *Historiography of Psychoanalysis*. Tola Rank's paper was published in German in the journal *Imago*, which she edited with Otto Rank (in the context of the Society's publishing house, or *Verlag*). This publication gained her admittance into the exclusive Viennese Psychoanalytic Society. Among her publications, see Beata Rank, "Adaptation of the Psychoanalytic Technique for the Treatment of Young Children with Atypical Development," *American Journal of Orthopsychiatry* 19, no. 1 (January 1949): 130–39.

77. Hegel once described his preference for this type of sculpted eye that "should not protrude or, as it were, project itself into the real world." Emerson Bowyer, "The Presumption of White," in *Life Like*, 76, 275, n.1. Bowyer cites G[eorg] W[ilhelm] F[riedrich] Hegel, *Aesthetics: Lectures on Fine Art*, trans. T. M. Knox, 2 vols. (Oxford: Clarendon Press, 1975), vol. 2: "The sculpted eye, 'should not protrude or, as it were, project itself into the external world'" (734).

78. The first work that Tola Rank purchased was Orloff's *Mother and Child*, 1924, marble (M79), Private Collection.

79. Deutsch became a leader in the psychoanalytic study of female subjectivity and sexuality, and Oberholzer has been described as "one of the very first child analysts." See Paul Roazen, *Helene Deutsch: A Psychoanalyst's Life* (New Brunswick: Transaction Publishers, 1992). On Mira Gincburg-Oberholzer, see Geissman-Chambon and Geissman, *A History of Child Psychoanalysis*, 33.

80. This piece is related to another portrait of her son from this period dressed in a sailor suit, *My Son, Marine*, 1927 (see plate 15).

81. Anaïs Nin, *The Diary of Anaïs Nin, 1931–1934* (New York: Houghton Mifflin Harcourt, 1969), 332.

82. Nin, *Diary of Anaïs Nin*, 332.

83. Nin had an abortion in 1934, during the time she was in a relationship with Henry Miller.

84. Lieberman, *Acts of Will*, 344.

CHAPTER 9

1. Elisabeth Chase to Chana Orloff, November 21, 1927. Ateliers Chana Orloff. In several letters to Orloff, Chase describes being on "a mission" to help Orloff get an exhibition contract in New York. Orloff's 1926 bust of Chase was reproduced in French *Vogue*. Coutard-Salmon, "Chana Orloff," 59.

2. Reba White Williams, "The Weyhe Gallery between the Wars, 1919–1940" (PhD diss., The City University of New York, 1996); The Weyhe Gallery Archives, Archives of American Art, the Smithsonian Institution, Washington, DC.

3. Carl Zigrosser became the head curator of prints and drawings at the Philadelphia Museum of Art from 1941 to 1963.

4. Picasso, *Head of a Woman (Fernande)*, 1909, plaster model, bronze cast: Foundry Désiré or Florentin Godard, Paris, made to order for Ambroise Vollard between July 27, 1926, and March 11, 1927, bronze, Metropolitan Museum of Art, New York, Promised Gift from Leonard A. Lauder Cubist Collection.

5. *America After the Fall: Painting in the 1930s* (London: Royal Academy of Art, 2017).

6. Anne Wealleans, *Designing Liners: A History of Design Afloat* (London: Routledge, 2006).

7. "Smith and Walker Speak on New Liner," *New York Times*, June 30, 1927.

8. "Ile de France Here on Her Maiden Voyage," *New York Times*, June 29, 1927.

9. "Ile de France Here on Her Maiden Voyage."

10. My description is based on the narrative and photographs provided in William H. Miller Jr., *The Great Luxury Liners: A Photographic Record* (New York: Dover Publications, 1982), 21. The capacity of the ship was 1,786 passengers.

11. Ateliers Chana Orloff, #14. The telegraph was sent by Madame Rank, and the other names listed are Bernstein, Gruen, Iluscha, Rechter, Fleg, Lowenthal, and Eric.

12. F.S., "Impressions d'Amérique, par Chana Orloff," *L'Atlantique*, September 26, 1930. This was the publication of the navigation company called Sud-atlantique.

13. For more on the history of the Shelton Hotel, now the New York Marriott East Side, see http://www1.nyc.gov/assets/lpc/downloads/pdf/announcements/Shelton%20Hotel%20Final_160509.pdf.

14. While some of Orloff's correspondence from this period was addressed to the Shelton Hotel (see letter #95 to Orloff from M. Vomaret, dated November 29, 1929, others, such as a telegram from Frank Crowninshield, were addressed to Orloff at 54 West 74th Street, a residential address on the Upper West Side of the city that presumably was the private apartment of a friend or patron (telegram from Frank Crowninshield, December 27, 1929, Ateliers Chana Orloff, #241).

15. Orloff remarked, "That's not bad for our tired European nerves." F.S., "Impressions d'Amérique."

16. Among the portraits on display were *Accordionist (Per Krohg)* (see figure 7.4); *Mme. Peretz Hirschbein*; *Woman with Turban (Madame X)* (see figure 9.2), an early maternity; and a *Bretonne*, a portrait of the woman she hired to care for Élie when he was younger.

17. Innis Shoemaker, curator in charge of prints and drawings, informed the author that Zigrosser donated many drawings that had served as pro-

motional images for exhibitions at the Weyhe Gallery to the Philadelphia Museum of Art. Innis Shoemaker, email message to author, March 8, 2018.

18. After the exhibition concluded, Orloff offered the drawing to Carl Zigrosser, the gallery director, as a way of expressing her appreciation.

19. Frank Crowninshield, *Sculpture by Chana Orloff (November 11th to 30th, 1929)* (New York: The Weyhe Gallery, 1929).

20. Crowninshield, *Sculpture by Chana Orloff*.

21. Crowninshield, *Sculpture by Chana Orloff*.

22. After the exhibit closed, Frank Crowninshield sent Orloff a telegram, addressed to 54 West 74th Street, dated December 27, 1929: "So many thanks to you my dear genius benefactress artist and friend. Am tremendously proud to own those two beautiful drawings. How kind of you. all my gratitude Frank Crowninshield." Ateliers Chana Orloff.

23. Anonymous, "Chana Orloff's Sculpture Makes Striking Display at Weyhe Galleries," *Brooklyn Daily Eagle*, November 17, 1929.

24. Anonymous, "Motherhood and Childhood Most Appeal to Chana Orloff, Russian Sculptress, as Subjects for Her Skilled Chisel," *New York Sun*, December 26, 1929. This particular critic chose to reproduce several of Orloff's portraits of children, including *Portrait of Monina Farr* from the Rubinstein collection, with the following caption: "American childhood seen through the eyes of a great Russian sculptress. Chana Orloff, who has here strikingly portrayed Miss Monina Farr."

25. *Vanity Fair*, December 1929.

26. Anonymous, "Chana Orloff's Sculpture Makes Striking Display at Weyhe Galleries."

27. Green Harris, "Further Comment on Art Exhibitions in New York."

28. Green Harris, "Further Comment on Art Exhibitions in New York."

29. A number of critics pointed to Orloff's *Accordionist* as a standout piece in the exhibition. See *Creative Art: A Magazine of Fine and Applied Art* (December 1929) (5): 90.

30. See Golan, *Modernity and Nostalgia*, 142–143.

31. See Sue Ann Prince, *The Old Guard and the Avant-Garde: Modernism in Chicago, 1910–1940* (Chicago: University of Chicago, 1990).

32. Paintings by Modigliani, Arts Club of Chicago, November 15–30, 1929.

33. Carl Zigrosser to Alice Roullier, Roullier Art Galleries, Chicago, November 9, 1929. The Newberry Library, Midwest MS Arts Club, Series 1: Exhibitions, Chana Orloff Sculpture (E. Weyhe, Prints and Books on Fine Arts), Box 9, Folder 189.

34. Blair later donated the piece to the Tel Aviv Museum of Art. See "Mrs. C.J. Blair Dies, an Art Collector," *New York Times*, August 6, 1940.

35. Schofield also was a wealthy collector whom Orloff met in Paris in the 1920s. See Daniel Sherman, "'Flora Schofield,' Modernism in the New City: Chicago Artists, 1920–1950," http://www.chicagomodern.org/artists/flora

_schofield/.ulliet; C. J. "Artists of Chicago, Past and Present, no. 89: Flora Schofield," *Chicago Daily News*, June 3, 1939; J. Z. Jacobson, *Art of Chicago Today, Chicago, 1933* (Chicago: L. M. Stein, 1933), 115; Flora Schofield, Pamphlet file P-19798. Ryerson Library. Art Institute of Chicago; and Alice Sinkevitch, *AIA Guide to Chicago* (Boston: Mariner Books, 2004), 132.

36. Aldis was said to have "worked behind the scenes to garner interest and support for the controversial exhibition [The Armory Show] among the museum's trustees and the city's well-to-do." http://extras.artic.edu /armoryshow/cast.

37. Chana Orloff, *Woman with a Basket*, 1926. Bronze h. 24½ in. Gift of The Arts Club of Chicago, 1930.227, Chicago Art Institute. Among the local collectors with whom Orloff met in Chicago was Ellen W. Borden, who wrote to tell her how delighted she was by her purchase of Orloff's work.

38. Assistant Secretary of the Arts Club to Carol Zigrosser, January 21, 1930. Newberry Library. A letter from Mrs. Ellen W. Borden to Chana Orloff, January 16, 1930, Ateliers Chana Orloff, expresses enthusiasm for her newly acquired sculpture of a fish.

39. Dr. David M. Levy was known for introducing the Rorschach test for measuring personality traits and general intelligence in the United States, along with terms like "sibling rivalry." He was also credited with originating the idea of "play therapy," where children act out their emotions in playful scenarios. "Dr. David M. Levy, 84, A Psychiatrist Dies," *New York Times*, March 4, 1977. Adele Rosenwald Levy was celebrated as "both a discriminating art patron and collector and founder" of a charity, The Citizens' Committee for Children of New York: Stuart Preston, "'Masterpieces,' Display at Wildenstein's is Tribute to Adele Rosenwald Levy," *New York Times*, April 6, 1961.

40. Reuven Rubin met Mildred Otto and her father, a businessman named Alfred Stone, who introduced him to George Hellman, along with the Lewisohn, Lehman, and Seligman families, "the aristocracy of the Jewish community at the time." See Rubin, *Rubin: My Life, My Art*, 173–76. Mildred Otto invited Orloff to sculpt her portrait holding her young child (*Maternity*, 1929, plaster and bronze). Private Collection. Grobot-Dreyfus, "Sociabilités familiales," vol. III, cat. 168, 379.

41. See Oko correspondence with Orloff, AJA archives, Cincinnati. This example of Orloff's bronze portrait of Bialik now resides in the Skirball Cultural Center, Los Angeles.

42. Her studio was located near her residence hotel, at 54 West 74th Street. See Orloff, *Portrait of M. Stone*, 1930, plaster and bronze, Private Collection.

43. Klein, *Helena Rubinstein*, 99.

44. *Portrait of Monina Farr*, 1925; *Portrait of Elisabeth Chase*, 1925; *Woman with Turban (Madame X)*, 1925 (see figure 9.2). The latter two works were reproduced in French *Vogue* (December 1, 1926) with an article promoting Orloff's solo exhibition at the Parisian Galerie Druet.

45. Rubin, *Rubin: My Life, My Art*, 179.

46. Klein, *Helena Rubinstein*, 99.

47. Klein, *Helena Rubinstein*, 100.

48. "A Beauty Salon in Modern Art," *Good Furniture* (May 1928): 242–44; Klein, *Helena Rubinstein*, 99; Suzanne Slesin, *Over the Top* (New York: Pointed Leaf Press, 2006), 46.

49. "A Beauty Salon in Modern Art."

50. Chana Orloff, *Woman with Turban (Madame X)*, 1925, wood, is in the collection of the Musée Sainte-Croix, Poitiers. Orloff also painted *Portrait de Madame Sarah Lipska*, 1925, Private Collection.

51. Sarah Lipska worked in Paris as a fashion designer and sculptor, and collaborated with Léon Bakst as a set designer and costume designer for the Ballets Russes. A collection of samples of embroidered textiles attributed to her resides in the collection of the Metropolitan Museum of Art. See Morris de Camp Crawford, *The Ways of Fashion* (New York: G.P. Putnam, 1941).

52. Klein, *Helena Rubinstein*, 99; Joubert, *Helena Rubinstein*.

53. "A Beauty Salon in Modern Art," 242–44.

54. Mason Klein, *Helena Rubinstein*, 100.

55. Orloff exhibited a second cast of her bust of Maria Lani concurrently in a group sculpture exhibition at Brownwell-Lambertson Galleries, New York, NY. See "Gallery Notes," *Parnassus* 2, no. 7 (November 1928): 16–21; 24–29. The venues of the Maria Lani exhibition include Brummer Gallery, New York, November 1–28, 1929; Arts Club of Chicago, December 3–17, 1929; Galerie Alfred Flechtheim, Berlin, June 1930; Leicester Galleries, London, August–September 1930; Galerie Georges Bernheim, Paris, November 15–30, 1930; Rotterdamsche Kunstkring, Rotterdam, January 11–February 1, 1931. See Jon Lackman, "Maria Lani's Mystery," *Art in America* 102 (June/July 2014): 49–52.

56. Lackman, "Maria Lani's Mystery," 50; Maurice Sachs, *Au temps du Boeuuf sur le toit* (Paris: Grasset, 220–21).

57. "Maria Lani—The Subject of Many Modern Painters," *Vanity Fair* 33, no. 4 (December 1929): 76–77.

58. Jon Lackman traces the origins of this rumor to Jean Cocteau's diary. Lackman, "Maria Lani's Mystery," 49.

59. Lackman, "Maria Lani's Mystery," 52.

60. Ruth Green Harris, "C'est Pas La Même Chose: How the Many Look at Maria Lani—Artists Offer Pictures in Various Galleries," *New York Times*, November 3, 1929.

61. Green Harris, "C'est Pas La Même Chose," 52.

62. Tola Rank donated her *Portrait of Maria Lani* to the Rose Art Museum, Brandeis University. Another bronze cast was donated to the Mount Holyoke Museum collection. Elise Stern Haas (who signed her correspondence Mrs. Walter A. Haas) confirmed she purchased her bust

in 1929 directly from Orloff in a letter dated March 13, 1972, to Andrée Justman (Orloff's daughter-in-law).

63. Matthew Kaplan, "The *Menorah Journal* and Shaping American Jewish Identity: Culture and Evolutionary Sociology," *Shofar: An Interdisciplinary Journal of Jewish Studies* 30, no. 4 (2012): 61–79; Lauren B. Strauss, "Staying Afloat in the Melting Pot: Constructing an American Jewish Identity in the *Menorah Journal* of the 1920s," *American Jewish History* 84 (1996): 315–31; James Burkhart Gilbert, *Writers and Partisans: A History of Literary Radicalism in America* (New York: Columbia University Press, 1968); Alexander Bloom, *Prodigal Sons: The New York Intellectuals and Their World* (New York: Oxford University Press, 1986); Alan Wald, *The New York Intellectuals: The Rise and Decline of the Anti-Stalinist Left* (Chapel Hill: University of North Carolina Press, 1987); Neil Jumonville, *Critical Crossings: The New Intellectuals in Postwar America* (Berkeley: University of California Press, 1991).

64. Andrea Pappas, "The Picture at *Menorah Journal*: Making 'Jewish Art,'" *American Jewish History* 90, no. 3 (2002): 205–38.

65. Orloff met Lowenthal and his wife Sylvia in the mid-1920s when they lived in Paris.

66. Chana Orloff, *Marvin Marx Lowenthal*, 1930 (M165). Lowenthal introduced Orloff to Rabbi Stephen S. Wise of the Free Synagogue in New York. See Ateliers Chana Orloff, letter #173, for a letter from Rabbi Stephen Wise, Free Synagogue, to Orloff, in which he invited her to dinner at his home with his wife.

67. Henry Hurwitz to Chana Orloff, Dec. 23, 1929. Henry Hurwitz Papers, MS-2, Box 41, Folder 7, American Jewish Archives, Cincinnati.

68. The inserts began in 1922 and continued in every issue. See Pappas, "Picture at *Menorah Journal*," 208–9.

69. Pappas, "Picture at *Menorah Journal*," 236.

70. André Salmon, "Chana Orloff: Sculptor," *Menorah Journal* 12, no. 3 (June/July 1926): 272–73.

71. Salmon, "Chana Orloff," 272–73.

72. Pappas, "Picture at *Menorah Journal*," 235.

73. Pappas, "Picture at *Menorah Journal*," 235.

74. Reuven Rubin, "I Find Myself," *Menorah Journal* 12 (1926): 497–99.

75. In this case, the frontispiece image was paired with an article by John W. Vandercook, with an illustration by Marcus Rothkowitz entitled "Jungle Judaism," about a Jewish colony in Suriname.

76. "Notes on Contributors," *Menorah Journal* 18, no. 1 (January 1930): 95.

77. Pappas, "Picture at *Menorah Journal*," 237.

78. F.S., "Impressions d'Amérique."

79. F.S., "Impressions d'Amérique." The H. O. Havemeyer Collection

was donated to the Metropolitan Museum of Art in 1929, and on view to the public from March 10 through November 2, 1930.

80. F.S., "Impressions d'Amérique."

81. He is best known today as the longtime publisher and chairperson of the *Washington Post* (which he purchased at a bankruptcy auction in 1933). The Meyers' daughter, Katharine Meyer Graham, was the legendary publisher of the paper during the Watergate scandal.

82. Orloff's portrait was titled *Dick Meyer*, 1931 (M176); this was Eugene Meyer's nickname.

83. Marie Sterner to Chana Orloff, April 4, 1930, Ateliers Chana Orloff.

84. William M. Hekking, *Catalog of an exhibition of bronzes and drawings by Isamu Noguchi and a group of bronzes by Chana Orloff*, Catalogue d'exposition, Albright Art Gallery, 24 décembre 1930–25 janvier 1931 (Buffalo: The Buffalo Fine Arts Academy, Albright Art Gallery, 1930), n.p.

85. *Catalogue of an exhibition by the Toronto chapter of the Ontario Association of Architects: An Exhibition of Sculpture by Chana Orloff and Isamu Noguchi* (Toronto: Art Gallery of Toronto, 1931).

86. Hekking, *Catalog*.

87. Amy Lyford, *Isamu Noguchi's Modernism: Negotiating Race, Labor and Nation, 1930–1950* (Berkeley: University of California Press, 2018).

CHAPTER 10

1. Gutman, like Orloff, was a Russian Jew who emigrated to Palestine from Odessa in 1905. The two likely first met in their youth at the Gymnasia Herzliya. Gutman studied art in Vienna, Berlin, and Paris between 1920 and 1926, and he and Dora lived in Paris briefly during the early 1930s.

2. Lea Naor, *Nahum Gutman: A Quest for Colors* (Jerusalem: Yad Yitzrak Ben Zvi, 2012), 287 [Hebrew].

3. Hyman, *Jews of Modern France*, 145; cited in Nadia Malinovich, *French and Jewish: Culture and the Politics of Identity in Early Twentieth-Century France* (Portland: The Littman Library of Jewish Civilization, 2008), 235.

4. Hyman, *Jews of Modern France*, 145; Schor, *L'Antisemitisme en France pendant les années trentes*; Michael Robert Marrus and Robert O. Paxton, *Vichy France and the Jews* (Stanford, CA: Stanford University Press, 1995); Pierre Birnbaum, *Anti-Semitism in France: A Political History from Léon Blum to the Present* (Oxford: Cambridge University Press, 1992); Richard Millman, *La Question juive entre les deux guerres ligues de droite et anti-sémitisme en France* (Paris: Colin, 1992).

5. The Perret house is located next door, at 7 bis Villa Seurat.

6. Rechter is famous for his building Binyanei Ha'uma (International Convention Center), 1950, the Tel Aviv Court House (together with his son, Yaacov Rechter), and the Mann Auditorium (together with Karmi), 1951.

7. The house was later demolished. See Nitza Metzger-Szmuk, Des

Maisons sur Le Sable, Tel Aviv, Mouvement Moderne et Esprit Bauhaus, Éditions de l'éclat, Paris, 2004.

8. Mann, *Place in History*; Maoz Azaryahu and S. Ilan Troen, eds., *Tel-Aviv, the First Century: Visions, Designs, Actualities* (Bloomington: Indiana University Press, 2012); Michael D. Levin, *White City: International Style Architecture in Israel; A Portrait of an Era* (Tel Aviv: Tel Aviv Museum of Art, 1988).

9. Rechter's first job in the Yishuv was to measure the land that became Allenby Road. In 1924 he designed Beit Hakadim (The Vase House), named for the large vases on its cornices, located at the corner of Nahalat Binhyamin and Rambam Streets.

10. My observations on the relationship between Orloff and Rechter in this period are based on two interviews with Tuti Sara Rechter (born 1932) at her home in Tel Aviv. The first interview was conducted by Ayelet Carmi on May 21, 2014, and the second was conducted with the author, June 2, 2017.

11. Tuti Sara Rechter, interview with the author, June 2, 2017, Tel Aviv.

12. Tuti Sara Rechter, interview with the author, June 2, 2017, Tel Aviv.

13. On the history of Jewish education in Paris, see Erik H. Cohen, *L'étude and L'éducation juive en France ou l'avenir d'une communauté* (Paris: Editions du Cerg, Collection Judaïsme [Toledot], 1991).

14. Tuti Sara Rechter, interview with the author, June 2, 2017, Tel Aviv.

15. Tuti Sara Rechter, interview with the author, June 2, 2017, Tel Aviv.

16. Tuti Sara Rechter, interview with the author, June 2, 2017, Tel Aviv.

17. Justman Tamir, Justman, and Birnbaum, *À la rencontre*, 30.

18. Rechter would develop this concept of the curved walls further in his later Bauhaus-influenced houses in Tel Aviv, such as the home of the photographer Avraham Soskin, designed in 1933. Ran Shchori, *Zeev Rechter* (Tel Aviv: The Culture and Art Public Committee, 1987) [Hebrew].

19. Chana Orloff, "Small Talk," *Ketuvim*, October 24, 1929. This article is cited in Nathan Harpaz, *Zionist Architecture and Town Planning: The Building of Tel Aviv (1919–1929)* (West Lafayette, IN: Purdue University Press, 2013), 166–67, n.5. My account is sourced from Ayelet Carmi's English translations of Orloff's article. *Ketuvim* was published by Agudat HaSofrim V'Hasifrut Ha'Ivrit B'Eretz Isrzel (The Association of Hebrew Writers) between 1926 and 1933, with initial support from Bialik. Bialik, however, broke with the Association of Hebrew Writers and its periodical, *Ketuvim*, a year later in 1927.

20. Orloff, "Small Talk."

21. Orloff, "Small Talk."

22. Orloff, "Small Talk."

23. Known today as the "modernists" of Tel Aviv, such stylistic innovations and rejection of the Bezalel tradition created the basis for a new

national style, according to the "master narrative" of Israeli art, first articulated by Tel Aviv Art Museum curator and director Haim Gamzu, and later developed by art historians Gideon Ofrat and Yigal Zalmona. See Gideon Ofrat, *One Hundred Years of Israeli Art* (New York: Basic Books, 1998); Yigal Zalmona, *A Century of Israeli Art* (Farnham: Lund Humphries in association with The Israel Museum, Jerusalem, 2013). After Edward Said's book *Orientalism* (1979) challenged the discourse of the West's historical, cultural, and political perceptions of the East, Israeli scholars writing during the first decade of the twenty-first century characterized Gutman's and Rubin's works, which are often unpopulated or include idealized or exoticized Arab inhabitants of Palestine, as "Orientalist." See Dalia Manor, "Orientalism, Primitivism and Folklore," *Art in Zion*, 134–62.

24. Orloff, "Small Talk."

25. Orloff, "Small Talk."

26. Margaret Olin, "Review: Dalia Manor, Art in Zion: The Genesis of Modern National Art in Jewish Palestine," *Images: Journal of Jewish Art and Culture* 2 (2009): 227–30; Golan, *Modernity and Nostalgia*.

27. See Goldman Ida, "The Child of My Delight: From House to Museum," in *Five Moments: Trajectories in the Architecture of the Tel Aviv Museum* (Tel Aviv: Tel Aviv Museum of Art, 2012), E31. For other studies on the founding of the Tel Aviv Museum of Art, see Tami Katz-Freiman, "Founding the Tel Aviv Museum, 1930–1936, Tel Aviv Museum Annual Review" (January 1982): 9–48.

28. Cited in Goldman Ida, "Child of My Delight," E25–34.

29. Cited in Yael Neuwirth, "Commemorating Zina," in *The Lady of the White City: Zina Dizengoff*, Chapter 9, Kindle Edition.

30. Gabriel Talphir, *Chana Orloff: Her Life and Art* (Tel Aviv: Gazit, 1950), 13.

31. Goldman Ida, "Child of My Delight," n.8: Rubin quoted in Nathan Danovitz, *Tel Aviv: From San Dunes to City* (Jerusalem and Tel Aviv: Schoken, 1959, in Hebrew); Reuven Rubin, "Tel Aviv Gets a Museum," in *Rubin: My Life, My Art*, 195–97.

32. Meir Dizengoff to Chana Orloff, July 4, 1930, written in Hebrew, translated by Ayelet Carmi. Ateliers Chana Orloff.

33. Orloff likely knew Dizengoff during the period in which she lived in Neve Tzedek as a young woman before moving to Paris.

34. Meir Dizengoff to Chana Orloff, July 4, 1930: "But, in order to prevent any misunderstandings, I wish you would talk with him first, and if he accepts the terms, I will send him a formal invitation."

35. In response to his letter, Orloff sent Dizengoff several short letters in Hebrew; in one of them, she warned Dizengoff not to ask Chagall for a painting for the new museum as part of the arrangement: "he will not be so pleased about that, I could sense it." Chana Orloff to Meir Dizengoff, September 30,

1930, Tel Aviv Museum Archive, translated by Ayelet Carmi. And in another she affirms that "it will be better to order a painting from him in advance."

36. Cited in Benjamin Harshav, *Marc Chagall and His Times: A Documentary Narrative*, trans. Benjamin and Barbara Harshav (Stanford, CA: Stanford University Press, 2004), 363–64.

37. While it took some time for Orloff to meet with Chagall, who was then living in Paris, Dizengoff sent Chagall a formal letter of invitation a few months after his visit with Orloff: "Dear Master, I have just asked you to accept the invitation delivered by Madame Chana Orloff to come spend some time in Tel Aviv." See Meir Dizengoff to Marc Chagall, October 17, 1930, cited in Harshav, *Marc Chagall and His Times*, 366. He amended the proposal he had shared with Orloff by stating that Chagall was welcome to stay in his home "as long as [he] want[ed]," adding that "the period of April through November is the best weather to visit the Holy Land" when "it is not too warm."

38. Harshav, *Marc Chagall and His Times*, 351, 363. In 1929 Chagall proposed founding a Jewish museum to the center of Yiddish culture, the YIVO (Yiddish Scientific Institute) in Vilna, which materialized in 1935.

39. Harshav, *Marc Chagall and His Times*, 367–368. Marc Chagall in Paris to Meir Dizengoff in Tel Aviv, Paris 1930.

40. Harshav, *Marc Chagall and His Times*, 367–68.

41. Harshav, *Marc Chagall and His Times*, 266, n.8.

42. "Chagall on Palestine: An Interview in Paris with Ben-Tavriya (June 1931)," cited in Harshav, *Marc Chagall and His Times*, 377.

43. Jonathan Wilson, *Marc Chagall* (New York: Schocken, 2007), 109–10.

44. Wilson, *Marc Chagall*, 109–110; Harshav, *Marc Chagall and His Times*, 386–86.

45. Chana Orloff to Meir Dizengoff, October 27, 1930, Tel Aviv Museum of Art Archives [Hebrew], translated by Ayelet Carmi.

46. Chana Orloff to Meir Dizengoff, October 27, 1930.

47. Chana Orloff to Meir Dizengoff, November 17, 1930, Tel Aviv Museum of Art Archives [Hebrew], translated by Ayelet Carmi.

48. The ceremony took place on April 8, 1934 (23 Nissan 5694). Neuwirth, "Commemorating Zina."

49. See "Chapters from the Early History of the Tel Aviv Museum: From the Memoirs of Karl Schwarz, on the First Anniversary of His Death," *Haaretz*, November 1, 1963. Schwartz was an art historian who was the former director of the Jewish Museum in Berlin and emigrated to Palestine to direct the Tel Aviv Museum of Art.

50. Goldman Ida, "Child of My Delight," E26–27. See also Levin, *White City*, 50, n.156 [in Hebrew].

51. Esther Raab to Gabriel Talphir, October 28, 1934, Paris, translated by Ayelet Carmi. Cited in *Fragments from Esther Raab's Letters to Gabriel*

Talphir, quoted in Gabriel Talphir, "The Red House in the Heart of Golden Sands," *Moznaim (Scales)* 5, no. ND, (April 1982): 35–37 [Hebrew].

52. Dalia Manor, "Facing the Diaspora: Jewish Art Discourse in the 1930s Eretz Israel," in *Israeli Exiles: Homeland and Exile in Israeli Discourse*, ed. Ofer Shiff (Jerusalem: The Ben-Gurion Research Institute, Ben-Gurion University of the Negev Press, 2015), 13–52.

53. Graciela Trachtenberg, "Between Inclusion and Exclusion: Women Artists in the Eye of Israeli Art Criticism," in *Women Artists in Israel, 1920–1970*, ed. Ruth Markus (Tel Aviv: Migdarin [Genders] Series, Hakibbutz Hamehuchad Publishing House, 2008), 39 [Hebrew]. Manor, "Facing the Diaspora."

54. Coutard-Salmon, "Chana Orloff," 67.

55. Chana Orloff, *Shmaryahu Levin*, 1935. Bronze, Haifa Museum of Art. Shmaryahu Levin founded the Technion in Haifa.

56. Coutard-Salmon, "Chana Orloff," 68.

57. Anonymous, "Tel Aviv: Dizengoff's First Speech after His Recovery at the Opening of Chana Orloff's Exhibition," *Doar Hayom*, February 3, 1935.

58. "The beauty of Yefet adorns the tents of Shem." (Genesis 9:27) (Megilla 9b).

59. Cited in Anonymous, "Tel Aviv."

60. Mordechai Narkiss, *Davar*, December 25, 1934, 3.

61. Eugen Kolb, "Small Change," *Doar Hayom*, March 11, 1935: 3.

62. Reuven Rubin, "Chana Orloff's Show: Opening at Tel Aviv Museum," 1935. Ateliers Chana Orloff.

63. Rubin, "Chana Orloff's Show."

64. Rubin, "Chana Orloff's Show."

65. Miriam Bernstein-Cohen, "Chana Orloff," *Te'atron ve-Omanut*, October 15, 1925, 4–5.

66. Shari Golan, "Meta-Present: Feminism and Gender in Israeli Art—Two Curatorial Case Studies," *Feminism and Israeli Art, Beit Berl College Publication* 10 (2007): 160–61.

67. Anonymous, "The Magic Needle of Chana Orloff," *Doar Hayom*, February 4, 1935, 3.

68. Anonymous, *Palestine Post*, March 24, 1935.

69. K. Baerwald, "Orloff's Sculpture: An Appreciation," review of her solo exhibition at Steimatsky Gallery, Jerusalem, 1935. Uncited press clipping, Ateliers Chana Orloff.

70. Uncited interview signed S.W., "From Petah Tikvah to Paris: Interview with Chana Orloff," *Palestine Post* [undated press clipping, Ateliers Chana Orloff]; cited in Coutard-Salmon, 68.

71. *Palestine Post*, April 12, 1935.

72. Franck Salameh, *The Other Middle East: An Anthology of Modern Levantine Literature* (New Haven, CT: Yale University Press, 2017), 170,

347, n.38. Salameh cites two letters from Eliahu Elath (Epstein) to Corm (dated May 6, 1935, and January 25, 1938, Charles Corm Archives), in which Epstein discusses inviting Orloff and the archaeologist Nahum Slouschz to Lebanon to participate in the intellectual exchanges that Corm hosted.

73. Salameh, *Other Middle East*, 169.

74. Salameh, *Other Middle East*, 170.

75. Salameh, *Other Middle East*, 169.

76. Salameh, *Other Middle East*, 169.

77. H.K., "Chana Orloff. Sculptor of International repute," *Art Notes*, 1936. Ateliers Chana Orloff; reprinted in the Australian Jewish newspaper *The Westralian Judean* (September 1, 1936). See Grobot-Dreyfus, "Sociabilités familiales," vol. I, 260, for the critical reception to this show.

78. Ruth Green Harris, "Varied Fare for the London Palate," *New York Times*, August 2, 1936.

79. On Berthe Weill, see Marianne Le Morvan, "Berthe Weill: A Pioneering yet Overlooked Gallery Owner," *Archives Juives* 50, no. 1 (2017): 10–25; Marianne Le Morvan, *Berthe Weill, 1965–1951: La petite galleriste des grandes artistes* (Paris: L'Harmattan, 2011); *Berthe Weill: Indomitable Art Dealer of the Parisian Avant-Garde* (Grey Art Gallery, New York University), Sept. 1–Dec. 1, 2024 (traveling to Montreal Museum of Art); Berthe Weill, *Pow! Right in the Eye: Thirty Years Behind the Scenes of Modern French Painting*, ed. Lynn Gumpert, translated by William Rodarmor (Chicago: University of Chicago Press, 2022).

80. I am grateful to Marianne Le Morvan for sharing a photograph and documentation of this event with me from the Berthe Weill Archives. The names of many people in the photograph are identified in *Bulletin de la Galerie B.Weill* no. 106, *4e année de l'exposition du groupe Barat-Levraux, Capon, Kars, Mouillot, Sabbagh, Savin, Smith, Vergé-Sarrat*, du 18 janvier au 1er février 1932, Berthe Weill Archives, collection Marianne Le Morvan.

81. For more on FAM and its history, see Birnbaum, *Women Artists in Interwar France*; Paula J. Birnbaum, "The Exhibitions of the Femmes Artists Modernes: Paris, 1931–38," *Artl@s Bulletin* 8, no. 1 (Spring 2019): 152–65.

82. Orloff exhibited a few sculptures with this group in all but two of their annual exhibits (she exhibited annually between 1932 and 1937, missing only the 1931 and 1938 shows).

83. "Les Femmes Artistes d'Europe," Paris, Musée Jeu de Paume, January 11–February 28, 1937. See Marine Servais, "'Les femmes artistes d'Europe exposent au Musée du Jeu de Paume' en février 1937: Bilan et analyse du statut et de la production des artistes femmes sous le Front populaire" (master's thesis, Université de Paris I, Panthéon Sorbonne, September 2014).

84. Valentine Prax, Andrée Jouclard, Marie Laurencin, Suzanne Lalique,

Suzanne Valadon, Helene Marre, Louise Hervieu, Marie Mela Muter, Cheriane, Hermine David.

85. James D. Herbert, *Paris 1937: Worlds on Exhibition* (Ithaca, NY: Cornell University Press, 1998); Coutard-Salmon, "Chana Orloff," 69–70.

86. Herbert, *Paris 1937*.

87. Stephanie Barron, ed., *Degenerate Art: The Fate of the Avant-Garde in Nazi Germany* (Los Angeles: Los Angeles County Museum, 1991).

88. Harshav, *Marc Chagall and His Times*, 282–83.

89. Julian Jackson, *France: The Dark Years: 1940–1944* (Oxford: Oxford University Press, 2003), 106, 184–86; Paula Hyman, *From Dreyfus to Vichy: The Remaking of French Jewry, 1906–1939* (New York: Columbia University Press, 1979), 65–67, 105; Pierre-Andre Taguieff and Annick Durafour, *Céline, la race, le Juif* (Paris: Fayard, 2017).

90. Dr. Mira Oberholzer commissioned portraits of herself and her husband, Dr. Emile Oberholzer, in 1936; Adele Levy commissioned portraits of herself and Dr. David Levy in 1937. Orloff's portrait of David Levy resides in the collection of the New York Psychoanalytic Institute.

91. Edward Alden Jewell, "Sculpture on the 'Must,'" *New York Times*, February 6, 1938. See Jewell's more comprehensive review, "Sculpture Shown By Chana Orloff," *New York Times*, February 4, 1938.

92. Anonymous press review from Marie Sterner Gallery exhibition, 1938. Ateliers Chana Orloff. Grobot-Dreyfus, "Sociabilités familiales," vol. II, Doc. 121, 145.

93. Anonymous press review from Marie Sterner Gallery exhibition, 1938.

94. Grobot-Dreyfus, "Sociabilités familiales," vol. I, 257.

95. To learn more about David R. Pokross and Muriel Kohn Pokross, who bequeathed their art collection to Smith College, see https://scma.smith.edu/blog/shared-inspiration-about-collectors.

96. A. J. Philpott, "Chana Orloff's Striking Sculpture Shown at Museum," *Boston Globe*, February 16, 1938, 11.

97. Chana Orloff, *Reuven Rubin*, 1926, bronze, 26 × 20 × 8½ in., The Brooklyn Museum, Brooklyn, NY, https://www.brooklynmuseum.org/opencollection/objects/46907; Chana Orloff, *Young American*, bronze, 33 × 9 × 6 in., The Brooklyn Museum, Brooklyn, NY, https://www.brooklynmuseum.org/opencollection/objects/46908.

98. Chana Orloff, *The Dancers (Sailor and Sweetheart)*, 1923 (cast 1929), cast by Eugène Rudier, Paris, bronze, 38½ × 21 × 16 in., The Philadelphia Museum of Art, Philadelphia, PA, https://www.philamuseum.org/collection/object/45507.

99. H.D., "Artists and Relief Work," *New York Times*, May 1, 1938.

100. H.D., "Artists and Relief Work."

CHAPTER 11

1. André Warnod, "Visite d'atelier, Chana Orloff est rentrée à Paris," *Arts*, September 7, 1945.

2. Monica Bohm-Duchen, *Art and the Second World War* (Princeton, NJ: Princeton University Press, 2013), 111; 267, n.17, cited in Laurence Bertrand Dorléac, *Art of the Defeat, France 1940–1944* (Los Angeles: Getty Research Institute, 2008), 56.

3. I am grateful to Kerry Wallach for sharing her research on this exhibition with me, author of a forthcoming book (to be published by Penn State Press) on artist Rahel Szalit-Marcus, who lived in Montparnasse from 1933 until her arrest and deportation to Drancy and then Auschwitz.

4. *Jüdische Welt-Rundschau* was a German-language newspaper printed in Paris from March 1939 to May 1940 and distributed internationally, including in Palestine. See Max Osborn, "Jüdische Kunstausstellung in Paris," *Jüdische Welt-Rundschau* 1, no. 19 (July 21, 1939): 6.

5. On the 1939 "vente-exposition," see also "La Vente-Exposition Palestinienne du Kéren-Kayémeth Leisraël," *L'Univers Israélite* 94, no. 38 (June 9, 1939): 697; "Une exposition d'art juif," *L'Univers Israélite* 94, no. 41 (June 30, 1939): 740; and "A l'exposition d'art juif," *L'Univers Israélite* 94, no. 42 (July 6, 1939): 765. The exhibition also was reviewed in the Yiddish *Naye Prese* and the monthly magazine of the French Jewish National Fund, *La Terre Retrouvée*. See also Rachel Wischnitzer, "From My Archives," *Journal of Jewish Art* 6 (1979): 2–20.

6. Carl Zigrosser to Tola Rank, July 10, 1940. Beata Rank Archive.

7. Silver and Golan, eds., *Circle of Montparnasse*, 115.

8. Chana Orloff, "Mon ami Soutine," *Evidences* 21, (November 1951): 21.

9. Ernest Hiemer, *Der Pudelmopdachelpinscher (The Poodle-Pug-Dachshund-Pincher)* (Nuremberg: Der Stürmer-Buchverlag, 1940), 35.

10. See the Panzer II (1936–45), followed by the Wespe (German for "wasp"), a self-propelled German gun (1943–45).

11. Robin Lumsden, *Himmler's SS: Loyal to the Death's Head* (Cheltenham: The History Press, 2009), 201–6.

12. André Dezarrois to Chana Orloff, February 21, 1939. Ateliers Chana Orloff.

13. Dezarrois to Chana Orloff, February 21, 1939.

14. "L'Exode de Paris," exhibition catalog, Liberation of Paris Museum.

15. Chana Orloff to Tola Rank, July 8, 1940. Beata Rank Archive.

16. Orloff to Tola Rank, July 8, 1940.

17. Orloff to Tola Rank, July 8, 1940.

18. Ariane Justman Tamir, with Élie Justman, "L'exil" and "La fuite," two unpublished documents, Ateliers Chana Orloff.

19. Orloff, "Mon amie Soutine," 20. See also Stanley Meisler, *Shocking*

Paris: Soutine, Chagall and the Outsiders of Montparnasse (New York: Palgrave Macmillan, 2015), 159.

20. Orloff, "Mon amie Soutine," 20.

21. The decree passed on October 18, 1940.

22. This ordinance passed on July 16, 1940.

23. Bohm-Duchen, *Art and the Second World War*, 109.

24. The exhibit ran from September 5, 1941, through January 15, 1942. It was organized and funded by the propaganda arm of the German military administration in France (via the Insitut d'études des questions juives), and a film version came out in French cinemas in October 1941. Debbie Lackerstein, *National Regeneration in Vichy France: Ideas and Policies, 1930–1944* (New York: Routledge, 2016), 263.

25. Gaston Poulain, "Les grands exilés de l'école de Paris: Chana Orloff," *La Depèche de Paris*, August 2, 1946.

26. Madame Sautreau was the daughter of the first Norwegian Nobel laureate for literature, 1903, Bjørnstjerne Martinius Bjørnson.

27. Marrus and Paxton, *Vichy France and the Jews*, 188–89.

28. Poulain, "Les grands exilés."

29. The exact date of their departure is uncertain from Frédéric's account, but Orloff later reported that they did not leave Paris until sometime during the first week of August.

30. Chana Orloff to Tola Rank, August 11, 1942. Letter courtesy of Tola Rank Archives.

31. Rachel Perry, "Georges Kars," in *The Ghez Collection: Memorial in Honor of Jewish Artists, Victims of Nazism*, ed. Rachel Perry (Haifa: Weiss-Livnat International MA in Holocaust Studies, Strochliz Institute for Holocaust Research, Hecht Museum, University of Haifa, 2019), 50–55.

32. Perry, "Georges Kars," 52.

33. Alan Riding, *And the Show Went On: Cultural Life in Nazi-Occupied Paris* (New York: First Vintage Books, Penguin Random House, 2011), 175–76.

34. S.W., "From Petah Tikvah to Paris."

35. Justman Tamir, with Justman, "L'exil."

36. Justman Tamir, with Justman, "La fuite."

37. Poulain, "Les grands exilés."

38. Ruth Fivaz-Silbermann, "La fuite en Suisse: migrations, strategies, fuite, acceuil, refoulement et destin des refugiées juifs venus de France durant la Seconde Guerre mondiale" (PhD diss., Université de Genève, 2017, no. L. 884), 621; Françoise Seligmann, *Liberté, quand tu nous tiens . . .* (Paris: Fayard, 2016), 77–92; Michel Germain and Robert Moos, *Les sauveteurs de l'ombre: Ils ont sauvé des Juifs: Haute-Savoie 1940–1944* (Bourdeux: Mollat/ La Fontaine de Siloué, 2010).

39. Poulain, "Les grands exilés."

40. Ruth Fivaz-Silverman, email message to author, December 17, 2017.

Françoise Seligmann, *Liberté*, 77–92; Germain and Moos, *Les sauveteurs de l'ombre*, 94.

41. Fivaz-Silbermann, "La fuite en Suisse," 629 n.106. The private property on Swiss soil belonged to the Mottet family.

CHAPTER 12

1. Official documentation regarding Orloff and her son's legal status as Jewish refugees in Switzerland can be consulted at Archives de l'État de Genève (AEG), Geneva, Switzerland, Justice et Police, Ef 2-1057, Justman-Orloff, Chana; for Georges Kars, see AEG, Ef2-1087. References to documents from the Justman-Orloff and Georges Kars dossiers in this archive will hereafter be abbreviated as: AEG, Justice et Police. See also Archives federales Suisses (AFS), Bern. Fonds: E4264, N, Dossier No. 7799, Carton No. 678 (Chana Orloff) and Dossier No. 7252, Carton No. 621 (Georges Kars). See also: Mario Kënig and Bettina Zeugin, eds., *Final Report of the Independent Commission Experts Switzerland—Second World War* (Zürich: Pendo Verlag GmbH, 2002). www.uek.ch, www.pendo.de; Valérie Boillat, *Switzerland and Refugees in the Nazi Era* (Taiwan: The Commission, 1999).

2. Other people in this group included a family, Albert Jacobson, Hedwig Jacobson-Wetiz and her mother, Marie Wetiz-Markus. They passed the border December 17, 1942, at Landecy ("Region Rozon: Landecy pont de Combe à travers champs, groupe de personnes, 22h"). I am grateful to Ruth Fivaz-Silbermann for sharing this information with me from the Archives federales, Geneva, Switzerland, Justice et Police.

3. *Switzerland, National Socialism and the Second World War Final Report*, 108.

4. AEG, Justice et Police.

5. Simon Erlanger, "The Politics of Transmigration: Why Jewish Refugees Had to Leave Switzerland from 1944 to 1954," *Jewish Political Studies Review* 18, no. 1–2 (Spring 2006): 71–85.

6. Erlanger, "Politics of Transmigration"; Georg Kreis, "Swiss Refugee Policy, 1933–1945," in *Switzerland and the Second World War*, ed. Georg Kreis (London: F. Cass, 2000), 103–31; Jacques Picard, "Investigating 'Anti-Semitism': On the Concept and Function of Anti-Semitism and Problems Involved in Research," in Kreis, ed., *Switzerland and the Second World War*, 132–57.

7. Kreis, "Swiss Refugee Policy."

8. Kreis, "Swiss Refugee Policy"; Alfred Häsler, *The Lifeboat Is Full* (New York: Funk & Wagnalls, 1969), translated from German by Charles Lam Markmann.

9. Poulain, "Les grands exilés."

10. Georges Kars, exhibition brochure, Galerie Georges Moos, 1932.

11. Simon Erlanger, *"Nur ein Durchgangsland": Arbeitslager und Inter-*

nierungsheime für Flüchtlinge unter Emigranten in der Schweiz 1940–1949
("Only a Transit Country": Work Camps and Internment Homes for Refu-
gees among Emigrants in Switzerland, 1940–1949) (Zürich: Chronos Verlag,
2006); *Switzerland, National Socialism and the Second World War Final
Report*, 148–51.

12. Dr. Alan Morris Schom, "The Unwanted Guests: Swiss Forced Labor
Camps, 1940–44" (Los Angeles: Simon Wiesenthal Center, 1998).

13. According to Schom, the Swiss also imposed what was called a "Jew
tax" on all wealthy Jewish refugees, who were forced to disclose the details
of their bank accounts. Schom, "Unwanted Guests."

14. Poulain, "Les grands exilés."

15. Anecdote shared in Justman and Justman Tamir, "La fuite,"
unpublished document based on memories of Élie Justman, 1983. Ateliers
Chana Orloff.

16. A woman named Madame Bachoulkova-Brun is associated with this
address.

17. Poulain, "Les grands exilés."

18. Germaine Richier to Chana Orloff, March 17, 1943. Ateliers Chana
Orloff.

19. Lievin also shared the studio during the war years with another Jewish
émigré artist, a painter named Sigismond Kolozsváry. Chana and Élie moved
into Lievin's apartment, located at 3 rue Duchosal, on April 5, 1944, after
living in Geneva for fourteen months.

20. Warnod, "Visite d'atelier." Warnod also wrote several interviews and
articles on Orloff that were translated into Hebrew and published in *Gazith*
in this period.

21. Marianne Colin, "Chana Orloff" February 7, 1946, uncited newspaper
clipping, artist's pressbook, Ateliers Chana Orloff. Colin describes this self-
portrait as "this figure at once round and acute, an observer and a creator,
perceptive and maternal, is a perfect success."

22. Chana Orloff, *Portrait of M. Kundig*, 1943, plaster, bronze, 26 × 30 ×
24 cm. Location unknown.

23. Tola Rank Archives, The Estate of Beata Rank.

24. AEG, Justice et Police (Georges Kars). See also Archives federales,
Bern. Fonds: E4264, N, Dossier No. 7252, Carton No. 621 (Georges Kars).

25. AEG, Justice et Police; Georges Kars to Swiss Justice Department,
December 25, 1942.

26. Georges Kars to Chana Orloff, January 6, 1943. Ateliers Chana Orloff.

27. AEG, Justice et Police. Letter from Dr. Rudolf Kopecky to the head of
the Swiss Police (Pt. Gindraux), December 26, 1942.

28. Georges Kars to Chana Orloff, February 12, 1943. Ateliers Chana Orloff.

29. Georges Kars to Chana Orloff, March 20, 1943. Ateliers Chana Orloff.

30. Georges Kars to Chana Orloff, August 2, 1943. Ateliers Chana Orloff.

31. Georges Kars to Chana Orloff, August 2, 1943.

32. Georges Kars to Chana Orloff, August 2, 1943.

33. Georges Kars to Chana Orloff, August 2, 1943.

34. Georges Kars to Chana Orloff, August 2, 1943.

35. Georges Kars to Chana Orloff, September 14, 1943. Ateliers Chana Orloff.

36. Georges Kars to Chana Orloff, September 14, 1943.

37. Georges Kars to Chana Orloff, October 14, 1943. Ateliers Chana Orloff.

38. Telegram from Tola Rank to Chana Orloff, October 19, 1943. Ateliers Chana Orloff.

39. AEG, Justice et Police (Justman-Orloff, Chana).

40. AEG, Justice et Police (Justman-Orloff, Chana).

41. Zvi Nishri to Chana Orloff, April 28, 1943 (in which he acknowledges receipt of a letter from her dated February 23, 1943, from Geneva). Ateliers Chana Orloff.

42. Zvi Nishri to Chana Orloff, April 28, 1943.

43. Masha and Dov Skibin to Chana Orloff, July 25, 1943 (English): "Why don't you write to us, and why don't you send us a certificate from the British ambasedor [*sic*] that you need money for your living? Without this certificate we can't send you money from here. Please let us know if you want to come to Palestine so we can get you certificates." Ateliers Chana Orloff.

44. Masha and Dov Skibin to Chana Orloff, May 1944 (English). Ateliers Chana Orloff.

45. Dov Skibin to Vaad Ha-Hatzalah, July 7, 1944. Catalog number S26\29: The Central Zionist Archives.

46. The Nordmann family later had the work cast in bronze.

47. Jean Nordmann to Andrée Justman, Ateliers Chana Orloff.

48. Élie Justman. Letter to Police dated July 31, 1943. AEG, Justice et Police (Justman-Orloff, Chana).

49. Milich to Chana Orloff, March 30, 1944. In this letter, Milich explains to Orloff how to navigate travel to Lugano under military control.

50. Docteur Charlie Saloz to Police, March 23, 1944. AEG, Justice et Police (Justman-Orloff, Chana).

51. Docteur Charlie Saloz to Police, March 23, 1944. AEG, Justice et Police (Justman-Orloff, Chana).

52. Fonds Galerie Moos (1913–2012) [29 boxes]. Section: Archives de la Bibliothèque d'art et d'archéologie de Genève (BAA), du Musée d'Art et d'Histoire; BAA Archives Galerie Moos. See Carton 18, "Tableaux en Depôt, 1941–1955," 39. The gallery took five works in bronze on consignment from "Orloff-Salmanovitz" on November 8, 1943. Only one of them (#1547) was sold: #1545: Bronze, Chana Orloff, *L'Autriche*; #1546: Bronze, Chana Orloff, *Tête verte*, price listed as 1,000 Swiss francs; #1547: Bronze, Chana Orloff, *Ophèlie*, sold on March 28, 1944, to R. Junot for 800 Swiss francs; #1548:

Bronze, Chana Orloff, *Couché assis*; #1548: Bronze, Chana Orloff, *Couché debout.*

53. Jacques Salmanowitz was chairman of the Geneva-based inspection company Société Générale de Surveillance (SGS) from 1919 until his death in 1966.

54. The gallery took a commission of 160 Swiss francs, and the profit of 640 Swiss francs went directly to Salmanowitz as creditor. As for the four works that did not sell, it is unclear whether Salmanovitz kept them for his own collection.

55. The Swiss Radical Party was nonetheless a bourgeois party at this time.

56. M. Louis Gielly to M. Du Pasquier, Interior Secretary General, March 24, 1943.

57. M. Louis Gielly, "Un protectionnisme déplacé," *Le Genevois*, March 25, 1944.

58. Response from Rothmund to Gielly, April 6, 1944. AEG, Justice et Police (Justman-Orloff, Chana).

59. Response from Rothmund to Gielly, April 6, 1944.

60. First, Moos wrote to the Monsieur Berthoud, director of the Bureau du Permis de Séjour; then the Swiss artist Alexandre Mairet, president of the Geneva chapter of the Society of Swiss Painters, Sculptors and Architects, wrote to this same official, expressing the support of his organization; finally, Orloff sent her own note to Police Captain Gauthier in Geneva, requesting permission to participate in the exhibit. Georges Moos to M. A. Berthout, Director of the Bureau du Permis de Séjour, December 19, 1944; Alexandre Mairet wrote to M. A. Berthout, Director of the Bureau du Permis de Séjour, January 4, 1945: "Orloff's works are appreciated in artistic circles," and "the artists in this organization are not opposed to her exhibiting her work at the Galerie Moos." Chana Orloff wrote a letter to Monsieur le Capitaine Gauthier, January 17, 1945, Arrondissement Territoriel in Geneva, asking for permission to have an exhibition at the Galerie Georges Moos, February 17–March 8, 1945.

61. Poulain, "Les grands exilés."

62. Dorette Berthoud, "Channa Orloff," *La Suisse*, 1945 [press clipping, Ateliers Chana Orloff]; Albert Rheinwald, "Chana Orloff," *Journal de Genève*, February 26, 1945; J. de F., "Chana Orloff," Ateliers Chana Orloff; Ed. M., "L'Exposition Chana Orloff," *La Suisse*, February 28, 1945.

63. The pose of Eve in all three of Orloff's renditions is nearly identical to that of Eve's in Masaccio's *The Expulsion from Paradise* (1425). Orloff would likely have been familiar with that work, located in the Brancacci Chapel in Florence, given her academic training and study in the history of art.

64. Berthoud, "Channa Orloff."

65. Berthoud, "Channa Orloff."

66. Berthoud, "Channa Orloff."

67. The Moos Gallery sales log lists her friends Salmanovitz and Zychlinski.

68. Kars died on February 6, 1945.

69. The actual mortuary masks are missing.

70. Nora Kars to Chana Orloff, May 1945.

71. Perry, "Georges Kars," 52.

72. Chana and Élie left Geneva on May 2, 1945.

73. Grobot-Dreyfus, "Sociabilités familiales," vol. I, 365, on details of Rudier's work casting for Arno Breker's exhibition in May 1942 at the Musée de l'Orangerie, organized by Pierre Laval. In 1945 Rudier's three studios were destroyed, and there are still many questions regarding his collaboration with the Nazis.

74. Warnod, "Visite d'atelier."

75. Michèle S. Cone, *Artists Under Vichy: A Case of Prejudice and Persecution* (Princeton, NJ: Princeton University Press, 1992).

76. Warnod, "Visite d'atelier."

77. Poulain, "Les grands exilés."

78. Riding, *And the Show Went On*, 346.

79. The exhibit included twenty-seven sculptures and forty drawings created between 1937 and 1944. It included the portrait *Chana Rovina*, 1935 (see figure 10.3) and *Grasshopper*, 1939 (see figure 11.4).

80. Francis Jourdain, "Chana Orloff," Galerie de France, exh. Cat. 1946. In 1939, Jourdain was Secretary General of the World Committee Against War and Fascism.

81. Jourdain, "Chana Orloff."

82. Jourdain, "Chana Orloff."

83. For example, see G. Arout, "Femmes Sculpteurs: Chana Orloff," *Heures Nouvelles*, February 4, 1946, 4; Bernard Dorival, "Mort d'un Univers," *Les Nouvelles Littéraires*, February 14, 1946, 5; Lo Duca, "Chana Orloff," *Le Monde Illustré*, March 9, 1946, 314; Michel Florisoone, "Chana Orloff, Galerie de France," *Beaux-Arts*, February 14, 1946, 2; Maximilien Gauthier, "D'une rive à l'autre," *Les Nouvelles Littéraires*, February 14, 1946, 6; René Jean, "Les arts: Petites Expositions," *Le Monde*, February 21, 1946; Marie-Louise Sondaz, "Les Arts À Paris: un grand sculpteur: Chana Orloff," *L'Ordre*, February 12, 1946.

84. Marianne Colin, "Chana Orloff," February 7, 1946, uncited newspaper clipping. Ateliers Chana Orloff.

85. Colin, "Chana Orloff."

86. Colin, "Chana Orloff."

87. "Chana Orloff," Wildenstein, New York, May 7–31, 1947.

88. "Current Sculpture Contrasts," *New York Times*, May 11, 1947; *Menorah Journal* (Autumn 1947).

89. Alfred Frankfurter, *Art News*, May 7–31, 1947; the same text appears in the exhibit brochure "Chana Orloff," Wildenstein.

90. Undated and uncited document, Ateliers Chana Orloff, in reference to the Wildenstein exhibition.

91. "Chana Orloff," M.H. de Young Memorial Museum, Golden Gate Park, San Francisco, CA. November 7–December 8, 1947.

92. Patricia P. Coleman, "Chana Orloff—Sculptures," Press Release, de Young Museum, October 16, 1947. Archives, Fine Arts Museums of San Francisco.

93. Coleman, "Chana Orloff—Sculptures."

CHAPTER 13

1. Chaim Gamzu, *Chana Orloff (1888–1958): Exposition Retrospective—120 Sculptures—60 Dessins* (Tel Aviv: Tel Aviv Museum of Art, 1969).

2. Préface, Chana Orloff. Association des Musées d'Israel (Spring 1961).

3. Bashan, "Chana Orloff."

4. The 1947 UN Partition Plan divided the area into three entities: a Jewish state, an Arab state, and an international zone around Jerusalem. While Arabs rejected the proposal and started a war to prevent it, David Ben-Gurion, then chairman of the executive board of the Jewish Agency, believed that compromise was the best option for the Jews. He proclaimed the establishment of the state of Israel as an immigration state where citizenship is automatically granted to Jews.

5. Gideon Ofrat, *Origins of Eretz-Israeli Sculpture, 1906–1939* (Herzliya: Herzliya Museum, 1990). [Hebrew and English].

6. Bashan, "Chana Orloff."

7. Paula Apenshlak, "Conversation with Chana Orlov," *Al HaMishmar*, April 13, 1949, 3. See also Oz Almog, *The Sabra: The Creation of the New Jew* (Berkeley: University of California Press, 2000), 1–2.

8. S.W., "Tel Aviv Notes: Chana Orloff," *Palestine Post*, May 9, 1949.

9. S.W., "Tel Aviv Notes."

10. Gamzu served as director of the Tel Aviv Museum of Art twice: 1947–49 and 1962–76.

11. Haim Gamzu to Chana Orloff, June 26, 1947. Tel Aviv Museum Archives.

12. Chana Orloff to Haim Gamzu, July 17, 1947. Tel Aviv Museum Archives.

13. Haim Gamzu to the British Embassy, August 3, 1947. Tel Aviv Museum Archives.

14. Haim Gamzu to Chana Orloff, August 10, 1947. Tel Aviv Museum Archives.

15. S.W., "Tel Aviv Notes."

16. Gamzu, *Chana Orloff* (1949).

17. Ariane Justman Tamir was born in Paris on September 4, 1948. Orloff's other grandchildren, Michaël Justman and Éric Justman, were born in 1950 and 1953, respectively.

18. Tal, "Hanna Orloff."

19. See Roumain, "'Toute femme,'" August 8, 1935.

20. Yehudit Winkler, "Chana Orloff's Exhibition: The Woman Who Proved Sculpting Is Not Only a Form of Art, But a Philosophy as Well," *Herut*, March 17, 1961, 4.

21. Winkler, "Chana Orloff's Exhibition."

22. Among the few other female sculptors working in the Yishuv at this time were Batia Lichansky, who immigrated from Ukraine in 1910 and sculpted many monuments, and Miriam Berlin, who sculpted portraits of Bialik and Dizengoff, both of which were shown at the Jewish Pavilion at the 1937 Paris International Exhibition. Orloff was close friends with Israeli painters Anna Ticho, Sionah Tagger, Lea Nikel, and others.

23. "Chana Orloff Exhibition," *Al HaMishmar*, April 18, 1949, 4.

24. Eugen Kolb, "A World of Beauty and Truth: Chana Orloff at the Tel Aviv Museum," *Al HaMishmar*, May 6, 1949.

25. See Manor, "Pride and Prejudice"; and Manor, "Turning to Diaspora," 13–52.

26. Dr. Lisetta Levy, *Devar HaShavna*, April 15, 1949, 23. Levy was a well-known art critic who was born in Milan in 1917 and moved to Brazil in 1954 after working for the newspaper *Devar ha-Shavua* in Israel.

27. Arie Lerner, "A Great Artist Returns to Homeland," *Devar*, March 6, 1949.

28. Gamzu, *Chana Orloff* (1949).

29. Apenshlak, "Conversation with Chana Orlov," 3. See also Almog, *Sabra*, 1–2.

30. Jacob Fichman, "The Female Artist in Israel," *Devar*, May 6, 1949, 14.

31. Anonymous, "Magic Needle," 3; Manor, "Facing the Diaspora," 13–52; Trachtenberg, "Between Inclusion and Exclusion," 29.

32. *Maariv*, February 25, 1949, 4.

33. *Maariv*, February 25, 1949, 4.

34. Especially considering that *Maariv* is an Israeli newspaper with an Israeli audience.

35. Anonymous, "Magic Needle," 3.

36. Trachtenberg, "Between Inclusion and Exclusion," 39.

37. Documentation of Orloff's Ben Gurion portrait is lacking.

38. Zalmona, *Century of Israeli Art*, 100–107.

39. Tuti Sara Rechter, interview with the author, June 2, 2017, Tel Aviv.

40. Undated press clipping, source unknown. Ateliers Chana Orloff.

41. To Orloff's left is her niece, Nechama Ofek, her sister Masha Skibin's daughter, and to her right, Nechama's husband, Pinhas Ofek.

42. My account of Orloff's monument at Ein Gev builds upon the research of Maoz Azaryahu, "A Tale of Two Monuments," *Gender, Place and Memory in the Modern Jewish Experience: Re-Placing Ourselves*, eds. Judith Tydor Baumel and Tova Cohen (London: Valentine Mitchell, 2003), 252–68. See also Esther Levinger, *Monuments for the Fallen in Israel* (Tel Aviv:

Hakibbutz Hameuchad, 1993), 9–110; Rachel Dezi, "The Bee Will Bloom the Desert," in *Masoret Haya* (*A Living Tradition*), ed. Tzafi Zeba-Elran, Haya Milo, and Idit Pintel-Ginsberg (Haifa: Pardes Publishing, 2020), 183–93 [Hebrew]; Tali Tamir, "*Still Alive*, or The Dark Silhouette's Travels Around the World," https://www.erev-rav.com/archives/52053, October 12, 2020 [Hebrew, translated by Maya Shimony].

43. The kibbutz Ein Gev was founded by a group of pioneers from Germany, Austria, and the Baltic countries as a "tower and stockade" settlement, a settlement method used by Zionists during the 1936–39 Arab Revolt. Azaryahu, "Tale of Two Monuments."

44. Azaryahu, "Tale of Two Monuments."

45. "Women of the Israel Defense Forces: History in Combat Units," Jewish Virtual Library, https://www.jewishvirtuallibrary.org/history-of-women-in-idf-combat-units.

46. "Women of the Israel Defense Forces," Jewish Virtual Library.

47. Edna Lomsky-Feder and Orna Sasson Levi, *Women Soldiers and Citizenship in Israel: Gendered Encounters with the State* (London: Routledge, 2019).

48. The kibbutz members later published the book as *The Battle of Ein Gev: The Fortress on the Eastern Shore of Lake Kinneret* (Tel Aviv, 1950).

49. Efra, *The Battle of Ein Gev* (Tel Aviv, 1950), 213; quoted in Azaryahu, "Tale of Two Monuments," 268, n.14.

50. Azaryahu, "Tale of Two Monuments," 262, n.16, Ein Gev (the kibbutz bulletin), May 1980, 13.

51. See Paula Kabalo, *Israeli Community Action* (Bloomington: Indiana University Press, 2020).

52. Esther Levinger, "Women and War Memorials in Israel," *Woman's Art Journal* 16, no. 1 (1995): 40–46.

53. Although Orloff began the project in 1949, it took several years for kibbutz members to raise the funds—approximately several thousand dollars—from monies provided to the families of fallen soldiers by the Israeli government along with assistance from American donors.

54. Cited in Tamir, "*Still Alive*."

55. Boris Iofan, a Jewish Soviet architect from Odessa, designed the Pavilion, and Riga-born Vera Mukhina created the statue that crowns the top. Orloff's sculpture, however, predates Yevgeny Vuchetich's monument *The Motherland Calls* (1967), which, at eighty-five meters tall, was declared the tallest statue in Europe, the tallest outside of Asia and the tallest statue (excluding pedestals) of a woman in the world. See Aaron J. Cohen, *War Monuments, Public Patriotism and Bereavement in Russia, 1905–2015* (Idaho Falls, ID: Lexington Books, 2020).

56. Oppenheim immigrated to Palestine from Germany in 1937 with friends from the B'Telem group, who were members of the Hehalutz youth

movement and were the founding nucleus of kibbutz Ein Gev. Cited in Ofer Aderet, "Who Is the Mysterious Woman Beside Rachel's Grave?" *Haaretz*, November 17, 2013.

57. Azaryahu, "Tale of Two Monuments," 264, n.20. "With the dedication of the statue" (Ein Gev archive).

58. Azaryahu, "Tale of Two Monuments," 264, n.19. Ein Gev (the kibbutz bulletin), June 1952.

59. Kibbutz Ein Gev Archives. Cited in Tamir, "Still Alive."

60. Barnet Litvinoff, "Kiryat Montparnasse," *Jewish Chronicle*, February 1, 1952.

61. Azaryahu, "Tale of Two Monuments," 264, n.18. Ein Gev (the kibbutz bulletin), May 1952.

62. Azaryahu quotes a number of members of kibbutz Ein Gev who interpreted Orloff's statue as representing "a farmer woman, rooted in the soil," who protects her offspring "from any enemy or danger." Azaryahu, "Tale of Two Monuments," 264.

63. M. Baigel, "L'art de Chana Orloff," *La Presse Nouvelle*, August 1968.

64. For a feminist analysis of the Book of Ruth, see Jennifer L. Koosed, *Gleaning Ruth: A Biblical Heroine and Her Afterlives* (Columbia: University of South Carolina Press, 2012).

65. Reuven Rubin to Chana Orloff, April 3, 1955. Ateliers Chana Orloff.

66. Reuven Rubin to Chana Orloff, July 17, 1955. Ateliers Chana Orloff.

67. Reuven Rubin to Chana Orloff, July 17, 1955.

68. A letter from Esther Rubin to Orloff acknowledges the tension surrounding the commission: "Regarding your sculpture for the Histadrut, you cannot imagine how much work and effort Rubin has put in to make this materialize. He doesn't even want to write you about it as you would never realize it without being here on the spot so that he could explain it." Esther Rubin to Chana Orloff, June 13, 1955. Ateliers Chana Orloff.

69. Nechama Genosar, "Meetings with Chana Orloff," *Al HaMishmar*, April 20, 1969, 3.

70. David Giladi, "With Chana Orloff," *Maariv*, February 19, 1957.

71. Giladi, "With Chana Orloff."

72. Namir also was a Knesset member and government minister, as well as being one of the heads of the Labor Zionist movement.

73. Giladi, "With Chana Orloff."

74. Giladi, "With Chana Orloff."

75. Reuven Rubin to Chana Orloff, December 7, 1959. Ateliers Chana Orloff.

76. Orloff exhibited works from this series in two group exhibitions in Paris: *La Semeuse* or *The Sower* was included in the Salon Comparaisons, Paris, Musée d'Art Moderne de la Ville de Paris, March 8–31, 1958; *Woman with a Basket* was included in Sculpture Française Contemporaine et l'École de Paris, Musée Rodin. Paris, June–October 1958.

77. On the history of pronatalism in the formation of the Israeli nation-state, see Sarah S. Willen, "Seeing the 'Holy Land' with New Eyes," in *Reproaching Borders: New Perspectives on the Study of Israel-Palestine*, eds. Sandra Marlene Sufian and Mark LaVine (Lanham, MD: Rowman & Littlefield, 2007), 145–76.

78. The Irgun (Irgun Zvai Le'umi b'Eretz Yisrael or The National Military Organization of the Land of Israel, otherwise known as Etzel or IZL after its Hebrew acronym) was an underground Zionist paramilitary organization founded in 1937 by a group of Haganah commanders. It was identified with the right-wing Revisionist Movement within Zionism, who rejected the Haganah's policy of "restraint." The latter movement was founded by Vladimir Jabotinsky. Arthur Hertzberg, *The Zionist Idea: A Historical Analysis and Reader* (Philadelphia: The Jewish Publication Society, 1997), 257–70. Led by future Israeli prime minister Menachem Begin in 1944, the Irgun declared a mutiny on the British, followed by violent attacks on British targets. John Bowyer Bell, *Terror Out of Zion: The Fight for Israeli Independence* (New York: Transaction Publishers, 1996), 163–203.

79. Shimon-Erez Blum, "Between the Lion Cub of Judea and the British Lion: cause lawyers, British rule and national struggle in Mandatory Palestine," *Comparative Legal History* 7, no. 1, (2019): 3.

80. Shimon-Erez Blum, "Between the Lion Cub of Judea and the British Lion," 4.

81. Mapai later merged with the Israeli Labor Party in 1968. Bruce Hoffman, *Anonymous Soldiers: The Struggle for Israel* (New York: Knopf, 2015).

82. David Whittaker, *The Terrorism Reader*, 4th ed. (London: Routledge, 2012), 29; Bell, *Terror Out of Zion*, 172.

83. Iona and Peter Opie, *The Oxford Dictionary of Nursery Rhymes* (Oxford: Oxford University Press, 1951, 2nd. Ed. 1997), 442–43.

84. Zalmona, *Century of Israeli Art*, 58–61.

85. Zalmona, *Century of Israeli Art*, 58–61.

86. *Davar*, March 3, 1964, 3. The Miriam Talphir Prize was created to honor writer and translator Miriam Talphir, who collaborated with her husband, Gabriel Talphir, on the journal *Gazith*.

CHAPTER 14

1. Haim Gamzu, "Introduction," *Chana Orloff (1888-1968)*.

2. *Davar*, December 20, 1968, 16.

3. *Omer*, April 15, 1969 (a daily newspaper for new immigrants, which was a supplement of *Davar*).

4. Gamzu, "Introduction."

5. Gamzu, "Introduction."

6. Gamzu, "Introduction."

7. Manor, "Facing the Diaspora," 13–52.

8. Eli Frankel, "Forty Years of Sculpting: A Talk with Chana Orloff," *Maariv*, May 2, 1952, 4.

9. Hana Kofler, *Chana Orloff: Line and Substance, 1912–1968* (Tefen: The Open Museum, Tefen Industrial Park, 1993). The Open Museum, Tefen, closed in 2020; Naama Riba, "Family Is Looking for Home for 120 Artworks," *Haaretz*, May 18, 2021.

10. *Chana Orloff: Sculptures et Dessins* (Paris: Musée Rodin, 1971).

11. *Chana Orloff: Sculptures et Dessins*, 7.

12. Gamzu, *Chana Orloff*; Talphir, *Chana Orloff*.

13. Pascale Samuel and Paul Salmona, *Chagall, Modigliani, Soutine*.

14. Chana Orloff, Instagram photo, November 26, 2018.

15. "Chana Orloff: Feminist Sculpture in Israel." https://www.mkm.org.il /eng/Exhibitions/4795/Chana_Orloff%3A_Feminist_Sculpture_in_Israel.

16. Dana Gillerman, "Forever a Woman," in *"Seven Nights Supplement"* of *Yediot Aharonot* (July 4, 2017) [Hebrew].

17. Smadar Keren, "Still Alive, Noa Tavori," Great Mother group show, Nehoshtan Museum, Ashdot Yaakov, February–August 2020, http://noatavori .com/. The "Great Mother" exhibition also featured the artists Doris Arkin, Natalie Schlosser, Ester Schneider, and Gershon Knispel. For an important analysis of Tavori's piece, see Tamir, "Still Alive."

18. Interview with the author, October 25, 2021.

19. Keren, "Still Alive, Noa Tavori."

20. Keren, "Still Alive, Noa Tavori."

21. Keren, "Still Alive, Noa Tavori."

22. Tamir, "Still Alive."

23. Tamir, "Still Alive."

24. Keren, "Still Alive, Noa Tavori."

SELECTED BIBLIOGRAPHY

I list here only the foremost writings that have been of use in writing this book. This bibliography is by no means a complete record of all the works and sources I have consulted. It indicates the substance and range of reading upon which I have formed my ideas about Chana Orloff's life and work. Primary sources such as exhibition reviews, interviews, and archival sources appear in the notes, but not the bibliography.

Alroey, Gur. *Unpromising Land: Jewish Migration to Palestine in the Early Twentieth Century*. Redwood City, CA: Stanford University Press, 2014.

Azaryahu, Maoz. "A Tale of Two Monuments." In *Gender, Place and Memory in the Modern Jewish Experience: Re-Placing Ourselves*, edited by Judith Tydor Baumel and Tova Cohen, 252–268. London: Valentine Mitchell, 2003.

Azaryahu, Moaz, and S. Ilan Troen, eds. *Tel-Aviv, the First Century: Visions, Designs, Actualities*. Bloomington: Indiana University Press, 2012.

Bard, Christine. *Les Garçonnes; Modes et fantasmes des Années folles*. Paris: Flammarion, 1998.

Barron, Stephanie, ed. *Degenerate Art: The Fate of the Avant-Garde in Nazi Germany*. Los Angeles: Los Angeles County Museum, 1991.

Benbassa, Esther, and M. B. DeBevoise. *The Jews of France: A History from Antiquity to the Present*. Princeton, NJ: Princeton University Press, 1999.

Benstock, Shar. Women of the Left Bank: Paris, 1900–1940. Austin: University of Texas Press, 1986.

Bernstein, Deborah S. *The Struggle for Equality: Urban Women Workers in Pre-State Israeli Society*. New York: Praeger, 1987.

Bernstein, Deborah S. *Pioneers and Homemakers: Jewish Women in Pre-State Israel*. Albany: State University of New York Press, 1992.

Bernstein, Deborah S. "Daughters of the Nation between the Public and Private Spheres in Pre-State Israel." In *Jewish Women in Historical Perspective*, edited by Judith Reesa Baskin, 287–312. Detroit: Wayne State University Press, 1998.

Birnbaum, Paula J. *Women Artists in Interwar France: Framing Femininities*. Farnham: Ashgate Publishing, 2011.

Birnbaum, Paula J. "Chana Orloff: Sculpting as a Modern Jewish Mother." In *Reconciling Art and Motherhood*, edited by Rachel Epp Buller, 45–56. Farnham: Ashgate Publishing, 2012.

Birnbaum, Paula J. "Chana Orloff: A Modern Jewish Woman Sculptor of the School of Paris," *Modern Jewish Studies* 15, no. 1 (January 2016): 65–87.

Birnbaum, Paula J. "Chana Orloff: Gender and the Modern Artist as Émigré." Comité International d'Histoire de l'Art (CIHA) 34th World Congress of Art History, Beijing, China. Conference proceedings, 2020.

Birnbaum, Pierre. *Anti-Semitism in France: A Political History from Léon Blum to the Present*. Oxford: Cambridge University Press, 1992.

Bohm-Duchen, Monica. *Art and the Second World War*. Princeton, NJ: Princeton University Press, 2013.

Campbell, Louise. "Perret and His Artist-Clients: Architecture in the Age of Gold." *Architectural History* 45 (2002): 409–40.

Campbell, Louise. "'Un Bel Atelier Moderne': The Montparnasse Artist at Home." In *Designing the French Interior: The Modern Home and Mass Media*, edited by Anca I. Lasc, Georgina Downey, and Mark Taylor, 179–189. London: Bloomsbury, 2015.

Chadwick, Whitney, and Tirza True Latimer, eds. *The Modern Woman Revisited: Paris Between the Wars*. New Brunswick, NJ: Rutgers University Press, 2003.

Chapin, David A., and Ben Weinstock. *The Road from Letichev: The History and Culture of a Forgotten Jewish Community in Eastern Europe*, Volume 1. Lincoln, NE: iUniverse, 2000.

Cone, Michèle S. *Artists Under Vichy: A Case of Prejudice and Persecution*. Princeton, NJ: Princeton University Press, 1992.

Corn, Wanda M., and Tirza True Latimer. *Seeing Gertrude Stein: Five Stories*. Berkeley: University of California Press, 2011.

Coutard-Salmon, Germaine. "Chana Orloff (1888–1968) et son Époque." PhD diss., Université de Paris-IV-Sorbonne, 1980. [French].

Da Costa Meyer, Esther, ed. *Pierre Chareau: Modern Architecture and Design*. New Haven, CT: Yale University Press, 2016.

Dell, Simon. "After Apollinaire: SIC (1916–19); Nord-Sud (1917–18); and L'Esprit Nouveau (1920–5)." In *The Oxford Critical and Cultural History of Modernist Magazines*, edited by Peter Brooker, Sascha Bru, Andrew Thacker, and Christian Weikop, 142–59. London: Oxford University Press, 2009.

Des Courières, Edouard. *Chana Orloff: Les sculpteurs français nouveaux*. Paris: Gallimard, 1927.

Drot, Jean-Marie, and Dominique Polad-Hardouin. *Les heures chaudes de Montparnasse*. Paris: Hazan, 1999. [French].

Fivaz-Silbermann, Ruth. "La fuite en Suisse: migrations, strategies, fuite, acceuil, refoulement et destin des refugiées juifs venus de France durant la Seconde Guerre mondiale." PhD diss., Universite de Genève, 2017, no. L. 884. [French].

Gamzu, Haim. *Chana Orloff.* Tel-Aviv: Tel Aviv Museum of Art, 1949. [Hebrew].

Gamzu, Haim. *Chana Orloff.* Tel Aviv: Massada, 1951. [Hebrew].

Gamzu, Haim. *Chana Orloff (1888–1958): Exposition Retrospective—120 Sculptures—60 Dessins.* Tel Aviv: Tel Aviv Museum of Art, 1969. [French].

Gamzu, Haim, Jean Cassou, Cécile Goldscheider, Germaine Coutard-Salmon, eds. Musée National d'Art Moderne, Centres Pompidou: *Chana Orloff.* Brescia: Shakespeare and Company, 1980. [French].

Gitelman, Zvi. *A Century of Ambivalence: The Jews of Russia and the Soviet Union, 1881 to the Present.* 2nd ed. Bloomington: Indiana University Press, 2001.

Golan, Romy. "The École Français' vs. the 'École de Paris': The Debate about the Status of Jewish Artists in Paris between the Wars." In *The Circle of Montparnasse: Jewish Artists in Paris, 1905–1945,* edited by Kenneth E. Silver and Romy Golan, 81–87. New York: Universe Books, 1985.

Golan, Romy. "From Fin de Siècle to Vichy: The Cultural Hygienics of Camille (Faust) Mauclair." In *The Jew in the Text,* edited by Linda Nochlin and Tamar Garb, 156–73. London: Thames and Hudson, 1995.

Golan, Romy. *Modernity and Nostalgia: Art and Politics in France Between the Wars.* New Haven, CT: Yale University Press, 1995.

Golan, Romy. "The Last Seduction." In *Paris in New York: French Jewish Artists in Private Collections,* edited by Susan Chevlowe, 10–21. New York: The Jewish Museum, 2000.

Goldman Ida, Batsheva. "The Child of My Delight: From House to Museum." In *Five Moments: Trajectories in the Architecture of the Tel Aviv Museum,* 25–34. Tel Aviv: Tel Aviv Museum of Art, 2012.

Gonnard, Catherine, and Elisabeth Lebovici. *Femmes Artistes, Artistes-Femmes.* Paris de 1880 a nos jours. Paris: Hazan, 2007.

Green, Christopher. *Art in France, 1900–1940.* New Haven, CT: Yale University Press, 2000.

Grobot-Dreyfus, Anne. "Sociabilités familiales, intellectuelles, artistiques et politiques autour d'une dessinatrice, illustratrice, graveuse et sculpteur: Chana Orloff (1888–1968), entre Paris, l'Amérique et Israël (1916–1968)." PhD diss., University of Burgundy, Dijon, 2018. [French].

Grossman, Cissy. "Restructuring and Rediscovering a Woman's Oeuvre: Chana Orloff, Sculptor in the School of Paris, 1910–1940." PhD diss., The City University of New York, 1998.

Harpaz, Nathan. *Zionist Architecture and Town Planning: The Building of Tel Aviv (1919–1929).* West Lafayette, IN: Purdue University Press, 2013.

Harshav, Benjamin. *Marc Chagall and His Times: A Documentary Narrative.* Stanford, CA: Stanford University Press, 2004.

Hyman, Paula E. *The Jews of Modern France*. Berkeley: University of California Press, 1998.

Jimerson, Lauren. *Painting Her Pleasure: Three Women Artists and the Nude in Early Twentieth-Century Paris*. Manchester: University of Manchester, 2023.

Joubert, Hélène. *Helena Rubinstein: Madame's Collection*. Paris: Skira, 2019.

Justman Tamir, Ariane, Éric Justman, and Paula J. Birnbaum. *À la rencontre de Chana Orloff*. Paris: Àvivre Éditions, 2012.

Kaplan, Matthew. "The *Menorah Journal* and Shaping American Jewish Identity: Culture and Evolutionary Sociology." *Shofar: An Interdisciplinary Journal of Jewish Studies* 30, no. 4 (2012): 61–79.

Kark, Ruth, Margalit Shilo, and Galit Hasan-Rokem, eds. *Jewish Women in Pre-State Israel: Life History, Politics, and Culture*. Lebanon, NH: Brandeis University Press, 2008.

Kaufman, Haim. "Jewish Sports in the Diaspora, Yishuv and Israel." *Israel Studies* 10, no. 2 (2005): 147–67.

Kelly, Debra. *Pierre Albert-Birot*. London: Associated University Presses, 1997.

Kelly, Debra. "Pierre Albert-Birot and SIC: The Avant-Garde Review as Collective Adventure and Personal Poetics." In *La Revue: The Twentieth-Century Periodical in French*, edited by Charles Forsdick and Andy Stafford, 237–248. Oxford: Peter Lang, 2013.

Kleeblatt, Norman, ed. *The Dreyfus Affair: Art, Truth & Justice*. Berkeley: University of California Press, 1987.

Klein, Mason. *Helena Rubinstein: Beauty Is Power*. New York: Jewish Museum, New York, 2014.

Klein, Mason. "Unmasking Modigliani." In *Modigliani Unmasked*, edited by Mason Klein, 1–27. New Haven, CT: Yale University Press, 2017.

Klüver, Billy, and Jean Cocteau. *A Day with Picasso*. Cambridge, MA: MIT Press, 1999.

Klüver, Billy, and Julie Martin. *Kiki's Monparnasse: Artists and Lovers 1900–1930*. New York: Harry N. Abrams Inc., 1989.

Kofler, Hana. *Chana Orloff: Line & Substance, 1912–1968*. Tefen: The Open Museum, Tefen Industrial Park, 1993.

Kolosek, Lisa Schlansker. *The Invention of Chic: Thérèse Bonney and Paris Moderne*. New York: Thames and Hudson, 2002.

Kreis, Georg, ed. *Switzerland and the Second World War*. London: Routledge, 2000.

Lackerstein, Debbie. *National Regeneration in Vichy France: Ideas and Policies, 1930–1944*. New York: Routledge, 2016.

Latimer, Tirza True. *Women Together, Women Apart: Portraits of Lesbian Paris*. New Brunswick, NJ: Rutgers University Press, 2005.

Levinger, Esther. *Monuments for the Fallen in Israel*. Tel Aviv: Hakibbutz Hameuchad, 1993.

Levinger, Esther. "Women and War Memorials in Israel." *Woman's Art Journal* 16, no. 1 (1995): 40–46.

Lieberman, James E. *Acts of Will: The Life and Work of Otto Rank*. New York: The Free Press, 1985.

Linett, Maren Tova. *Modernism, Feminism, and Jewishness*. Cambridge: Cambridge University Press, 2007.

Lyford, Amy. *Surrealist Masculinities: Gender Anxiety and the Aesthetics of Post-World War I Reconstruction in France*. Berkeley: University of California Press, 2007.

Lyford, Amy. *Isamu Noguchi's Modernism: Negotiating Race, Labor and Nation, 1930–1950*. Berkeley: University of California Press, 2018.

Malinovich, Nadia. *French and Jewish: Culture and the Politics of Identity in Early Twentieth-Century France*. Portland: The Littman Library of Jewish Civilization, 2008.

Mann, Barbara E. *A Place in History: Modernism, Tel-Aviv, and the Creation of Urban Jewish Space*. Stanford, CA: Stanford University Press, 2006.

Manor, Dalia. *Art in Zion: The Genesis of Modern National Jewish Art in Jewish Palestine*. London: RoutledgeCurzon, 2005.

Manor, Dalia. "Pride and Prejudice: Recurrent Patterns in Israeli Art Historiography." *History and Theory, Bezalel: Parallel Lines* 1 (2005).

Manor, Dalia. "Art and the City: The Case of Tel-Aviv." In *Tel-Aviv, the First Century: Visions, Designs, Actualities*, edited by Maoz Azaryahu and S. Ilan Troen, 268–269. Bloomington: Indiana University Press, 2012.

Manor, Dalia. "Facing the Diaspora: Jewish Art Discourse in the 1930s Eretz Israel." In *Israeli Exiles: Homeland and Exile in Israeli Discourse*, edited by Ofer Shiff, 13–52. Jerusalem: The Ben-Gurion Research Institute, Ben-Gurion University of the Negev Press, 2015.

Marcilhac, Félix. *Chana Orloff: Sculptures–Catalogue Raisonée*. Paris: Les Éditions De L'Amateur, 1991.

Marrus, Michael Robert, and Robert O. Paxton. *Vichy France and the Jews*. Stanford, CA: Stanford University Press, 1995.

Meisler, Stanley. *Shocking Paris: Soutine, Chagall and the Outsiders of Montparnasse*. New York: Palgrave Macmillan, 2015.

Mendelsohn, Amitai. *Prophets and Visionaries: Reuven Rubin's Early Years, 1914–23*. Jerusalem: The Israel Museum, 2006.

Millman, Richard. *La Question juive entre les deux guerres ligues de droite et antisémitisme en France*. Paris: Colin, 1992. [French].

Morineau, Camille, and Lucia Pesapane, eds. *Pionnières, artistes d'un nouveau genre dans le Paris des années folles*. Paris: Réunion des musées nationaux, 2022. [French].

Nishri, Zvi. "Old Workers in the Second Aliyah." In *The Book of the Second Aliyah*, edited by Bracha Habas, 298–300. Tel Aviv: Am Oved, 1947. [Hebrew].

Nishri, Zvi. "Walid al-mut." In *The Book of the Second Aliyah*, edited by Bracha Habas, 199–201. Tel Aviv: Am Oved, 1947. [Hebrew].

Nochlin, Linda, and Tamar Garb, eds. *The Jew in the Text: Modernity and the Construction of Identity*. London: Thames and Hudson, 1996.

Nora, Pierre. "Between Memory and History: Les Lieux de Memoire." *Representations*, no. 26 (1989): 7–24.

Offen, Karen M. *European Feminisms, 1700–1950: A Political History*. Stanford: Stanford University Press, 2000.

Offen, Karen M. *The Woman Question in France, 1400–1870*. Cambridge: Cambridge University Press, 2019.

Offen, Karen M. *Debating the Woman Question in the French Third Republic, 1870–1920*. Cambridge: Cambridge University Press, 2020.

Ofrat, Gideon. *Origins of Eretz-Israeli Sculpture, 1906–1939*. Herzliya: Herzliya Museum, 1990. [Hebrew and English].

Ofrat, Gideon. *One Hundred Years of Israeli Art*. New York: Basic Books, 1998.

Pappas, Andrea. "The Picture at *Menorah Journal*: Making 'Jewish Art.'" *American Jewish History* 90, no. 3 (2002): 205–38.

Perry, Gillian. *Women Artists and the Parisian Avant-Garde: Modernism and "Feminine" Art, 1900 to the Late 1920s*. Manchester: Manchester University Press, 1995.

Perry, Rachel. "Georges Kars." In *The Ghez Collection: Memorial in Honor of Jewish Artists, Victims of Nazism*, edited by Rachel Perry, 50–55. Haifa: Weiss-Livnat International MA in Holocaust Studies, Strochliz Institute for Holocaust Research, Hecht Museum, University of Haifa, 2017.

Petrovsky-Shtern, Yohanan. *The Golden Age Shtetl: A New History of Jewish Life in East Europe*. Princeton, NJ: Princeton University Press, 2014.

Pollock, Griselda. "Modigliani and the Bodies of Art." In *Modigliani: Beyond the Myth*, edited by Mason Klein, 55–74. New Haven, CT: Yale University Press, 2004.

Reeder, Jan Glier. "The House of Paquin." *Textile and Text* 12 (1990): 10–18.

Reeder, Jan Glier. "Historical and Cultural References in Clothes from the House of Paquin." *Textile and Text* 13 (1991): 15–22.

Reichel, Nirit. "The First Hebrew 'Gymnasiums' in Israel: Social Education as the Bridge between Ideological Gaps in Shaping the Image of the Desirable High School Graduate (1906–48)." *Israel Affairs* 17, no. 4 (October 2011): 604–20.

Riding, Alan. *And the Show Went On: Cultural Life in Nazi-Occupied Paris*. New York: First Vintage Books, Penguin Random House, 2011.

Roberts, Mary Louise. *Civilization without Sexes: Reconstructing Gender in Postwar France, 1917–1927*. Chicago: University of Chicago Press, 1994.

Rubin, Reuven. *Rubin: My Life, My Art*. New York: Funk & Wagnalls, 1971.

Scudder, Janet. *Modeling My Life*. New York: Harcourt, Brace and Company, 1925.

Shafir, Gershon. *Land, Labor and the Origins of the Israeli-Palestinian Conflict, 1882–1914*. Berkeley: University of California Press, 1996.

Shaw, Jennifer L. *Exist Otherwise: The Life and Works of Claude Cahun*. London: Reaktion, 2017.

Shilo, Margalit. "The Transformation of the Role of Women in the First Aliyah, 1882–1903." *Jewish Social Studies, New Series* 2, no. 2 (1996): 64–86.

Shilo, Margalit. "Self-Sacrifice, National-Historical Identification and Self-Denial: Immigration as Experienced by Women of the 'Old Yishuv.'" *Women's History Review* 11, no. 2 (2002): 201–30.

Shilo, Margalit. "The Double or Multiple Image of the New Hebrew Woman." In *Israeli Feminist Scholarship: Gender, Zionism, and Difference*, edited by Esther Fuchs, 72–89. Austin: University of Texas Press, 2014.

Shilo, Margalit. *Girls of Liberty: The Struggle for Suffrage in Mandatory Palestine*. Hanover, NH: University Press of New England for Brandeis University Press, 2016.

Shilo, Margalit. "Professional Women in the Yishuv in Mandatory Palestine: Shaping a New Society and a New Hebrew Woman." *Nashim* 34 (Spring 2019): 33–53.

Shilo, Margalit. "Second Aliyah: Women's Experience and Their Role in the Yishuv." *Jewish Women's Archive*. http://jwa.org/encyclopedia/article/second-aliyah-womens-experience-and-their-role-in-yishuv.

Silver, Kenneth E. *Esprit de Corps: The Art of the Parisian Avant-Garde and the First World War, 1914–1925*. Princeton, NJ: Princeton University Press, 1989.

Silver, Kenneth E., and Romy Golan. *The Circle of Montparnasse: Jewish Artists in Paris, 1905–1945*. New York: Universe Books, 1985.

Sirop, Dominique. *Paquin*. Paris: Adam Biro, 1989.

Spinner, Samuel. *Jewish Primitivism*. Redwood City, CA: Stanford University Press, 2021.

Strauss, Lauren B. "Staying Afloat in the Melting Pot: Constructing an American Jewish Identity in the *Menorah Journal* of the 1920s." *American Jewish History* 84 (1996): 315–31.

Talphir, Gabriel. *Chana Orloff: Her Life and Art*. Tel Aviv: Gazit, 1950.

Tamir, Tali. "*Still Alive*, or The Dark Silhouette's Travels Around the World," https://www.erev-rav.com/archives/52053, October 12, 2020. [Hebrew, translated by Maya Shimony].

Troen, S. Ilan. *Imagining Zion: Dreams, Designs, and Realities in a Century of Jewish Settlement*. New Haven, CT: Yale University Press, 2003.

Wayne, Kenneth. *Modigliani and the Artists of Montparnasse*. New York: Abrams, 2002.

Werth, Léon. *Chana Orloff*. Paris: Éditions G. Crés & Cie, 1927.

Wight, Frederick S. "Recollections of Modigliani by Those Who Knew Him." *Italian Quarterly* 2, no. 1 (Spring 1958): 42–46.

Wilson, Jonathan. *Marc Chagall*. New York: Schocken, 2007.

Zborowski, Mark, and Elizabeth Herzog. *Life Is with People: The Culture of the Shtetl*. New York: Schocken Books, 1952.

ILLUSTRATION CREDITS

Orloff produced her sculptures in many different materials. She cast them in bronze in editions of eight. Therefore, multiple bronze casts of the same work exist in numerous public and private collections, sometimes in multiple *editions*. She also often produced the same work in different materials. I have provided the names of public collections in the text and notes where one can view a specific work of art.

SOURCES AND PERMISSIONS
FOR ILLUSTRATIONS

Figures I.1, 5.1, 5.5, 6.10, 8.13, 11.2, Plate 5, Plate 6, Plate 15: Courtesy of Ateliers Chana Orloff; Photographs by S. Briolant.

Figures I.2, 8.2, 8.5, 8.8, 8.9: Courtesy of Ateliers Chana Orloff. © Thérèse Bonney, The Regents of the University of California.

Figures 1.1, 1.2, 1.3, 2.1, 2.3, 3.1, 3.2, 4.2, 4.3, 4.4, 5.2, 5.3, 5.4, 6.1, 6.2, 6.4, 6.7, 6.11, 6.12, 6.13, 6.14, 7.1, 7.2, 7.4, 7.5, 7.6, 7.7, 7.8, 7.9, 7.10, 7.11, 8.1, 8.3, 8.6, 8.10, 8.11, 8.12, 9.2, 10.2, 10.4, 11.1, 11.3, 11.4, 11.6, 12.1, 12.4, 12.5, 12.6, 12.7, 12.8, 12.9, 13.2, 13.3, 13.4, 13.9, 13.10, 14.1, Plate 1, Plate 2, Plate 3, Plate 4, Plate 7, Plate 8, Plate 10, Plate 11: Courtesy of Ateliers Chana Orloff.

Figure 2.2: YIVO Institute for Jewish Research.

Figure 3.3: Courtesy of the Collection of the Zionist Archives, Zvi Nishri Archive for the History of Physical Education and Sports, Wingate Institute, Israel.

Figures 4.1, 11.6, 13.7: Public domain.

Figures 4.5, 6.3, 6.5, 6.6, 6.8, 6.9, 6.15, 7.3, 8.7, 10.3, 11.5, Plate 12, Plate 13, Plate 14: Photographs by the author.

Figures 8.4, 13.1, 14.2: Courtesy of Israel Zafrir Archive, The Information Center for Israeli Art, The Israel Museum, Jerusalem.

Figure 9.1: Philadelphia Museum of Art, Gift of Carl Zigrosser, 1975. Object Number: 1975-188-58.

Figure 9.3: Gift of Mrs. Randall Chadwick. Mount Holyoke College Art Museum, South Hadley, Massachusetts; Photograph by Petegorsky/Gipe 1956.3.M.OI.

Figure 10.1: Courtesy of Gnazim – The Asher Barash Bio-Bibliographical Institute of the Hebrew Writers Association, catalog number 11960/4.

Figure 11.7: Drawing by Maurice Baudrion, La Salévienne.

Figure 12.2: Courtesy of the Beata Rank Archive.

INDEX

Page numbers for images appear in *italics*.